Cashmere

Translated from the French *Cachemires: La création française 1800-1880* by
Ruth Sharman

First published in the United Kingdom in 2013 by Thames & Hudson Ltd,
181A High Holborn, London WC1V 7QX

www.thamesandhudson.com

First published in 2013 in hardcover in the United States of America by
Thames & Hudson Inc., 500 Fifth Avenue, New York, New York 10110

thamesandhudsonusa.com

Original edition © 2012 Éditions de La Martinière, Paris
This edition © 2013 Thames & Hudson Ltd, London

British Library Cataloguing-in-Publication Data
A catalogue record for this book is available from the British Library

Library of Congress Catalog Card Number 2013932076

ISBN 978-0-500-51712-3

Printed and bound in China

MONIQUE LÉVI-STRAUSS

Cashmere

A FRENCH PASSION
1800–1880

298 illustrations, 285 in color

Photographs of the shawls from the Etro collection
and the author's collection by Massimo Listri

Contents

AUTHOR'S NOTES
Shawl dimensions are given warp (length) first, excluding the fringe. Unless otherwise indicated, each shawl reproduced in this book was woven as a single piece.

* The asterisks that appear in this book refer to entries in the glossary (pp. 312–13).

The following acronyms have been used in the text:
AEDTA Association pour l'Étude et la Documentation des Textiles d'Asie
CNAM Conservatoire National des Arts et Métiers
INPI Institut National de la Propriété Industrielle

Lith par Lemoine

Lith. Imp. du Petit Carreau

Châle Cachemire, fabrique de frédéric Hébert et Ce à Paris.

Preface

In the early 1950s my husband and I used to go to the Paris Flea Market, lured by our love of the unusual. In those days our purchases were, of necessity, mainly utilitarian. But what a marvellous time that was: when we could eat our meals off a dinner service made at Creil-Montereau a century earlier but that cost no more than new china; when I used to wrap a cashmere shawl (once the pride and joy of a nineteenth-century aristocratic lady) around myself like a cloak in the evenings. I was able to buy these shawls very cheaply as it was not worth the dealers' while to restore them. Often all it took was a wash in cold water to bring the glowing colours back to life and restore the much sought-after caressing warmth of the soft goat's fleece. Sometimes I tried my hand at being a textile restorer – a difficult but rewarding job. Repairing and then wearing these shawls led me to wonder when and where they had been woven. Dealers and even textile experts did not seem to know, so I turned to written sources for the answers, realizing how much the women of the previous century had coveted them and what an enormous expense such a purchase would have been for the men who had paid for them: in those days a cashmere shawl cost about the same as a mink coat today.

It did not take me long to consult the relevant catalogue entries and read all the books listed under the headings 'Cashmere' and 'Shawls' at the Bibliothèque Nationale, the Bibliothèque Forney, the Musée des Arts Décoratifs and the Musée Guimet. While such travellers as François Bernier (1664), Victor Jacquemont (1831) and Carl von Hügel (1836) were not experts on the subject, they have provided valuable descriptions of the technique of cashmere shawl weaving.[1] From Jean Rey, an historian and shawl manufacturer, we learn how the Paris shawl industry operated in 1823 and the European techniques employed to copy oriental shawls. Another shawl manufacturer, Émile Frédéric Hébert, depicted the life of a Parisian shawl weaver in an 1857 monograph entitled 'Tisseur en châles à Paris', published by Frédéric Le Play, which Claudine Reinharez (an expert on costume) kindly suggested I should read soon after I embarked on my quest.

The terminology used by these authors in the descriptions of the various techniques and tools of the craft would, especially in the absence of any illustrations, only

Cashmere Shawl Made by Frédéric Hébert & Co., Paris. *Plate no. 4 from the* Souvenir de l'Exposition des Produits de l'Industrie Française de 1839.
Paris, Bibliothèque Forney, shelf mark 0161.41 '1839'. Border of pines for a long shawl. Two confronted (facing) pines and part of one adorsed (back-to-back) pine, marked only by outlines, are superimposed on a complex design of flowers, leaves and creepers.

[1] The dates given in parentheses in this sentence are the dates on which these people visited the East and collected information on shawl weaving. Their publications are cited in the bibliography, pp. 316–17.

be intelligible to those well-versed in the subject. In short, more questions were raised than answered. Three albums of shawl designs were extant, devoid of any explanatory text, compiled by Fleury Chavant (and exhibited in 1837 and 1839) and by Victor Delaye (prior to 1867). In addition, both the Cabinet des Dessins of the Musée des Arts Décoratifs and the Musée des Techniques of the Conservatoire National des Arts et Métiers housed good collections of drawings of shawls.

However, there were no apparent links between these texts without pictures, the pictures without text and the unattributed shawls that we were studying. It was perhaps this gap that, in 1955, had prompted John Irwin (at that time keeper of the Indian section at the Victoria and Albert Museum in London) to write a book entitled *Shawls: A Study in Indo-European Influences*. The book traces the history of Kashmir shawls and nineteenth-century European copies of them. Thirty-six plates show examples of the oriental weavers' production; fifteen plates are of shawls manufactured in Britain (Norwich, Edinburgh and Paisley). Plate number 50 shows a long shawl with a white background from a private collection, which is attributed to a manufacturer in Paisley, and dates from about 1850. It is, however, identical to the pattern by the French designer Antony Berrus, shown on page 244, left, of this book, except for the horizontal border and the harlequin fringe. So was this shawl woven in Paisley after all? This is just one of many unsolved mysteries that may continue to elude researchers, so jealously did manufacturers guard their trade secrets.

John Irwin's project was courageous: with over fifty illustrations of shawls in the book (each with explanatory text, and date and place of origin) he laid himself wide open to correction and thereby earned a reputation as a pioneering spirit among students of the history of Kashmir shawls in Europe. Although some of its dates have subsequently been revised, his book opened up a new area of research into the cross-fertilization of influences between the East and Europe during the nineteenth century – of which shawls provide one of the best examples. In 1973, his first book long out of print, Irwin produced a second, revised, edition entitled *The Kashmir Shawl*. Eight additional plates were included, showing *boteh* (or pine) patterns brought back from India by William Moorcroft in 1823 (now in the Metropolitan Museum, New York); eight new illustrations of cashmere shawls were also included. But all the examples of shawls from Norwich, Edinburgh and Paisley were omitted. Irwin justifies this change in the preface: 'This has been considered necessary in view of the subsequent expansion of knowledge about European shawl history, and because more specialized studies by the appropriate authorities are now in preparation. I have reached this decision in consultation with my colleagues in the Museum's Department of Textiles, and I am especially grateful to Miss N. K. Rothstein and Miss W. E. Hefford for going carefully through the text and making many detailed suggestions.'

Although I was familiar with the relevant books and documents, I was still at a loss to date or find a provenance for the shawls I found in antique dealers' shops, auction rooms or private hands. I was also unable to equate the nineteenth-century terminology with the various types of shawls. I therefore approached the Musée Historique des Tissus in Lyons, which I regarded as the mecca of the textile world, and met with the keeper, Jean-Michel Tuchscherer, and his technical assistant, Gabriel Vial, who had taught at the École de Tissage, Lyons. The former soon dashed my hopes by bursting out laughing:

'Kashmir shawls? We know absolutely nothing about them. In fact, if you want to write something on the subject, I'll gladly publish it.' He was very kind in allowing me to examine the shawls in the museum. Gabriel Vial did his best to explain to me the technical differences between shawls from the two continents. I, in return, was able to share information that I had gleaned in the course of my reading on the subject. We agreed to meet again.

The opportunity presented itself a few months later, through Krishna Riboud, an expert on ancient Chinese textiles, who had been collecting Asian materials for thirty years. She had just founded the Association pour l'Étude et la Documentation des Textiles d'Asie (AEDTA) and invited Monsieur Vial and me to examine her collection of shawls, most of which come from Kashmir and nearby regions. Monsieur Vial's comments shed new light on some obscure sections of the historical texts that I had failed to understand. We spent days at a time studying shawls together, in the company of Odile Valansot (an assistant curator at the Musée Historique des Tissus). I should like to pay tribute to Monsieur Vial's knowledge and to express my appreciation of his generosity in sharing it with me. Without his and Madame Riboud's encouragement, I would probably have abandoned the project. Madame Riboud died in 2000, and her heirs donated her entire collection of Asian textiles, including more than one hundred cashmere shawls, to the Musée Guimet.

Monsieur Vial introduced me to Christiane Lassalle, keeper of the Musée du Vieux Nîmes. This museum, which occupies the former bishop's palace, has about one hundred cashmere shawls in its collection. The majority are of European origin; Nîmes ranked third among the centres of the French shawl industry and some of the examples I was shown were produced there, so I was able to gain a good idea of a typical Nîmes shawl.

Having gathered as much information as possible from books and from the shawls themselves, I explored the textile collections in the Paris museums. I found shawls in the Asian Department of the Musée de l'Homme; in the Costume Department of the Musée des Arts et Traditions Populaires; in the Textile Department of the Musée des Arts Décoratifs and, more predictably, at the Musée de la Mode et du Costume de la Ville (later known as the Musée Galliera) in Paris, where Madeleine Delpierre was head keeper. She spent nearly two hours showing me about thirty shawls she had assembled from the museum's reserves, held in storage in various parts of the city. It was then that I had the idea of exhibiting the museum's shawls. I planned to complete the display by asking AEDTA to loan some Kashmir shawls, and by drawing on other collections. Madeleine Delpierre agreed to mount an exhibition of shawls in the spring of 1982. While I was examining the shawls, she remarked that I was using precise criteria for establishing dates, which influenced her decision to stage an exhibition of cashmere shawls at the museum. A historian by training, she confessed that she had always been hesitant about displaying the shawls draped over the shoulders of mannequins for fear of committing an anachronism. On this topic, I have noticed that costume designers working on films set in the eighteenth and nineteenth centuries often make mistakes when it comes to matching cashmere shawls with dresses. It is partly for their benefit that I am publishing the fruits of my research.

In 1978 the historian Louis Lomüller had published an impressive biography of the industrialist Guillaume Ternaux, who became famous as a shawl manufacturer during the first third of the nineteenth century. I wrote to Monsieur Lomüller, who gave

me a list of Ternaux's descendants. Mademoiselle Delpierre contacted them to ask whether they had any shawls woven by their ancestor. They lent us four shawls for the forthcoming exhibition; two of these matched the description of shawls ordered from Ternaux in 1811 by Napoleon (pp. 119–23). This was our first success.

We knew of a French shawl in the Victoria and Albert Museum that had caused a sensation at the 1839 Exhibition. The museum agreed to lend it to us. The assistant keeper of the Textile Department, Miss Hefford, had identified the shawl from a reproduction of its original design drawing that appeared in a contemporary publication, *Souvenir de l'Exposition de 1839*. It had been woven by Gaussen the elder to a design by Amédée Couder who had called it the *Nou-Rouz* (pp. 151–56). N. K. Rothstein, deputy keeper of the department, discovered the original design for the shawl hanging on the wall of a staircase in the Conservatoire National des Arts et Métiers (CNAM) in Paris. These two colleagues of Irwin have studied the superb European shawls that were acquired by the Victoria and Albert Museum throughout the course of the nineteenth century.

The Musée de l'Impression sur Étoffes in Mulhouse holds both woven and printed cashmere shawls. This museum also houses a wealth of accessible archive material, which helps in the identification of locally printed shawls. But the identification of European shawls from other sources (Normandy, Provence, Britain) is more problematic. Under the supervision of Jacqueline Jacqué, the curator, a second exhibition of shawls was held in Mulhouse in February 1983. In December of the same year a third exhibition opened at the Musée Historique des Tissus in Lyons. Finally, in 1988, Martine Nogarède, who was Madame Lassalle's successor at the Musée du Vieux Nîmes, asked me to curate the exhibition 'Nîmes et le châle' (Nîmes and the Shawl). My aim in all four exhibitions was the same: to show the host museum's entire collection of cashmere shawls and to demonstrate to the visiting public how the designs and the various techniques had evolved. A catalogue was not published for the Mulhouse exhibition, but the catalogues for the exhibitions in Paris, Lyons and Nîmes now constitute the inventories of collections in these three museums.

My various investigations over the years had enabled me to draw up a rough chronology (many entries were tentative), which proved helpful to keepers wishing to date items in their textile collections. I relied on each exhibition to put my classification to the test and to confirm my methodology. Errors were of course inevitable. As each exhibition came and went I aimed, ideally, to correct dates where necessary or at least to reduce margins of error. There were also some unexpected colour harmonies – for example, when a shawl could be linked to a dress of the same date, thereby dispelling any lingering doubts.

In the Indian subcontinent, and in Kashmir in particular, shawls have been woven for centuries. The great Indian collections, at the Victoria and Albert Museum, the Museum of Fine Arts in Boston and AEDTA in Paris – to mention just a few of the most outstanding – possess shawls or fragments of shawls woven in Kashmir before 1800. Kashmir's role in fashion and in the European textile industry is, however, limited to the nineteenth century. I therefore confine myself in this book to that period in the history of the Kashmir shawl, and to French production. I made the decision to concentrate on shawl-making in France, even though important shawl industries also flourished elsewhere: for example, in Britain (Edinburgh and Norwich initially, and later in Paisley); Austria (Vienna)

and Germany, where production centred on Elberfeld; and Russia (Nizhny Novgorod). I had good reason for limiting my coverage in this way: British, Austrian and German manufacturers were inspired by the French designers' products, just as the Lyons and Nîmes producers looked to Paris. This relationship did not change throughout the period in question. Limiting myself to a study of French shawl designs is, therefore, not as restrictive as it might first appear. It will then be up to specialists in each country, following on from my contribution, to research documentary evidence for their own national shawl industries and publish the results. My coverage of such areas would have been limited to secondary sources (details of previous publications are listed in the bibliography at the end of this book). I thought it preferable to reproduce the greatest possible number of previously unpublished, reliably authenticated French examples and documentation rather than cover more ground superficially.

Although I have isolated the history of French shawl production from that of other European countries, I could not separate it from that of Kashmir: development in these two regions was closely linked throughout the the nineteenth century. In this book we move from France to Kashmir and back, as the story unfolds. Unlike their British counterparts, French museums did not buy shawls at the time of the great national or international exhibitions. Those now in the French state collections were given or bequeathed to them, with no information as to their provenance. This reveals the low esteem in which nineteenth-century industrial arts were long held in France. Fortunately, signed and dated original shawl designs were conserved by two Paris museums (see the chapters on Couder and Berrus). The Cabinet des Dessins of the Musée des Arts Décoratifs was given all the design drawings and gouaches from Berrus's studio by his widow; hundreds of pencil drawings, bound in albums, can be studied there by arrangement. Dozens of other outline designs by Berrus and Gonelle are filed in drawers. The then keeper of the Cabinet des Dessins, Marie-Noël de Gary was kind enough to allow me access to this collection whenever I wished. The other collection of designs belongs to CNAM; they are hung on a wall by a staircase that is often closed to the public. These designs, about thirty in all, are signed Couder, Berrus and Sevray. The earliest dates from 1823 and the latest from 1878; they were all exhibited at the national industrial exhibitions. It is vital to refer back to such evidence in order to understand how the style of shawls evolved.

It is all too apparent that the designs of other, less famous names are now lost to us, since the number and variety of extant shawls is greater than those recorded by surviving designs. What can be asserted with confidence is that the design drawings that we are lucky enough to be able to publish in this book exerted significant influence on the development of style. I should like to thank Michèle Bachelet of CNAM, who allowed me access to the famous staircase over many years and authorized the publication of Couder's handwritten *Notices Explicatives*, concerning three of his designs that had at one time been exhibited and that she found in the museum's archives.

In studying the design drawings reproduced here, the reader may wonder why only one square shawl design has been included (p. 134). The reason is that this example was the only design drawing of its type to be exhibited; it dates from 1834, when square shawls enjoyed greater popularity than long shawls because they were better

suited to the cut of contemporary clothes. The Berrus albums contain dozens of pencil and pen-and-ink designs for square shawls, but long shawls were endowed with more prestige.

My original intention had been to drape most of the shawls when they were photographed for this book. However, I abandoned the idea after realizing that although the smaller decorative motifs would still be visible (despite the folds), the larger motifs would be obscured by shadows and the overall impression of the design composition would be lost. But I have to admit that a Kashmir shawl loses much of its allure when it is laid flat.

To those who would like to know more about the origins and symbolism of the pine (or *boteh* in Kashmir) I can offer the following brief explanation: this motif probably first appeared in Persia or India, but there is such controversy on the subject that it is very difficult to opt for any one of the many hypotheses. Much has been written about its probable significance, from 'tree of life' to 'mango', with others opting for 'cypress' and 'palm'. I have opted for the term 'pine' throughout the book since it is most widely used in the English-speaking world; and I gratefully acknowledge Miss Hefford's help in providing English equivalents for the specific terms related to the shawl industry.

After cataloguing several public collections of cashmere shawls in Europe, I was given the opportunity to examine collections in some of the great museums of the United States. Having almost resolved the issue of the dating of shawls, I then began to study the production of every French shawl maker singled out by the juries of industrial exhibitions. In the second part of this book, therefore, readers will find monographs dedicated to the most famous names in this new profession. At the Institut National de la Propriété Industrielle (INPI), I searched for patents filed by manufacturers regarding spinning, weaving and dyeing processes. At the Archives de Paris, I immersed myself in company documents; these record when companies were formed and dissolved, by whom, where, and under what financial conditions. Civil registries were also useful in specifying relationships between manufacturers. Designs that were filed with industrial courts by manufacturers are also currently preserved at the Archives de Paris. Brigitte Lainé, the head archivist, was a great help in this regard. With unfailing patience, she acted as my guide within the maze of the archives. I would also like to thank Roxane Dubuisson, whose collection of pre-1870 Parisian invoices was a mine of information; she welcomed me into her home and gave me access to her wonderful documents. At the request of Catherine Join-Diéterle, head curator at the Musée Galliera, I curated a second cashmere exhibition in 1998 on Parisian shawl makers. The fruits of my research were published in its catalogue.

This book is the culmination of more than thirty years of work. Once again, I should like to express my heartfelt gratitude to all those who opened the doors of their institutions, allowed me access to documents and gave me so much encouragement on so many occasions. I would particularly like to thank the textile designer Gerolamo Etro in Milan, who made his magnificent collection of cashmere shawls available to me whenever I asked, and who supported my endeavours to publicize the work of the intrepid pioneers of shawl making in Paris. With his customary generosity, he has allowed me to reproduce some forty of his Parisian shawls in this volume.

Invoice.
Paris, Debuisson collection.

Monique Lévi-Strauss

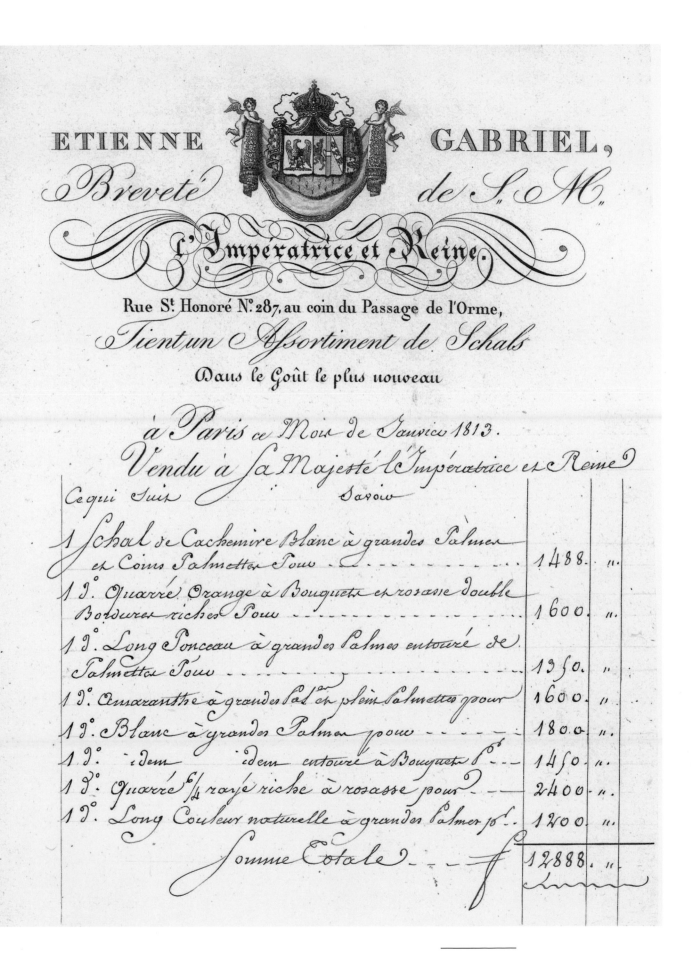

ETIENNE GABRIEL,

Breveté de S. M.

L'Impératrice et Reine.

Rue St. Honoré Nº 287, au coin du Passage de l'Orme,

Tient un Assortiment de Schals

Dans le Goût le plus nouveau

à Paris ce Mois de Janvier 1813.

Vendu à Sa Majesté l'Impératrice et Reine

Ce qui Suit Savoir

1 Schal de Cachemire Blanc à grandes Palmes et Coins Palmettes Pour	1488.	"
1 d°. Quarré Orange à Bouquets et rosasse double Bordures riches Pour	1600.	"
1 d°. Long Ponceau à grandes Palmes entouré de Palmettes Pour	1350.	"
1 d°. Amaranthe à grandes P. en plein Palmettes pour	1600.	"
1 d°. Blanc à grandes Palmes pour	1800.	"
1 d°. idem idem entouré à Bouquets P.	1450.	"
1 d°. Quarré F. rayé riche à rosasse pour	2400.	"
1 d°. Long Couleur naturelle à grandes Palmes P.	1200.	"
Somme Totale	12888.	"

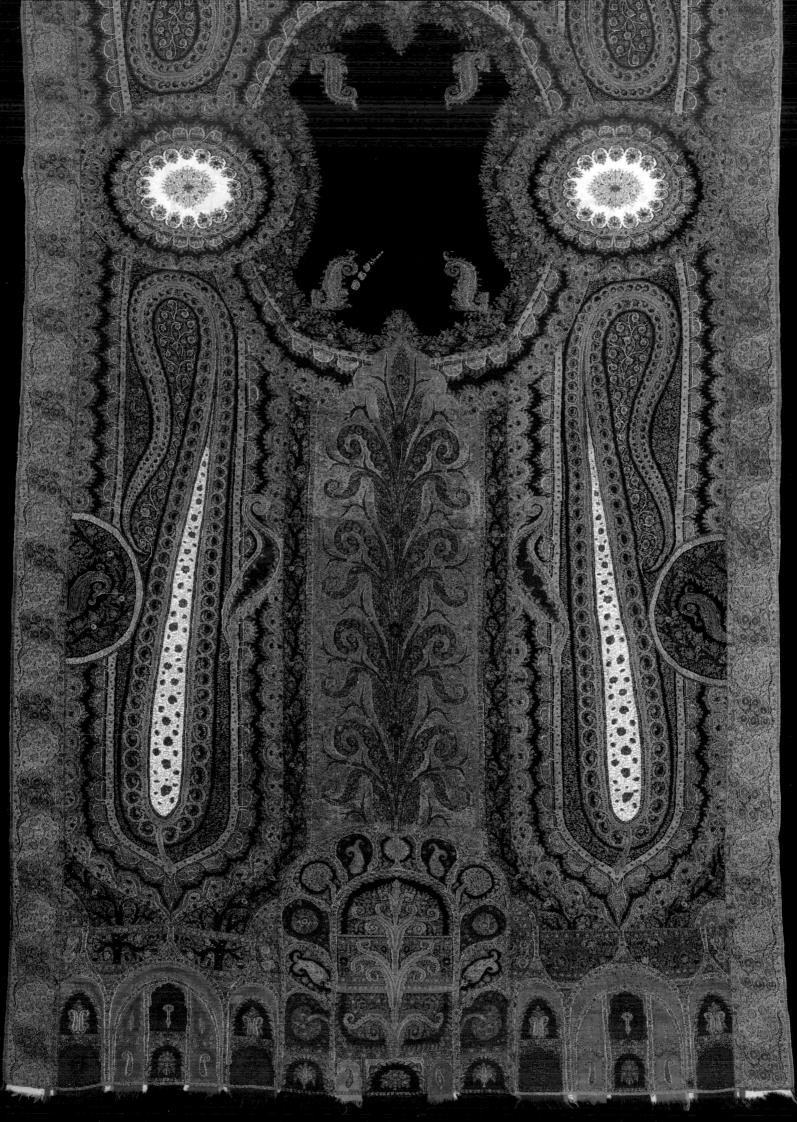

From India to Europe

Kashmir is bounded on the east by China, to the north by Russia, and on the west by Afghanistan and Pakistan. The capital, Srinagar, lies in the Kashmir Valley, an area just over 150 km (93 miles) long and 30 km (19 miles) wide. The foothills of the Himalayas rise high above Kashmir (which is itself situated at an average altitude of 1,800 m [5,906 ft]), creating an enclosed basin that is watered by the River Jhelum and its numerous tributaries. The river forms a lake in the centre of the plain and then flows on southwards until it reaches Punjab.

In this fertile valley, with its terraced rice fields, grow fruit trees, poplars, plane trees, cypresses and cedars. Sheep and goats are reared beneath snow-capped peaks that tower more than 8,000 m (26,247 ft) high and are mirrored in the calm, wide waters of the River Jhelum. Flowers abound, particularly roses and rhododendrons, giving Kashmir its popular reputation as 'the paradise of India'.

Kashmir had already been invaded many times by the mid-fourteenth century, when the Muslims succeeded in wresting it from its Indian overlords. The province was conquered by Akbar, the great Moghul emperor, in 1586. In 1739 the Kashmiris were forced to accept the Afghans as their masters, followed in 1819 by the Sikhs under Ranjit Singh. In 1846 Gulab Singh, Rajah of Lahore, signed a treaty with the British by which they recognized his title to territories extending over mountainous areas of some 218,000 sq. km (84,170 sq. miles), including Kashmir. Gulab Singh was succeeded by Rambhir Singh, in whose reign the 1846 charter defining the respective rights of the British and Kashmiris was renewed. Rambhir Singh was to pay an annual tribute to Queen Victoria consisting of a horse, twenty-five pounds of wool and three pairs of shawls. In return, Britain acknowledged the Rajah's right to a twenty-one gun salute. When Rambhir Singh died in 1855 he was succeeded by his son, Pertab Singh. British suzerainty came to an end in 1947.

BEFORE 1800: THE FIRST EUROPEAN IMITATIONS

Kashmir produced outstandingly fine and light shawls – qualities that were remarked upon by travellers from the West. In 1664 François Bernier, the first European to visit Kashmir, wrote of his amazement at the delicacy and softness of the local textiles.[1]

OPPOSITE
Lower section of long shawl.
Northwest India, c. 1855–60.
Twill-tapestry weave, woven in several
pieces that were then assembled; cashmere,
321 × 138 cm (126¼ × 54¼ in.).
Paris, author's collection, no. 53.
A tree of life in the centre is flanked by two tall pines.
The coloured squares above the fringe are decorated with
mihrabs (niches in the inner walls of mosques to indicate
the direction of Mecca); these are woven, not embroidered,
unlike most Indian shawls.

[1] François Bernier, pp. 306–7.

These shawls – woven on handlooms by men, who were assisted by young children – were about 180 cm (70⅞ in.) long and 120 cm (47¼ in.) wide. The wide decorative borders* at both ends of the shawl, were just under 30 cm (about 1 ft) in height. In winter, both men and women, Muslim and Hindu alike, wore the shawls over their heads, draping them over the left shoulder like a cloak. Bernier observed that two types of shawl were made: one with local, very fine wool; the other, far more expensive, with the soft underfleece hairs from the breast of the wild goat. He noted that he had never seen anything so exquisitely fine and it was a pity that they were often attacked by worms.

A series of seventeenth-century miniatures provides us with a detailed portrait of a Moghul prince (opposite) who is wearing a shawl that must have come from Kashmir – which leads one to speculate on when shawl weaving would have begun in the province. According to Carl von Hügel,[2] who visited Kashmir in 1836, the credit for starting the industry must go to Sultan Zayn al-Abidin who, in the fifteenth century, summoned a highly skilled weaver named Nakad Begh from Turkestan to build a loom for weaving

The asterisks that appear in this book refer to entries in the glossary (pp.312–13).

Border fragment from a long shawl.
Kashmir, mid-17th century.
Twill-tapestry weave, cashmere.
Paris, Musée Guimet, verbal legacy of Krishna Riboud, 2003, AEDTA no. 1276.

OPPOSITE
Portrait of Sayyid Raju Qattal.
India, Deccan school, Golconda, late 17th century (1680?).
Gouache, gold and silver on paper, 24.5 × 16.2 cm (9⅝ × 6⅜ in.).
Paris, Musée Guimet, Fonds Musée Napoléon, inv. no. 35667.
To protect himself from the cold, this nobleman has wrapped a small fur around his neck and covered it with a cashmere shawl. One of the shawl borders is worn over his left shoulder and down his back; the other is thrown forward over the same shoulder. In the late 17th century, borders were often decorated with a very simple design of flowering plants.

shawls. Four centuries later, von Hügel wrote that weavers continued to lay flowers on their revered guru's grave; shawl weaving had by then become one of Kashmir's main sources of income.

In winter the wild goats (*Capra hircus*) that are found on the high plateaus of Tibet and Central Asia grow a layer of soft down on their underbellies, beneath their normal coat of longer, coarser hairs: this underfleece helps them to survive the extreme cold at high altitude. In spring the animals discard this extra layer of insulation by rubbing their bodies against bushes and rocks. The local inhabitants gather the fleece that has been shed and sell it in the Kashmir Valley. Travellers who witnessed this fleece 'harvest' thought the precious substance used in the weaving of shawls was a plant that grew like cotton. In other areas, including Kashmir itself, domesticated goats also produce an underfleece and are combed to remove it, but the shawls that are woven with this wool are of inferior quality.

The fleece was sold and distributed among the Kashmiri women, who picked out the kemp or coarse, rough hairs and sorted the fleece into two different qualities

2 Carl von Hügel, vol. II, pp. 303–4.

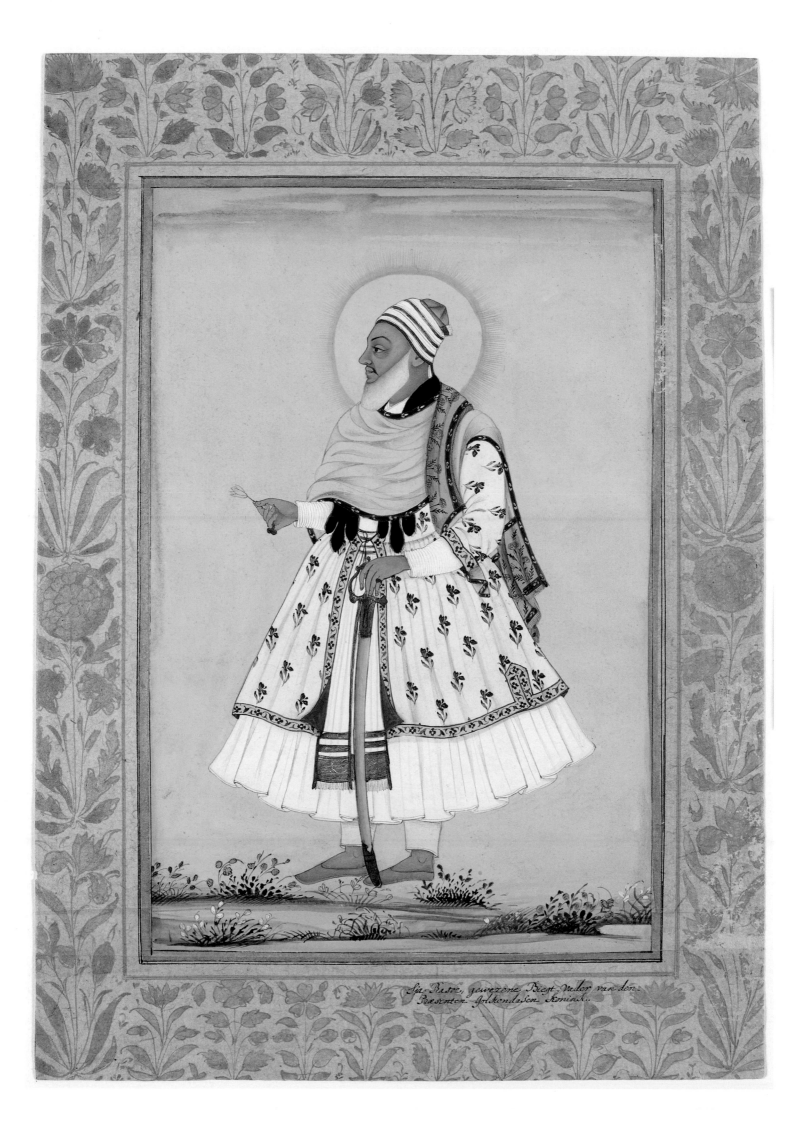

Sja Besoe, gewezene Biegt Vader van den
Præsenten Golkondasen Koninck.

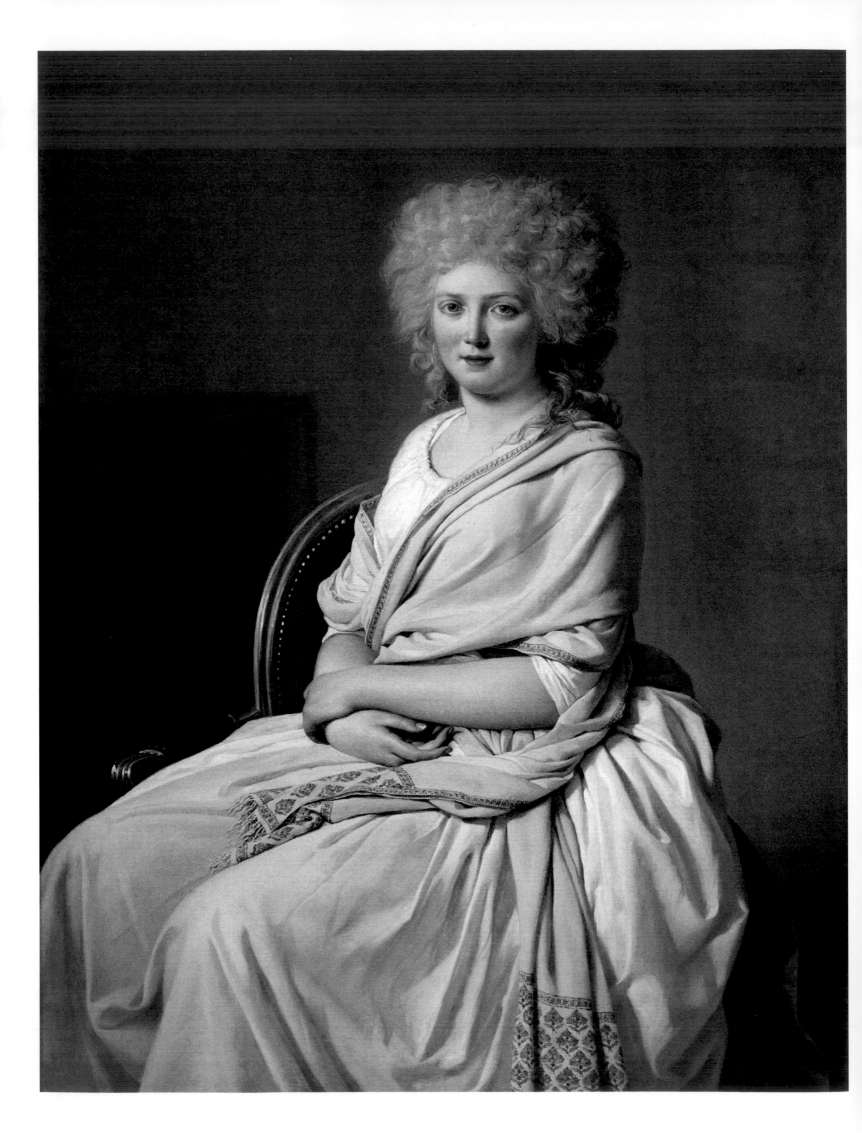

before spinning it on a spinning wheel. The superior fleece was reserved for the warp* threads and for the finest shawls; being almost white, it was either used just as it was or dyed a light colour. The slightly coarser, greyish fleece was dyed and used for the weft.*

Kashmiri weavers – always men – used a horizontal loom: two or three of them would sit side by side at the same loom. The women prepared the warps by 'doubling' the thread, drawing it out while twisting it slightly. Then came the turn of the warpers, the men who put the warp into the loom: anything from 2,000 to 3,000 warp threads were required for a shawl of 120 cm (47¼ in.) wide. The vertical borders were woven on silk warp threads to give them more strength. The designer, known as the *naqqash*, decided on the pattern; the 'colour caller', or *tarah-guru*, read the design from the bottom upwards and called out each colour in turn, together with the number of warp threads under which the bobbin* of weft had to pass. A pattern master, the *talim-guru*, then wrote these instructions down using the traditional signs or 'shawl alphabet'. The weavers kept this transcription (the *talim*) in front of them as they worked.

The technique used in the weaving of Kashmir shawls is similar to that used for Gobelins tapestries: the decoration is formed by weft threads interlocked where the colours change; the weaver passes them between the warps using bobbins, around which the variously coloured threads are wound. The weave of these shawls, however, differs

OPPOSITE
Jacques-Louis David (1748–1825), Portrait of the Marquise de Sorcy de Thélusson, 1790. Oil on canvas, 129 × 97 cm (50¼ × 38¼ in.). Munich, Sammlung der Bayerische Hypotheken- und Wechsel-Bank, Neue Pinakothek. The marquise has a very attractive shawl draped around her shoulders, the borders of which are decorated with five rows of symmetrical pines. She was in advance of French fashion, since the craze for shawls only took a firm hold eight or nine years after this portrait was painted.

from that of a tapestry in that it is in 2/2 twill.* Working on the back (or reverse side) of the textile, the weavers interlock the coloured weft threads, producing a slight ridge where the joins have been made: raised and two-coloured on the back but invisible on the right side (p. 22). This twill-tapestry or *espoliné** weave technique produces a stronger border than the single colour field,* whose fragile, almost transparent material does not wear well and sometimes has to be completely replaced when damaged. Twill-tapestry can reproduce any design, in a wide range of colours, but it is a very slow process: two men would work at their loom for eighteen months to make the average shawl, while a top-quality article would take three years.

Detail of a long shawl, border decorated with small pines. Kashmir, late 18th century. Twill-tapestry weave, cashmere, 336 × 130 cm (132¼ × 51¼ in.). Paris, Musée Guimet, verbal legacy of Krishna Riboud, 2003, AEDTA, no. 291.

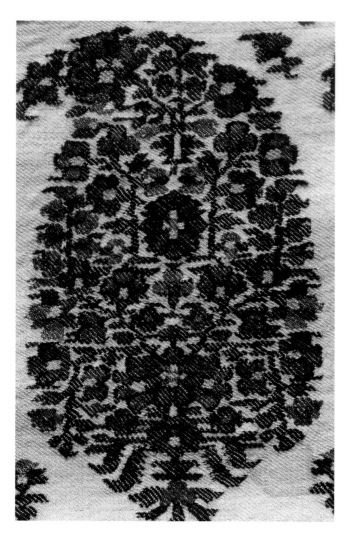

Pine detail of the shawl border shown opposite, below.
Seen from the front.

The same border shown above left, seen from the back, revealing the
twill-tapestry weave. Note the two-colour ridges where the wefts join.

OPPOSITE, ABOVE
Louis-Léopold Boilly (1761–1845),
The Downpour or Paying to Cross, 1805.
Oil on canvas, 32.5 × 40.5 cm (12¼ × 16 in.).
Paris, Musée du Louvre.
This painting shows a family, caught in a heavy shower of rain,
walking along a plank on wheels to avoid the mud in the street. The
man on the left is taking payment for people to use the plank. The young
woman clutches her most precious belongings: her little dog, her purse
and her shawl.

OPPOSITE, BELOW
Detail of the border of a long shawl.
Kashmir, c. 1800.
Around 1860, this long shawl was turned into a square shawl.
Twill-tapestry weave, 162 × 160 cm (63¼ × 63 in.).
Paris, author's collection, no. 70.
This shawl has three rows of pines on the border and looks remarkably
similar to the shawl in Boilly's painting (opposite, above).

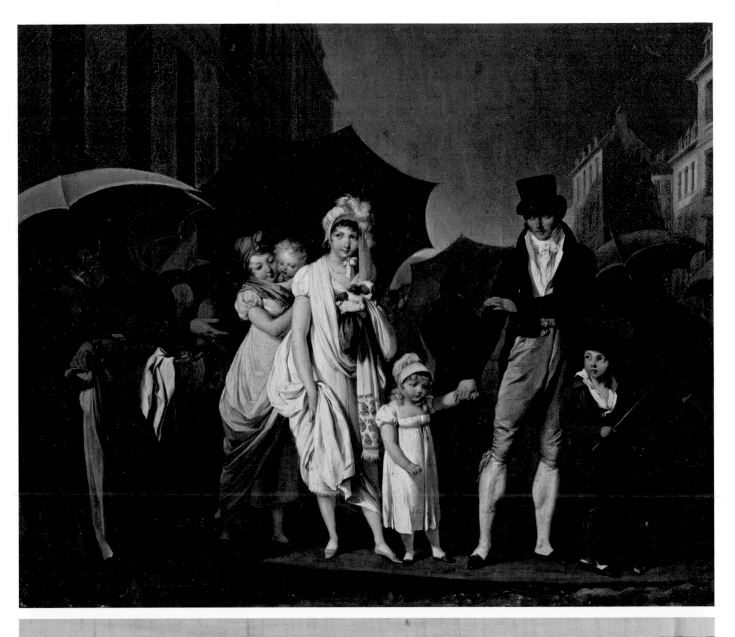

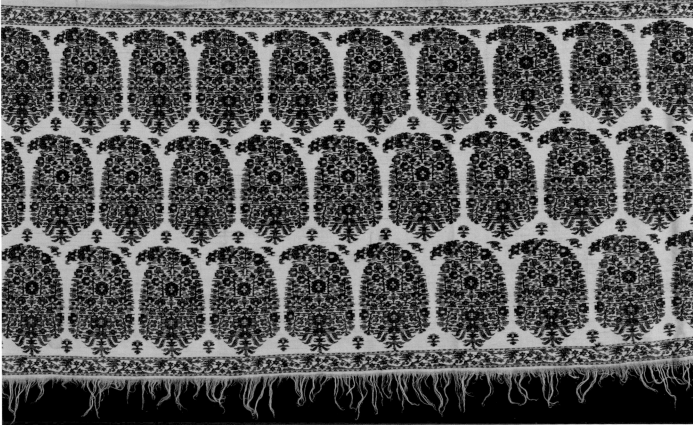

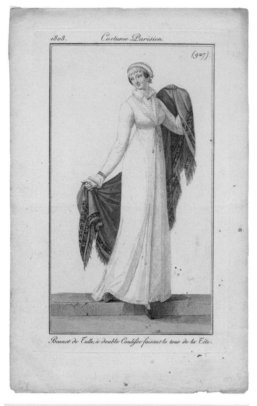

Bonnet de Tulle, à double Coulisse faisant le tour de la Tête.

Coeffure en Cheveux ornée de Perles. Robe de Cachemire.

³ Thomas Vigne, vol. II, pp. 129–30.

Shawls were made in one piece until the early nineteenth century. The warp threads had to remain stretched taut on the loom for the entire time it took to weave the shawl. Sometimes they broke, or the woven section was torn during the later stages of manufacture: this entailed the most incredibly meticulous repairs, known as 'lost mending' since it had to be invisible from the right side. The men who performed this minutely detailed work were doomed to a total or partial loss of sight over the years. In order to help the warp threads to withstand the strain of being on the loom for so long, and to prevent them fraying, they were moistened at frequent intervals with a very thin rice-flour paste; when the shawls were finished, they were washed to eliminate the starch and the resulting stiffness. 'The best water', wrote Thomas Vigne, who travelled to Kashmir in 1840 or thereabouts, 'is that of the canal which links the lake to the Drogjan lock. There is a round hole in the limestone blocks of the wash-house, measuring one and a half feet across and a foot in depth; the shawl is placed on the bottom and while water is poured on to it from above, it is trampled with bare feet for five minutes. A man takes it to the canal where he stands in the water and pulls it to and fro; he then slaps it hard against a flat stone. This last operation is repeated three or four times before the shawl is plunged into the canal water again. Finally, the shawl is set to dry in the shade…. Something in the canal water gives these shawls their ineffable softness.'³

Until the end of the eighteenth century these long shawls had a decorative border at both ends, with the ornamentation consisting of a row of flowering plants or small pines* on a natural unbleached or a coloured background. The Kashmiris also wove striped shawls* and square ones decorated with medallions* for the Turkish and Persian markets. A large part of the population was engaged in the industry, whose products were exported all over the Middle and Near East.

The British were the first European nation to develop an interest in the Kashmiris' woven goods, which reached them via the ships of the East India Company. Those ladies who could afford them found they subtly enhanced clothes that had a softer, more natural look to them than those of their French sisters, whose sleeker lines betrayed the presence of whalebone corseting. During the last quarter of the eighteenth century, British ladies took the Kashmir shawl to their hearts. In France only a few daringly chic individuals sensed the approach of a wind of change in customs and fashion and started to wear them. Among them was the Marquise de Sorcy de Thélusson, as can be seen from Jacques-Louis David's enchanting portrait of her, painted in 1790 (p. 20). This painting is probably the first evidence of France's incipient passion for cashmere. Among the artists who have recorded details of cashmere shawls for us was Jean-Auguste-Dominique Ingres. When he was seventeen or nineteen (art historians are uncertain whether it was in 1797 or 1799), he sketched a young woman artist, Barbara Bansi, as she watched André-Jacques Garnerin's parachute jump. She is holding a small telescope and, more pertinently, has a light cashmere shawl of very simple design, with one row of pines (p. 25), draped about her.

Until this period, French women had been at a loss to know what to do with the exquisite shawls that their attentive menfolk brought home from their travels. When Napoleon's officers returned from the Egyptian campaign bearing gifts of these exotic weaves, their recipients were entranced by them. Fashionable ladies realized that nothing

could be better suited to the new, classically inspired fashions than the softly draped folds of these shawls. Their discreet floral motif ornamentation added detail and interest to the sobriety of the plain textiles used for clothes at that time. These soft, swaying stoles also had the advantage of echoing arm movements, conferring particular grace on a dance that was, for this reason, called the dance 'du schall' (to use the contemporary spelling in France).

Towards the end of the eighteenth century, the young and beautiful Lady Hamilton used to entertain her friends in their Neapolitan drawing rooms with theatrical displays, using cashmere shawls as props. Here is how the Countess de Boigne describes these entertainments: '...her usual costume was a white tunic, gathered at the waist; her hair hung loose or was caught up with a comb.... When she agreed to a performance, she would gather together two or three cashmere shawls, a large antique vase, an incense-burner, a lyre and a tambourine. With these few theatrical props, in her classical garb, she took up a position in the centre of the drawing room. She would then throw over her head a shawl which reached right down to the ground and covered her completely and, hidden thus, draped the others about herself. The first shawl would then be lifted suddenly, sometimes she removed it altogether, sometimes only half removed it, so that it formed part of the draperies of the subject portrayed by her pose.'[4]

Madame Vigée Le Brun also practised the art of draping shawls and used to compose *tableaux vivants* (living pictures) in St Petersburg between 1791 and 1800: 'I used to choose the most handsome men and the most beautiful women for my models and draped them with some of the countless cashmere shawls at our disposal.' She later wrote to

OPPOSITE
Two fashion plates (1808 and 1811).
Paris, da Silveira collection.
The young woman in the lower plate is wearing a dress made out of a shawl and has another shawl to drape around her shoulders. The effect is reminiscent of the Empress Josephine's portrait on page 27, but here the colour scheme has been reversed.

[4] Countess de Boigne, vol. I, p. 91.

Jean-Auguste-Dominique Ingres (1780–1867),
Barbara Bansi, c. 1797.
Charcoal, stump and some white highlights on paper,
16.8 × 37.2 cm (18⅛ × 14⅝ in.).
Paris, Musée du Louvre, Cabinet des Dessins,
inv. no. R.F. 11 684.
In her left hand this young woman holds a telescope, through which she has been watching the balloonist Garnerin make a parachute jump from a hot air balloon. The borders of her shawl are decorated with small pines. Ingres often included cashmere shawls in his portraits of women. They are painted with such detail that they are not only beautiful but also provide valuable documentary evidence.

an English painter who, it seems, was no great admirer of her work: 'It appears that you dis-approve of my lace, but I have not painted any these fifteen years past. I far prefer shawls.... Shawls really are a godsend for painters.'[5]

1800—14: CASHMERE AT COURT

In France the craze for shawls spread like wildfire. Determined to emulate Josephine Bonaparte, the future empress, fashionable women had to have at least one shawl, and preferably several, as an accessory for their many gowns. In 1809 Baron Gros painted a full-length portrait of the Empress Josephine. She is shown wearing a dress made out of a long white cashmere shawl, its pine ornamentation enhancing the lower part of the skirt; a red shawl is wound around her waist – one end trails on the ground like a train, while the other end, draped forwards over her left shoulder, hangs down in front (opposite). Records show that Josephine owned about sixty shawls, some of which had cost as much as 8,000 to 12,000 francs, an exorbitant price in those days. Despite their expense, demand for these shawls soon outstripped supply and the weavers of Kashmir had to change their production methods in order to increase their output.

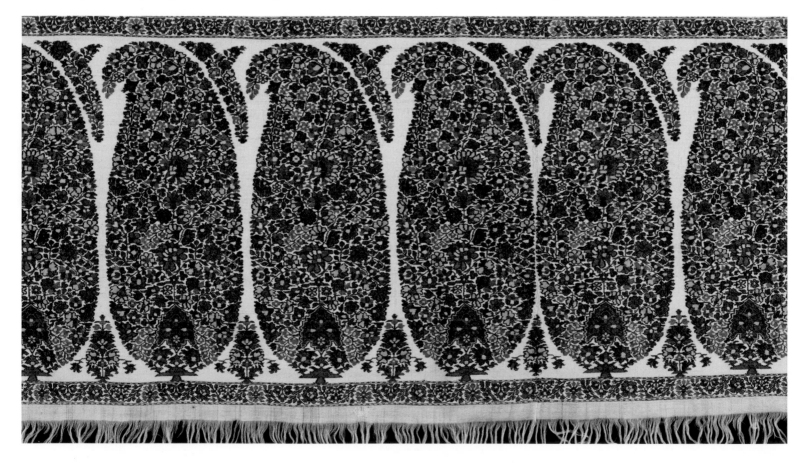

BELOW
Detail of a long shawl border.
Kashmir, c. 1800.
This shawl was altered to make a square shawl.
Twill-tapestry weave, 148 × 149 cm (58¼ × 58¾ in.).
Paris, author's collection, no. 68.
The ten pines on each border are made up of flowers, with a small bunch of flowers between each base and a flowering branch separating the apices.

OPPOSITE
Antoine-Jean Gros (1771–1835),
The Empress Josephine, 1809.
Oil on canvas, 217 × 141 cm (85¼ × 55½ in.).
Nice, Musée Chéret.
The Empress Josephine's dress has been made out of a long shawl, the border of which has pines similar to those shown on this page. Another shawl is wrapped around her waist and thrown over her left shoulder. She had two children: a son, Eugène, whose bust is seen in profile on the left of the painting, and a daughter, Hortense, who is symbolically represented by the hydrangeas (French: hortensias) in the vase bearing the initial 'J' for Josephine.

At this time shawls were made in two pieces, on two looms. After the two pieces had been woven, they were taken off the looms and joined together. A *rafugar*, or invisible mender, used a needle to join them together, picking up the loose warp threads of one unfinished edge and entering them into the corresponding section of the other half.

5 Élisabeth Vigée Le Brun, vol. I, p. 319 and vol. II, p. 42.

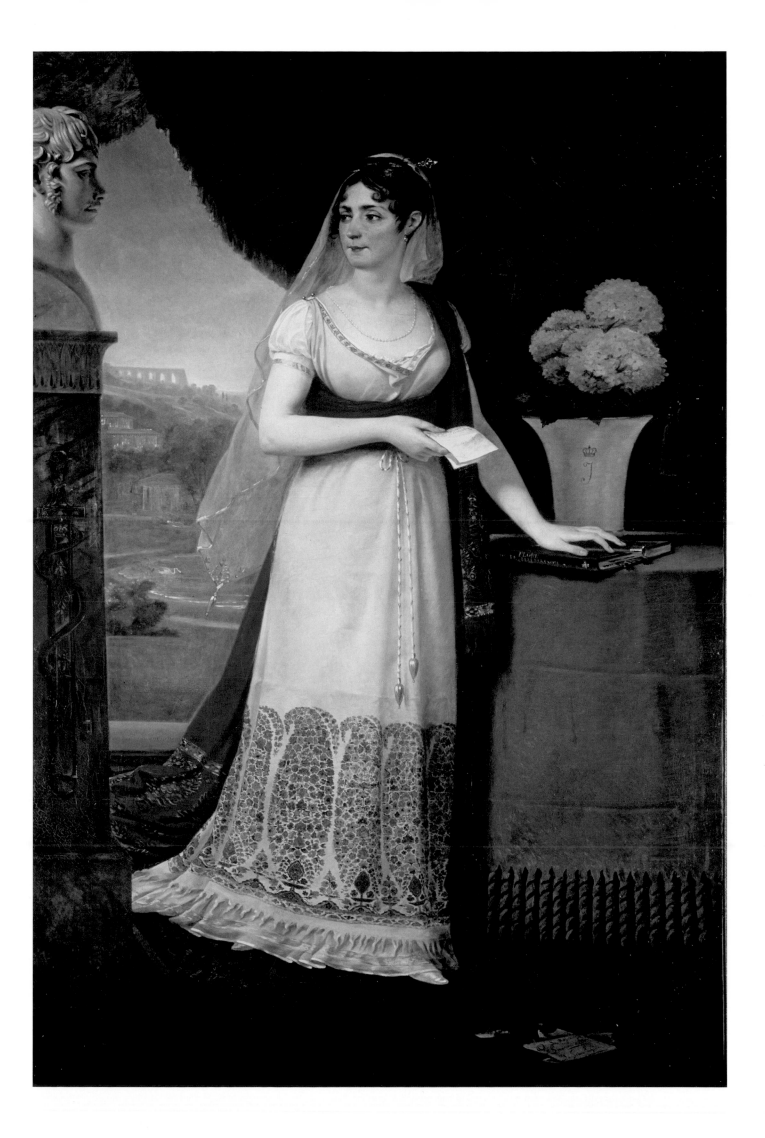

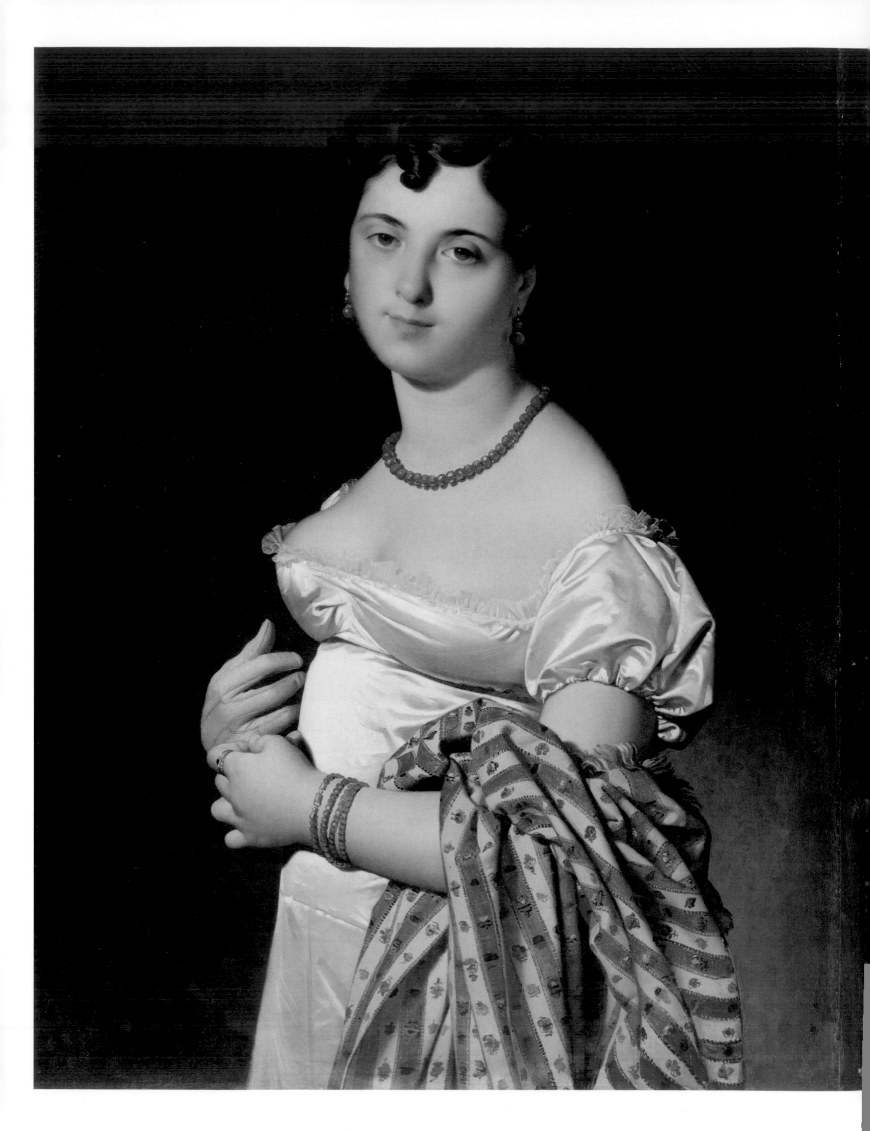

Decoration was sometimes embroidered rather than woven into the shawl: the latter took three times as long as embroidering. The resulting lower price of these embroidered shawls amazes Europeans, who consider embroidery to be the height of artistry. *Espoliné* or twill-tapestry weave, a sort of embroidery on the loom, calls for infinitely greater accuracy. Any mistake made while embroidering with a needle can be unpicked and put right without it affecting the rest of the composition. The slightest error in twill-tapestry, however, must be detected at once if it is to be corrected, otherwise all the subsequent weaving has to be undone. In Kashmir a shawl that has been made in a single piece, with twill-tapestry ornamentation, is called a *kanikar;* when the decoration is applied to a plain ground by embroidering with a needle, the shawl is known as *amlikar*. After 1810, the weavers who were making shawls in two pieces, with twill-tapestry borders, began embroidering the four corner ornaments with a needle.

From the early days of the First Empire in France (1804–14), a cashmere shawl was considered a suitable wedding gift from a bridegroom to his future wife, together with jewels and lace, which were more traditional gifts at the time. All this finery was reserved exclusively for married women and was considered inappropriate for a young, unmarried girl. Napoleon's wedding gifts to his second wife, Marie-Louise, included seventeen shawls. From a watercolour by Benjamin Zix (p. 31),[6] we know that many of the aristocratic ladies who formed part of the Imperial couple's wedding procession in 1810 carried a cashmere shawl folded carefully over one arm as they progressed through the Great Gallery of the Louvre (p. 31). Even though they were so costly, shawls were increasingly sought after in Europe. In order to satisfy a less exclusive clientele, the Jouy factory of Oberkampf and the Mulhouse manufacturers started to produce printed 'cashmere' shawls, which were extremely attractive.

In 1806 Napoleon announced his Continental Blockade: goods that had been carried in British ships were to be prohibited from entering France (and other European countries). Since this inevitably applied to Indian textiles and shawls, the blockade proved a boon for the French silk industry, which had been in decline since the Revolution of 1789 and subsisted on orders from Napoleon's court. French manufacturers were quick

The Marriage Chest, *fashion plate, 1831.*
Paris, da Silveira collection.
A young bride selects a cashmere shawl from among her husband's wedding gifts to her. Her marriage chest is made of richly inlaid wood.

OPPOSITE
Ingres, Madame Panckoucke, *1811.*
Oil on canvas, 93 × 68 cm (36⅛ × 26¾ in.).
Paris, Musée du Louvre.
The coral red of Madame Panckoucke's shawl matches her jewelry; its design is not unlike the pattern shown below.

Detail of a striped long shawl.
Kashmir, early 19th century.
Twill-tapestry weave, cashmere,
224 × 130 cm (88⅛ × 51¼ in.).
Paris, Musée Guimet, Verbal legacy of Krishna Riboud, 2003, AEDTA, no. 2292.
Most Kashmiri-woven striped shawls were made for the Turkish and Persian markets.

[6] The watercolour is preserved in the Louvre's Département des Arts Graphiques.

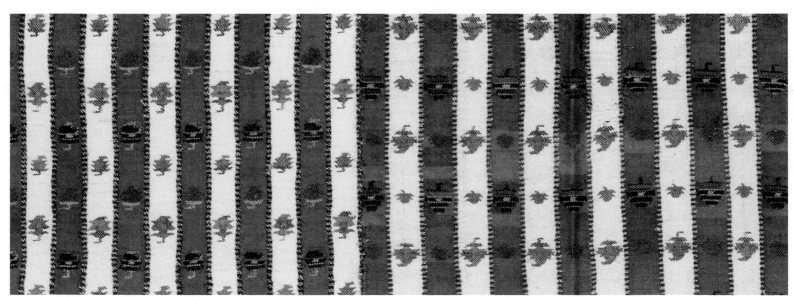

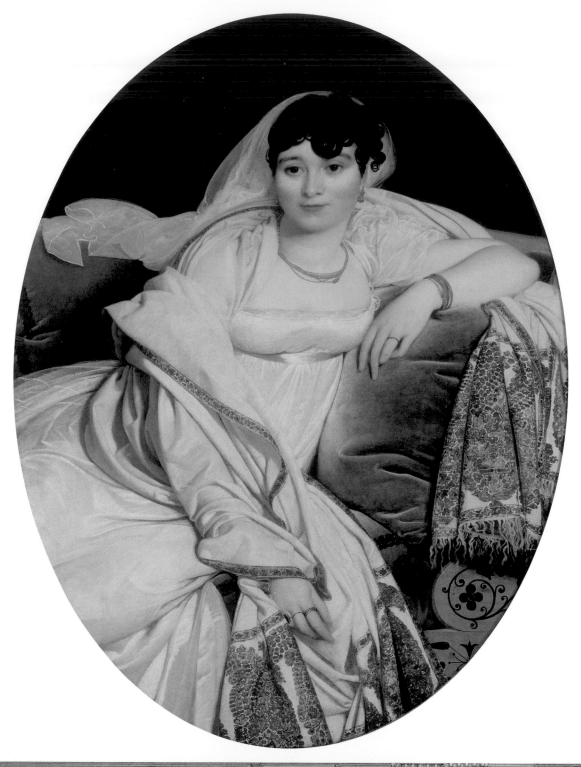

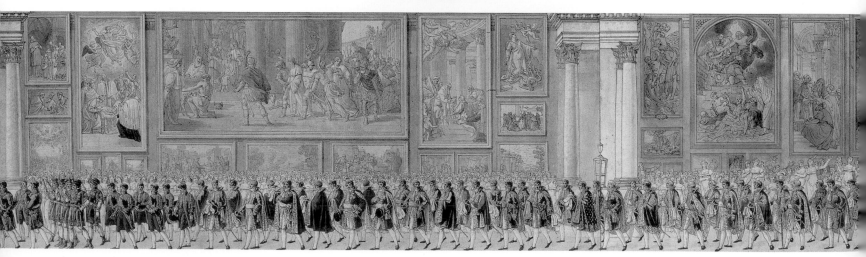

to capitalize on the frustration felt by women who could now only acquire Kashmir shawls if they had been smuggled in or imported via Russia, at fabulous prices, and pitted their wits against each other in their efforts to produce imitation oriental shawls. Production increased considerably.

The most resourceful shawl manufacturer at the time of the First Empire was Guillaume Ternaux (1763–1833), who contrived to produce shawls of high quality (see pp.115–27). He had a factory in Rheims that specialized in shawls with white backgrounds, and another at Saint-Ouen, near Paris, which was renowned for its shawls with black grounds. Ternaux managed to import the special downy goat's fleece by way of Russia and tried to reproduce the Kashmiri twill-tapestry weave. He employed women and children to keep his labour costs low. While accepting that both the raw material (the goat's fleece) and the technique (twill-tapestry) of Kashmir's shawl industry outshone their European equivalents, Ternaux was determined to market shawls with a distinctively French look. Thus, in 1811, when the Minister of the Interior, Montalivet, placed an order with him for twelve shawls for the Court at the behest of Napoleon, Ternaux asked the painter Jean-Baptiste Isabey to design them. On 31 December 1812 these twelve shawls were delivered to the Empress Marie-Louise, who kept some for herself and distributed the rest among her ladies-in-waiting, thus setting the fashion for French shawls.

OPPOSITE
Ingres, Madame Philibert Rivière, *1805.*
Oil on canvas, 116 × 90 cm (45⅝ × 35¼ in.).
Paris, Musée du Louvre.
The pines on the border are much larger than in 18th-century shawls and still have a single-colour background.

Benjamin Zix, The Wedding Procession of Napoleon and Marie-Louise of Austria, *1810.*
Watercolour, pen and ink, 24 × 172 cm (9½ × 67¼ in.).
Paris, Musée du Louvre, Département des Arts Graphiques.
The wedding procession is making its way through the Great Gallery at the Louvre. The imperial couple are in the middle, preceded by dignitaries and followed by family members, the men in two-pointed hats and the women wearing a train. Court guests are bringing up the rear of the procession. A number of these women are carrying a shawl, rather than a train, over one arm.

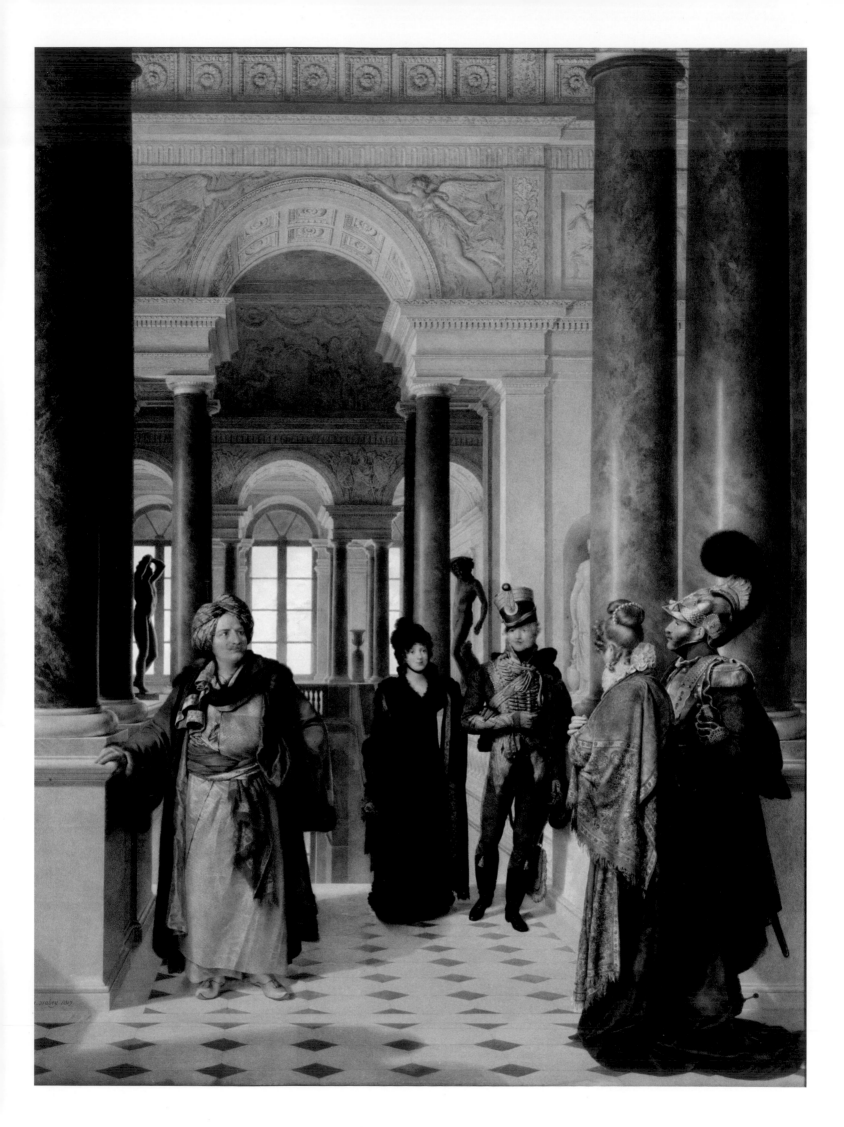

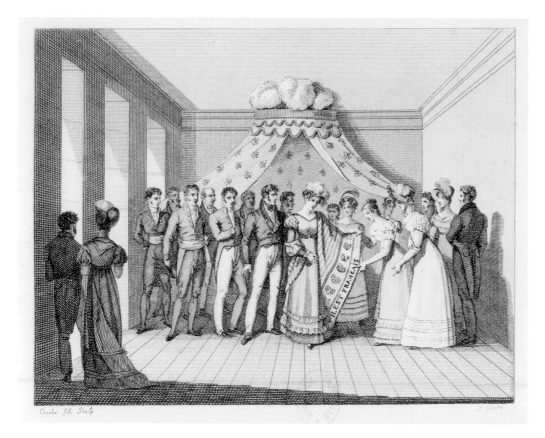

Until about 1870, French manufacturers continued to vie with one another in weaving *espoliné* shawls. These were one-off products, so to speak: intended as a special order for an aristocratic lady or as exhibits for one of the many industrial exhibitions, which, held at five-yearly intervals, punctuated the nineteenth century and gave each manufacturer the chance to impress. During those seventy or so years, France's shawl manufacturers made periodic attempts to bring about the demise of the fantastical decorative schemes of oriental shawls. The promotion of a distinctive French style would, they hoped, lead to the imported shawls, which competed with their own products, becoming outmoded. But they failed to convince women that Europe could outdo the East in artistry. It was this same European clientele, however, with its insatiable desire for change, that was to force the weavers of Kashmir to alter their traditional shawl designs.

1814–30: CASHMERE ON THE STREETS

In April 1814 Napoleon was exiled to the island of Elba. The monarchy was restored in the person of Louis XVIII, and many members of the aristocracy who had lived in exile during the First Empire returned to France. Protagonists and ethos changed but the backdrop remained the same. The Countess de Boigne wrote in 1814: 'Having taken our leave of the Duke of Angoulême, we stepped straight out into the *pavilion de Flore* which in those days was just a covered way, paved and open to the elements with no doors or windows, so we were as cold as if we were out in the street; one was not allowed to walk through the palace rooms. This left us with a choice: we could either make our way through the underground kitchen passages and the outdoor galleries, or use our carriages to reach the *pavilion de Marsan*. The former entailed walking the whole way without one's shawl or

François Couché, A Royal Princess is Given a Cashmere Shawl with IT IS FRENCH Woven into the Border.
Engraving, c. 1815.
Paris, Bibliothèque Nationale, Cabinet des Estampes, shelf mark Ef 215a, p. 23.
After Napoleon's Continental Blockade was lifted, dealers were once again able to import shawls from India for their fashionable female clients. Such competition threatened French manufacturers, who did their best to convince high-ranking ladies to set a good example by buying French goods.

OPPOSITE
Jean-Baptiste Isabey (1767–1855),
The Grand Staircase of the Museum, *1817.*
Watercolour, 86 × 66 cm (33¾ × 26 in.).
Paris, Musée du Louvre, Département des Arts Graphiques.
The man dressed in oriental costume (left) is wearing three cashmeres: the first as a turban, the second as a waistband and the third loosely draped around his neck. The two young women are wearing long shawls decorated with pines that are larger than those that had been in fashion at the time of the Empire.

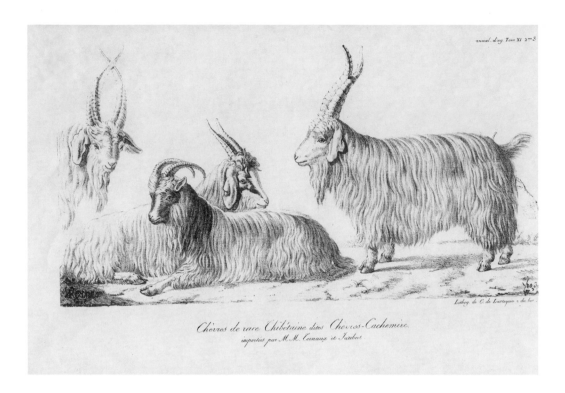

Tibetan Goats known as Cashmere Goats, Imported by Messrs Ternaux and Jaubert. *Engraving.*
Paris, private collection.

OPPOSITE
Corner of a long shawl, France, c. 1810.
Woven au lancé, trimmed on back, wool,*
292 × 134 cm (115 × 52¾ in.).
Paris, author's collection, no. 49.
The pattern on this shawl is typically Kashmiri, but simplified so as to use fewer colours. It is reminiscent of the famous shawls woven by Ternaux in Rheims, where the pattern appears on a white ground.

[7] Countess de Boigne, vol. I, pp. 261–62.
[8] Oil on canvas, Louvre, Paris.
[9] Tessier.

pelisse since etiquette banned these from the chateau.'[7] Shawls were obviously no longer considered formal attire. Ingres was still painting portraits of shawl-clad ladies in the early days of the Bourbon Restoration (1814–30), but he was working in Rome, while David painted his *Three Ladies of Ghent* with simple, unpretentious shawls around their shoulders.[8] Isabey was alone in depicting three of his subjects in 1817 wearing five shawls between them at the top of the grand staircase in the Louvre: two ladies and a Persian gentleman, this last with no fewer than three draped about his person. The ladies could be almost anyone: wearing a Kashmir shawl was no longer out of the ordinary for prosperous people. François Couché's engraving (p. 33) entitled *A Royal Princess is Given a Cashmere Shawl, with IT IS FRENCH Woven into the Border,* illustrates official disapproval of imported shawls.

French shawl manufacturers constantly vied with each other in their endeavours to perfect their products. Spinners began to import the legendary goat's fleece from the high plateaus of Asia. In 1816 the first French shawls woven with pure cashmere warp and weft made their appearance, under the name of 'French Kashmir shawls'. Two years later, in 1818, Guillaume Ternaux financed an expedition to the East to bring some of the special goats back to France. Amédée Jaubert[9] was put in charge of this mission, which ended in partial failure: of the 1,289 goats purchased from the Kirghiz tribesmen, only 400 survived the arduous journey. Moreover, France's mild climate meant that the goats that did survive did not produced enough of the precious downy under-fleece (see p. 124). However, the ever-enterprising Ternaux was undaunted and set about crossing the shawl-goats with other breeds, which was one example among many of his tremendous entrepreneurial spirit. He was a true captain of industry, always prepared to take risks: he had realized how vital it was to mechanize, to trade on a global scale and to promote social progress. He was, however, too far ahead of his time and died impoverished in 1833. In belated recognition of his efforts, the public referred to the new shawls as 'Ternaux shawls'.

In 1818 French weavers started to have the first Jacquard* mechanisms fitted to their looms. Joseph-Marie Jacquard had presented his new invention to Napoleon in 1805. The mechanism was driven by a foot pedal worked by the weaver. This pedal drew forward a succession of punched cards, whose perforations ensured that the correct warp threads were lifted to weave the desired design. When the entire sequence of cards had been used, the set was run through again, resulting in a design repeat. Jacquard's invention did away with the need for a drawboy to pull the cords and raise the warp threads of the drawloom* manually. It also enabled far larger designs to be woven. A leading authority on nineteenth-century weaving theory, Jean Bezon, writes: 'Not only did this admirable invention prove very helpful in the development of the shawl industry, but conversely most of the improvements made to the Jacquard mechanism as time went by were those deemed necessary by the shawl manufacturers who used it.'[10]

Without attempting to catalogue the benefits of the Jacquard process to weaving in general and to shawls in particular, it is worth noting its most significant effects. At the time of the First Empire, the pine-decorated main borders, the vertical borders and the plain field were woven separately and had to be sewn together. During the Restoration, French manufacturers first managed to weave their shawls in one piece on a silk warp, although the fringe gates* and wool fringes* had still to be woven separately and sewn on as shawl ends* since silk fringes had a tell-tale sheen and sparseness, betraying the shawl's European provenance. Wool fringes gave the product the look of a 'real' Kashmir shawl. From 1825 this was no longer necessary, as cashmere wool was henceforth frequently used for the warp threads. Shawls could now be made in one piece. It is worth remembering that the process was reversed during the nineteenth century in Kashmir, where shawls had been woven in a single piece for centuries.

The technical progress brought about by the introduction of the Jacquard loom, combined with the vistas opened up by the 1819 national exhibition of manufactured goods, encouraged shawl manufacturers to create new designs: 1819 saw the first reference to a harlequin* shawl. This was a long shawl, often with a white field, the border decorated by eight to ten pines in individual rectangular compartments, each of which had a different ground colour. An example can be seen in Daniel Saint's portrait of the Duchess of Berry, painted in around 1825 (see opposite); the daughter-in-law of Charles X wears a long shawl with a blue ground and a harlequin border. It is not known where the idea for this new type of shawl originated but it met with great success in France and in Britain, where harlequin shawls were at their most popular in 1825.[11]

By the 1820s many shawls had already been in use for twenty years and were showing signs of wear, particularly in the plain field, where mending was far more obvious than in the decorated sections. If the owner were to be able to continue wearing the shawl, this plain section would have to be replaced by a newly woven piece (when a change of colour might be welcome). Alternatively, the damaged section could be discarded and the various borders repositioned around the intact part of the field and sewn back on again. As a result, many a long shawl became square and the end borders were then sewn on to adjacent sides to form a right angle at one corner while the other two sides were bordered by what had once been the vertical borders, sewn on to the back. This ingenious idea meant

OPPOSITE
Daniel Saint (1778–1847),
The Duchess of Berry, c. 1825.
Gouache on vellum, 34 × 28 cm (13¼ × 11 in.).
Chambord, State property, inv. CH/41/0579.
The Duchess of Berry was renowned for her elegance. Here, she poses for the artist wearing a shawl decorated with harlequin pines.

10 Jean Bezon, vol. V, p. 29.
11 See West Surrey College of Art and Design catalogue.

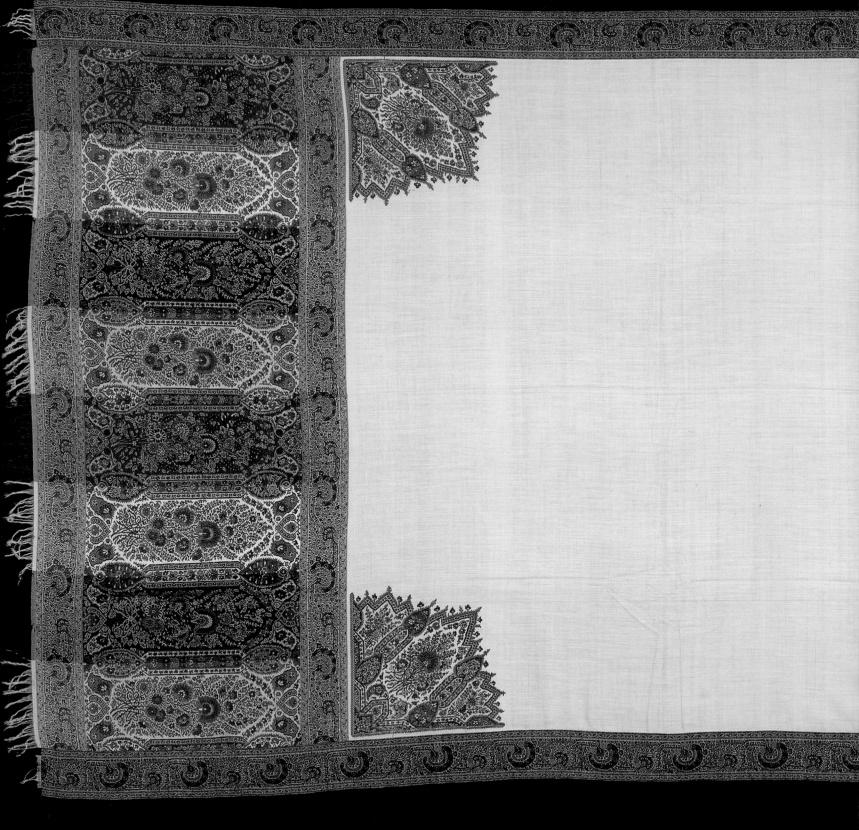

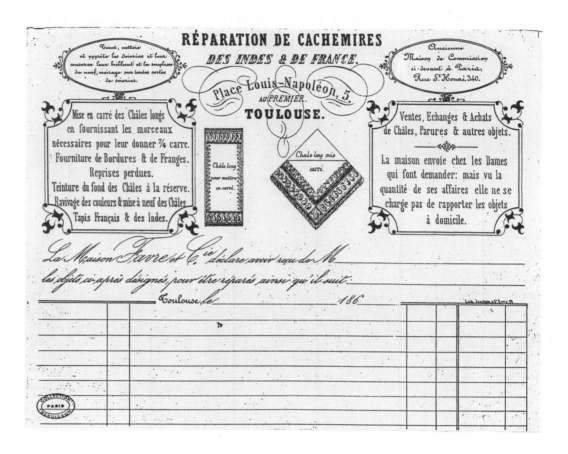

Long harlequin shawl, France, c. 1820.
Au lancé weave, trimmed on back, cashmere,
296 × 138 cm (116½ × 54⅜ in.).
Milan, Etro collection, no. 105.
The borders are decorated with bouquets of small flowers
in place of the more traditional eight pines.

ABOVE
Invoice.
Paris, Debuisson collection.
This document lists the various ways in which a shawl
could be transformed.

OPPOSITE
Detail of a square turnover shawl folded into a
triangle, with a border decoration of twenty pines.
Woven in Kashmir, c. 1810, subsequently remodelled
in France.
Twill-tapestry weave, cashmere,
164 × 162 cm (64⅜ × 63¾ in.).
Paris, author's collection, no. 74.
The corner with no pines was sewn on in reverse, so that
when this corner was folded over both decorated sections
were displayed, one above the other.

that when the shawl was folded in half diagonally, just short of the middle or 'hypotenuse' of these two differently bordered right-angled <u>triangles</u>, both borders would be on display. The result was known as a *double-pointe* or turnover shawl* (opposite). Several damaged long shawls could be cut up and used to make one harlequin shawl, as long as the pines from the salvaged shawls were of approximately the same size. Some women specialized in this work: they concealed all the joins on the newly assembled shawl by embroidering over them, and would even go to the length of painting in any faded colours with a brush (see invoice, above).

After the shawl had been woven it was handed over to the shearer or *tondeur* who trimmed off the floating wefts; then the dresser or *appreteur* made sure that the cloth had sufficient sheen and body to it. Both these finishing processes were sometimes carried out by the same craftsman. However, this chain of production all began with the designer. His was the truly creative role and, traditionally, he was a permanent employee of the manufacturer. The designer, familiar with the various problems inherent in the weaving process, would make allowances for the limitations of contemporary technology and the need to keep the cost price as low as possible. During the Bourbon Restoration artists were recruited to design shawls. The concept of art in the service of industry, and therefore accessible to the masses, was an altruistic one, and some artists responded positively to it, the most famous being Amédée Couder (1797–1864). He formed a combined design studio and school in 1820 that aimed to embrace all aspects of industrial design for several related industries – and it was in his studio that some of the most notable industrial designers of the period learned their craft (pp. 129–37).

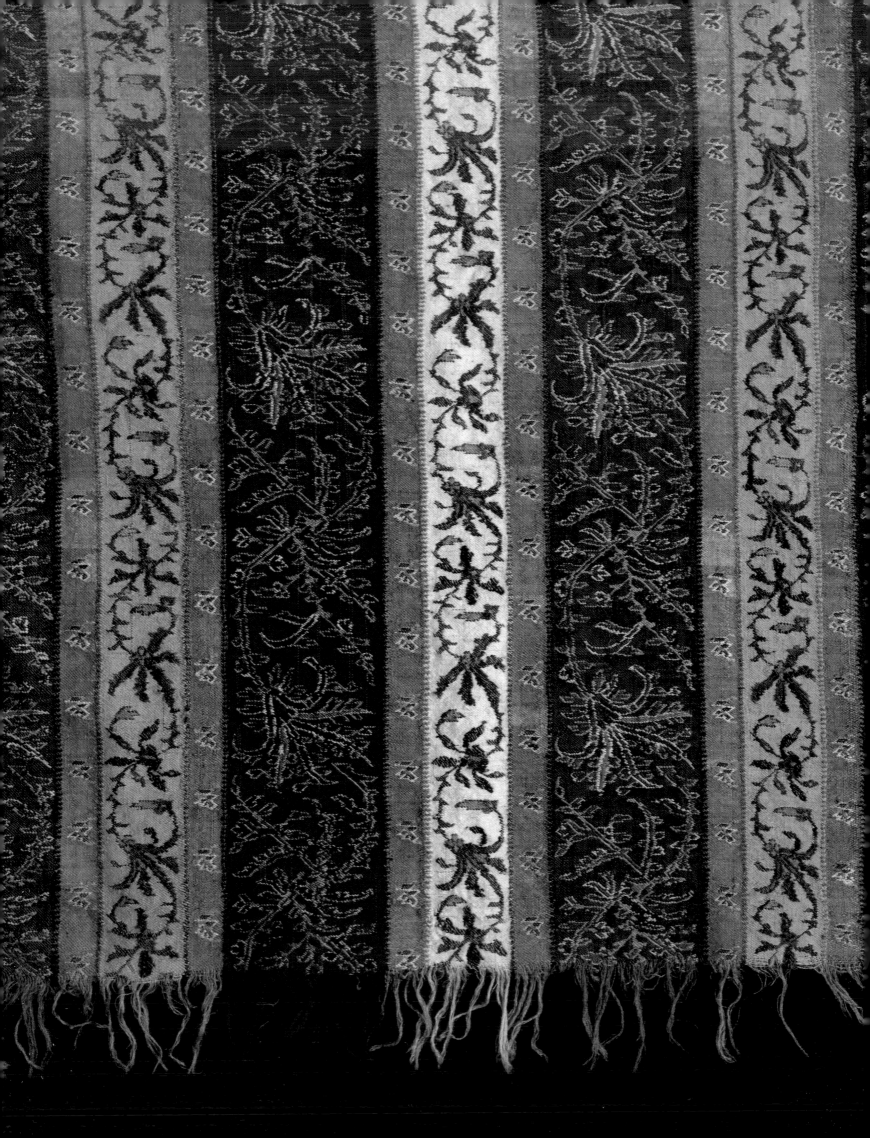

In 1823 French shawl manufacturers were already exporting their goods. Ternaux even sold some in Asia. Travellers and designs made their way to and fro between Europe and the East. An English veterinary surgeon named William Moorcroft brought back a set of eight very beautiful pine designs from Kashmir, which are now in the Metropolitan Museum in New York. The general feeling at the time was that shawls from the Indian subcontinent had become a public necessity, along with coffee, tobacco, pepper and cinnamon. French dealers knew what their customers wanted and set off for Kashmir and the Punjab to order shawls from the weavers. They not only expressed preferences but sometimes went so far as to tell the weavers exactly what was required, prompting new ornamentation and influencing style in general.

French shawls had changed very little since the beginning of the nineteenth century, although they were more richly decorated and their size had increased. The original ten pines on the borders had become nine or eight by the end of the Restoration but had grown taller. The space between the pines was filled with sprigs. The vertical and horizontal borders that surrounded the plain field had grown wider, from 2 cm (¾ in.) to 10 cm (3⅞ in.). In around 1810, corner ornaments* started to appear in the four corners of the field. Five years later a gallery* was added to the borders to form a double frame for the field; this was embellished by an extra gallery from 1825 onwards (see 'Anatomy of the shawl', p. 314).

1830–48: TECHNOLOGICAL ADVANCES

In 1828 the botanist Victor Jacquemont was sent to India by directors of the Jardin du Roi (now the Paris Natural History Museum). Born in 1801, he was to die of cholera in Bombay in 1832. While carrying out his assignment in India, Jacquemont kept a journal, later published under the title *Voyage dans l'Inde* (Travels in India). His observations during the period starting in February 1831 are of particular interest to us: when he arrived at the Punjabi town of Ludhiana, he discovered the existence of a 'Kashmir' shawl industry maintained by a colony of more than 1,000 Kashmiris, working 400 shawl looms. The prohibitive taxes levied in Kashmir at the time had forced these men to work outside their own country for a while. Extracts from Jacquemont's journal provide us with a considerable amount of detailed information on the lives of these shawl weavers.

Jacquemont first encountered shawl weavers in Ludhiana. His clear, precise description contains only one mistake: he uses the term 'weft' when he means 'warp'. This was a common error in those days and a contemporary historian of the shawl industry, Jean Rey, had already complained about it in 1823. The word 'weft' has therefore been changed to 'warp' wherever necessary in the following excerpt from Jacquemont's journal.

Ludhiana, 14 February 1831

...The weaving manufactory is called a dokan or workshop. The warp is first stretched from a roller which rotates on the block of the loom. Ordinary shawls vary in width from 120–125 cm [47¼–49¼ in.]; three weavers work at the loom together, seated on a bench as long as the beam around which the warp is wound. Each weaver is in charge of at least sixty bobbins which he manipulates with the utmost dexterity if he is an experienced worker. Usually the man seated in the

OPPOSITE
Detail of a striped stole.
Northwest India, first half of the 19th century.
Twill-tapestry weave, woven in three rectangular pieces;
cashmere, 268 × 61.5 cm (105½ × 24¼ in.).
Paris, author's collection, no. 66.
This type of striped weave, with no borders, is called
a jamewar, or gown piece, in its native country.

ABOVE AND OPPOSITE
Details of a long shawl with a border decorated
with three groups of pines.
Northwest India, c. 1845–50.
Twill-tapestry weave, woven in several rectangular
pieces; cashmere, 310 × 142 cm (122 × 55⅞ in.).
Paris, author's collection no. 73.
Here the pines have grown over the inner horizontal border,
traces of which are discernible in the background.

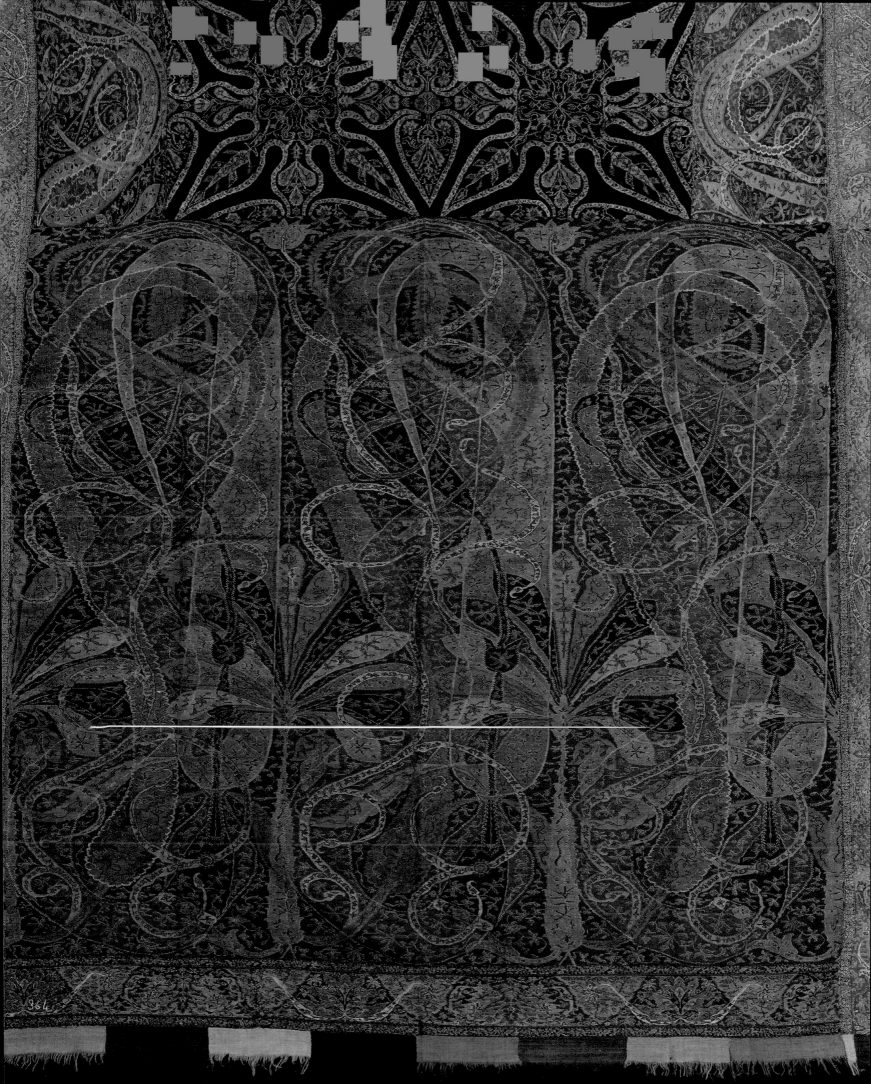

centre is the most highly skilled; while carrying out his own work, he keeps an eye on that of his companions, points out their mistakes, guides and counsels them. This head weaver checks his own work by glancing at a pen-and-ink pattern tracing which shows the shape of the pines he is weaving but not their colours; while he is weaving he can see only the reverse side of his work. Unless he is exceptionally skilled, he keeps an old manuscript in front of him, well thumbed and greasy: from this he knows which bobbins to use, how many warp threads have to be lifted each time, etc.

The pines of Kashmir shawls, like the words of a language, are made up of a limited number of letters or syllables: they are simple shapes in themselves and it is the way in which they are arranged that produces the infinite variety of designs. The custom is for children who work under the tutelage of a more experienced weaver to recite the words of this language as they read them; they say what they are doing as they complete each stage and they talk at some speed, to keep pace with the speed of their hands. The master weaver knows the lesson they are reciting by heart and he stops them at the slightest mistake and corrects them. A workshop has two, three or four looms, usually arranged in pairs facing one another. Shawls are always woven and sold in pairs, as like to one another as possible.

Kashmir, 28 July, 1831. Profits and taxes.

The tax levied on shawls totals approximately 12 laks. One man collects the profit. He is always to be found in charge of a tribunal assisted by experts and in the presence of all the shawl dealers.

All the shawls from the looms are brought here to be valued and before they are stamped and returned to their owners, the latter must pay one quarter of the estimated value. If any clandestine weaving is discovered, very severe punishments are inflicted; as a result only narrow borders are woven in this way.

The 'collector' has to send a twelfth of this revenue to Lahore each month and collect what is due to him on all finished goods; this is why he never waits until a shawl is finished before removing it from the loom. Each day his agents visit all the workshops and no sooner do they find that a few inches of shawl have been woven than they cut it off the loom and take it to their master for him to assess its value, stamp it and levy the tax. The weavers never manage to complete more than a metre of a shawl before the rapacious collector exacts his dues. This is why, of the thousands of shawls I have seen in Kashmir, every one without exception was made up of at least five pieces sewn together. The very costly shawls have their borders decorated with large pines and the work is very fine, each shawl being made up of ten, twelve or even twenty pieces. Even the most inexperienced eye can, however, make out the joins since the pattern fragments are not sufficiently well matched. Although this would, to my mind, greatly lessen their value on the French market, it has no such effect in India or Persia. There are no exceptions to this practice here: for many years past all Kashmir shawls have been made by sewing pieces and fragments together.

The reprehensible, grasping behaviour of the kardar[12] does not stem only from his obligation to remit a regular sum to Lahore covering the previous month's production, but also from his constant fear that he may be supplanted without any warning at all and have to leave his successor with a windfall of untaxed production. The weavers have often volunteered to make progress payments for their work as it is completed, but since the tax is proportional to the estimated finished value of the shawl and this can only be assessed by the kardar's public tribunal, with the help of his experts and the shawl dealers, there seems no option but to cut even small sections of woven material off the looms.

OPPOSITE
Henri Valton, A Peddler Selling Shawls to Ladies in the Troyes Region, 1837.
Oil on canvas, 160 × 131 cm (63 × 51⅝ in.).
Troyes, Musée Historique de Troyes et de la Champagne.
French countrywomen (shown here) used to wear square shawls, smaller and less flamboyant than those favoured by their city sisters. The woman in the centre of this painting, holding an umbrella, is wearing a harlequin-bordered shawl.

12 A *kardar* is a tax collector.

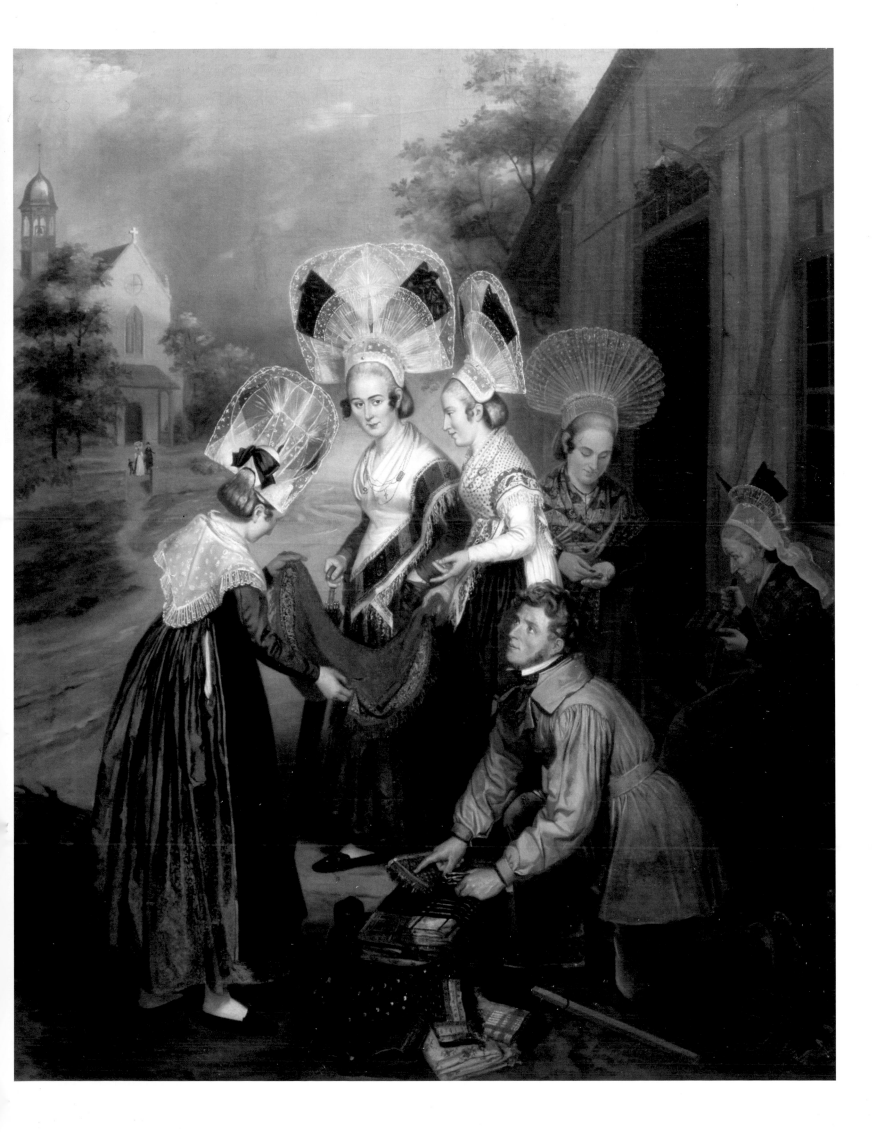

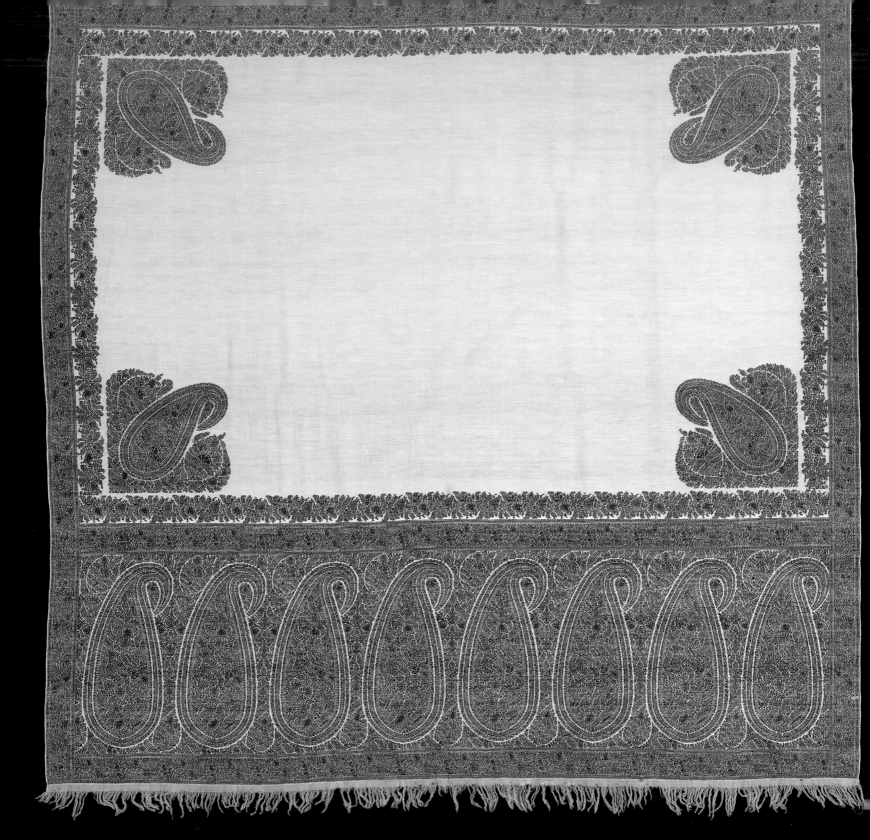

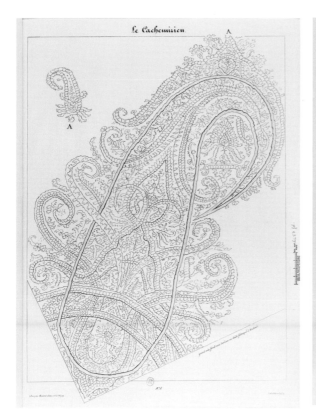

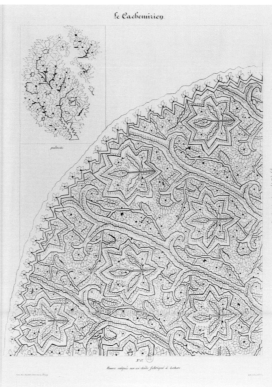

LEFT
Large Corner Ornament on
Black Field, from a Shawl Produced
in Kashmir.

RIGHT
Medallion Copied from a Shawl
Woven in Lahore.
*These were plates 5 and 12 of the thirty
that appeared in Fleury Chavant's
periodical* Album du Cachemirien,
Paris, 1837.
*Paris, Bibliothèque Nationale, Cabinet
des Estampes, shelf mark Lh 57. Fol.*
*These motifs, copied from Indian shawls
and published in 1837, were intended as
patterns for French shawl designers.*

OPPOSITE
*Lopsided shawl (*châle boiteux*).*
France, 1820–30.
*Woven au lancé, trimmed on back, silk
and wool; fringing sewn on to the single
border; 136 × 139 cm (53½ × 54¾ in.).*
Paris, author's collection, no. 7.
*The 'lopsided' shawl is so-called because
it has only one main border, which is
decorated in this case with eight pines.*

Even without the absurd and hateful method of levying this tax, the karkhandar[13] *would still weave all his shawls in several pieces, except for the inferior quality shawls which could be woven from start to finish on the same loom within the space of four or five months. The finest* jamewars* *and* dushalahs[14] *would have to stay on the same loom for years at a stretch (six, seven, even eight) before they were completed, so the borders of these are woven separately on other looms, as are the pines and the background or* zamine; *this means they can be completed in one year.*

According to Jacquemont, the pines ranged from 70 cm (27⅝ in.) to 1 m (3 ft 3⅜ in.) high; the smaller pines of the gallery were about 30 cm (11¾ in.) high; this means that the single colour field had shrunk considerably in size and must have measured only just over 1 m (3 ft 3⅜ in.) square. The shawls were woven in several pieces and some weighed a considerable amount.[15]

What was happening in France at this time? In 1830 Charles X lost the throne and was succeeded by Louis-Philippe, during whose reign commerce flourished as France caught up with industrialization. The shawl industry shared in this prosperity, not only in Paris but also in Lyons and Nîmes. The Jacquard mechanism meant that more shawls could be produced, in less time. The price of a standard quality shawl could now be afforded by a large number of women (see pp. 103–4 for examples of 1839 prices). At the same time, a wealthy and ambitious middle class was swelling the ranks of the aristocracy and the numbers of elegant ladies. Even countrywomen wore shawls, as a painting by Henri

PAGE 50
Square shawl.
France, 1840–45.
*Woven au lancé, trimmed on back, cashmere,
180 × 180 cm (70⅞ × 70⅞ in.).*
Paris, author's collection, no. 45.
*This shawl, in the 'renaissance' style, has motifs
enclosed in broken arches.*

PAGE 51
Square shawl.
France, 1840–45.
*Woven au lancé, trimmed on back, wool,
188 × 188 cm (74 × 74 in.).*
Paris, author's collection, no. 24.
*Pines with smooth outlines are juxtaposed with others
that have jagged edges, like acanthus leaves. By the time
this shawl was woven (1840–45), square shawls were
larger; the decoration covered their surface, and their rich
colours meant that they could be worn with the most
elegant clothes.*

13 The *karkhandar* is the proprietor of the weaving factory.
14 A *dushalah* is a pair of shawls.
15 Victor Jacquemont, vol. III, pp. 36–65 and 280–91.

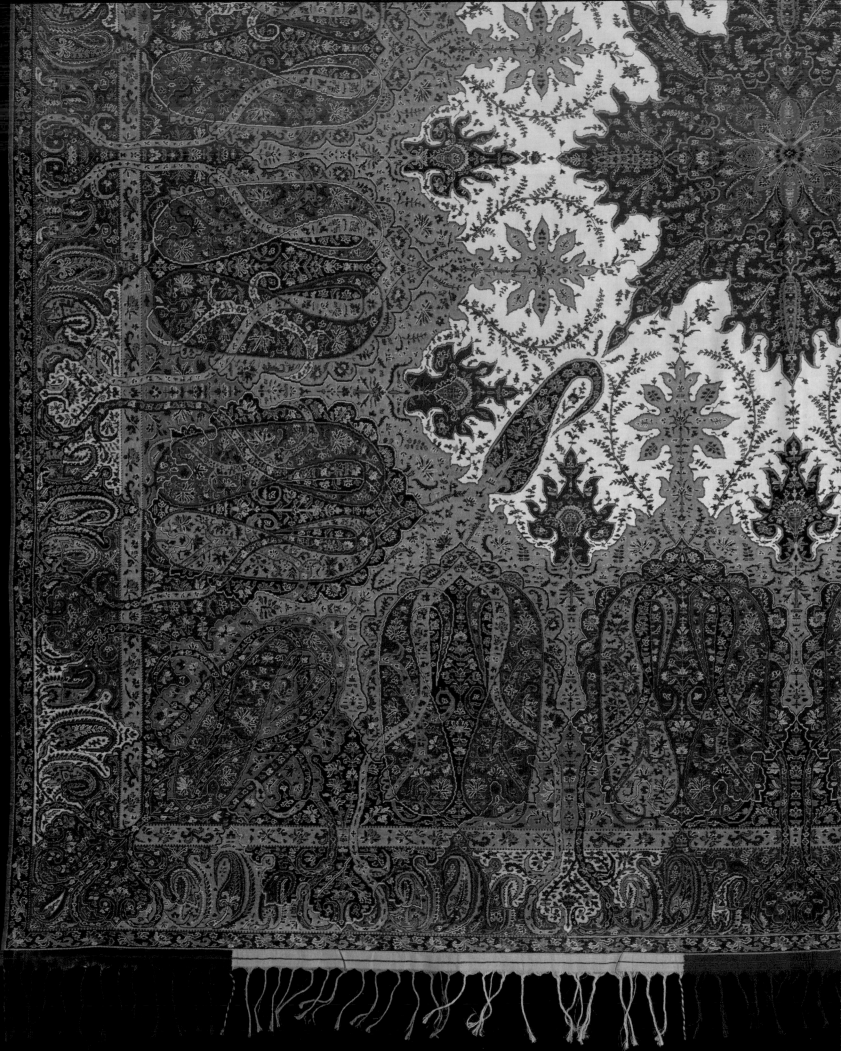

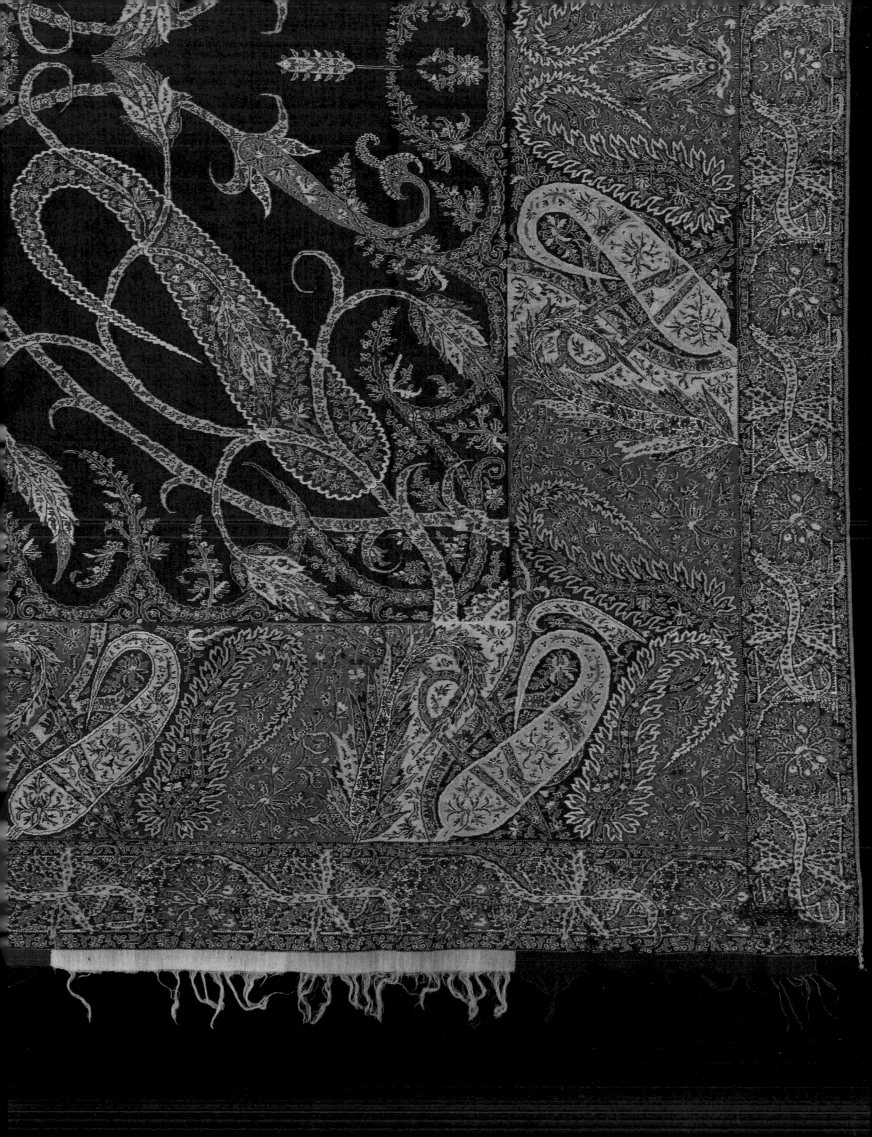

Three Shawls in One, *a small poster showing a shawl produced by Champion & Gérard of Paris in 1847. Paris, Bibliothèque Nationale, Cabinet des Estampes, shelf mark Oa 20, 1847.*
A long shawl, three sides decorated with a border of small pines, the fourth with a border of large pines. The shawl could be folded so that the exposed portion showed the larger or smaller design, with a corner folded outwards over the shoulders (centre and right), or folded right over in half, with the fold hidden, to look like a square shawl (left).

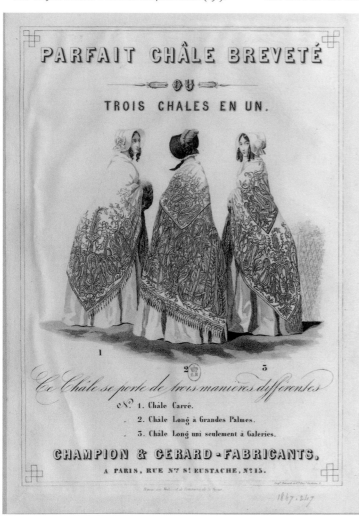

OPPOSITE
Long shawl of the 'three shawls in one' type. Paris, Champion & Gérard, c. 1850. Woven au lancé, trimmed on back, wool, 350 × 175 cm (137¾ × 68¾ in.). Milan, Etro collection, no. 225.

[16] Edmond de Goncourt, vol. II, p. 164.

Valton shows (p. 47). There was obviously a considerable difference between the various qualities of shawl marketed: a range of smaller shawls, which were not such luxury items as the long shawls with their pine decorations or the square shawls with large medallions, were sold at reasonable prices. Their modest ornamentation consisted of scattered flowers or small pines, or corner pines on a plain background, framed by a simple border. If a long shawl were torn or came apart it could be cut lengthwise in half, into two long scarves, or cut across the middle to make two nearly square shawls, each having only one deep border of pines: these were called *boiteux* or lopsided* shawls (p. 73). These smaller items sold well and were often woven as such by the manufacturers; they sold for half the price of a complete long shawl. Long, narrow scarves were particularly popular in southern France, where the warmer climate called for something less all-enveloping.

The raw materials also varied. The most expensive shawls were woven with pure cashmere warp and wefts; next down the scale were those with silk warp and wefts of cashmere or wool of varying fineness and quality. The real criterion when judging the quality of a French shawl was how many different colours had been used for the weft. The number had an effect on the cost price: good-quality shawls were woven with seven colours; less expensive shawls would have fewer than seven colours; and 'rich' shawls* would have eight to fifteen.

Some Paris manufacturers hit upon the idea of a long shawl with hybrid decoration and patented it: one half had an ornamental gallery along three sides, like a square shawl, the other half was decorated with large pines. Its owner could wear her shawl to show off its various facets on different occasions, so she effectively had three shawls in one. This proves that in 1847 the shawl industry was making every effort to tempt a less moneyed but far larger clientele. In 1837 the publisher Fleury Chavant brought out a magazine called *Le Cachemirien*, reproducing quantities of cashmere patterns that designers and manufacturers could consult for inspiration (p. 49). Shawl dealers sold their shawls in special white boxes with the shop's name printed in gold letters. The boxes opened down the centre by folding back both halves of the top; once closed the box was fastened by tying the laces. Ladies who owned one or more cashmere shawls could keep each one in its box, but the done thing was to store them in a small wooden chest, purpose-made in fine wood. Edmond de Goncourt had just such a box in his bedroom: 'I almost forgot to mention the marquetry box, made in the beautiful wavy, satiny sandalwood so sought after during the last century. This was where my elegant grandmother kept only the most beautiful of her cashmeres – she had so many of them....'[16]

The new fashions changed the outward female form: from 1820, waists gradually dropped to return to their rightful anatomical position; skirts grew slightly shorter, and fuller; the new leg-of-mutton sleeves, puffed out just below the shoulder, called for more bouffant hairstyles; more significantly, the new fashions were ill-suited to long shawls.

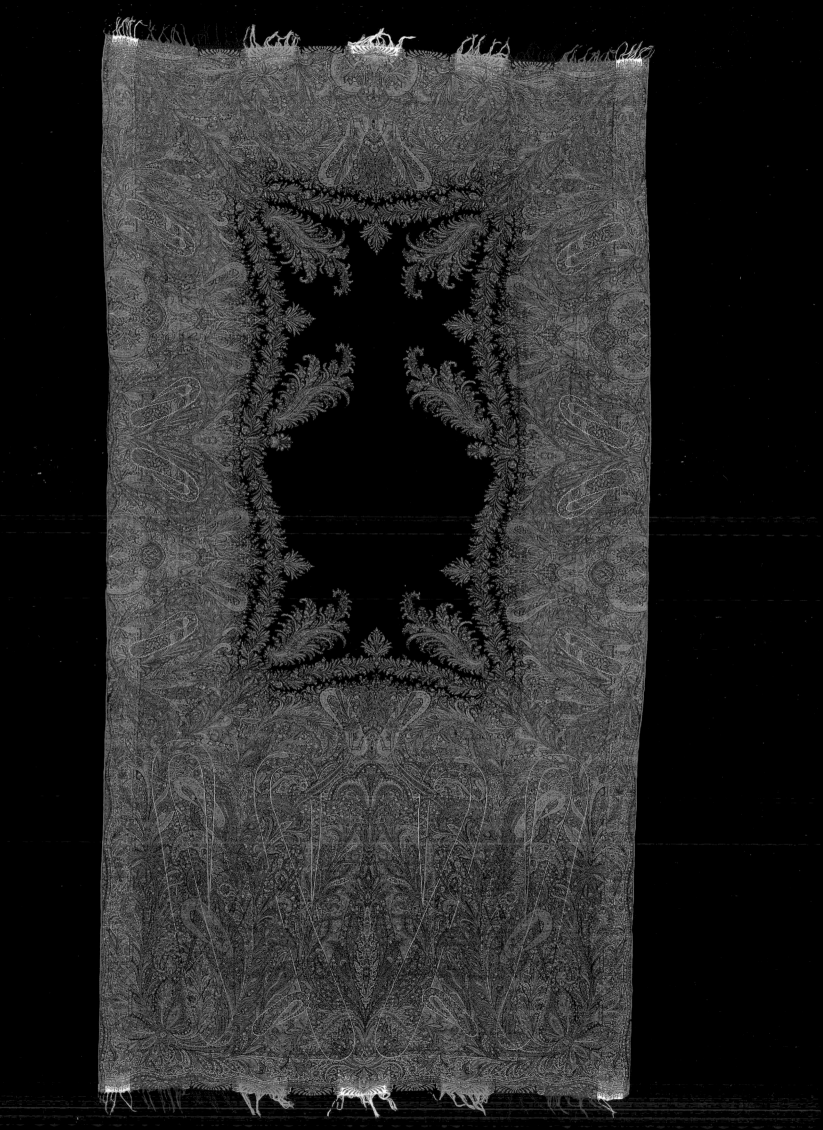

The square shawl, which had previously measured only about 140 to 150 sq. cm (22–23 sq. in.) and not been considered an elegant accessory, now expanded to 180 sq. cm (70⅞ sq. in.) and was worn on all occasions. Many early nineteenth-century long shawls were remade into square shawls and embellished with rich decoration to underline their new status as high-fashion accessories. The growth of the industry enabled the development of the Jacquard mechanism; wider decorative schemes could be produced without any sacrifice of quality of weave and design detail. The weavers could now work with fine, even and strong thread.

A new type of shawl was launched on the market in the early 1830s: the quartered shawl, or *châle au quart*, where the design scheme, which could now be up to 90 cm (35⅜ in.) wide, fills a quarter of the shawl and is repeated on the other quarters.

BELOW LEFT
Detail of the last plate in the album Souvenir de l'Exposition des Produits de l'Industrie Française de 1839, *reproducing a shawl design by Amédée Couder, the* Nou-Rouz, *which was woven by the Paris manufacturer Gaussen.*
Paris, Bibliothèque Forney, shelf mark 0161.41 '1839'.

BELOW RIGHT
Vernis of the same detail by Amédée Couder.*
Paris, author's collection.

OPPOSITE
Plates 10 and 11 from the album Souvenir de l'Exposition des Produits de l'Industrie Française de 1839 *showing Hérault & Léon's shawl design, which was subsequently woven by the Paris manufacturer Bournhonet, Ternaux's successor.*
Paris, Bibliothèque Forney, shelf mark 061.41 '1839'.

It is therefore hardly surprising that several manufacturers submitted 'rich' square shawls for the 1834 exhibition. One manufacturer, Gaussen, wove a quartered shawl to a design by Amédée Couder who had called it the *Isfahan* shawl. Here the ornamentation, woven in ten colours, shows Persian-style buildings set against an emerald green background; the cupolas of the mosques are decorated with flags and point towards a central medallion.

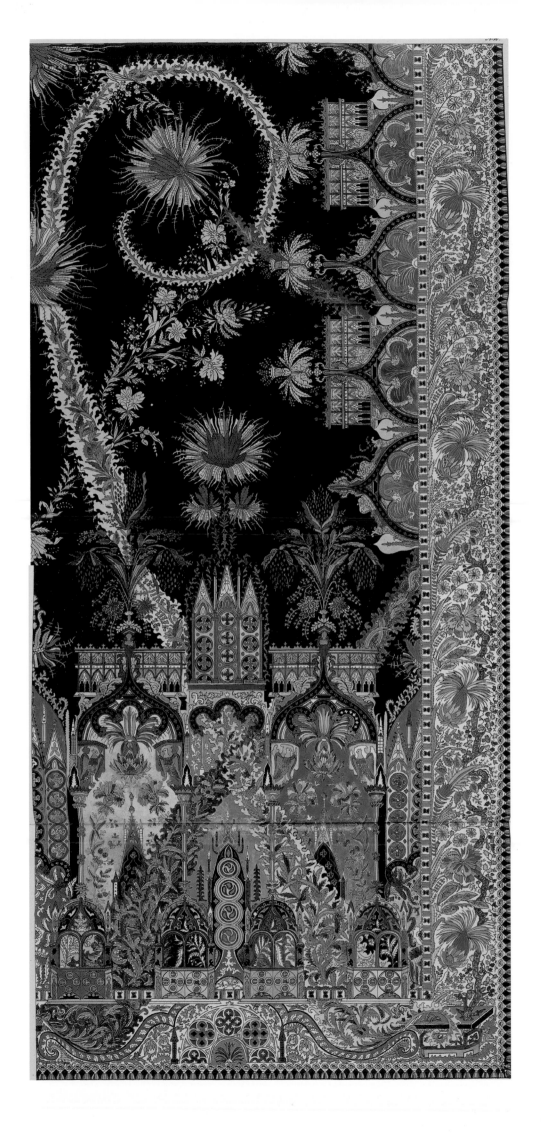

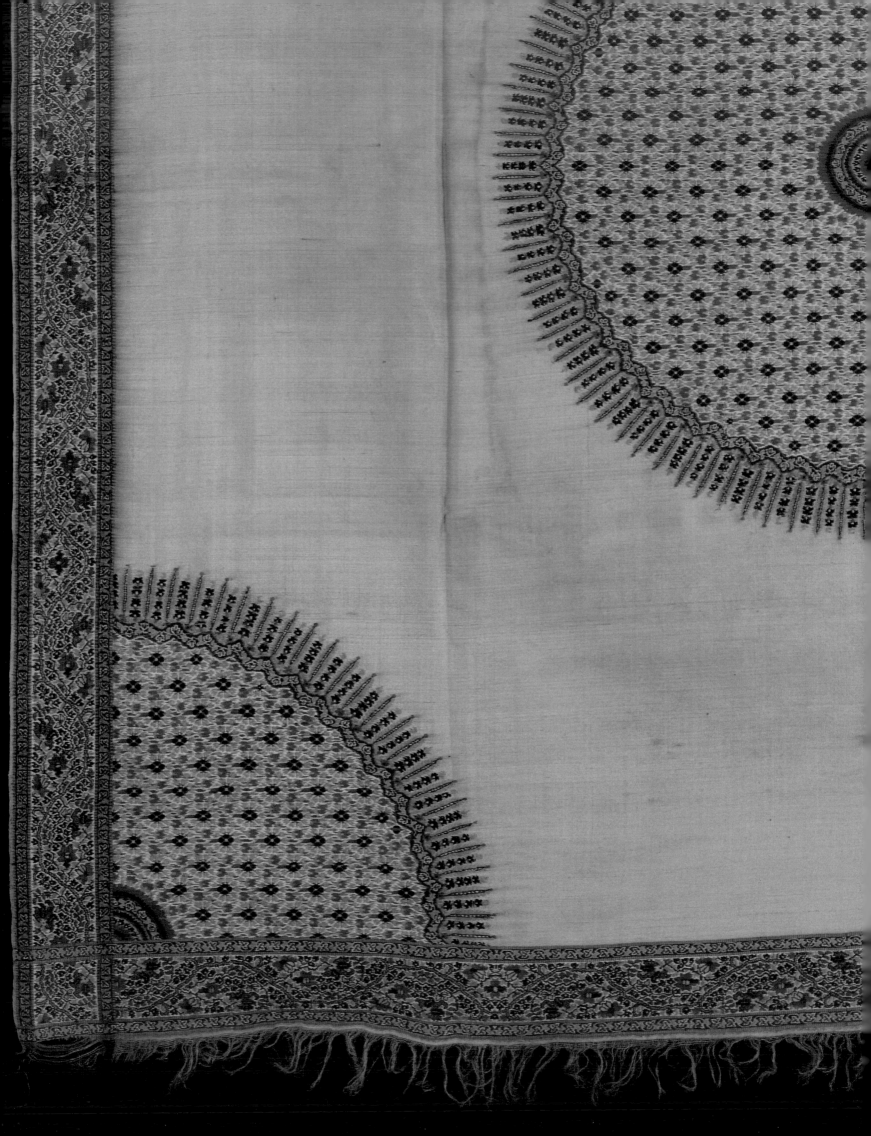

At the 1839 exhibition Gaussen displayed a long shawl based on another design by Couder, called the *Nou-Rouz*. It depicted Persians in procession before the Shah on New Year's day, accompanied by horses, elephants and camels. Shawls of this type are known as renaissance shawls and are characterized by a realistic, figurative style, bereft of any imitation of Kashmir ornamentation. It is easy to see why these revolutionary new designs led French manufacturers to believe that, at long last, they were no longer the pupils of Eastern master craftsmen. Although the fashion for these designs soon passed and the industry reverted to the imitation of Indian products, the renaissance shawls nevertheless had a lasting effect on shawl decoration, which henceforth was a synthesis of pines and architectural motifs. Couder points out that Indian designs already echoed some of the more graceful, curving contours created by French artists.

Another manufacturer, Paul Bournhonet, who had taken over Ternaux's business, displayed a long shawl at the same exhibition in 1839. Designed by Hérault & Léon, it featured Gothic architectural motifs with long, serrated pines crossing over them (p. 55). The revolution in style heralded by the renaissance shawls also led to other changes. Fine-quality shawls began to have harlequin fringe gates; this was nothing new for striped and harlequin shawls, where it was inherent in the design. Now, however, harlequin fringe gates became the norm for all top-quality shawls, regardless of border ornamentation. The fringe gates altered gradually between 1834 and 1870 and these changes provide a rough guide to the dating of shawls (p. 315).

Long shawls came back into vogue around 1839, after being out of fashion for a while, for by then sleeves were fuller further down the arm, closer to the wrists, while skirts grew longer once more. In the album *Souvenir de l'Exposition de 1839* an equal number of square and long shawls are shown. The designer of one of the latter probably drew on an Indian shawl for inspiration (p. 8). The classic decorative scheme is retained: large pines on the border and a gallery of smaller pines surrounding the field. But these large and small pines do not all face the same way: they are arranged back to back or facing one another. Renaissance shawls had already discarded the inner horizontal border that had previously separated the large pines from the gallery. The new shawls only retained the vertical and outer horizontal borders to provide a frame.

After 1840 Indian-style shawls gradually lost this inner horizontal border. Sometimes it was retained in the form of arches over the pines (p. 61); sometimes the pines and their attendant scrolls crossed over the inner horizontal border, partially

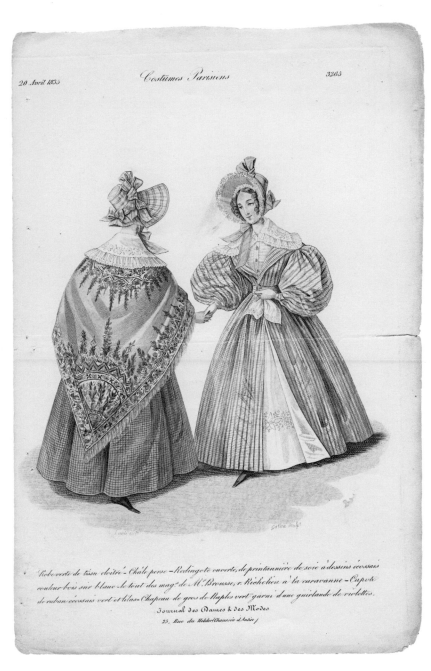

Fashion plate, 1835.
Paris, da Silveira collection.

OPPOSITE
Square shawl with medallions.
France, 1815–20.
Woven au lancé, trimmed on back; silk, cotton and wool,
134 × 136 cm (52¾ × 53½ in.).
Paris, author's collection, no. 6.

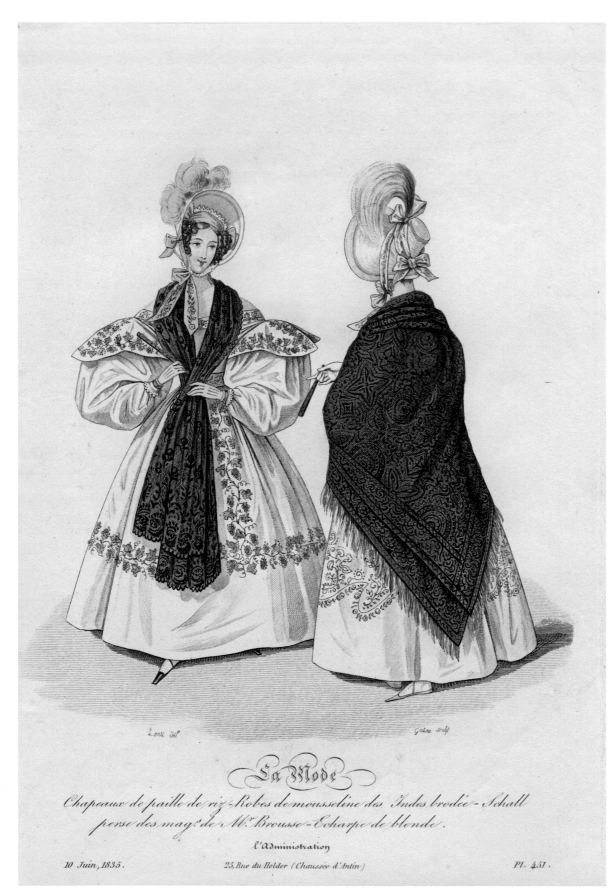

La Mode

Chapeaux de paille de riz—Robes de mousseline des Indes brodée—Schall perse des magⁿ de Mˢ Brousse—Echarpe de blonde.

l'Administration

10 Juin, 1835. *25, Rue du Helder (Chaussée d'Antin)* *Pl. 451.*

Fashion plate, 1835.
Paris, da Silveira collection.

OPPOSITE
Square shawl.
France, c. 1840.
Woven au lancé, trimmed on back;
silk and wool, 180 × 184 cm
(70⅞ × 72½ in.).
Paris, author's collection, no. 21.
In the style of Amédée Couder, with
large broken arches radiating from
a central medallion.

hiding it (p. 45); and occasionally this border was pushed higher, encroaching further on the field, to make room for ever-larger pines, giving the effect of a bar across the shoulders when the shawl was worn. This was not popular, however, and the inner border disappeared before 1850.

By 1836, or thereabouts, pines of all sizes had encroached on the field of Kashmirian shawls. Ornamentation grew ever more profuse and the shawls increasingly heavy to wear. Carl von Hügel, who was in Kashmir at that time, thought they were really more like carpets, made for the Persian and European markets, for they were no longer worn in India. The deep border sported two rows of pines, only leaving room for a much smaller field. The most popular shawls were those that were copies of English imitations.

Von Hügel also describes a workshop in Kashmir:

> *Twenty-four weavers work at eleven looms in the following way:*
> *2 looms with 3 weavers each for the large pines*
> *4 looms with 2 weavers each for the small pines*
> *1 loom with 2 weavers for the field*
> *4 looms with 2 adolescent weavers each for the borders*

> *Each of the very best shawls is made up of fifteen pieces. Two shawls are always woven at the same time. Looms weaving the same pattern are worked simultaneously; one of the weavers who is thoroughly familiar with the design recites each step for his fellow workers. These twenty-four weavers will take from six months to a year to complete a pair of shawls. Jamewar, or striped weaves, are about 2.65 m [8 ft 8 in.] long and 1 m [3 ft 3 in.] wide and are woven in four pieces; the Indians wear them over their tunics in winter, but never as turbans nor over their shoulders as a shawl. Plain materials woven in pashmina* are produced in the Punjab and in Hindustan by emigré weavers. In the days of the Moghul emperors there were 40,000 looms each worked by an average of three weavers, making a total of 120,000 weavers in Kashmir. Under Afghan rule there were still 23,000. Nowadays [1836], there are only 2,000, 1,000 of whom specialize in long and square shawls, 600 in jamewar and 400 are engaged in weaving plain shawls or Kashmir material. These weavers produce a total of 3,000 shawls and pieces of material, and 1,200 jamewar each year.* [17]

There were many reasons for the decline in the numbers of weavers in Kashmir. The principal one was the exorbitant taxes imposed by the Sikhs, which forced the weavers to leave their native country. Then there were the recurrent famines and cholera epidemics that ravaged Kashmir. Another reason was simply that the milder climate of the Punjab was more congenial and the weavers found they did not need to spend so much to eat, clothe themselves and keep warm. Expatriate weavers settled in Nurpur, Jommlu, Amritsar, Ludhiana and even Delhi. But, as Bernier had already commented in the seventeenth century, the most beautiful shawls of all were made in Kashmir: the workforce and the raw materials could be moved to another country, but Kashmir's pure air and incomparable water were irreplaceable. The properties of water have an effect on how dyes take and on the washing of the shawls, when they should become very soft. After Kashmiri shawls had been washed they were taken to a government official who affixed his stamp, the size

OPPOSITE
Long shawl with three central fields in red,
green and pink.
Paris, c. 1845.
Woven au lancé, trimmed on back; cashmere,
372 × 160 cm (146½ × 63 in.).
Paris, author's collection, no. 25.
The three arches of the inner horizontal border
each enclose a pair of adorsed (back-to-back) pines.

[17] Carl von Hügel, vol. II, pp. 304 and 312–20.

of a man's hand, to them in return for a payment, which varied according to the value of the shawl. Anyone found in possession of a shawl that did not have this seal was liable to a fine; when a shawl was washed after use the stamp disappeared and the official would stamp it again, this time free of charge.

In addition to these and other reasons for the decline of the shawl industry in Kashmir, von Hügel mentions the unpopularity of Indian shawls in Europe and the fact that even the Indians themselves were beginning to express a preference for English shawls. In 1872, when William Cross addressed a Scottish audience, he told them that the Franco-Indian style had exerted great influence on the Paisley shawl-making industry from 1842 onwards.[18] Both men and designs were travelling further than ever before.

1848–78: FORMS FILL THE FIELD

The designer who had the greatest influence on the last thirty years of the great age of shawl production was Antony Berrus (1815–83). Having studied at the École de Dessin in Nîmes, where he was born, he became resident designer at a carpet factory. He later worked for a shawl manufacturer in Nîmes who moved his factory to Lyons in 1838 and took Berrus on as his business partner. Berrus eventually founded his own company in Paris, leaving the management of day-to-day affairs to his brother Émile. The two brothers predictably traded under the name of Berrus Frères and met with enormous success: towards the end of its existence the company employed nearly two hundred designers. Berrus designs were sold to manufacturers in Paris, Lyons and Nîmes as well as to the Scottish and Austrian shawl industries, and were even bought by shawl makers in the Kashmir Valley. Berrus was the creator of the most widely successful French cashmere style. His designs were not, however, bought by the most famous shawl manufacturers, who kept to their traditional practice of having a designer among their permanent employees. This meant that Berrus's dazzlingly accomplished shawl designs never took shape on the looms of the great masters of the craft (pp. 240–81).

In 1848, following the abdication of King Louis-Philippe, Prince Louis Napoleon was elected President of the Republic; he was proclaimed Emperor of France four years later. During this turbulent time another exhibition was held, in 1849, at which a new type of shawl made its mark: the châle végétal or floral-style shawl. This style provided the inspiration for a number of Berrus's most accomplished extant designs. Waving pines stretch up towards the centre among luxuriant flowering branches and ferns. Sometimes the elongated pines turn into a palm tree, with a typical scaled trunk and its apex transformed into a treetop. This wealth of exotic and imaginary vegetation sometimes sheltered wildlife: snakes, salamanders and butterflies, with birds of paradise on the wing in pursuit of insects. The only surviving shawl of this type known to the author (pp. 64–65) is woven in twelve colours, a sure sign of its rarity. The animal motifs on the Nou-Rouz shawl (1839) have already been noted, with ogival arches holding birds of paradise. At the same 1839 exhibition, Frédéric Hébert displayed a shawl whose field was adorned with large lyre birds. It is not unheard of for borders woven in Kashmir to feature small parrots – their presence added value to a shawl, perhaps because they were considered to be lucky. In her memoirs, the Duchess of Abrantès told how Princess Caroline, the sister of Napoleon, had given the

OPPOSITE ABOVE
Border of a long shawl.
Kashmir, c. 1810.
Twill-tapestry weave, cashmere,
284.5 × 132 cm (112 × 52 in.).
Paris, Musée Guimet, verbal legacy of Krishna Riboud,
2003, AEDTA no. 1359.

OPPOSITE BELOW
Border of a long shawl.
Kashmir, c. 1800.
Twill-tapestry weave, cashmere,
308 × 129 cm (121¼ × 50¾ in.).
Paris, Musée Guimet, verbal legacy of Krishna Riboud,
2003, AEDTA no. 1130.
Small birds perch between the pines in both borders.

PAGE 64
Four details of the shawl on page 65, showing a snake,
a bird of paradise, a butterfly and a salamander.

PAGE 65
Lower half of a long shawl with a deep border, typical
of the style végétal or floral style.
Paris, c. 1850.
Woven au lancé, trimmed on back, cashmere,
383 × 166 cm (150¾ × 65¼ in.).
Paris, author's collection, no. 26.
The decorative scheme of this shawl is reminiscent of
Berrus's designs between 1848 and 1850. Here two palm
trees intertwine on both sides of the tree of life. The inclusion
of animals makes it a rarity, as does its exceptionally
rich range of colours: the weft is made up of no fewer than
twelve colours.

[18] William Cross, p. 21.

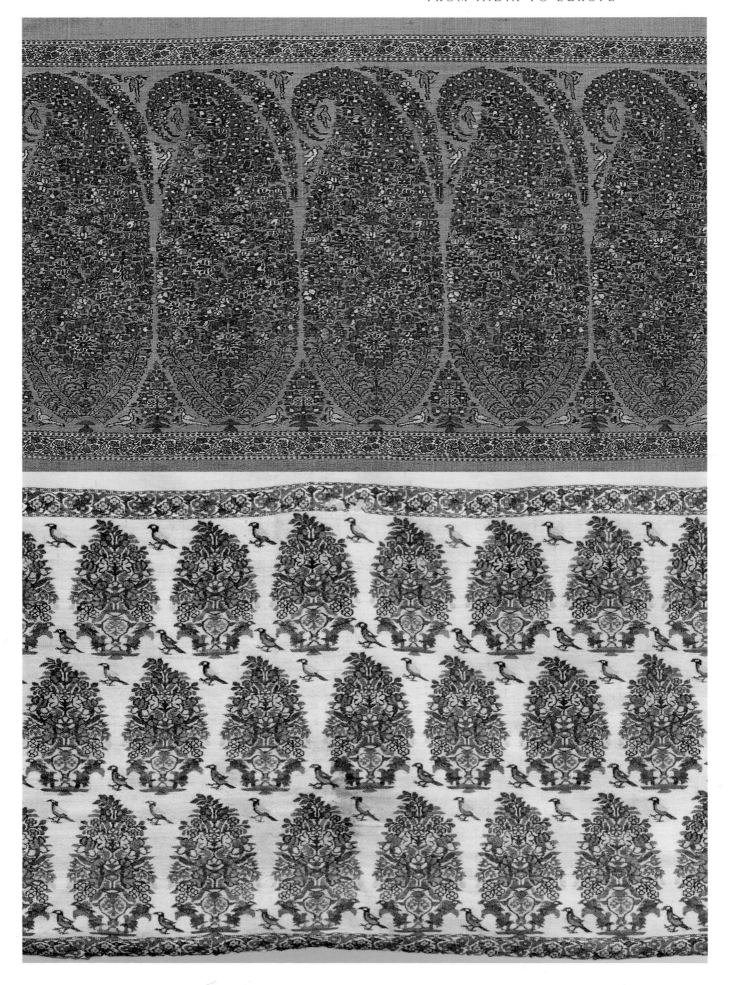

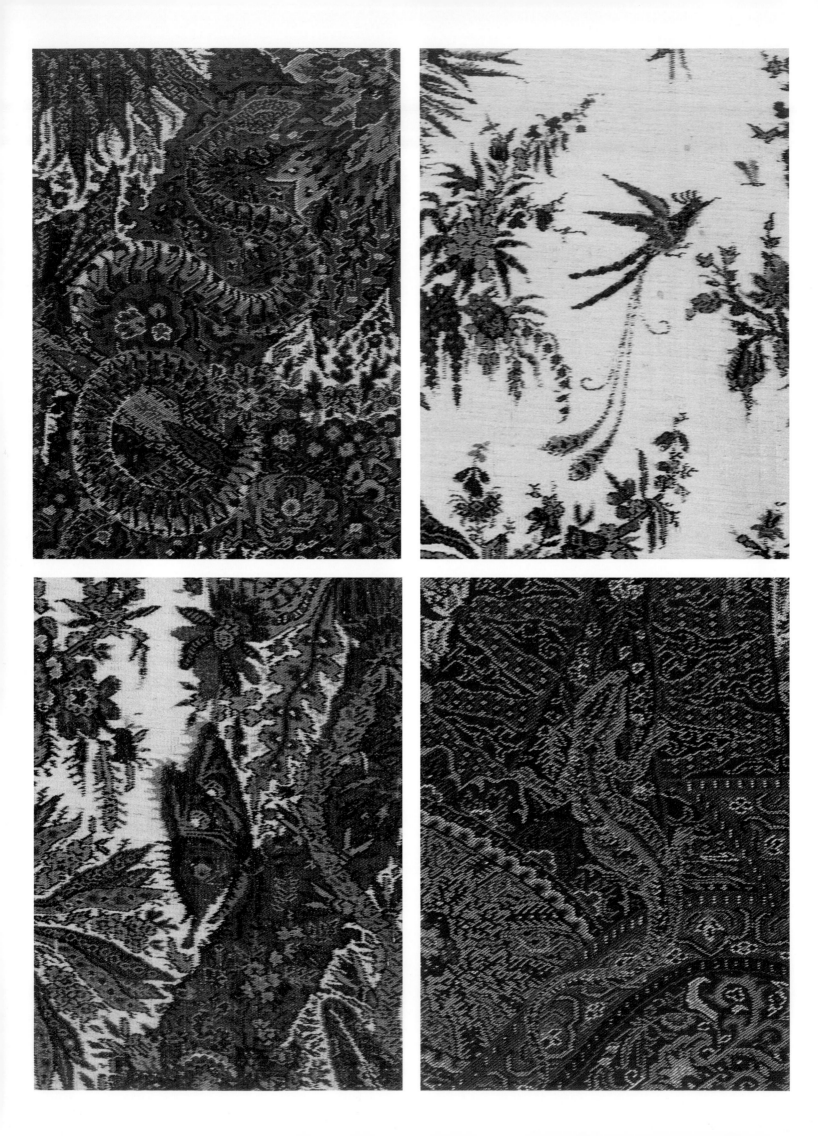

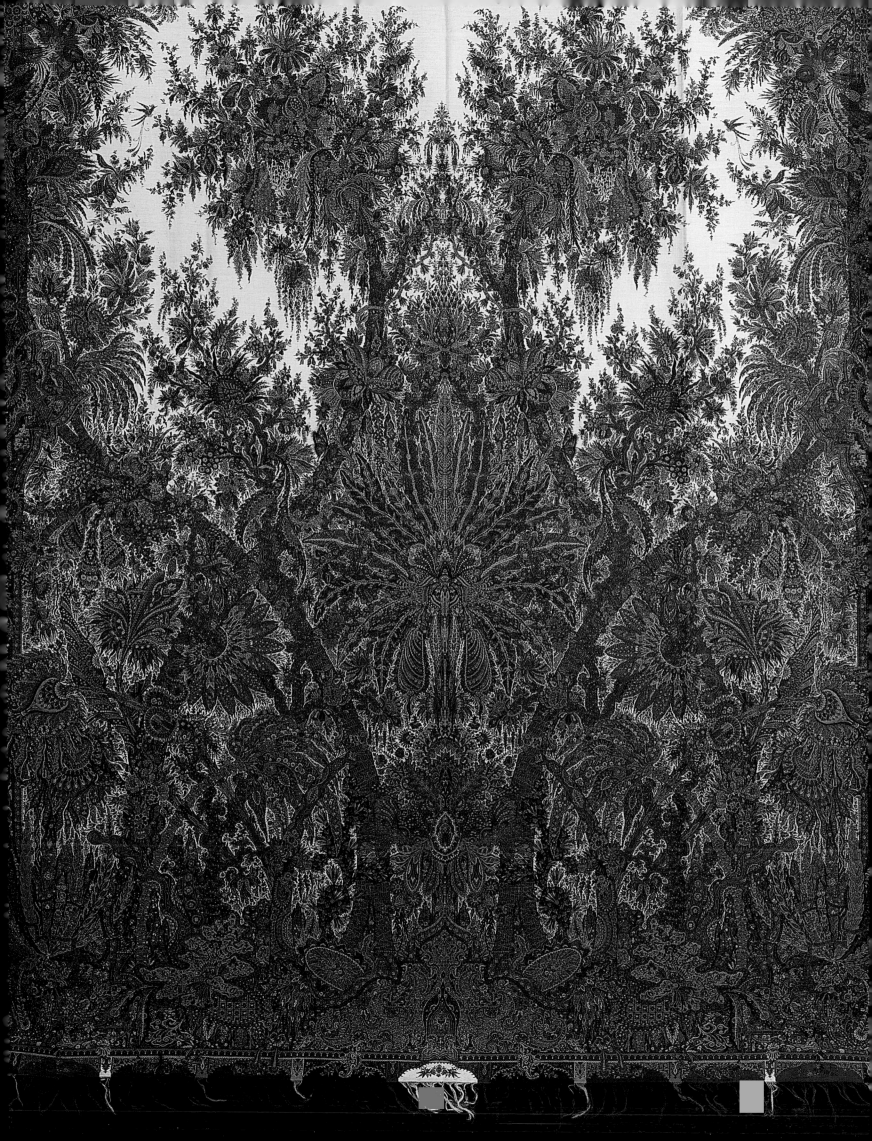

Square shawl with all-over decorated ground.
Paris, Lion Frères, c. 1852–55.
Woven au lancé, trimmed on back, wool,
190 × 190 cm (74¾ × 74¾ in.).
Milan, Etro collection, no. 26.
A shawl of this type, with a repeating design and
restrained effect, could be worn on almost any occasion.
When cashmere shawls went out of fashion, they found
another use (and still do today) as covers for square or
round tables.

LEFT Detail of the square shawl (above) showing the
initials 'L. F.' woven into each of the left-hand corners.
They belong to the Paris manufacturers Lion Frères.

RIGHT Detail of the long shawl shown opposite.
Once again, the Gothic initials 'L. F.' belong to the
Paris manufacturers Lion Frères.

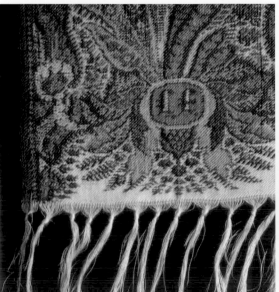

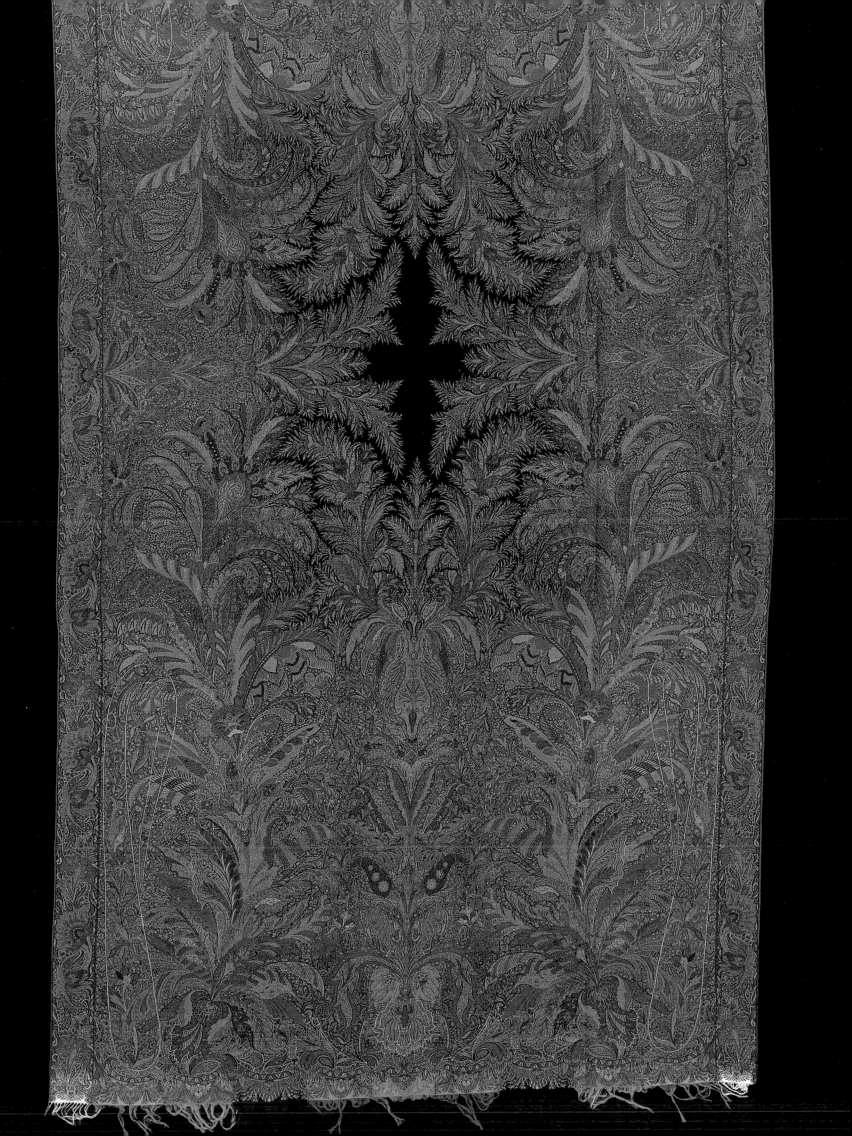

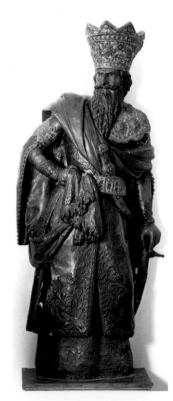

¹⁹ Duchess of Abrantès, vol. VI, p. 29.

Countess of S...: 'a very handsome shawl of white cashmere, with a feature that made it particularly rare. Its borders were decorated with parrots. They were very like the real parrots of Kashmir, although of course one cannot talk to the parrots on a shawl, but nonetheless they were very fine. The Countess of S...was therefore very proud of her shawl.'¹⁹

In Honoré de Balzac's *Gaudissart II*, written in 1844 (and just one of the many volumes that make up his vast work *The Human Comedy*, first published between 1829 and 1847), a lyrical description is given of one of the most famous shawl shops in Paris. Another store, known as Au Persan (The Persian) after its famous statue (now on display at the Musée Carnavalet), and located at 76 Rue de Richelieu, was also a fine place to observe what Balzac called 'the comedy of cashmeres':

> For a middle-class lady, the oldest assistant is sent forward. He brings out a hundred shawls in fifteen minutes; he turns her head with colours and patterns; every shawl that he shows her is like a circle described by a kite wheeling round a hapless rabbit, until after half an hour, when her head is swimming and she is utterly incapable of making a decision for herself, the good lady, meeting with a flattering response to all her ideas, refers the question to the assistant, who promptly leaves her on the horns of a dilemma between two equally irresistible shawls. 'This, madame, is very becoming – apple green, the colour of the season; still, fashions change; while as for this other black-and-white shawl (an opportunity not to be missed), you will never grow tired of it, and it will go with any dress.'
> This is the ABC of the trade.

Not all shawls, however, were so easy to sell. One such item was known as the 'Selim shawl':

> ...an absolutely unsaleable article, yet whenever we bring it out, we sell it. We keep always a shawl worth five or six hundred francs in a cedar-wood box, perfectly plain outside, but lined with satin. It is one of the shawls that Selim sent to the Emperor Napoleon. It is our Imperial Guard; it is brought to the front whenever the day is almost lost; it is sold and sold, and yet it never dies.

Then an Englishwoman arrives in the store and the assistant comments to his colleagues:

> There are women who slip through our fingers like eels; we catch them on the staircase. There are lorettes who chaff us, we join in their laughter, we have a hold on them because we give credit. There are sphinx-like foreign ladies; we take a quantity of shawls to their houses, and arrive at an understanding by flattery; but an Englishwoman! – you might as well attack the bronze statue of Louis Quatorze!

Fortunately, the store possesses a virtuoso salesman. The battle begins between him and the English customer:

> 'These are our best quality in Indian red, blue, and pale orange – all at ten thousand francs. Here are shawls at five thousand francs, and others at three.'

But the lady is not impressed, and asks to see more.

> The young man went in search of cheaper wares. These he spread out solemnly as if they were things of price, saying by his manner, 'Pay attention to all this magnificence!'

'These are much more expensive,' said he. 'They have never been worn; they have come by courier direct from the manufacturers at Lahore.'

'Oh! I see,' said she; 'they are much more like the thing I want.' [...]'What price?' she asked, indicating a sky-blue shawl covered with a pattern of birds nestling in pagodas.

'Seven thousand francs.'

She took it up, wrapped it about her shoulders, looked in the glass, and handed it back again.

'No, I do not like it at all.'

The manager of the store then enters the fray:

'I have only one shawl left,' he continued, 'but I never show it. It is not to everybody's taste; it is quite out of the common. I was thinking of giving it to my wife. We have had it in stock since 1805; it belonged to the Empress Josephine.'

Intrigued, the lady asks to see it.

'It cost sixty thousand francs in Turkey, madame.'

'Oh!'

'It is one of seven shawls which Selim sent, before his fall, to the Emperor Napoleon. The Empress Josephine, a Creole, as you know, my lady, and very capricious in her tastes, exchanged this one for another brought by the Turkish ambassador, and purchased by my predecessor; but I have never seen the money back. Our ladies in France are not rich enough; it is not as it is in England. The shawl is worth seven thousand francs; and taking interest and compound interest altogether, it makes up fourteen or fifteen thousand by now....' [...]

With precautions that a custodian of the Dresden Grüne Gewölbe might have admired, he took out an infinitesimal key and opened a square cedar-wood box. The Englishwoman was much impressed with its shape and plainness. From that box, lined with black satin, he drew a shawl worth about fifteen hundred francs, a black pattern on a golden-yellow ground, of which the startling colour was only surpassed by the surprising efforts of the Indian imagination.

She tries it on and admires it. But will she buy it? No, she changes her mind and decides that she would rather buy a carriage (which gives an idea of the selling price of a shawl in that era). No matter: the manager also has a fine carriage to sell her, left in payment for goods received by a Russian princess. He insists that the customer keeps the shawl on, to try out its effect in the carriage, and off they go together.

Twenty minutes later the proprietor returned.

'Go to the Hotel Lawson (here is the card, "Mrs. Noswell"), and take an invoice that I will give you. There are six thousand francs to take.'

'How did you do it?' asked Duronceret, bowing before the king of invoices.

'Oh, I saw what she was, an eccentric woman that loves to be conspicuous. As soon as she saw that everyone stared at her, she said, "Keep your carriage, monsieur, my mind is made up; I will take the shawl."'

And the last word goes to the store's best salesman:

'Now we will go through our old stock to find another Selim shawl.'[20]

OPPOSITE
Lower half of a long 'four seasons' shawl.
Towler and Campin, Norwich, 1848–53.
Woven au lancé, trimmed on back, wool,
323 × 162 cm (127⅛ × 63¾ in.).
Milan, Etro collection, no. 246.
The pattern may have been designed by Berrus
(who is known to have sold his designs abroad).
If not, it was certainly inspired by him.

[20] The quotations on this page and page 68 are from
Honoré de Balzac, Gaudissart II, 1950, pp. 853–62.

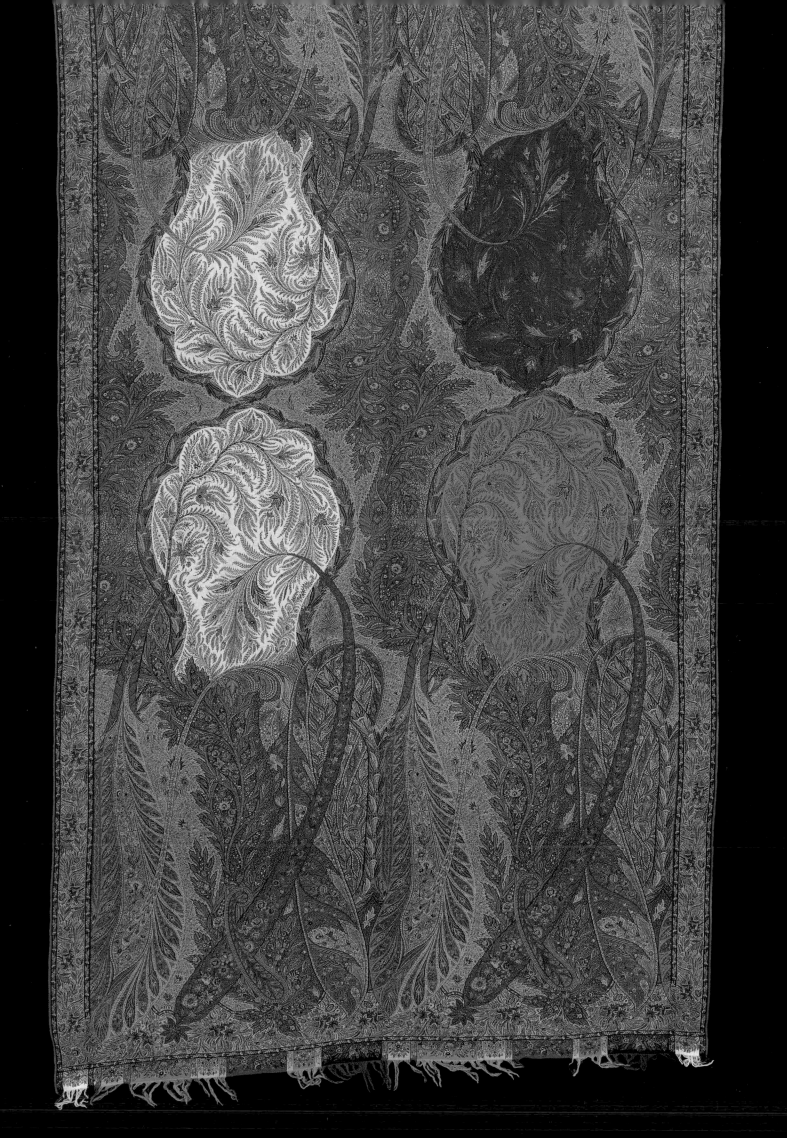

The theme of a shawl that is so difficult to sell that it becomes a legend also provided the subject for a one-act comedy by Eugène Marin Labiche, called *Le Cachemire X.B.T.*: it was first performed on 24 February 1870.

Shawls with plant forms remained in vogue until 1851. Carnations, dahlias and irises (see pp. 295–311) were discernible in some of the designs, proof of the oriental style's disfavour: in some shawls only the framing borders and the harlequin shawl gates survived. Floral-style shawls were also made in silk, both long and square, and the latter were sometimes reversible. These reversible shawls called for a far more intricate weave: there were no floating wefts to be trimmed, so that they did not have to be folded in half to hide the back; Lyons was one of the production centres, exporting to Britain and South America. The wider, crinolined skirts of the Second Empire (1852–70) brought square shawls back into fashion.

In 1844 Paul Godefroy, a shawl manufacturer and textile printer, invented a technique for colour printing the warp to match the outlines of the design to be woven. His remarkable achievement meant that some shawls were now made with their centre section divided into compartments with different ground colours; the ornamentation was the same but the fields were woven with different colour wefts (p. 71).

Pivoting* designs (*châles à pivot*) made their first appearance at the same time as the floral-style shawls. Similar in style, the difference lay in the arrangement of the decoration, with only one design repeat. After half the shawl had been woven, this one design was swivelled through 180 degrees around a central point to give a diagonal effect (p. 90). Several of the most outstanding manufacturers produced pivoting shawls and put them on show at the exhibitions, which became international from 1851 onwards. Berrus excelled in this type of design.

The Great Exhibition of 1851 was held in London, at the Crystal Palace. Manufacturers from both sides of the Channel exhibited some breathtaking products. Couder sent one of his shawl designs while Berrus sent at least three, one of which showed cupola-topped buildings emerging from luxuriant vegetation intertwined with palms (p. 249, right). The cupolas resembled those of the advertising columns, or Morris columns, that had been erected in the streets of Paris a year earlier.

This orgy of creative imagination was accompanied by a surge in the development of trade and industry, posing a threat to shawl manufacturers. They now had to contend with 'counterfeit' shawls. Laurent Biétry, a former spinner turned cashmere shawl producer, published a pamphlet in 1849 in which he asked other manufacturers to mark their products. He also inveighed against the unfair competition of shawls sold as cashmere products when they were actually made of cotton or mixtures of silk waste and wool. Responding to this invitation to sign and guarantee their work, some shawl makers wove their initials into the left-hand corners of the harlequin borders. Biétry himself wove the word '*Cachemire*' into the right-hand corner of some of his shawls (pp. 283–93). He also sewed round labels bearing his name and guaranteeing the cashmere content to the reverse side of some of his less expensive shawls. Other shawl makers followed his example. Frédéric Hébert wove an 'H', followed by the words '*Cachemire Pur*' into the central field of his shawls in wool of a contrasting colour.

PAGE 74
Square shawl with an all-over decorated ground (detail).
Paris, 1851.
Probably the work of Lion Frères, shortly before they adopted the practice of incorporating their initials.
Woven au lancé, trimmed on back, cashmere, metallic weft threads, 185 × 180 cm (72⅞ × 70⅞ in.).
Milan, Etro collection, no. 262.
Four little Chinese scenes form a repeating pattern picked out in gold and silver against a black ground.

PAGE 75
Square shawl with an all-over decorated ground (detail).
Paris, c. 1850.
Woven au lancé, trimmed on back, cashmere, metallic weft threads, 180 × 180 cm (70⅞ × 70⅞ in.).
Milan, Etro collection, no. 273.
Two repeating scenes that could be entitled 'Court pastimes' are picked out in five alternating columns on a white ground: in one (far left, centre and far right) the Emperor of China is watching a wrestling match; in the other the Empress is listening to a group of musicians. Nourtier, Lion Frères and Duché all produced similar designs, but the two-tone effect of the sky is particularly characteristic of Duché. Note the absence of harlequin shawl ends.

At the next exhibition, which was held in Paris in 1855, Berrus displayed another of his innovations: the coats of arms of his royal customers were woven into the corners of harlequin shawl-ends, reminiscent of the practice of tapestry manufacture. In this case the arms of the Emperor Napoleon III appeared on a pivoting shawl. Reporting on the industrial designs at this exhibition, a journalist did in fact note that the Empress Eugénie had ordered a Berrus design, to be woven by Biétry. But there is no proof that this was the shawl in question. The shawl shown on pages 288–89 is the same as Berrus's design on page 256 (left) except for the lower centre section, and has the British sovereign's coat of arms and mottoes in the corners: *Honi soit qui mal y pense, Dieu et mon droit.* Subsequently, manufacturers found it cheaper to affix a gilt seal to their shawls. This bore their initials, the cross of the Legion of Honour, if this had been awarded to them, and a list of their exhibition medals and prizes. Their practice of imitating the signatures of Indian shawls by weaving signs into the small central field has proved frustrating as they have yet to be deciphered. Between 1850 and 1855 square shawls without a plain central field were also in vogue (pp. 74–75).

Designs by Berrus featuring architectural motifs were in evidence as well. The shawl bearing the Royal Coat of Arms had separate pines, set in *mihrabs* (prayer niches) as if they were sacred objects; one design evokes the rococo style of the eighteenth century; another shows a round tent in the middle of a Persian garden flanked by small pagodas. An Englishman described the French shawl exhibits and exhorted manufacturers in his own country to emulate them but without copying their less felicitous details: 'Here are Chinese temples to decorate the back of a lady!'[21] Paisley and some American museums have chinoiserie shawls in their collections: the French examples probably date from 1855. These shawls were outstanding pieces of craftsmanship but were not really wearable.

From 1860 onwards, crinolines grew longer at the back, forming a sort of train, which made a good display platform for long shawls. Gonelle Frères' design studio introduced 'burnous'* shawls, which were worn like capes. A design for one of these shawls is shown on p. 77, along with a contemporary photograph that makes the wearer look rather dumpy to modern eyes. Unfortunately, too few women had the grace of Alfred Stevens's model (p. 76). She is shown wearing an Indian shawl with a small S-shaped pine in each corner of the field, similar to those of the shawl on page 16.

The member of the jury reporting on the shawl section of the Great Exhibition in London in 1862 was the elder son of Gaussen, the manufacturer of the *Isfahan* and *Nou-Rouz* shawls. He notes that 'examples of the two schools which have always provided inspiration for French shawl designers were represented: the Indian school, with

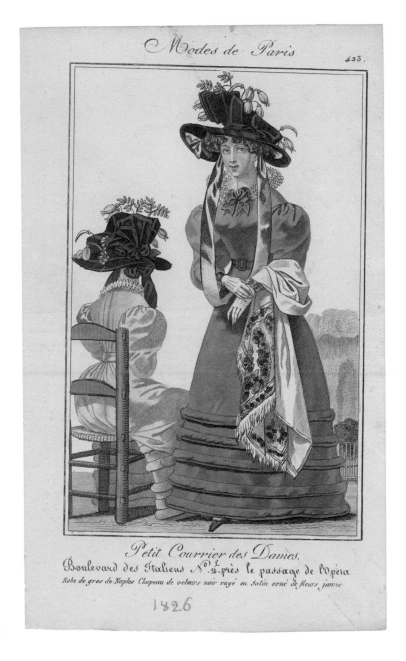

Fashion plate, Paris, 1826.
Paris, da Silveira collection.
The woman is carrying a lopsided shawl (châle boiteux) over her left arm.

[21] George Wallis, p. vi.

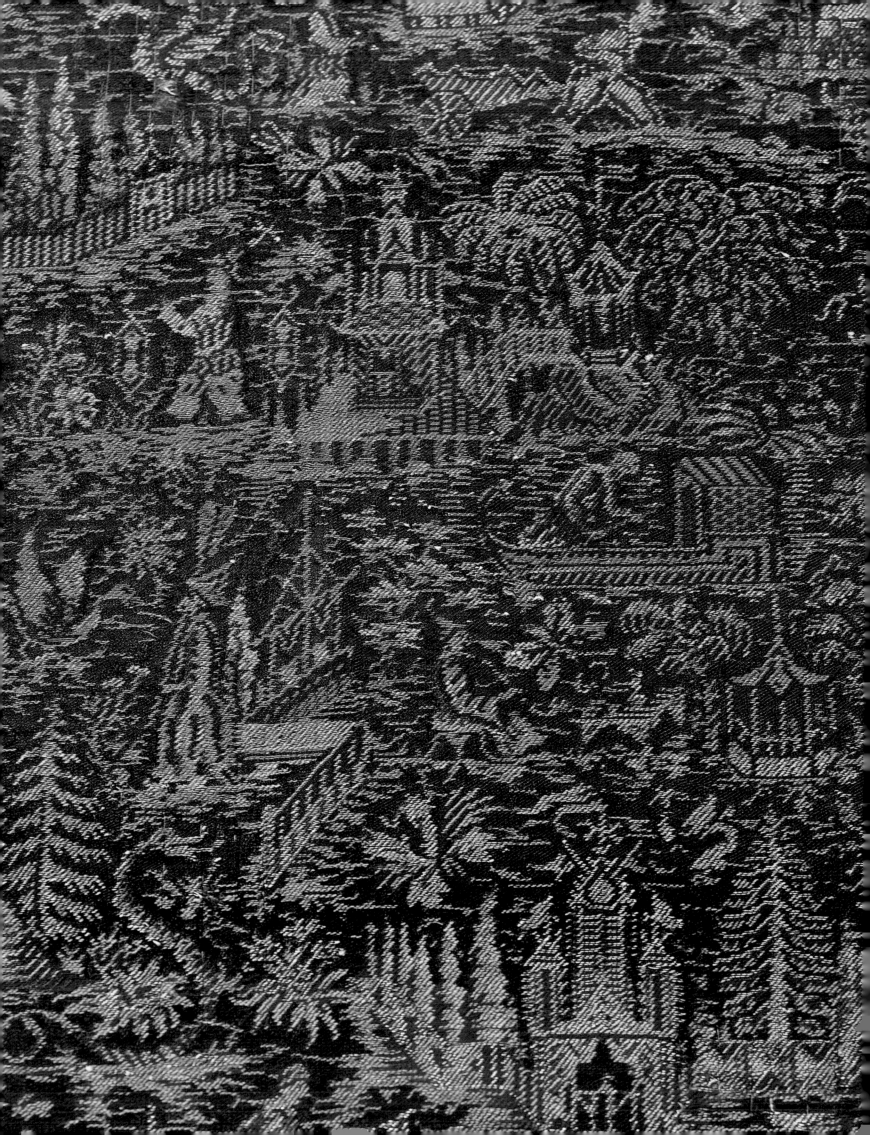

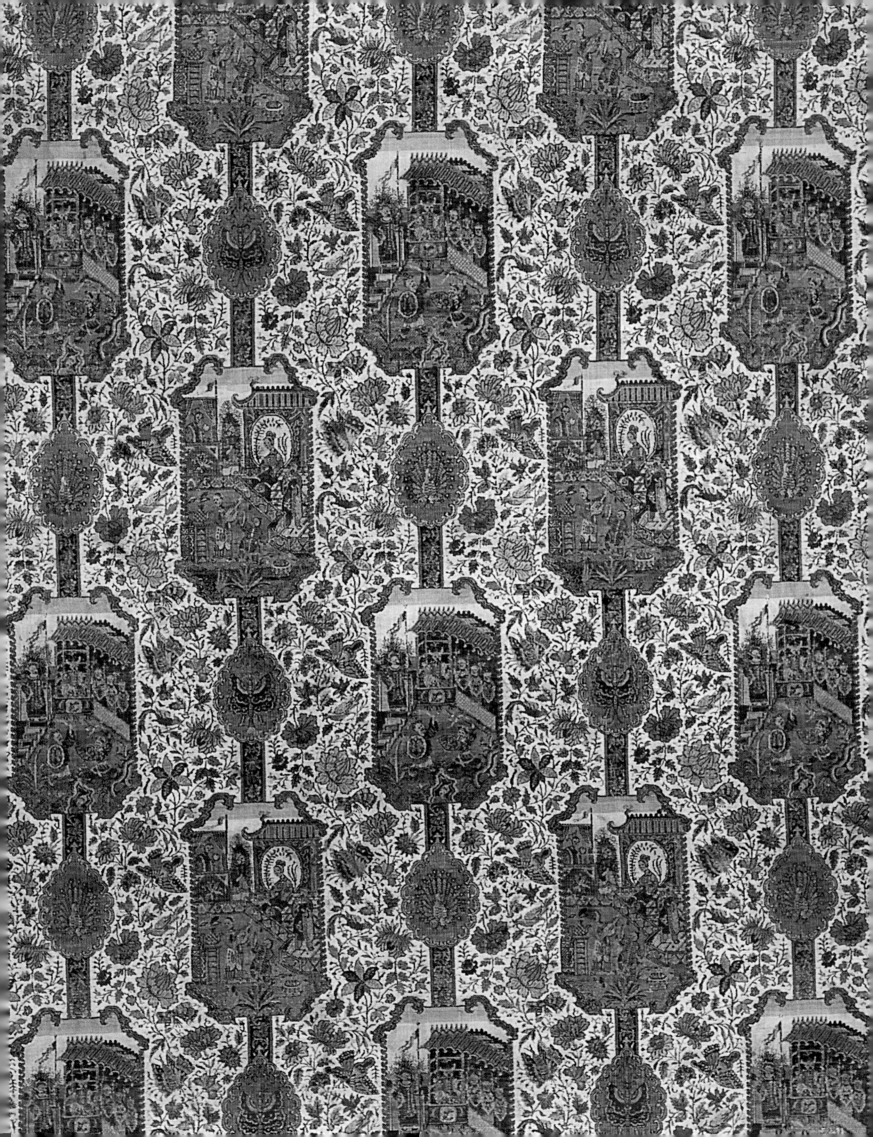

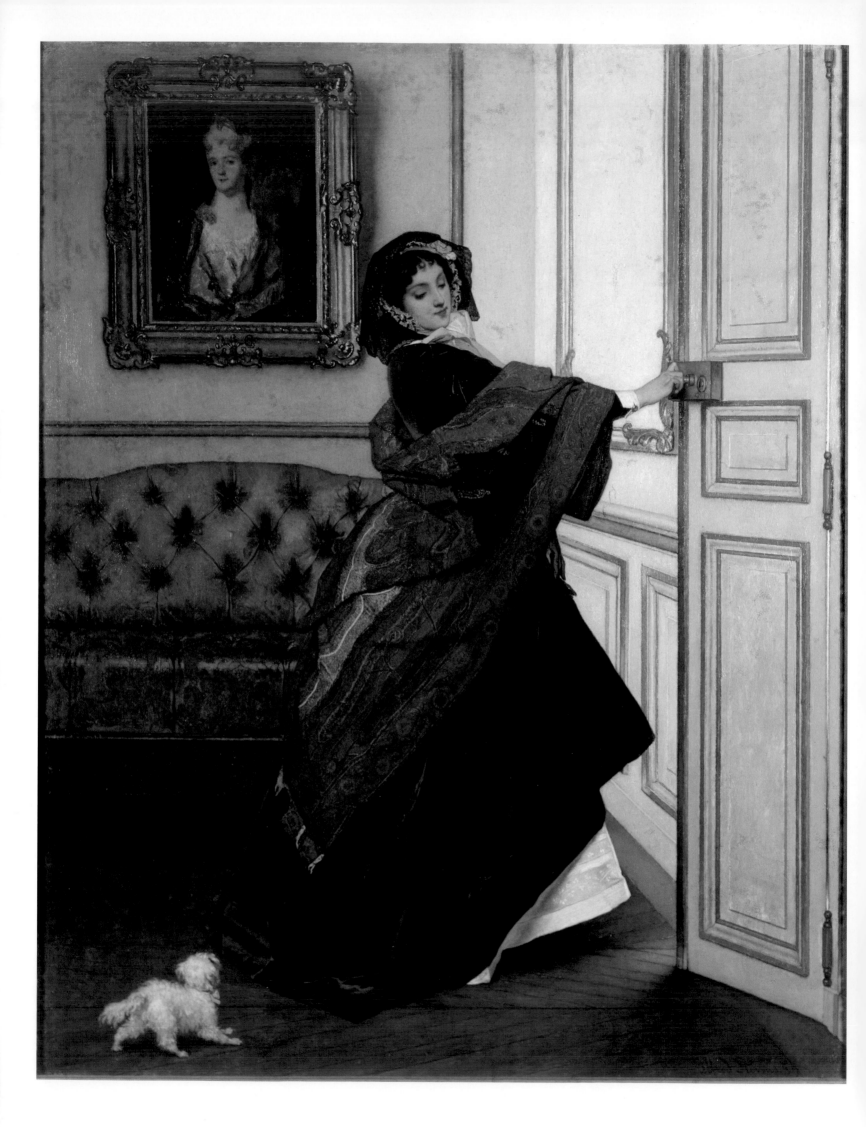

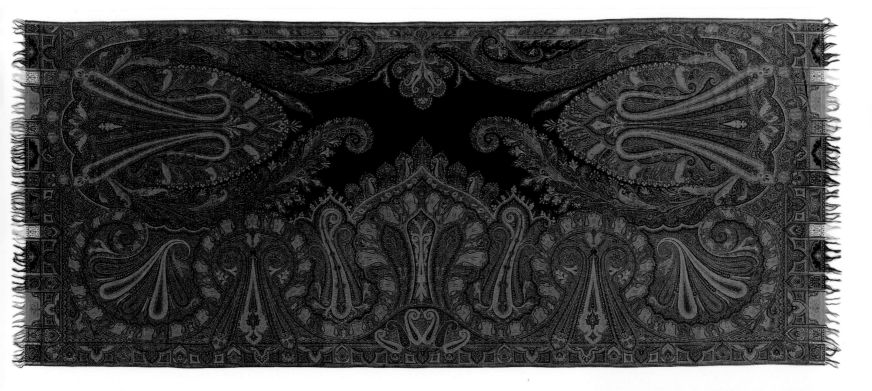

M. [Monsieur] F. Hébert, Jr., as its leader, and the *fantaisiste* or fantasy school, the best exponents of which were the house of Duché, A. Duché the younger and Brière & Company'. He goes on to say that, 'the Indian style is particularly suited to the home market and the fantasy style for export.' As for Berrus, it seems that his prolific output appealed to devotees of both schools. He sent numerous designs to the exhibition: shawl designs painted in gouache, and pen and ink drawings on tracing paper. One of these drawings shows a crowned female figure, enthroned above shawl draperies; various styles are represented: narrow pine-decorated borders; large pines; scattered smaller pines; and a shawl with plant forms. It is possible that this display was a homage to Queen Victoria (p. 79).

A close look at the Berrus designs of 1862 to 1874 shows that they are still full of flair, but the imagination that was so evident during the preceding fifteen years has started to grow stale. There are endless variations on the theme of two pines or two pairs of pines, extremely elongated with a backdrop of hackneyed oriental designs. Detail changes do occur: around 1862 the Greek key-pattern is sometimes displayed, giving way in 1867 to festoons and to a white edging, which picks out the outlines of the ornamentation.

Large numbers of shawls were produced at this time and many of them have survived, showing little variation in their colourings. Early chemical dyes were crude, and faded when exposed to light. These brownish-red shawls differ only in design. Industrial advances meant that machines, driven by steam or electricity, produced increasingly regular weaves without any human intervention, except in an emergency; output had increased dramatically but the penalty was the absence of any individual touches made as weaving progressed, such as the colour changes that make the oldest cashmeres so enchanting. Large shawls grew cheaper, bringing them within reach of the rural population, among whom they remained popular until the end of the century. A young country bride would wear a

TOP *Long 'burnous' shawl with a black ground.*
Paris, 1861.
Made by Robert & Gosselin to a design by Gonelle Frères.
Woven au lancé, trimmed on back, cashmere,
316 × 138 cm (124⅜ × 54⅜ in.).
Paris, Musée Galliera, inv. no. 1987.2.2.
The 'burnous' shawl was designed to be wrapped around the body. The pattern is only repeated once (reversed) in the whole length of the shawl.

ABOVE *Photograph taken in 1862 showing how Gonelle's shawl (top) was meant to be worn.*
The photograph measures 17.4 × 11.5 cm (6⅞ × 4½ in.).
Paris, Musée des Arts Décoratifs, Cabinet des Dessins, no. DOC 12.
The model is wearing the unfolded shawl wrapped around her, like a cape or cloak.

OPPOSITE
Alfred Stevens (1823–1906), Will You Go Out With Me, Fido?, *1859.*
Oil on canvas, 61.5 × 49cm (24¼ × 19¼ in.).
Philadelphia, Philadelphia Museum of Art, W. P. Wilstach collection.
The long shawl that the young woman has thrown over her shoulders to keep her warm during her walk can be compared with the shawl shown on page 16. It has the same decoration of S-shaped pines on a black central ground.

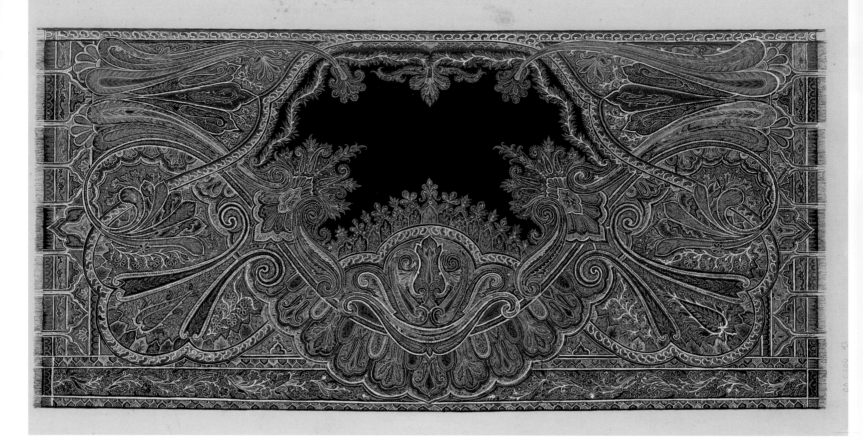

ABOVE *Design for a 'burnous' shawl.*
Gonelle Frères, 1862.
Gouache on paper, 53 × 25.2 cm (20⅞ × 9⅞ in.).
Paris, Musée des Arts Décoratifs, Cabinet des Dessins,
no. CD5304.13.
In order to appreciate this design, it is best to view it
horizontally: at the bottom of the black field two small pines
face each other, giving the impression of a lion's mask topped
by a crown.

BELOW *Design for a long shawl.*
Gonelle Frères, inscribed 'made by Robert & Gosselin', Paris, 1862.
Gouache on paper, 53.5 × 28 cm (21¼ × 11 in.).
Paris, Musée des Arts Décoratifs, Cabinet des Dessins, no. CD5304.14.
Two large side panels curve around the central field, and between them is
a motif of pines placed back to back; together they suggest the shape of an
urn. The festooned frieze encompassing the black central field is in turn
surrounded by polychrome mihrabs *(prayer niches), their apices pointing*
towards the centre.

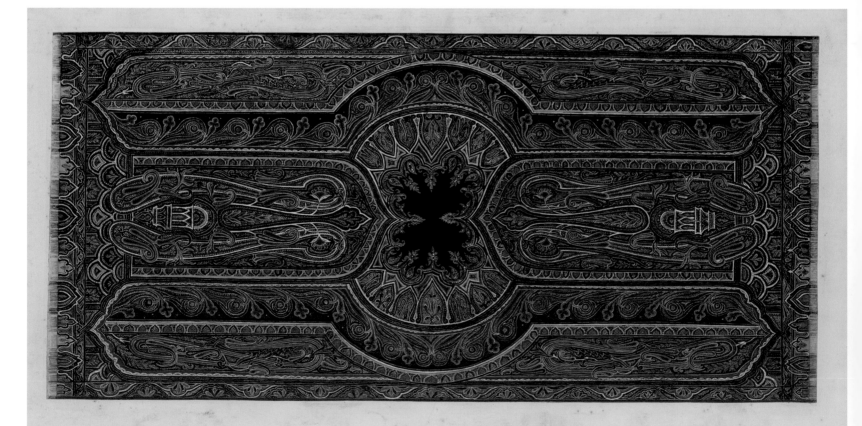

Shawl design by Berrus.
Great Exhibition, London, 1862.
Pencil and wash on paper, 95 × 39.3 cm (37⅜ × 15½ in.).
Paris, Musée des Arts Décoratifs, Cabinet des Dessins,
no. CD5436.20.
The crowned female figure seated on a throne may represent
Queen Victoria, which suggests this design could be a
tribute to the country that hosted the Great Exhibition.
The patterns shown on the layers of drapery hanging from
the throne give a retrospective view of the various styles
of cashmere shawls: first comes an example of the border
decorated with small pines, then the use of large pines and
finally, in the background, the style végétal, decorated
with plant life. On either side of the central scene, panels
with intricate ornamentation resemble columns supporting
a sculptured pediment.

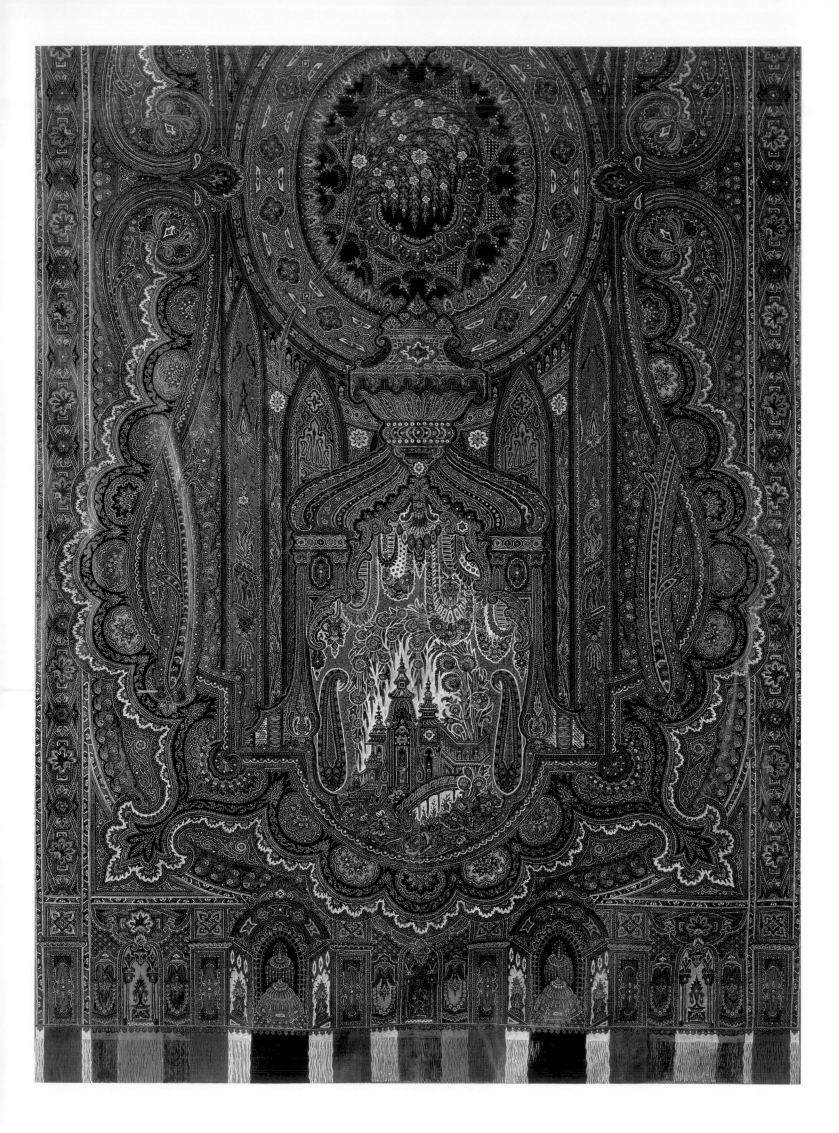

cashmere shawl over her black wedding dress; later on she would wrap her baby in it to keep the child warm by the font when it was baptized. Manufacturers could therefore turn out the same patterns year after year. The large shawl design by Charles Sevray (p. 80), shown at the 1878 exhibition, was probably the last. This exhibition took place at the Champ de Mars in Paris and two craftsmen were sent from India to demonstrate how shawls were made in their native country. One man wove a narrow band of patterns on his loom for his fellow worker to cut out then sew up like a patchwork, joining the small ornamental motifs together to make a decorated shawl that was called a *tilikar*.

From 1860 onwards, as European shawls dropped in price, Indian weavers were forced to increase their output. Shawls woven at speed were coarse and heavy. Western customers lost interest in Indian shawls and soon European shawls were also out of favour, mass production having robbed them of their prestige. From about 1869, when fashion took to bustles to accentuate the curve of the back, women could no longer dream of wearing shawls. The political and economic vicissitudes caused by the Franco-Prussian War (1870–71), which ended in defeat for the French, meant that the shawl industry in the Indian subcontinent found itself without this export market; the weavers had no work and many died in the famine of 1877.

Although the fashion for shawls had passed, it remained customary for a few more years for a French cashmere to be ritually included among wedding gifts. Smart newly married women kept them in their boxes and never wore them, which is why shawls of this period sometimes look as good as new. Towards the end of the nineteenth century they were used as wall hangings or as a covering for the piano. Older, worn shawls were cut up and made into *visites* or waisted jackets, the tails of which were slit at the back to adapt to the shape of the bustle. These jackets were lavishly braided to match the colours of the shawl material (pp. 82–83).

The vogue for cashmere shawls had created flourishing industries in Britain and France but lasted less than a century. During this time, the soft, light and discreetly decorated early weaves had gradually changed into over-ornate, heavy shawl-rugs; the plain field had shrunk with the encroachment of giant pines until it was just a small, black square. Textile and embroidery designers have never completely dropped the pine motif, which reappears every so often. Kashmir shawls have had no place in women's wardrobes for many decades, but during the past few years printed shawls and long scarves have revived the nineteenth century's alternative to the genuine article. Another generation is now able to appreciate the rich and strange patterns of a decorative style that lends itself to endless improvisation and variation. Perhaps this book and the images it contains may lead to fresh interpretations of this old and magnificent art.

Claude Monet (1840–1926), Madame Gaudibert, Wife of a Le Havre Shipowner, 1868.
Oil on canvas, 217 × 138.5 cm (85¼ × 54½ in.).
Paris, Musée d'Orsay.
Madame Gaudibert is wearing a square Indian shawl in which small pieces have been sewn together, with fringing on all four edges. This is one of the last paintings to show an elegant woman in a cashmere shawl. From 1869 the wearing of a bustle made shawls look ungainly.

OPPOSITE
Design for a long shawl by Charles Sevray, 1878.
Gouache on paper, 86 × 79 cm (33⅞ × 31⅛ in.).
Paris, Musée des Arts et Métiers, CNAM, no. 13.739.
It is not known whether a shawl was actually woven to this design. Perhaps it was destined only to be a shawl designer's nostalgic farewell to an art he knew to be doomed already by the onward march of fashion.

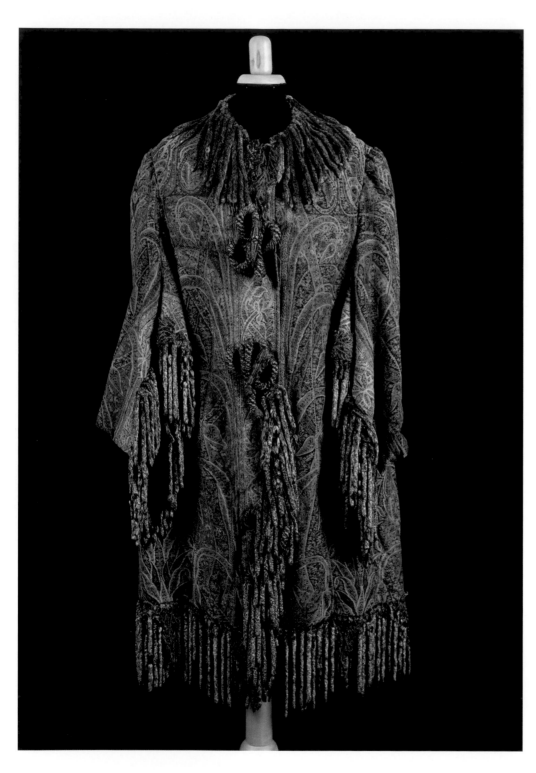

LEFT
A visite, *or waisted jacket, made in around 1875*
from an Indian shawl dating from the 1850s.
The label sewn inside bears the inscription
'G.H. à Saint-Vincent de Paul, 43, rue du Bac à Paris'.
'G.H.' are the initials of Gaildraud Henry.
Milan, Etro collection, no. 142.

OPPOSITE
The same visite *seen from the rear.*
Note the beading and chenille silk fringes colour-matched
with the shawl.

BELOW
Fashion plate, Paris, 1877.
Paris, da Silveira collection.
The woman on the right is wearing a visite *made from*
a cashmere shawl.

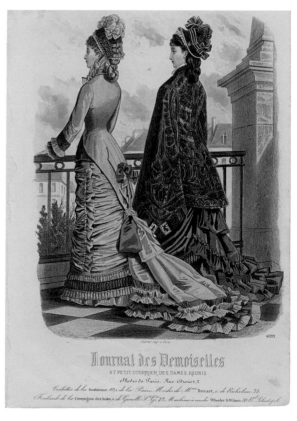

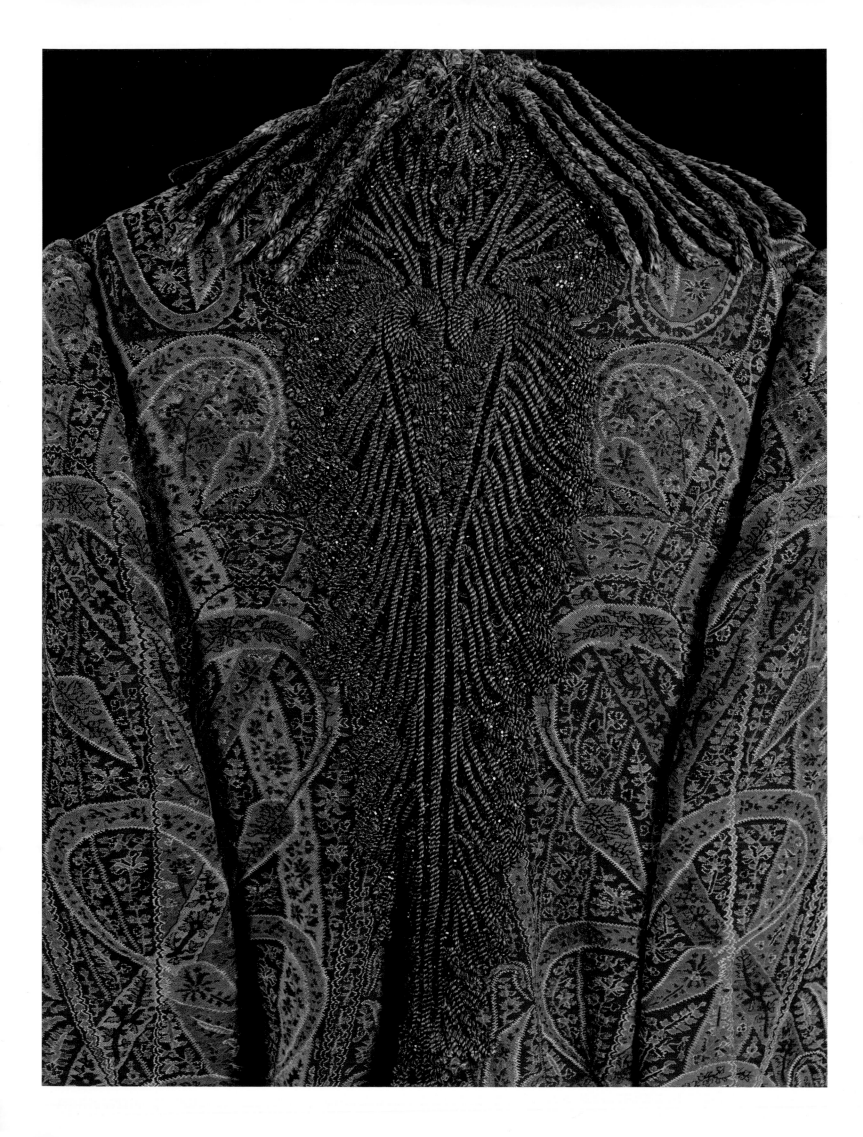

In a major study entitled *Les Ouvriers européens* (The European Workers), published in 1887, Frédéric Le Play devoted his seventh monograph to the 'Tisseur en châles de Paris' (Shawl Weavers of Paris). The chapter (pp. 299–372) is based on information gathered in situ, between January and March 1857, by Ernest Delbert and Frédéric Hébert, a well-known shawl manufacturer. The following are extracts:

Regarding the Distribution of Work Among Those Variously Employed in the Shawl Industry in Paris

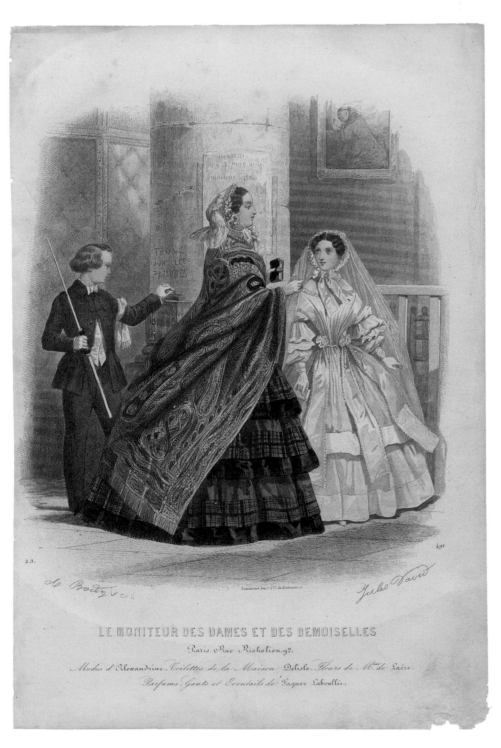

LE MONITEUR DES DAMES ET DES DEMOISELLES

Paris, Rue Richelieu, 92.

Modes d'Alexandrine. Toilettes de la Maison Delisle. Fleurs de M.de Laire.

Parfums, Gants et Éventails de Faguer Laboullée.

It was in Paris that the shawl industry developed, and Paris continues to be the principal manufacturing centre for those rich shawls known as French cashmeres. A great many people are involved in this manufacturing process, and we need to look at the individual functions of each if we are to understand their importance.

Heading the industry is the manufacturer himself, the person with the necessary capital and credit who manages the business and has primary responsibility for any financial liability. The manufacturer purchases the raw materials for his cloth from the mill owners, who produce it in special establishments and play no part in the actual manufacture. All the other people in the industry work for the manufacturer and fall naturally into one of two distinct categories, depending on whether they report directly to the manufacturer himself or only to the chefs d'atelier [head foremen].

The first category of employees includes the designers, the liseurs [readers], the warpers, dyers and chineurs [specialist dyers], winders and finishers. Their work can generally be described as preparatory or complementary to the actual weaving. Almost all of them are chefs de métier [senior craftsmen] who, given the way the industry is organized, are unable to work exclusively for one employer.

The designers, however, are in many cases the exception to this rule, since all big firms necessarily have their own special design studio. This studio is run by a chef d'atelier, who is an artist in his own right and works closely with the manufacturer, creating his own designs or combining existing Indian motifs in new and original ways. The chef d'atelier is paid an annual salary and supervises a body of workers of varying number who are paid by the piece to fill in the colours and prepare the mise en carte. There are also several independent design studios in Paris working for the industry as a whole, and especially for the smaller firms. Some of these studios have made a name for themselves in Europe and a few have, in exceptional circumstances, even sent shawl patterns to Indian manufacturers. Such have been the needs of the Paris shawl industry, moreover, that they have led to the creation of a veritable school of design, with application to all types of fabric, and the models produced by this school have been*

copied or imitated by similar industries in France and abroad. The huge influence exercised by our designers in Europe is a mark of their creative skill and a source of considerable glory; for this influence to extend to India, on the other hand, seems undesirable since Indian production must lose something of its beauty and its originality, especially, in following recommendations of European provenance.

The designer's final task is the mise en carte, the purpose of which is to represent, on paper, the desired effects of the warp and weft yarns of a particular weave by means of an ingenious combination of lines. The mise en carte prepares for the work of the liseur, who performs two tasks. The first is the lisage proper, whereby each dot on the squared paper of the mise en carte is interpreted in terms of the yarn required. The second involves punching out the design on pieces of card, the dots being reproduced as perforations which serve as a means of transferring the design to the machine. There are special techniques for executing both these operations swiftly and easily. The reader in charge of these processes is a contractor who employs both male and female workers in his workshop and pays them either by the day or by the piece.

Following the execution and reading of the design, the next stage in the manufacturing process involves preparing the yarns for weaving. The warper positions the yarns that are to be used lengthwise, assembling a number of parallel yarns of equal length and tension known collectively as the warp. The chineur is a specialist dyer who dyes this warp according to the specifications of the design. The weft yarns – those that run crosswise through the finished cloth – are entrusted to an ordinary dyer who colours them in accordance with samples supplied by the manufacturer. They are returned to him in the form of large plaited skeins and the manufacturer then passes these on to winders, who wind the yarn on to large bobbins known as volants [shuttlecocks].

The winding is the last of the operations that are carried out directly for the manufacturer. Those that follow, with the exception of the finishing and sometimes mending, are carried out through the chef d'atelier, for whom the employees in the second category work. The chef d'atelier will own a number of looms. He takes receipt of the following from the manufacturer: 1. the punched cards prepared by the reader; 2. the dyed weft wound on to bobbins; and 3. the dyed warp yarns. These materials remain his responsibility up until the point when he delivers the shawls, for whose manufacture they are intended, into the manufacturer's hands.

Before weaving can begin, the chef d'atelier has to dress his looms, which means assembling their various elements in accordance with the manufacturer's instructions. Sometimes the chef d'atelier does the work himself, but more often than not he employs the services of specialist loom-dressers. Once the loom has been dressed, the next step is the ployage: this operation consists of winding the warp on to a rounded shaft known as a beam in such a way that it will unwind as the work advances. The ployage is performed under the supervision of the chef d'atelier and with help from neighbours working in the same industry. Each of the warp yarns is then inserted through the mails, heddles and reeds. This is a lengthy and fairly delicate operation that can only be done by the chefs d'atelier themselves if they are not pressed for time. Nor is it required for each new piece, but only when a loom has been newly dressed or when, for whatever reason, the ends of the finished warp (which usually remain inserted through the mails, heddles and reeds) have been removed from the loom. Assuming that it is not necessary to remove them, each of the yarns of the new warp is joined to those of the old one so as to follow the same trajectory. This operation is carried out by specialist workers and is known as tordage.

As soon as the warp has been installed, the weaver can mount the loom and begin work with the help of the thrower, who sends the shuttles back to him; but he also needs the weft-winder (who generally works on site) to prepare the quills for him. When the weaving is complete, the workman cuts the shawl from the loom with a pair of scissors, then does the burling himself, using a needle to remove the knots and other defects that are an inevitable part of the weaving process and interfere with a true appreciation of the design. If there are any manufacturing faults in the cloth, these are repaired by the mender. The shawl is then delivered by the manufacturer to specialist workers who apply a finish and it returns to the shop ready to be offered up for sale [Le Play, pp. 344–47].

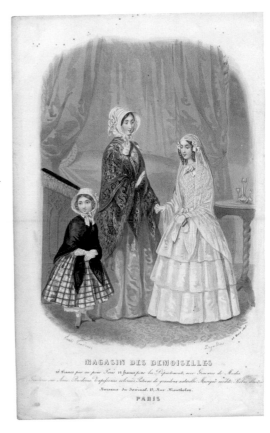

Fashion plate, Paris, 1848.
Paris, author's collection.
Her older sister's first communion is a perfect opportunity for this little girl (left) to wear a shawl.

OPPOSITE
Fashion plate, Paris, 1857.
Paris, author's collection.
A mother would have been expected to wear her best cashmere shawl to celebrate her child's first communion.

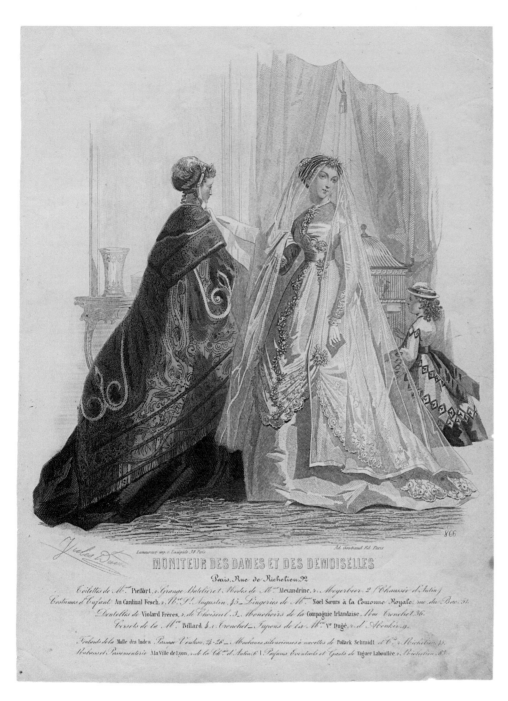

Fashion plate, Paris, 1867.
Paris, author's collection.
A daughter's wedding day was the ideal
occasion to wear a beautiful cashmere shawl.

WORK HIERARCHY

*This workman is a chef d'atelier. He owns four Jacquard shawl looms and occupies a middle-ranking position vis-à-vis his fellow workers, four looms being considered an adequate number when conditions are good. Like all chefs d'atelier who own no more than six looms, E** operates one of his own looms: he is thus both workman and chef d'atelier, but what distinguishes him as a workman from weavers in the proper sense of the word is the fact that he owns the loom as well as working on it. As is generally the case among Parisian chefs d'atelier, E** only has dealings with one manufacturer and he has been weaving for him for six years now [p. 306].*

JOBS AND INDUSTRIES

*The workman's jobs. For a chef d'atelier in circumstances like those in which E** finds himself, there are two distinct categories of work, depending on whether his role is as workman or chef d'atelier.*

*As a workman, E** is constantly at his loom. The weaver's work starts at seven o'clock in winter and five o'clock in summer and usually finishes at between eight and nine in winter and at seven in summer. There are two breaks during the day: one, from nine to ten, for lunch; the other, from two to three, for dinner; there are thus on average twelve hours of actual work.*

*As chef d'atelier, E** is responsible for supervising the piece-workers who operate his looms, keeping the equipment in good order and liaising with the manufacturer or his employees. During busy periods, this last part of his job requires him to go to the shop twice a week to deliver the finished shawls and take receipt of the warp and weft yarns needed for weaving. Since the workshop is about 5 kilometres [about 3 miles] from the manufacturer's house, each of these journeys takes half a day [p. 311].*

AGREEMENT BETWEEN CHEF D'ATELIER AND WORKER

The agreement between the chef d'atelier and the worker is a purely verbal one. No monies are given or received in advance, and no forfeits are customary. The length of the arrangement is measured in terms of the time required to complete a shawl. If either side wishes to terminate the agreement, he simply has to give notice that the shawl currently being woven is to be the last. Under no circumstances can the worker be forced to finish the whole warp, which comprises six long shawls or ten square ones [p. 352].

TIME REQUIRED FOR WEAVING A SHAWL

From the statistical tables drawn up by Le Play for the years 1853 to 1857 (pp. 336–37), it emerges that a worker would spend on average twelve working days weaving a long shawl and seven weaving a square one. These are probably minimum times for shawls of average quality; a 'rich' shawl, decorated with a complex design and employing more than seven colours, must have required much longer.

WOMEN'S WORK

Today, there are scarcely more than 30 women operating a loom, out of a total of 400 weavers. More than half these women are gathered under the same roof where the chef d'atelier *has established his own particular system and only employs women. Each loom, in this* atelier, *is occupied by two women working under equal conditions. Each of them takes it in turns to spend an hour throwing followed by an hour of weaving, with the result that they tire less easily and are capable of working faster. Their shared wage averages between 2 and 2.5 francs each. Those who have a family or who are called home for whatever reason are given permission to absent themselves from the workshop for one or two hours a day, their employer being sufficiently compensated for this loss of work time by the constant application and habitual docility of his work force. We might add that the* chef d'atelier *in question congratulates himself on the results obtained through this system, but he sees it as dependent on employing excellent female workers and never permitting two persons of the opposite sex to sit together at the same loom. In accordance with a practice sanctioned by the workers' representatives in 1849, this* chef d'atelier *and anyone like him employing women as weavers is entitled to deduct 3 francs a week from the wage owing to his female workers. Since decency prevents women from climbing up to the highest parts of the loom in order to put right any mechanical problems that might arise, the* chefs d'atelier *are granted the 3-franc deduction by way of compensation for the time they are obliged to spend carrying out repairs of this nature* [pp. 358–99].

CHILDREN'S WORK

In the weaving of linens and many other simple fabrics, the worker operating the loom also throws the shuttle to make the weft; but in the manufacture of shawls, where the average width is 1.8 metres [5 feet 11 inches] and each pick is made up of a fairly large number of yarns of various colours as required for the reproduction of the design, the worker requires an assistant who positions himself at one end of the loom to receive the shuttles thrown by the weaver and send them back to him in the order in which he receives them. This assistant is known as the thrower, and since the functions he performs are neither tiring nor difficult to accomplish, they have traditionally been entrusted to children of both sexes, or sometimes to women [p. 361].

By a strange twist of circumstance, the position of the child thrower is all the more burdensome in his being attached to a worker both more diligent and more organized than himself. Indeed, the weaver in possession of such qualities is more assiduous in his approach to the work: he begins his day at five in the morning and only finishes at eight or nine in the evening. It is easy to comprehend why, as his own master, he should be willing to take on such an excessive amount of work since he gains from it directly, whereas the child who can hope for no more than his fixed weekly wage finds himself the victim of this forced labour imposed by his master. Sometimes it is the child's own father who puts these excessive work demands upon him [p. 362].

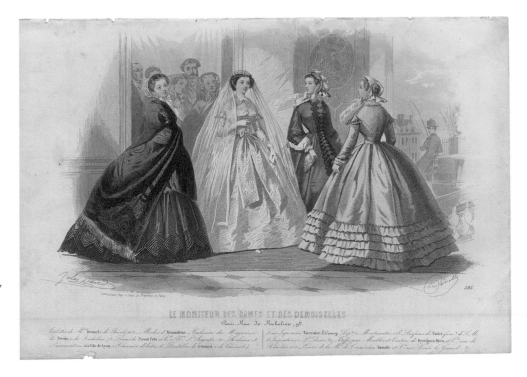

Fashion plate, Paris, 1860.
Paris, author's collection.
This young woman (left) is wearing a cashmere shawl at her sister's wedding.

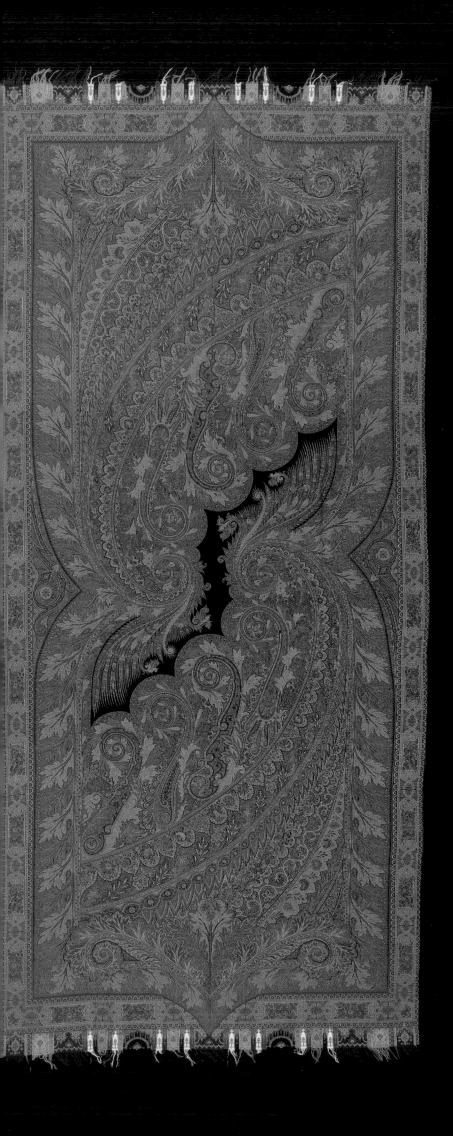

Long shawl decorated with a large à pivot design.
France, 1865–70.
Woven au lancé, trimmed on back, cashmere,
344 × 157 cm (135⅛ × 61¾ in.).
Milan, Etro collection, no. 238.
Berrus produced beautiful designs similar to this.

OPPOSITE Detail of the same shawl.

OVERLEAF
ABOVE Stole, à pivot design.
France, 1845–50.
Woven au lancé, trimmed on back, cashmere,
278 × 63 cm (109½ × 24¾ in.).
Milan, Etro collection, no. 266.
The style is reminiscent of Couder.

BELOW Stole, decorated with seven medallions.
Paris, 1844.
The date is embroidered in Arabic numerals.
Woven au lancé, trimmed on back, cashmere,
284 × 60 cm (111¾ × 23⅝ in.).
Milan, Etro collection, no. 155.

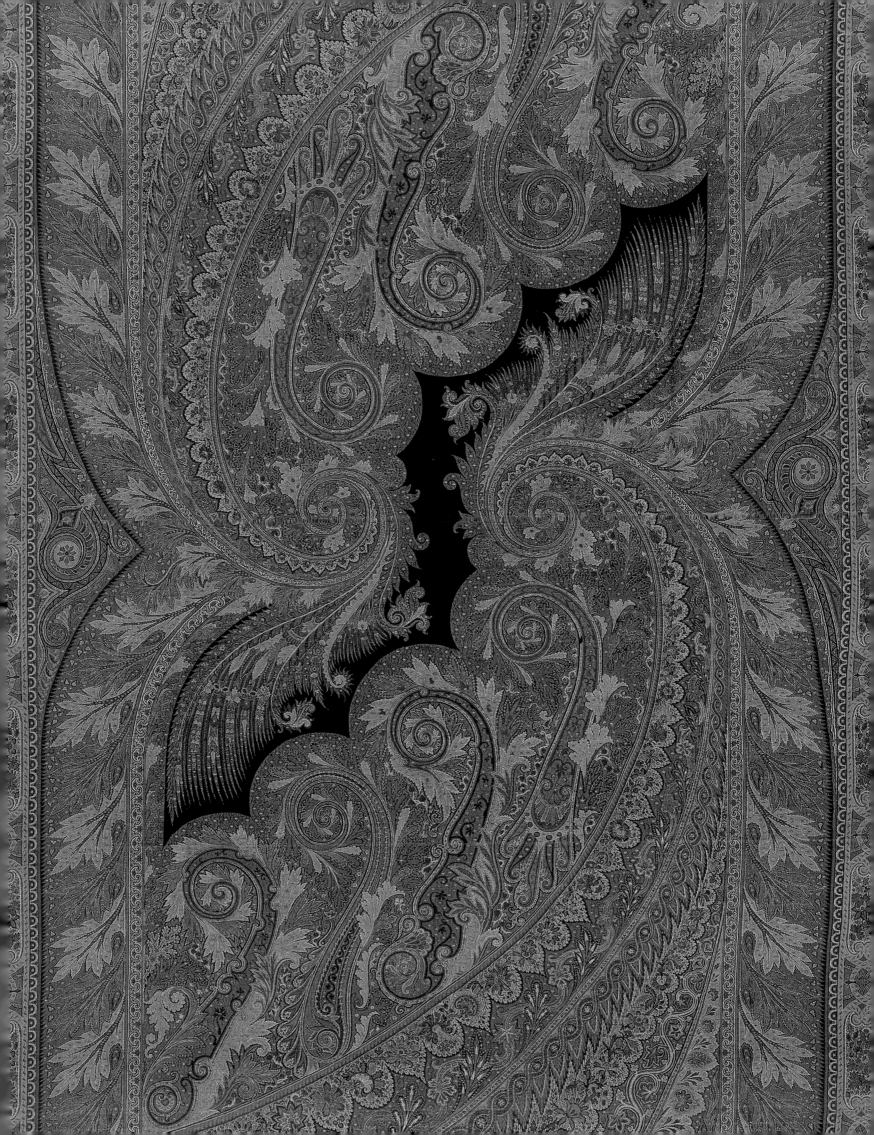

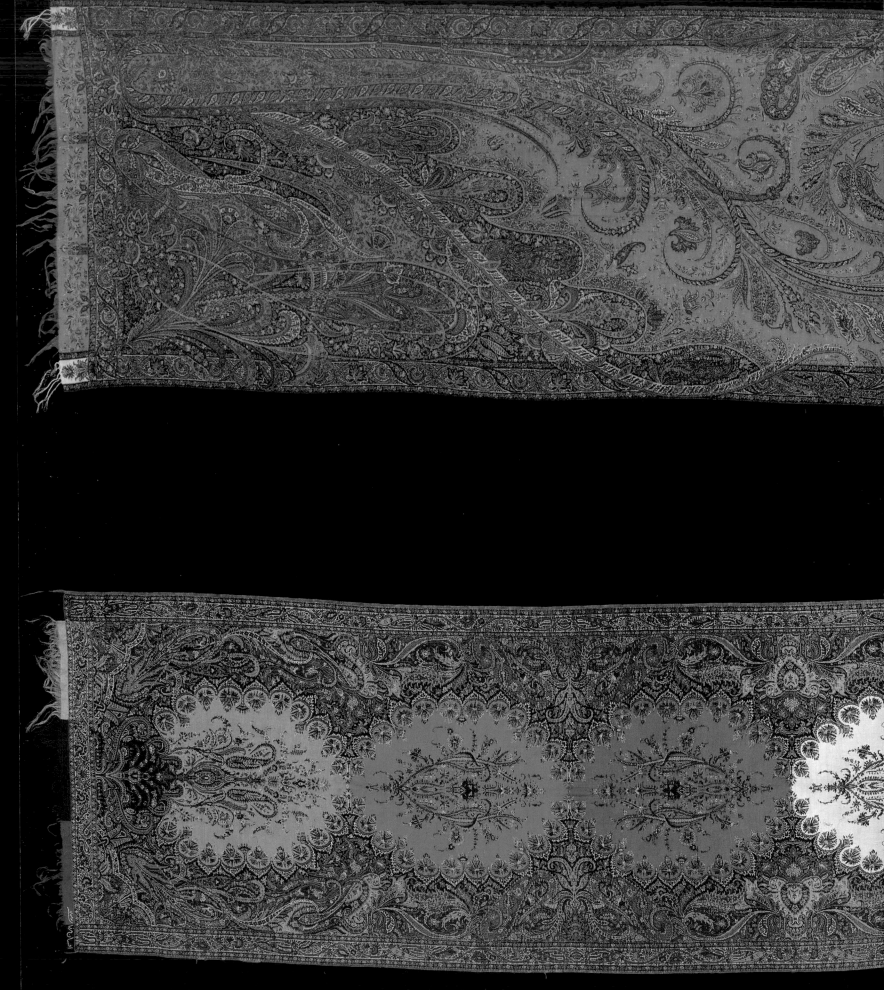

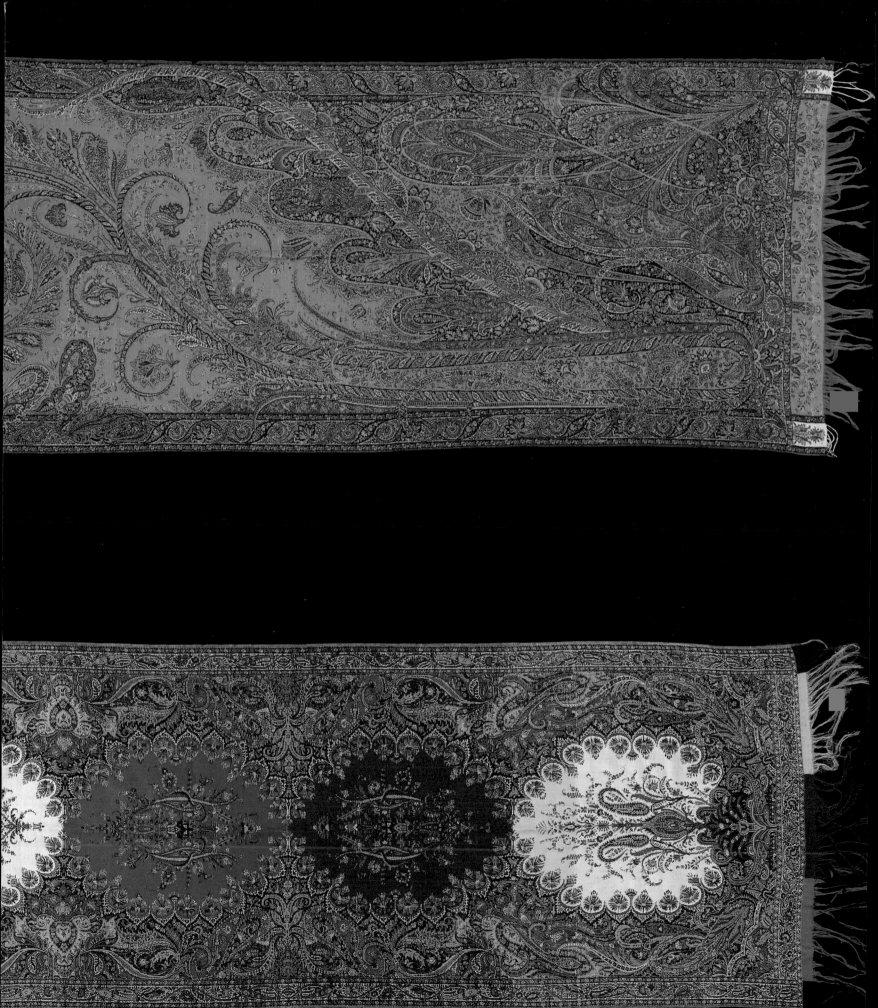

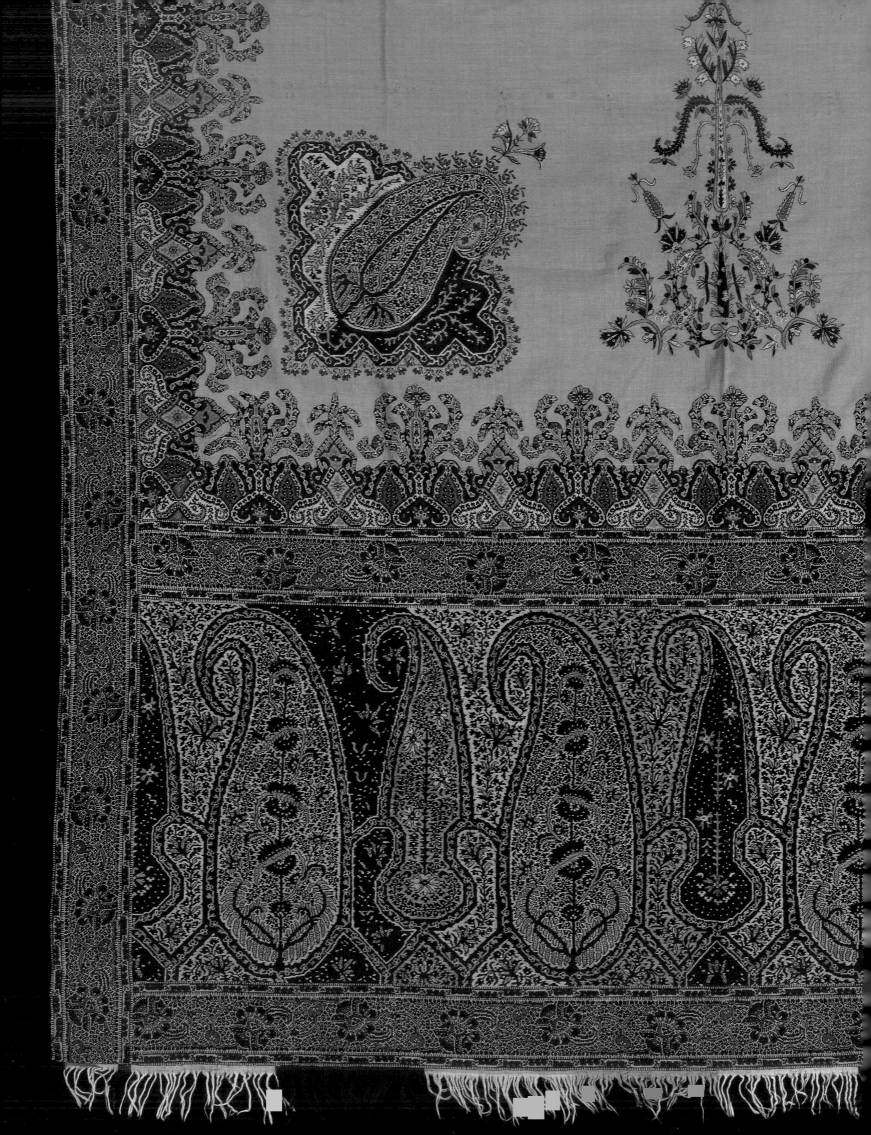

Parisian manufacture

S cottish manufacturers, in Edinburgh and later Paisley, were the first to imitate the imported Kashmiri shawls. In France, the 1789 Revolution had abolished court life and severely damaged the silk industry (p. 29); but, as things gradually returned to normal, French silk manufacturers seized on the idea of producing shawls as a way of opening up new employment possibilities for their workers. Drawlooms lent themselves particularly well to silk weaving, and shawls were often woven on silk warps during the first twenty years of the nineteenth century. Silk, being a continuous thread, is stronger than a woollen thread of the same grade. On the other hand, 'cashmere' (as the soft under-fleece of the wild goat was known) could no longer be imported by sea thanks to Napoleon's Continental Blockade and had to be brought from Makariev Market in Russia. Its use was consequently restricted prior to the Restoration, so the decorative sections of the first shawls – the rows of eight or ten pines woven at either end – employed silk, wool or cotton wefts.

Seen from the front and from a distance, French shawls could easily be mistaken for their Kashmiri models. It was only by inspecting the back of the shawl that one could tell that the piece had been woven *au lancé* (and was not *espoliné*) on a drawloom and then trimmed. Only a few weeks were needed to weave a shawl *au lancé* and to produce several copies. This made it possible to keep down the costs of the *mise en carte* and the prepa-ration of the simple, or semple. The simple,* activated by a drawboy, established once and for all which warp threads needed to be raised with each passage of the shuttle in order to achieve the desired motif. It enabled the weaver to reproduce the motif across the width of the cloth as many times as he needed to, and also to repeat it along the length of the cloth, either identically or as a mirror image if the drawboy reversed the order of the draw-strings. The shuttles were always thrown from selvedge to selvedge,* hence the term *lancé*. The weft threads only appeared at the front, where they formed part of the pattern; their ends were left floating at the back of the shawl, where they created a thick mat behind the decorative sections. These threads needed to be trimmed, once the weaving was done, to make the shawl as light as its Indian counterparts. Trimming the weft threads weakened the

OPPOSITE
Corner section of a long shawl with a border of harlequin pines.
France, 1820–25.
Woven au lancé, trimmed on back, silk and cotton; the borders were woven separately and the harlequin fringing was sewn on separately; 320 × 135 cm (126 × 53⅛ in.).
Paris, author's collection, no. 2.
Three large pines alternate with two waisted pines. The turquoise ground and embroidered motifs are not original; the original ground was replaced c. 1850.

Long shawl (detail of front).
France, c. 1810 (see page 35).
Woven au lancé, trimmed on back, wool,
292 × 134 cm (115 × 52¾ in.).
Paris, author's collection, no. 49.

Detail of the shawl shown opposite, seen from the back. The trimmed wefts give it an uneven, velvety texture, which is the distinctive feature of au lancé *as opposed to twill-tapestry weave.*

Invoice letterhead, 1815–20.
Paris, Debuisson collection.

OPPOSITE
Detail of a long shawl.
Paris, 1865–70.
Twill-tapestry weave, 340 × 146 cm (133¾ × 57½ in.).
Woven on a mechanical loom known as a spoulineur,
probably by Lecoq, Gruyer & Cie.
Milan, Etro collection, no. 119.
Lecoq, Gruyer & Cie won a first-class medal for their
'Indian shawls' at the World's Fair in 1867.

[1] Frédéric Le Play, monograph no. 7, 'Tisseur en châles
de Paris', information gathered in situ between
January and March 1857 by E. F. Delbet, in *Les
Ouvriers européens*, Paris, 1887, pp. 299–372.

fabric, however, and one ingenious manufacturer invented what was known as a *pas de liage*, which involved inserting a supplementary weft thread between the continuous wefts to stop them unravelling. Although the imported shawls could be as much as ten times dearer than French shawls, European women preferred them because they were *espoliné*, or twill-tapestry weave, and therefore infinitely stronger (even though they weighed the same).

In 1857 it was estimated that French shawl manufacturing 'turns out 50 million products each year; of this figure, half is to be attributed to Parisian manufacture and the remainder is shared between Lyons and Nîmes'.[1] These centres had certain features in common, but each was distinguished by a particular style of production. It is also noteworthy that at the beginning of the nineteenth century, European shawls were woven in sections: the two pine borders, the two vertical borders and the plain field were woven separately and then assembled.

Paris manufacturers, exasperated by the competition from imported Kashmiri shawls, made a point of producing at least a handful of twill-tapestry weave shawls, using drawlooms. They employed women and children, many of them orphans, and paid very little for their services. Manual production of twill-tapestry weave shawls was scarcely profitable but nevertheless continued throughout the first half of the nineteenth century. After 1860 the practice was replaced by mechanical production (see the shawl opposite). Seen from the back, hand-woven twill-tapestry weave shawls of Parisian manufacture are indistinguishable from their imported counterparts. It is only by inspecting the yarn that one may be able to tell the difference, since Parisian shawls sometimes have their cashmere warp threads wound around a silk core. In the case of the Ternaux twill-tapestry weave shawl shown on page 126, the border motifs are the giveaway: they are facing in different directions in the two borders – a consequence of being woven on a drawloom. If we are to believe the juries of the five-yearly exhibitions held in Paris between 1819 and 1851,

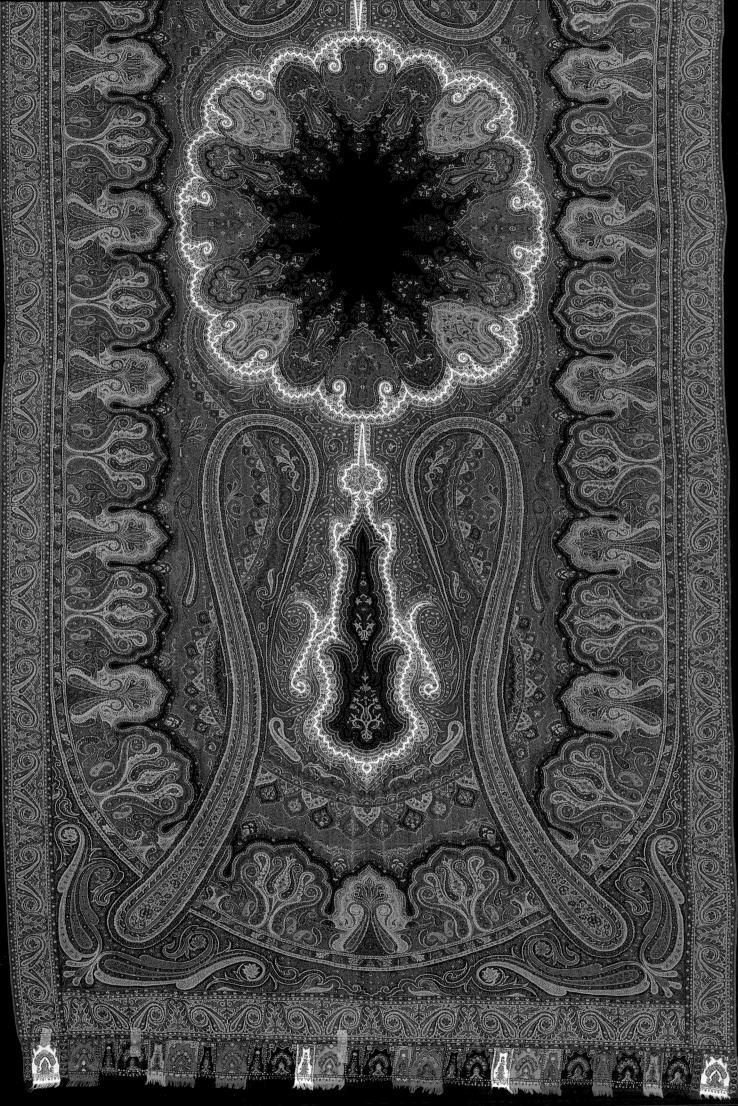

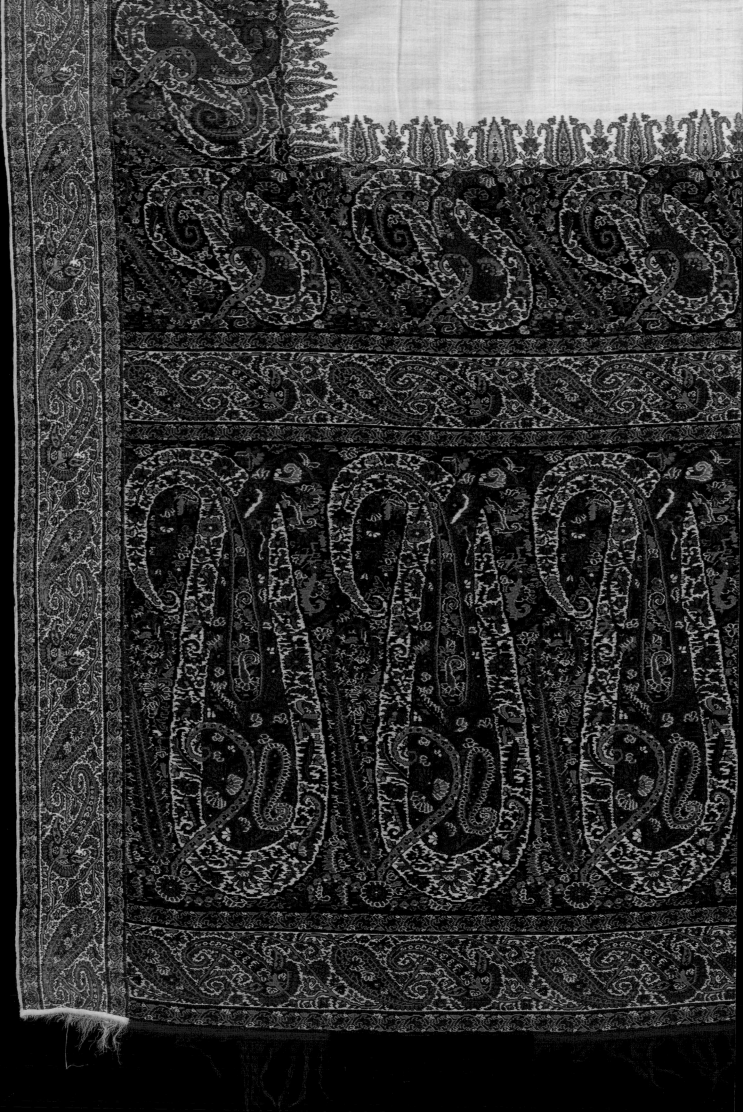

the capital saw the production of hundreds of twill-tapestry weave shawls, and if we fail to recognize them it is because they deceive us in the same way they deceived the public of their age. Perhaps by looking more carefully, assisted by powerful microscopes, we may one day succeed in uncovering clues concealed in the material and the torsion of the threads revealing the Parisian origin of certain 'Indian shawls'.

Two first-generation shawl manufacturers focused exclusively on manufacturing twill-tapestry weave shawls. Bauson, in Paris, was the official supplier to the Duchess of Angoulême. Girard, established in Sèvres, fulfilled the same role vis-à-vis the Duchess of Berry, and his name features on the awards lists of the national exhibitions of 1819 and 1844. We have never succeeded, however, in identifying a single shawl made by these two manufacturers. Aside from Bauson and Girard, Parisian manufacturers as a whole produced a small handful of prestigious shawls in twill-tapestry weave, but the bulk of their production was woven *au lancé* and trimmed on the back. These shawls, long ones for the most part, measured approximately 300 × 140 cm (118⅛ × 55⅛ in.). During the First Empire the decorated sections were woven separately and then sewn to the plain central field. The silk warp threads produced fringes with a 'thin' look – sparse and shiny – that betrayed their European provenance, so Parisian manufacturers took the trouble of attaching woollen fringes to their shawl ends.

When, in 1815, it became possible to start importing wild goat's fleece again, the warps of the finest shawls were made of cashmere, while seven colours or more were used for the wefts. Woven in a single piece, these 'rich' shawls could now show their natural fringes. In around 1817 the manufacturer Bellanger, a pioneer of the shawl industry to whom we owe the invention of the *pas de liage* (p. 96), was the first to install a Jacquard mechanism on a loom in place of a simple. This mechanism, which fulfilled the same function as the simple, meant it was possible to dispense with the services of the drawboy, since the weaver activated the mechanism himself by means of a pedal. As improvements were made to the mechanism, it soon became possible to create bigger and bigger motifs, in terms of both width and height.

Square 5/4 shawls were also woven; the 5/4 referred to an ell, which measured roughly 120 cm (47¼ in.): the shawls were therefore 150 cm (59 in.) square. Their decoration consisted either of fine stripes or of a central medallion, with quarter medallions in the corners, with the whole piece framed by a narrow border, or *talon*. After 1815 the border became bigger. The ground of medallion-decorated shawls was either striped or scattered with small motifs, miniature flowers or pines. These decorative designs conformed to models imported from Kashmir and even Persia, where striped shawls were highly prized. As the size of the rows of pines at either end of the shawl increased, their number diminished: there were ten during the First Empire, eight during the Restoration and six during the reign of Louis-Philippe. In parallel with these developments, the surface area of the plain field shrank and the narrow gallery that originally framed it became more prominent and was supplemented with a counter or secondary gallery (p. 314).

The first harlequin pines and harlequin shawl ends appeared shortly before 1820. The pines were identical in design, but either the central colours alternated or each pine was set against a field of a contrasting colour. This alternating effect was initially

OPPOSITE
Corner of a long shawl with a harlequin warp.
Paris, 1820–30.
Woven au lancé, trimmed on back, cashmere with ten weft colours, 305 × 148 cm (120¼ × 58¼ in.).
Paris, author's collection, no. 10.
A beautiful example of a shawl with a dyed warp (red and black).

achieved via the wefts alone, but between 1820 and 1830 manufacturers found that they got better results by dyeing the relevant sections of warp (corresponding to the shawl ends) in the requisite colours prior to weaving. When the compartments of the borders were each to have a differently coloured field (the sequence might be red, blue, yellow, green and then start all over again with red), which would be at least 40 cm (15¾ in.) high, the relevant sections of the warp threads had to be dyed before weaving began. The length of warp threads, sufficient for at least six long shawls, was sent to the dyer. He then dyed the different bundles or hanks of warps to the weaver's requirements, having first tightly bound those sections that were not to be dyed. This prevented the various colours from seeping further up the threads, confining the colour to the correct length. The warp was then sent back to the weaver to be put into the loom, and weaving could begin. This dyeing method meant that the compartments' backgrounds could be in unmixed colour. (French shawls were most frequently woven in 3/1 twill, which meant that the weft of the ornamentation crossed over three warps, masking them, and then under one warp thread, leaving it visible: if there were any difference in shade between warp and weft, the background colour would not be solid.) This method of tie-dyeing,* used by the silk industry in the eighteenth century and known as the *chiné à la branche* technique, was generally supplanted in 1816 by printing on the warp, a quicker and less laborious process. The shawl industry was almost alone in continuing with tie-dyeing for at least two thirds of the nineteenth century.[2]

The colours of the pines were strongly contrasting and the fringes produced the same harlequin effect, since each fringe was a continuation of the colour of each compartment's field (as was also the case for striped shawls). The fashion for harlequin shawls originated in the Orient and proved immensely popular in France, reaching its height around 1825. While the fashion for harlequin pines died out, polychrome shawl ends remained popular. They provide a helpful clue when it comes to dating shawls, since their presence indicates that the piece postdates 1819 (see 'Dating nineteenth-century European shawls', p. 315).

Between 1820 and 1870 harlequin shawl ends were constantly evolving: the segments became narrower, taller and more numerous. Measuring 1 cm (⅜ in.) in around 1820, they reached 5 cm (2 in.) in height in around 1850, and from this date onwards, they were always decorated. While the segments remained plain, Parisian weavers inserted the wefts using bobbins and interlocked them to prevent tears appearing where two colours met. Once manufacturers started decorating them, the harlequin shawl ends could be woven *au lancé* and trimmed on the back like the rest of the shawl. After 1865 their height frequently exceeded 12 cm (4¾ in.).

In 1819 one of the great pioneers of the shawl industry, François Lagorce (p. 147), installed two warps on the same loom. His aim was to produce pure unadulterated colours for his harlequin pines. One set of warps was white and was intended for the ground; the other warp threads were dyed in the colours of the various pines. The result was that the weft threads intersected with warp threads of the same colour. A number of manufacturers adopted this costly technique during the course of the century. This is the technique that was used to produce the shawls, woven between 1865 and 1870, that are shown on pages 103 to 109.

OPPOSITE
*Corner of a long shawl with a harlequin warp and weft. Paris, 1825–30.
Woven au lancé, trimmed on back, cashmere with nine weft colours, 312 × 155 cm (122⅞ × 61 in.). Paris, author's collection, no. 47.
The smaller pine compartments of the gallery also have a harlequin ground colour, contrasting in each case with the ground colour of the large pine compartment below it. In order to obtain even colour effects, the warp threads were dyed to match the weft threads prior to weaving.*

[2] M. F. Peyot, pp. 192–93.

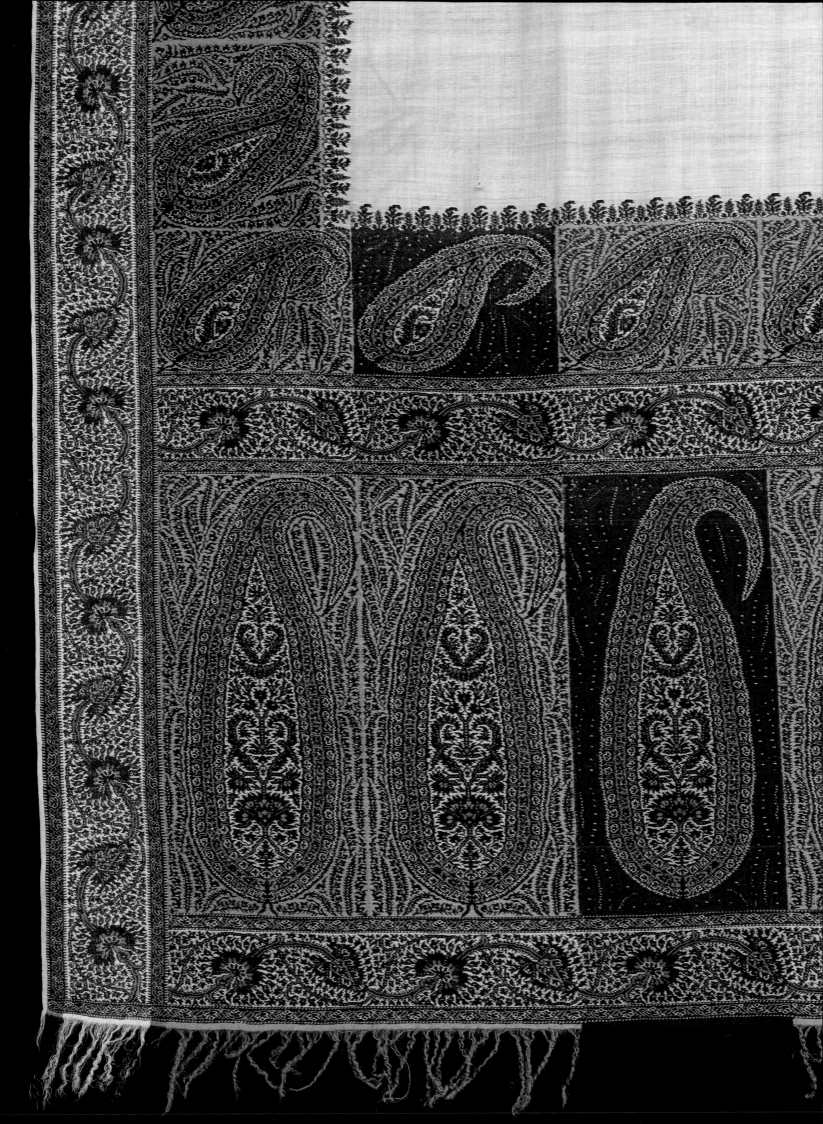

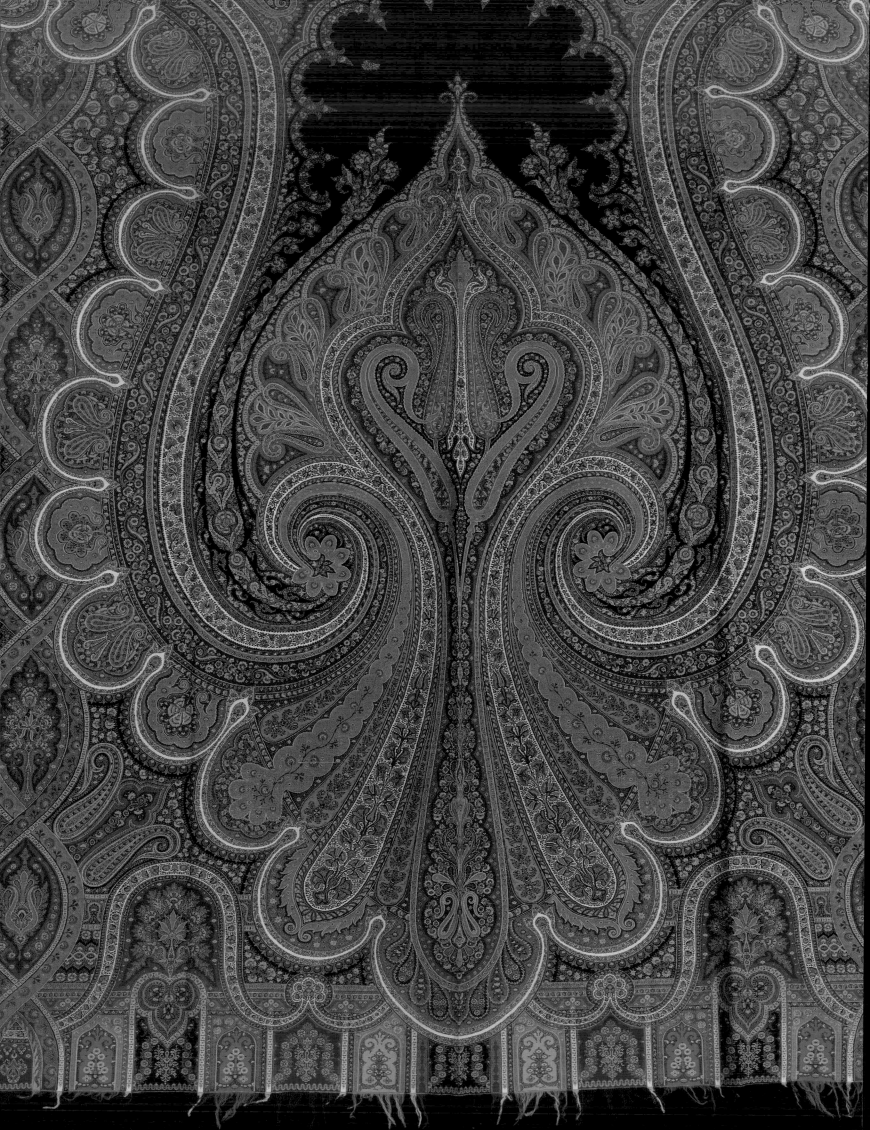

A less satisfactory but less onerous solution consisted in dyeing the warp prior to weaving. This method was invented by Paul Godefroy, a textile printer and manufacturer of brocaded shawls who obtained a patent for 'a process for dyeing the warps of brocaded shawls' in 1844.[3] Where the motifs were due to appear the warp threads were dyed red, while the ground was shielded from the dye using sheets of lead cut to match its contours; then the process was reversed and the dyed areas were masked with other lead sheets and the ground was dyed in the requisite colour. Previously it had only been possible to create a central field that was rectangular in shape, and this produced areas of unwanted colour where the edges of the design were not rectilinear. By following the dyed warp threads with a thread counter it is possible to determine whether they conform to the contour of the motifs and thereby whether a shawl postdates Godefroy's invention.

Further advances in technology made it possible to reduce the number of shuttles used: this was known as the *mariage de couleurs* or 'marriage of colours' and was invented before 1849 by two Paris shawl makers, Deneirouse and Duché. If orange was required, a red weft and a yellow weft were passed through the same shed;* for dark red, one red weft and one black weft were used together, and so on. Another sign of progress, dating from 1856, was the introduction of chemical dyes to take the place of vegetable and mineral dyes. This was one of the reasons for the uniformity of shawl colours after 1860.

Shawl weavers worked by the piece for the manufacturers, who supplied them with the punched cards for the Jacquard mechanism and the raw materials: the weft threads in the requisite colours and the dyed warp, some 25 m (82 ft) in length, sufficient for weaving six long shawls or ten square shawls (p. 86). The finest shawls were produced in Paris, in the vicinity of the Porte d'Italie and Belleville, where the manufacturer could keep an eye on the work as it progressed. More modest shawls were made in Bohain and Fresnoy-le-Grand (Aisne). Handlooms were gradually replaced by their factory steam-driven counterparts from 1870 onwards, initially in and around Lyons and then elsewhere. As many of the later shawls were manufactured in Lyons, it became commonplace to describe all shawls woven *au lancé* as 'Lyons shawls'.

After providing dimensions and prices, the jury report for the French industrial exhibition of 1839 notes that what distinguishes Parisian shawls from those of Lyons and Nîmes manufacture is the material. Here is the passage relating to Paris:

Paris manufacture produces three types of cashmere-style or imitation cashmere shawl.

1) Pure cashmere, where the warp and all the woven materials are in cashmere wool. The majority of these shawls are square and measure between 180 and 195 centimetres [70⅞ and 76¾ inches]. The prices vary between 220 and 500 francs. Rarely are fewer than eight colours used; the number is usually ten or eleven, sometimes as many as fourteen or fifteen.

Long shawls are also produced in pure cashmere: a few years ago they were the norm and the square shawl was the exception; today, thanks to the current dictates of fashion, the reverse is true. The long shawl is between 150 and 160 centimetres [59 and 63 inches] wide and between 360 and 380 centimetres [141¾ and 149⅝ inches] long. The price varies between 300 and 700 francs, only rarely exceeding this figure; it is generally in the region of 300 to 500 francs.

OPPOSITE
Lower section of a long shawl with a double warp. Paris, c. 1867.
Woven au lancé, *trimmed on back, cashmere, 334 × 161 cm (131½ × 63⅜ in.). Paris, author's collection, no. 156.*
The combination of a light warp (for the white and the paler shades) and a red warp (dyed black for the central field) gives this decorative scheme a wonderful sharpness. The manufacturer François Guillaumaud was well known for his double-warp shawls, made to designs by Henry Vichy. It is possible that this shawl is one of his.

3 INPI, patent no. 16759, application for five years, registered 2 May 1844.

2) The cashmere Hindu shawl, woven using the same materials as pure cashmere with the exception of the warp, which is in fancy silk made of two twisted yarns. In order to reduce the cost price still further, one or two fewer colours may be used. The shawl then fetches between 180 and 220 francs.

3) The woollen Hindu shawl, which has the same warp as the cashmere Hindu but where the weft and the lancé are in wool of varying fineness. This type of shawl usually calls for no more than six colours.... The prices are fixed somewhere between 75 and 130 francs; when the shawl is 195 centimetres [76¾ inches] square, the price can rise to between 150 and 170 francs.

Of all the Parisian shawls, this is the one most commonly purchased; it generates revenues of between 12 and 15 million francs annually.

With regard to pure cashmere, Paris has the monopoly; it is in the production of pure wool Hindu cashmeres that Lyons manufacturers are able to compete with their Parisian counterparts.

This text establishes the criteria for judging the quality of a shawl. Silk fringes and warps had a different look from cashmere and anyone with experience could distinguish cashmere wefts by their feel. The production of 'counterfeit' shawls by less scrupulous manufacturers post-1840 led to the need for guarantees. Actions were brought against the counterfeiters and the minutes of the court proceedings reveal just what bitter competition existed between manufacturers, all of them eager to keep their costs down. Silk manufacturers in Lyons had been registering their patterns since the beginning of the century and shawl designers now followed suit, seeking to protect their techniques by registering patents with the Institut National de la Propriété Industrielle (INPI), France's national intellectual property office. However, such measures proved inadequate. In 1849 Laurent Biétry (p. 283), cashmere spinner, shawl manufacturer, merchant and president of the Fabrics section of the Prud'hommes Registry, published a pamphlet inviting manufacturers to sign their products and guarantee the authenticity of their materials.

One way of signing a shawl was to sew on a label, which was what Biétry himself did. The shawls he sold in his shop carried round, white taffeta labels sewn on the reverse, with his name and address printed in black letters, as a guarantee of their cashmere content. The Billecoq firm had three different labels for three different types of shawl depending on whether it was 'guaranteed wool', 'guaranteed wool with cashmere ground' or 'guaranteed cashmere'. In 1858 Duché Aîné & Cie began using round labels in black silk. Calenge, Lhonneur, Françoise & Cie, successors to Gaussen Aîné, opted for an oval label in black fabric in 1863. And finally the Lyons manufacturer Tardy, a specialist in refurbishment, with branches in Marseilles and Toulouse, sewed a white oval label on the back of all the shawls that passed through its doors. These five companies are the only ones, to my knowledge, that used labels to sign their shawls.

Four European manufacturers produced shawls with the company name woven into the fabric itself. Three were based in Paris – Duché (p. 167), Deneirouse (p. 295) and Biétry (p. 283) – and one, Sawostjanow,[4] was in Moscow.

As time went on other Paris shawl makers, all of them manufacturers of top-quality goods with lavish ornamentation, began weaving their initials either in the centre of their shawls or in the harlequin shawl ends. As luck would have it, none of the

[4] Quoted in O. Gordejewa, L. Jefimowa and R. Belogorskaja (eds), p. 170.

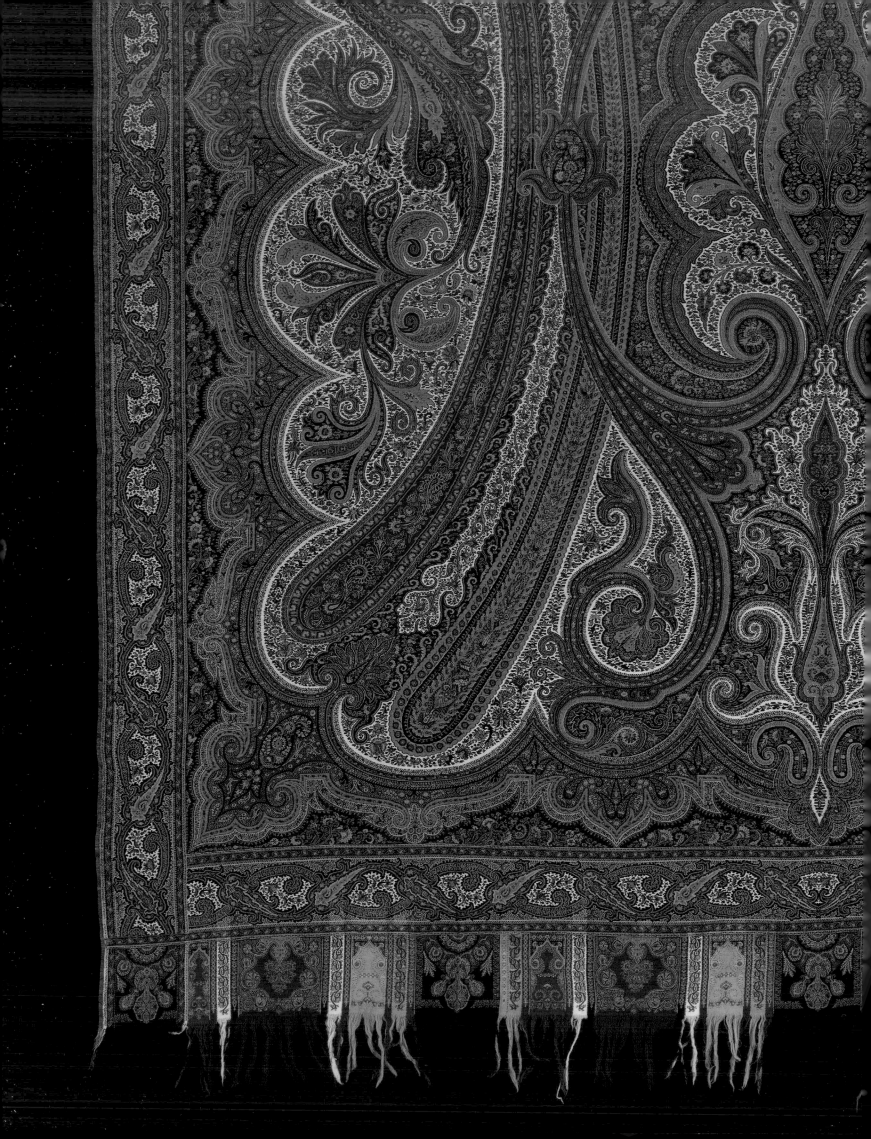

manufacturers operating at any one time had the same set of initials as another. Since 1981, when I started comparing the woven initials with the shawl makers mentioned in the jury reports from the various industrial exhibitions, I have never found a single ambiguity. There are a great many more possible letter combinations than there were shawl makers active in Paris between 1850 and 1880 and the name a company chose to trade under may have been deliberately selected in order to avoid confusion.

There was nothing to stop other European manufacturers from signing their shawls and yet, aside from the Moscow firm mentioned earlier, only four others did so. These were the exceptions to the general rule that every signed shawl was of Parisian provenance: the initials 'N. M.' in Cyrillic, belonging to the Russian Nadeshda Merlina, a manufacturer of twill-tapestry weave shawls operating in the vicinity of Nizhny-Novgorod (Russia) during the first half of the nineteenth century; the initials 'B. N.', which appeared inside a cartouche at the bottom of several stoles scattered with Kashmiri motifs, probably the work of the Lyons firm Bonnardel & Naville; the initials 'F. C.' woven into the corners of square shawls with a black fully decorated ground, which it is tempting to attribute to François Constant, a manufacturer from Nîmes who was awarded the first-class medal at the World's Fair in Paris in 1855; and finally, the initial 'R', which appears in the corners of several shawls made after 1860, which do not appear to be of French manufacture.

In about 1860, instead of weaving their initials in the corner of their shawls, most Paris shawl makers began incorporating it in the small central reserve* where the white lettering, imitating Arabic calligraphy, was often hard to decipher. A set of initials may be repeated on a number of shawls but still remain impossible for us to decipher – although it was presumably not a problem for those who sold and bought the shawls.

In 1856, following the Terrier patent concerning 'the method for obtaining gold and silver relief impressions for trademarks…, designs and lettering on all wool fabrics, whether pure or mixed',[5] some shawl makers began affixing a stamp bearing their name in gold letters on the reverse of their shawls. Often this stamp was also a guarantee of the material used. These gold stamps have tended to deteriorate with washing and the passing of time. As the passage quoted above (from the jury report) indicates, aside from 'pure cashmere', Paris shawl makers produced two qualities of brocaded shawl: the 'cashmere Hindu' and the 'woollen Hindu'. The two latter were also manufactured in and around Lyons and Nîmes. Those that were made in Paris were sold by street hawkers and drapers' shops – and later by the newly emerging department stores. Their sales catalogues and publicity materials demonstrate that shawls of modest quality were offered for sale without a manufacturer's stamp and at competitive prices. The sale of such articles made up the bulk of the shawl manufacturer's business.

The superior-quality shawls known as 'French cashmeres', or 'rich shawls', were only available from specialist shops scattered throughout what is now Paris's second arrondissement (see area map, pp. 112–13). As we shall see later, three at least of the manufacturers – Ternaux, Duché and Biétry – had their own shops, while others may have sold their goods directly to the public without actually owning a shop.

Invoices, fashion articles and exhibition reports give the prices of shawls, indicating their provenance and sometimes their format, but never the quality of

OPPOSITE
Corner of a long shawl with a double warp. Paris, c. 1867.
Woven au lancé, trimmed on back, cashmere, 355 × 156cm (139¾ × 61⅜ in.). Paris, author's collection, no. 160. Like the shawl shown on page 102, this may be a Guillaumaud shawl.

5 INPI, patent no. 23716, application registered 16 August 1855

Two examples of 'married' wefts.
TOP *Yellow and red wefts combined to create orange.*

ABOVE *Black and red wefts combined to create dark red.*

OPPOSITE
Detail of the shawl shown on page 106.

6 Adèle Foucher Hugo, vol. 2, p. 67.
7 National Archives, shelf mark 300 API 2419.
8 Moléon, Cochaud and Paulin-Désormeaux, vol. 1.

the weave or the yarn, or indeed the number of colours used – with the exception of the 1839 report quoted above. It is therefore impossible to compare prices or produce a price scale for each period. The following is a rough guide.

Indian twill-tapestry weave cashmere shawls:

Square 1,500–5,000 francs

Long 2,500–10,000 francs

Parisian twill-tapestry weave cashmere shawls:

Square 500–2,400 francs

Long 1,800–6,000 francs

Parisian cashmere shawls, woven *au lancé* and trimmed on the back:

Square 150–700 francs

Long 200–1,200 francs

From 1810 to the end of the century, prices remained more or less stable. Although increasingly extensive ornamentation added to the manufacturing cost, this was offset by the reduction in manufacturing time, thanks to advances in technology. We can see from the figures above that an Indian shawl cost approximately ten times more than a Parisian shawl in the same format but woven *au lancé* and trimmed on the back; and that a shawl woven in Paris in twill-tapestry weave cost considerably less than its Indian equivalent. If we are to believe their own evidence, Europe's aristocratic ladies never wore anything but the original Indian artefact, while novelists were keen to deck out their heroines in the same. Indian cashmeres – rather than their European counterparts – were the stuff of dreams.

Describing her wedding to the writer Victor Hugo, which took place at the Église Saint-Sulpice in Paris on 12 October 1822, Adéle Hugo recounts: 'The seven hundred francs that Victor earned for his *Odes* was not enough this time to keep him going for a year: he spent them in one fell swoop on a French cashmere that was the crowning piece of his wedding gifts.'[6] The frankness of Adèle's account is all the more valuable in that French writers seem to have thought it indelicate to mention the price of such a shawl.

The Duke and Duchess of Orléans saw the *Nou-Rouz* shawl at the French industrial exhibition of 1839 and subsequently purchased it from Gaussen the elder for the sum of 1,200 francs.[7] This shawl and the twelve delivered to the imperial court by Ternaux in 1812, each of them costing 2,000 francs, are the only examples where both the shawl and its initial price are known. The acquisition by Queen Marie-Amélie[8] of a Deneirouse shawl with a green ground at the 1834 exhibition and by the Empress Eugénie of a long Biétry shawl after a design by Berrus were, above all, politically motivated and intended as an encouragement to industry. If we consider these cases as exceptions, we have to conclude that it was the bourgeoisie, the wives of successful entrepreneurs closely linked with industry, who dared to wear these shawls with their novel ornamentation that were being offered for sale by Parisian manufacturers.

The following chapters retrace, in chronological order, the professional lives of the principal figures involved in the shawl industry in Paris, including designers, manufacturers and merchants.

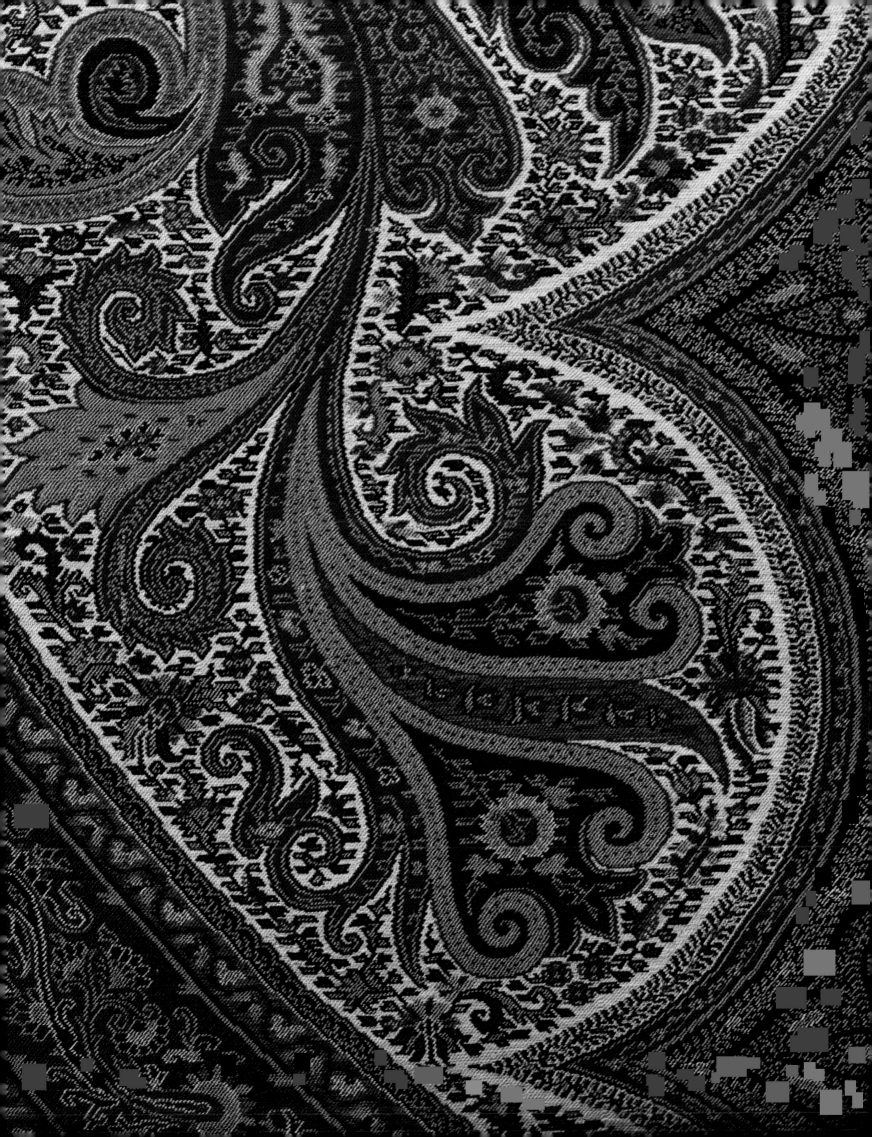

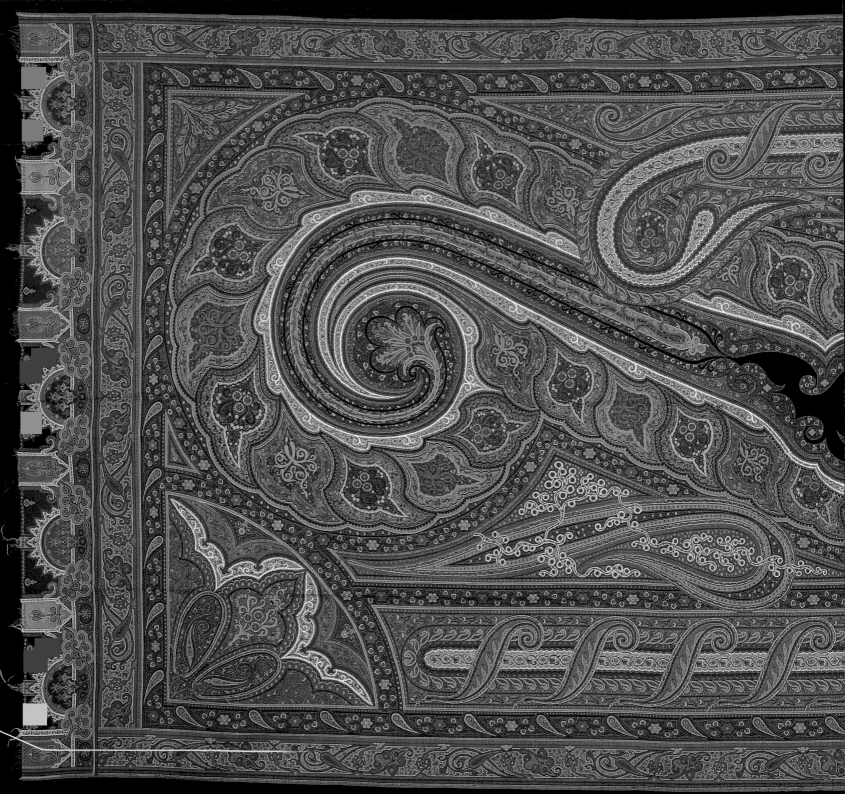

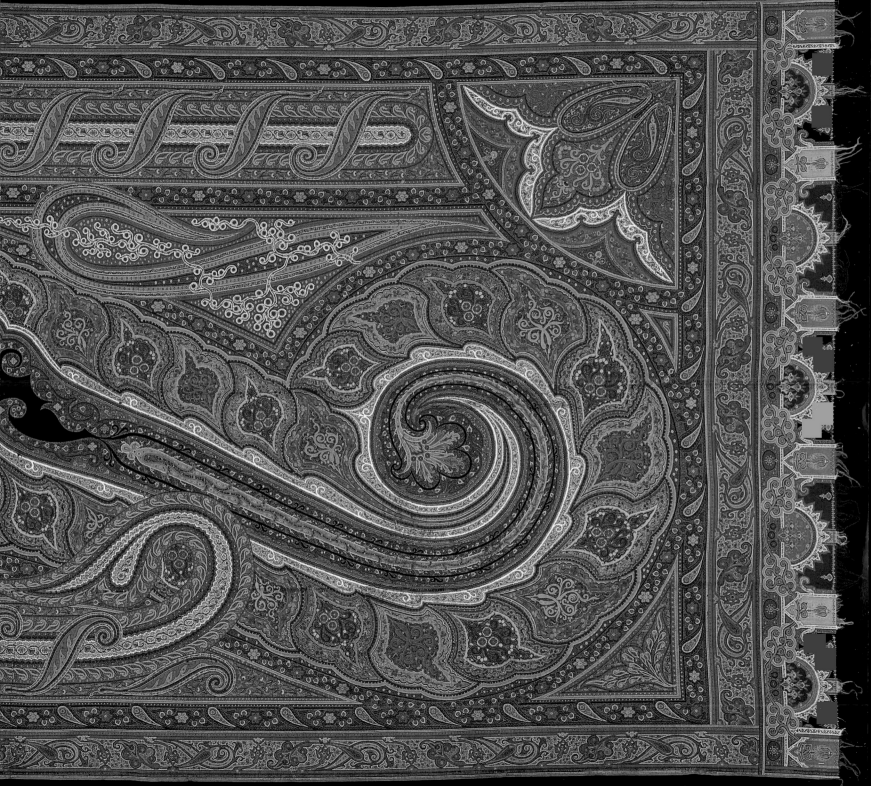

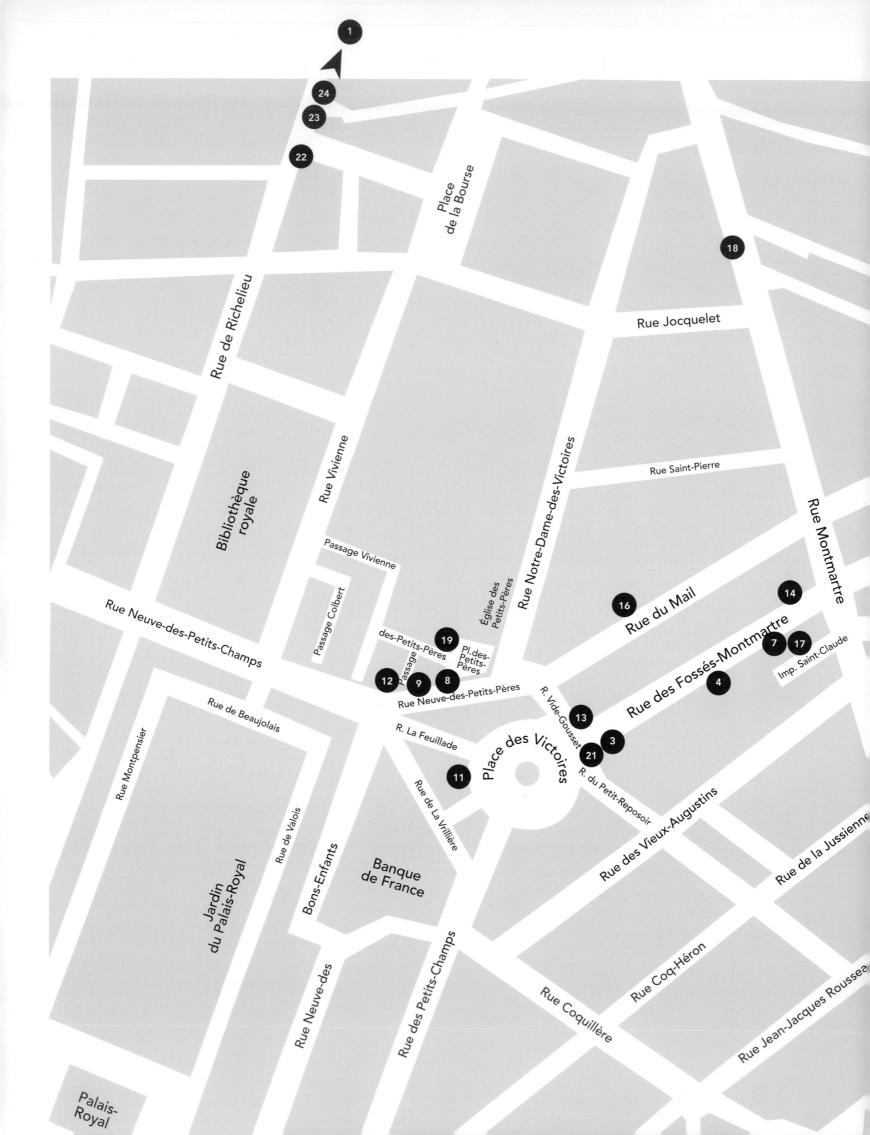

Map of Parisian Shawl Makers and Sellers

1 Biétry, 102 Rue de Richelieu; after 1855: 41 Boulevard des Capucines

2 Bourgeois Frères, 23 Rue Neuve-Saint-Eustache

3 Bournhonet, 2 Rue des Fossés-Montmartre

4 Chambellan, 8 Rue d'Aboukir*

5 Champion & Gérard, 15 Rue Neuve-Saint-Eustache

6 Chanel, 16 Rue Neuve-Saint-Eustache

7 Deneirouse & Boisglavy, 16 Rue des Fossés-Montmartre

8 Duché Aîné, 3 Rue des Petits-Pères**

9 Duché Paul, 1 Rue des Petits-Pères

10 Fortier & Maillard, 36 Rue Neuve-Saint-Eustache

11 Gaussen Aîné, 2 Place des Victoires

12 Gaussen Maxime, 1 Rue de la Banque

13 Gaussen Jeune, Fargeton & Cie, 2 Rue Vide-Gousset

14 Gérard & Cantigny, 27 Rue des Fossés-Montmartre

15 Guillaumaud, 63 Rue d'Aboukir

16 Hébert the elder, succeeded by his son; after 1834: 13 Rue du Mail

17 Heuzey-Deneirouse & Boisglavy, 16 Rue d'Aboukir

18 Lecoq, Gruyer & Cie, 131 Rue Montmartre

19 Lion Frères, 9 Place des Petits-Pères

20 Robert & Gosselin, 25–27 Rue Neuve-Saint-Eustache

21 Ternaux, 2 Rue des Fossés-Montmartre, 2 Place des Victoires

22 Au Persan, 78 Rue de Richelieu

23 La Compagnie des Indes, 80 Rue de Richelieu

24 La Caravane, 82 Rue de Richelieu

* In 1865, Rues des Fossés-Montmartre, Rue Neuve-Saint-Eustache and Rue Bourbon-Villeneuve were joined and named Rue d'Aboukir.

** After 1851, Passage des Petits-Pères became the start of Rue de la Banque.

The map shown left is based on Théodore Jacoubet's *Atlas général de la Ville de Paris* (General Atlas of the City of Paris), 1836.

PREVIOUS PAGES
Long shawl with a large à pivot design.
Paris, 1867–70.
Woven au lancé, trimmed on back, cashmere,
344 × 156 cm (135⅓ × 61⅓ in.).
Milan, Etro collection, no. 201.
Note what look like little bunches of grapes either side of the central axis. The jury report for the 1867 World's Fair mentions a design painted by Henry Vichy for the shawl manufacturer Guillaumaud whose 'white grape-like clusters were much remarked upon…'

A LA VALLÉE DE KACHMYR.

Place des Victoires, N° 6, l'entrée par la porte-cochère.

DÉPOT ET VENTE EN DÉTAIL

DES CACHEMIRES

TERNAUX ET LAGORCE.

Schalls des Manufactures Gaussen, Deneirouse, Hebert, etc., etc. Thibets, Merinos et Stoffs

Paris, le 14 9bre 1835

Vendu à M^{me} Guillot

1 Carton 74

Fr. C.

20 7

Jacqué

Dufay

Bénard, impr.-grav, pass. du Caire, n 2.

Les lettres et paquets doivent être adressés à M. Auguste Goguelat.

Guillaume Ternaux

G uillaume Ternaux was born in Sedan in the Ardennes region of France in 1763, the eldest of seven children. At the age of fourteen he was sent to work in his father's cloth mill. Two years later Ternaux senior ran into financial difficulties and was obliged to hand the business over to his son, who proved himself more than equal to the task of reviving the fortunes of the ailing firm. Within four years of assuming control Guillaume Ternaux had made his first 100,000 francs.

Acting in his capacity as town councillor, in August 1792 Ternaux countersigned the arrest order for the commissioners who came to Sedan to announce the dismissal of La Fayette, the French officer had played a key role in the 1789 Revolution but later lost the support of the revolutionaries: the municipality had sided with La Fayette in condemning the insurrection of 10 August, which put an end to the Legislative Assembly. A few months later the majority of Ternaux's colleagues were brought before the Revolutionary Tribunal in Paris and perished on the scaffold. Fearing the same fate, Ternaux fled to Germany and only returned to France after Robespierre's fall from power. Having succeeded in transferring his business (and much of his fortune) abroad, and absorbing everything that Germany and England could teach him about manufacturing, he returned with a wealth of knowledge and, despite the efforts of the Revolution, his financial capital intact, ready to restart his operations in France (as we shall see after a glance at his political career).

Despite his anti-imperial sentiments, Napoleon appears to have borne Ternaux no ill will. The Emperor came across the industrialist during an inspection of Louviers' manufacturing centres in 1810 and recalled visiting his factories in Marne and the Ardennes when he was First Consul: 'You're everywhere I go, aren't you?', he is said to have exclaimed, apparently unpinning his Legion of Honour cross and pinning it on to Ternaux's chest.

In 1818 Ternaux was elected deputy for the Seine *département*, defeating the writer Benjamin Constant . Louis XVIII had made him an officer of the Legion of Honour in 1816 and in 1819 conferred on him the title of baron. In 1827 Ternaux was re-elected deputy for Paris and for Haute-Vienne and opted for the latter, a mandate that was renewed in 1830. He aligned himself with the liberals and became involved in the revolution of July

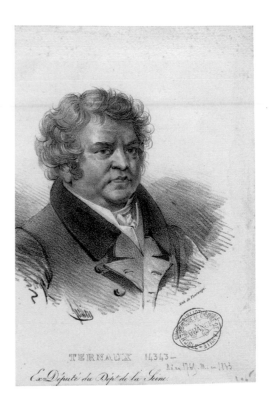

Portrait of Guillaume Ternaux.
Engraving.
Chartres, private collection.

OPPOSITE
Invoice.
Paris, Debuisson collection.

EXTRAIT du Procès-verbal des opérations du Jury nommé par le Ministre de l'Intérieur, pour examiner les produits de l'industrie française, mis à l'exposition des jours complémentaires de la neuvième année de la République.

TERNAUX FRÈRES, Manufacturiers à Louviers, Sédan, Rheims et Ensival, demeurant à Paris, Place des Victoires, N°. 17.

La fabrication de ces citoyens est la base d'un commerce très-étendu; elle est variée depuis les espèces communes jusqu'aux plus fines.

Les membres du Jury ont trouvé les casimirs présentés au concours, supérieurs à tous ceux qu'ils ont vu jusqu'ici dans le commerce. La pièce jugée la plus belle, a été fabriquée à Sédan par les frères TERNAUX. Ces Manufacturiers ont en outre exposé des draps superfins très-beaux; ils sont chefs de quatre établissemens considérables, où ils entretiennent de quatre à cinq mille ouvriers.

Le Jury leur a décerné une médaille d'or.

Le Ministre de l'Intérieur,

Signé CHAPTAL.

RAISONS DE COMMERCE.

à Sédan,	⎫
à Louviers,	⎪
à Ensival, département de l'Ourthe, . . .	⎬ Ternaux, frères.
à Livourne,	⎪
à Paris,	⎭
à Rheims,	Vᵉ. de Récicourt, Jobert, Lucas et Cᵉ.
à Bayonne,	Chéreau frères et Cᵉ.

La correspondance des fabriques de Sédan, Louviers et Ensival se tient à Paris.

Notice announcing the prizes awarded to the Ternaux brothers and their associates at the French industrial exhibitions of 1801 and 1802. Chartres, private collection.

PROCÈS-VERBAL des opérations du Jury nommé par le Ministre de l'Intérieur, pour examiner les produits de l'industrie française, mis à l'exposition des jours complémentaires de la dixième année de la République.

TERNAUX FRÈRES, demeurant à Paris, Place des Victoires, N°. 17.

Il fut accordé en l'an 9, aux frères Ternaux, une médaille d'or. Ils ont des fabriques à Louviers, à Rheims, Sédan et Ensival. Leurs draps de Louviers sont de la plus grande beauté. Ils ont présenté deux pièces de draps de Vigogne d'un très-grand effet, l'une en couleur naturelle, et l'autre teinte couleur brune. Leur fabrication de Sédan n'est pas moins remarquable. Il est difficile de voir des draps mieux exécutés que les draps noirs et blancs qu'ils ont exposés. Leurs casimirs les firent distinguer l'année dernière ; ceux de cette année sont supérieurs. Le Jury pense que leurs travaux méritent les plus grands éloges, car tous leurs produits sont encore plus parfaits que ceux qui, l'année dernière, leur valurent la médaille d'or.

La maison veuve de Récicourt, Jobert, Lucas et compagnie, de Rheims, à laquelle les frères Ternaux sont associés, a présenté plusieurs pièces d'une étoffe appelée *Duvet de Cygne*, qui n'avait pas encore été faite en France ; elle a été fabriquée à l'imitation d'échantillons étrangers remis aux frères Ternaux, par le Ministre de l'Intérieur. C'est encore dans cette maison qu'ont été fabriqués, en laine d'Espagne, de beaux schalls faits avec tant d'art, qu'ils jouent le schall de Cachemire ; ils sont susceptibles de recevoir les couleurs les plus brillantes et les plus solides.

Le Jury décerne à cette fabrique une médaille d'argent.

Le Ministre de l'Intérieur,
Signé CHAPTAL.

RAISONS DE COMMERCE.

à Sédan,	
à Louviers,	
à Ensival, département de l'Ourthe, . . .	Ternaux, frères.
à Livourne,	
à Paris,	
à Rheims,	Vᵉ. de Récicourt, Jobert, Lucas et Cᵉ.
à Bayonne,	Chéreau frères et Cᵉ.

La correspondance des fabriques de Sédan, Louviers et Ensival se tient à Paris.

1830, neglecting his business and pouring his fortune into his political commitments. He retired to his house in Saint-Ouen, his business in ruins, and died there in 1833.

Guillaume Ternaux controlled every stage of the production and marketing of his goods in order to minimize financial risk. He reared his own sheep and had washing plants in Paris and Sedan, where the wool was cleaned and treated. His cloth mill in Sedan (which Napoleon visited in 1803) had 150 looms, and in 1802 he opened another mill in Bertrix (Belgium), 28 km (17½ miles) northeast of Sedan, which employed 500 workers but was burnt down in 1807. In 1808 Ternaux opened a spinning mill in Rubécourt-et-Lamécourt (Ardennes), not far from Sedan, which employed 120 workers.

In 1825 he bought two former cotton mills in Aubenton (Aisne) and adapted them for the production of woollens and worsteds, with separate workshops for weaving, dyeing and finishing. His second son took over the running of these two mills, which employed 400 workers initially, with the figure later rising to 800.

Ternaux owned four factories in Champagne: three in Rheims and a spinning mill in Bazancourt, 16 km (10 miles) away. The three plants in Rheims had 650 looms between them: one specialized in the manufacture of *petites draperies*, or worsted goods, and had 350 looms; the second produced woven flannel goods and had 100 looms; the third, the Mont-Dieu cloth mill, with 200 looms, was where the famous Ternaux shawls were woven. He also owned four factories in Louviers: a spinning mill, a manufactory of fine woollen cloth,[1] a dye works and a fulling mill (a water mill used to felt cloth), which between them employed 1,200 workers. In addition, there was the wool mill at Elbeuf, which he co-owned with Mathieu Constant Leroy, where between 600 and 800 workers operated 100 looms producing workaday woollens.

During his most successful period, Ternaux owned 30 manufactories and 1,100 looms, employing 17,000 workers, and that was in addition to the workshops, washing plants and factories in Saint-Ouen and Boubers-sur-Canche. The goods manufactured in his various establishments made their way to the central warehouse in Sedan and were dispatched from there to the warehouses, outlets and shops that depended on Ternaux's business in Paris, the provinces and abroad. Guillaume's brother Nicolas (born in Sedan in 1765) was an associate until 1814 and managed the foreign trade.

Ternaux either owned or had investments in a number of shops in Paris. There was *La Vigogne*, at 4 Rue des Fossés-Montmartre, adjacent to his warehouse (Place des Victoires) and his private house, the old Hôtel de Massiac, situated at 2 Rue des Fossés-Montmartre, which he had bought from the Bank of France and lived in during the winter months. Immediately opposite, at 2 Place des Victoires, was *Au Bonhomme Richard*, a small wholesale business, of which he was an associate. He also had money invested in two other shops: *Aux Pyramides d'Égypte* at 3 Rue des Fossés Montmartre and the *Toison de cachemire* at 14 Rue Vivienne.

In addition to his various business enterprises, Ternaux was also his own banker, funding his various establishments according to their needs and paying them interest for the deposits he received from them.[2] He sometimes even operated as a banker for a third party. When, in the spring of 1811, Madame Hugo (mother of the writer Victor Hugo) was preparing to join General Hugo in Spain, she noted in her journal: 'Messrs Ternaux gave me

[1] Chevallier, tailor to Napoleon between 1800 and 1810, cut the Emperor's clothes from cloth made at the Louviers manufactory. See L. Lomüller, p. 93.
[2] The information concerning the consolidation of Ternaux's business ventures is taken from L. M. Lomüller, pp. 77–99.

a bill of exchange in Paris amounting to twelve thousand francs, instructing Messrs Chéraux of Bayonne to pay my travel costs to Spain, where I go to join my husband.'[3]

To get a better idea of Ternaux the shawl manufacturer as seen by his contemporaries, we need to evaluate his merits with respect to those of his fellow shawl makers and try to picture his shawls – this is a harder task, since only three exceptional pieces (replicas of shawls commissioned for the imperial court in 1812) survive; we have no original examples to go on.

In 1803 Ternaux bought the chateau of Saint-Ouen from Jacques Necker, one-time finance minister to Louis XVI, and used it as his summer residence. The grounds of the estate dropped down to the banks of the Seine. It was in his workshops at the chateau that the designs for Ternaux's shawls were conceived and trialled; they were then sent to Rheims, where several shawls were woven to each design. A report on the French industrial exhibition in 1806 notes that 'Messrs Ternaux Frères, manufacturers at Louviers, Sedan, Rheims and Ensival, resident in Paris, Place des Victoires, obtained a gold medal in year IX [p. 116], having finally succeeded in manufacturing superlatively fine shawls that mimic the effect of cashmere using merino wool.'[4]

A letter dated 13 May 1811 and dispatched to the Minister of the Interior requested his support in expanding the firm's operations:

Messrs Ternaux Frères submit for the consideration of His Excellency a project designed to promote the expansion of their cashmere manufacturing business. (Samples enclosed.)
2nd division, Office of Arts and Manufacture.

Sir,

You will be well aware of the problems that beset the transfer of an industry from one country to another, given the difficulty of training workers in an employment with which they are unfamiliar, whence arises the impossibility of manufacturing with sufficient competency at the outset to be able to compete, in terms of price and quality, with firms which have long been in a position to set the standards in these areas. In consequence, inventors and more especially importers frequently face financial ruin and rarely benefit themselves from the fruits of their labours, unless they are protected by laws prohibiting the importation of the same already accredited products.

This state of affairs, Sir, is one that affects us appreciably as regards the manufacturing of our cashmere shawls. In vain have we spared neither pain nor effort in importing from Asia the raw materials required for their manufacture, at great cost to ourselves, and thereby enriched France, which employs those same materials for the hat industry in preference to imported vicuña. In vain have we struggled for eight years now to train our workers, against formidable odds, to produce the level of workmanship which we have the honour of setting before you. In vain have we wasted 70,000 livres (as we can prove to Your Excellency) in endeavouring to achieve such a result. We must abandon this production, and France must be long, if not permanently, deprived of this type of industry, unless Your Excellency is prepared to lend it a helping hand and assist in extracting it from this unfortunate predicament.

You know, Sir, how desirable cashmere shawls are to lovers of luxury, how large are the sums of which these imports rob us and how utterly the public despises anything which describes itself as imitation: prejudice in this regard is so engrained that ladies, while agreeing that a <u>French cashmere</u>

3 Adèle Foucher Hugo, vol. 1, p. 128.
4 National Archives, shelf mark F12/985: 'Note relating to all those who obtained a gold medal in 1806, or in previous years'.

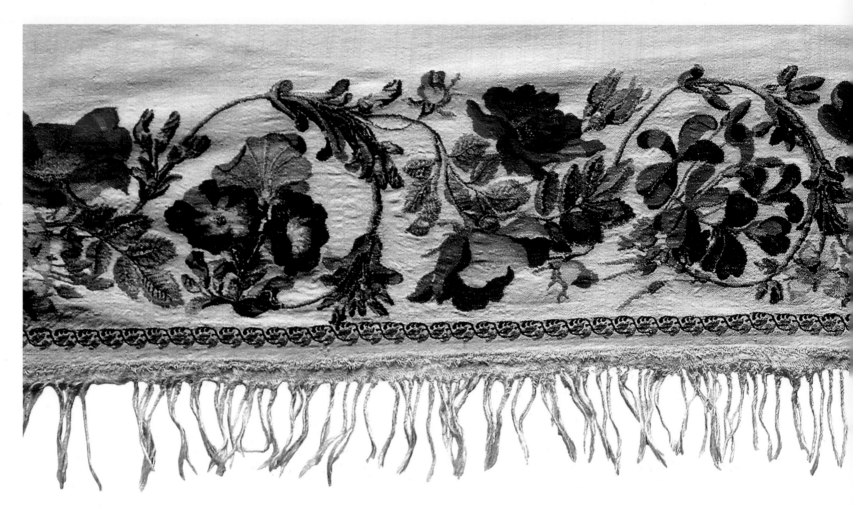

costing 600 francs is as good and almost as beautiful as one that comes from India and costs them 1,800 francs and often 3,000 francs, will reject the former because it is <u>imitation</u> and does not have the same cachet, the same feeling of opulence, as the <u>foreign one</u>.[5]

In order to remedy such an unfortunate state of affairs and attempt to free our industry from this malign influence, we propose, Sir, to manufacture cashmeres of such high-quality weave that we can have nothing to fear from the Indians, while for ornamentation, in lieu of the irregular and <u>bizarre designs</u> which we have been in the habit of copying up until now, we would substitute <u>pines in a French style</u>,[6] several different examples of which we are enclosing. The designs would be even more carefully and finely executed than those of the shawls presented here, where the pines imitate Indian pines. Suffice to say that in terms of the beauty of the work we would spare no effort, since our aim is that it should be worthy of being presented to our August Emperor.

Our wish is that it might please his Majesty to order a mere dozen shawls from us, as a gift to the Ladies of his court, and this, we have no doubt, would result in a general eagerness to acquire such shawls, the fashion for them catching on all the more readily in Paris, and thence in Europe, since ladies are extremely fond of change as regards objects of this sort, and while not yet weary of the cloth itself they are already beginning to tire of Indian pines.

We would ask that the shawls, made to six different designs, be paid for on delivery, at a cost of 100 napoleons [a term for French coins] a shawl. This represents the approximate cost to us of manufacturing the first shawls; the others should amount to little more than 30 napoleons. This is the price for which they could subsequently be sold and distributed throughout Europe.

By this cheap and simple expedient, Your Excellency will be saving an industry that is all the more precious since the value of the cloth lies entirely in the labour involved in its manufacture, the

[5] The underlining is Ternaux's.
[6] The underlining is the author's.

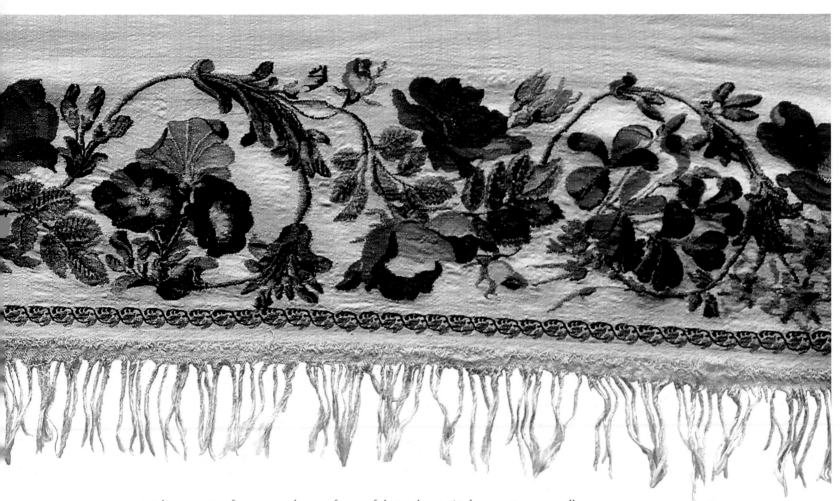

raw materials accounting for no more than 35 francs of the total cost. At the same time you will ensure a source of manufacturing for France which brings some honour, since we may confidently say that nowhere in Europe has the industry been so well developed, although attempts have been made throughout Germany and by a great many English manufacturers in particular. Moreover, Your Excellency will prevent the importation of cashmeres from India more surely by this means than by any other, and at significantly less cost. Finally, Sir, you will be procuring jobs thereafter for a great many workers which the government would not be in a position to occupy as gainfully in the present circumstances, even if it were to go to enormous expense.

If, despite all these probabilities, it transpired that we were deceived in our hopes, his Majesty would be making but a small sacrifice.

If we might be permitted to add some personal considerations to a request which we beg you to consider, Sir, merely in terms of the advancement of industry and public prosperity – since it is in that light alone that we ourselves envisage it – we would point out that any advantage accruing to us would be a truly slight compensation for the losses suffered by our Rheims firm thanks to the non-implementation of the law regarding patents.

With respect to this particular matter, we have sent you two memoranda and await a response through Council of State channels, since His Excellency the Judge, not wishing to take it upon himself to resolve the issues specified therein, has referred them to your ministry.

We beg to observe, Sir, that the success of our demand greatly depends upon the secrecy to be observed in this enterprise, and if the shawls are to be manufactured in the month of January 1812, we have no time to lose.

Respectfully yours, etc. Ternaux Frères

Border detail of a long shawl.
Paris, 1812.
Twill-tapestry weave by Ternaux, wool,
274 × 146 cm (107¼ × 57½ in.).
Vaiges, private collection.
A garland of European flowers runs around a plain
central field. Produced by Ternaux and still in the family
collection, this shawl may well have been designed by
Isabey and woven at the same time as the set of twelve
shawls delivered to the Emperor Napoleon in 1812.

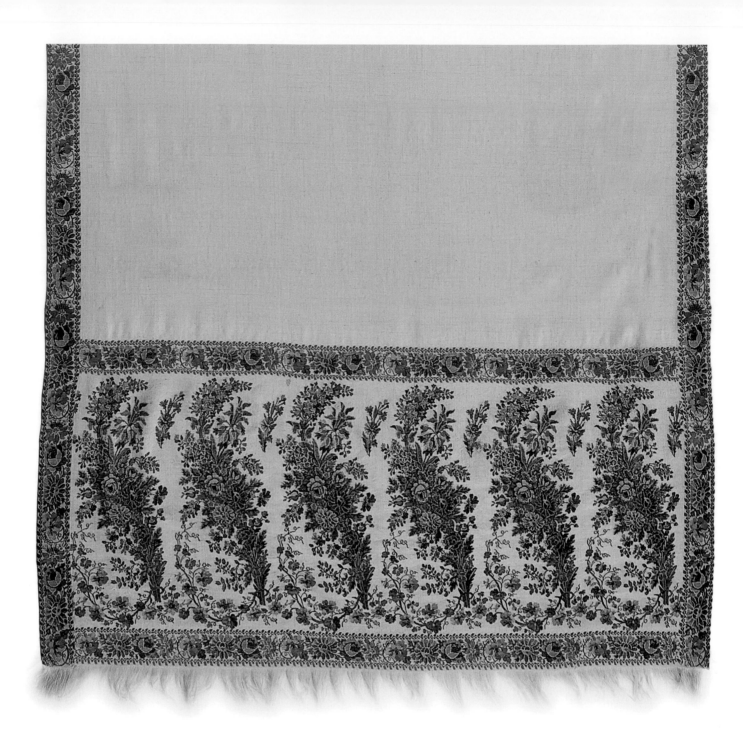

End section of a long half-shawl.
Paris, 1812.
Twill-tapestry weave by Ternaux, cashmere,
218 × 81 cm (85⅞ × 31⅞ in.).
Paris, Musée de la Mode et du Textile,
Musée des Arts Décoratifs, inv. no. 28268,
gift of Madame Janin Ditte, 1932.
The main borders are decorated with six pines
incorporating European flowers such as lilac, fritillaries
and roses. There is an identical design on a twill-tapestry
weave shawl produced by Ternaux that is still in the
family collection. The two shawls were probably designed
by Isabey and woven at the same time as the set of twelve
shawls delivered to the Emperor Napoleon in 1812.

7 National Archives, shelf mark F12/2414.
 The underlining is the author's.

P.S. Your Excellency would improve our chances of success with the proposed scheme if you were to write to His Majesty's portrait painter Isabey, whose style is very well known, and ask him to join us and consult with us regarding the choice of the designs.[7]

In response to this letter from the Ternaux brothers, Montalivet, the Minister of the Interior, sent the following report dated 24 June 1811, addressed to 'His Majesty the Emperor and King, Protector of the Confederation of the Rhine':

Sire!
Your Majesty will be aware how widespread a phenomenon is the costly fashion for cashmere shawls. There is no woman of relative means who does not pride herself on having at least one such shawl in her possession, and if we consider that their average price is in the region of 1,000 francs, we gain some idea of the sums that this superfluous article could be costing France...

The minister concluded his report by reiterating each of the arguments advanced by the Ternaux brothers. These two documents are conserved in the National Archives, along with another letter from the Minister of the Interior, dated 10 July 1811 and addressed to the painter Isabey:

Sir, the distinguished manufacturers Messrs Ternaux Frères wish to take advantage of your talent in seeking to create a number of tasteful designs which they plan to execute in woven materials. No one is better placed than you to enhance the success of their proposed scheme. Please be advised that in falling in with their wishes you will be providing a useful service to our industry, for which I shall be deeply indebted to you.

The same bundle of documents contains the Ternaux brothers' invoice dated 13 March 1813, in which they confirm 'that we have presented the twelve shawls to His Majesty, at his levee on 31 December 1812…and that the sum of twenty-four thousand francs is owing to us'.

We know that the Emperor ordered the twelve shawls and that Ternaux made and delivered them; what we do not have is Isabey's reply to Montalivet's letter. However, it is likely that he was responsible for some if not all of the designs, since the *Moniteur Universel* reports on 1 February 1813:

…The efforts of M. [Monsieur] Ternaux…to enrich us with an interesting industry could not fail to excite the solicitude of the Emperor, for whom the means of augmenting the prosperity of our manufactories remains a constant concern. Those efforts have recently been rewarded: His Majesty was so good as to applaud the zeal of this manufacturer when the latter begged to present to him the twelve shawls which His Majesty had ordered in 1811.

Ternaux's shawls are exceptionally well made. The woven material is as strong as one could wish and relies for its creation on a minimum of manpower. The yarns are more regular and the weave is finer than anything comparable that has come to us from abroad. The designs are the work of our best artists and are a welcome change from the bizarre and muddled ornamentation of foreign shawls. The pines of the latter have been replaced by bouquets and garlands copied from Europe's most exquisite flowers and their glowing and subtly nuanced colours have something of a painting about them – a difficult thing to achieve in woven material, and one that gives such value to the beautiful pieces produced by the imperial Gobelins manufactory….

The Empress Marie-Louise and her ladies-in-waiting must have worn the shawls. Some were also given to the female members of the Ternaux family; they passed them on to their daughters, who kept two of these precious shawls – both are long with an ivory ground and their decorative schemes correspond exactly to the description given by the *Moniteur Universel*. One of the shawls is decorated at either end with a border of eleven bouquets, in the traditional

Invoice.
Paris, Debuisson collection.

pine shape and composed of lilac, roses, crown imperial fritillaries, nasturtiums and other typically 'French' flowers (p. 122). The other (pp. 120–21) is bordered on all four sides with a garland of leaves and flowers in which we can identify wild roses, jasmine and convolvulus. The technique also matches the description in the *Moniteur Universel*: both shawls are woven in twill-tapestry weave, like the Gobelins tapestries and Kashmiri shawls. The fact that in the second border the design is reversed (p. 126) tells us that the shawls were almost certainly woven on a drawloom, where the simple retains the 'memory' of the design, which can thus be reproduced at will.

Ternaux used very fine-spun merino wool but had difficulty sourcing the wild goat's fleece in Makariev Market, so he decided to import some Tibetan goats from Asia and naturalize them in France in order to guarantee a permanent supply. What he had not taken into account was France's temperate climate, which resulted in the goats producing so little of the downy under-fleece that it was pointless rearing them. Ternaux nevertheless kept a handful of goats in the grounds of his Saint-Ouen estate.

The reporter for the 1819 French industrial exhibition mentions that Ternaux and son (trading under the name Jobert-Lucas & Cie) were showing products from their Rheims operation, where they owned 190 looms each operated by four or five workers: 'Plain and brocaded cashmere shawls, woven either *au lancé* in the French fashion, or *espoliné* according to Indian techniques, in various colours and qualities.'[8] However, Guillaume Ternaux was a member of the central jury, which meant that the shawls could not be entered in the competition.

Ternaux and son were awarded a silver medal in the Shawls section at the 1823 exhibition (Ternaux was not a member of the jury on that occasion) and the jury commented: 'The shawls they exhibited were exceptionally well made. The firm continues to occupy the distinguished position it has long held thanks to the efforts of these clever manufacturers in various genres (See Drapery and Merino Fabrics)'. Ternaux and son were also awarded a gold medal in the Drapery section.

The task of importing goats from Asia, entrusted to Amédée Jaubert between 1818 and 1819,[9] had involved both Ternaux and the State in vast expense. His fellow shawl manufacturers, who imported their goat's fleece from the high plateaus of Asia, inevitably felt threatened by the arrival of Ternaux's Kirghiz goats and Jean Rey, another famous manufacturer, devoted several pages to the matter in the book he published in 1823.[10] Although Ternaux's scheme failed and, in that respect at least, his competitors' fears were to prove unfounded, the publicity surrounding Jaubert's mission had the effect of boosting sales for Ternaux and enabling him to bring his prices down still further.

In 1823 the daily *Constitutionnel* published eight articles (unsigned) praising the products of French industry on display in the Louvre from 25 August. Three of these articles (the sixth, seventh and eighth), dated 13, 14 and 18 September 1823, relate exclusively to Guillaume Ternaux. In the last of the three, we read:

...one of two things is needed: either that all manufacturers lower their prices following M. [Monsieur] Ternaux's example, or that they simply allow him to monopolize the market both at home and abroad; for where the quality is equal we always opt for the cheapest, and where the

8 *Catalogue de l'Exposition des Produits de l'Industrie Française de 1819*, no. 29, p. 4. The word *lamé* (meaningless in the context) was used in the original and has been replaced by *lancé*.
9 Pierre Amédée Jaubert, professor of Turkish at the Bibliothèque Royale.
10 Jean Rey, pp. 113–19.

price is the same we always opt for the best quality.... Of all the manufacturers to whom [His Majesty] gave the most flattering reception, M. Ternaux was the one he particularly singled out, twice addressing and complimenting him, concerning not only the beauty and variety of his goods but also the reduction in his prices.... I would wish to see the monarch's honourable reception of M. Ternaux result in the latter being once more appointed to the jury whose job is to examine the products on display at the Louvre. It would no doubt be a burdensome task for a man already overwhelmed with weighty responsibilities; but it would provide a service to French industry. The jury members are telling their friends that the drapery section is incomplete and inadequate to the task, and a great many manufacturers are speaking out even more loudly to this effect. The additional appointment of M. Ternaux would satisfy them all; it would be a new guarantee that the prizes to be awarded for one of the most important branches of our applied arts would indeed be awarded from an informed standpoint and hence with complete equity.

These articles provoked outrage. Twenty-one leading Paris cashmere manufacturers and shawl makers signed the following letter addressed to the editor of *Le Constitutionnel*, which the paper published on 21 September 1823:

Paris, 19 September 1823

Sir,

Yesterday's *Constitutionnel*, in an article devoted to the products on show from M. [Monsieur] Ternaux's manufactories, having declared the section of the jury reporting on drapery to be incomplete and inadequate to the task, adds: 'a great many manufacturers are speaking out even more loudly to this effect. The additional appointment of M. Ternaux would satisfy them all; it would be a new guarantee that the prizes to be awarded for one of the most important branches of our applied arts would indeed be awarded from an informed standpoint and hence with complete equity.'

The manufacturers of shawls, cashmere cloth and merino wool, as it is known, admitted to the exhibition declare that they have no knowledge of making any such claim. Far from entertaining such a thought, which they would consider as insulting to the juries and the authority that created them, on the contrary they congratulate themselves on the choice of judges made by the government. Indeed, these judges, guided by a sense of delicacy common to decent people, have by way of assistance called upon the services of erstwhile manufacturers who combine total integrity with an undeniable knowledge of weaving.

We the undersigned are therefore confident of being judged from an informed standpoint and hence with complete equity. Moreover, rather than wishing for the additional appointment of M. Ternaux, a man already overwhelmed with weighty responsibilities, we would greatly prefer, if it proved necessary, to appoint one of our colleagues, now retired and master of his time, a genuine manufacturer who combines integrity equal to M. Ternaux's with much broader manufacturing knowledge, since it is to him, and not to M. Ternaux, that France is actually beholden for almost all the branches of the industry in which we the undersigned find ourselves involved.

Counting on your impartiality, we would ask you to be so good as to publish our objections to your article in your next issue.

We beg you to accept, etc...

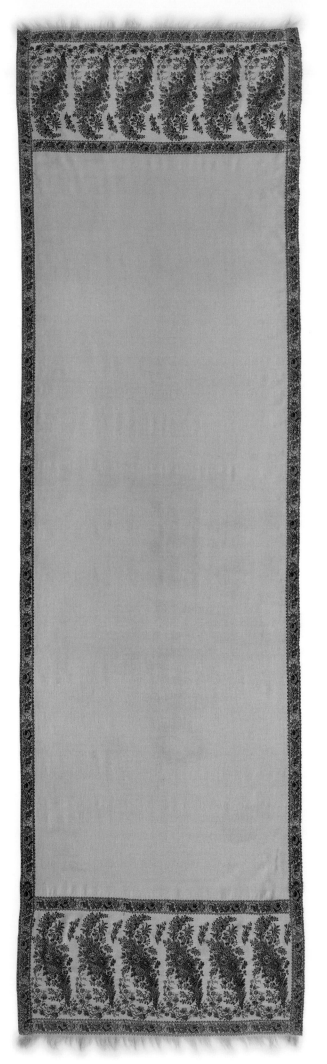

Half-shawl.
Paris, 1812.
(The caption on p. 122 describes this shawl.)
The fact that the pines face in opposite directions in the two
borders tells us that this twill-tapestry weave shawl was
not woven in Kashmir but on a European drawloom.

11 The author has corrected the spelling of some of
 these names. Polino, Hindenlang and Forster-
 Stair manufactured cashmere yarn; all the other
 signatories were shawl manufacturers. All had
 been singled out for distinction by the 1823 jury.
12 Honoré de Balzac, *L'Illustre Gaudissart*, 1947, p. 22.
13 From Émile Littré, *Dictionnaire de la langue française*,
 Librairie Hachette, Paris, 1873, vol. IV,
 p. 2194.

Bosquillon, G. Bayle, Lagorce Aîné & Cie, Delon Fils, Polino Frères, E. Lainné & Cie, Saint-Étienne, P. Channebot, Bauson, Douinet, Hindenlang Fils Aîné, d'Autremont & Cie, Rey, Fournel, Forster-Stair, Galon Frères, Desolme & Quériau, Maupetit & Cie for Dufour Frères, L. Piedanna, Legrand-Lemor.[11]

Ternaux's modern approach to manufacturing and distribution meant that he could afford to keep his profit margins down and sell his products more cheaply than his competitors, who were still operating on a much smaller scale. He represented a genuine threat and the profession, with one voice, protested against his potential nomination to the central jury. Ternaux was disappointed not to be appointed a jury member and felt humiliated that he had only received a silver medal for his shawls – thereby ranking lower than the four big Paris firms, which each received a gold medal. He was also clearly wounded by his colleagues' letter to the editor of *Le Constitutionnel*. On 23 September 1823 he wrote to the president of the central jury from Rheims, giving full vent to his feelings.

Ternaux submitted a double shawl invented by Tiret to the 1827 exhibition but received no mention. Bellanger & Rey (then no longer in business) were reporting for the Shawls section – a nomination that demonstrated the government's willingness to accede to the wishes of the signatories of the letter of 19 September 1823. By the time of the next exhibition, in 1834, Ternaux had died and Bournhonet had taken over the business.

Although there are numerous references to Ternaux shawls in the literature, actual descriptions of them are strangely lacking. Jury reports for the French industrial exhibitions simply praise the materials, the quality of the weave and the price. So what should we conclude? That the designs were attractive, simple or easy to copy? More information than this would be required to identify a Ternaux. What we do know is that his shawls were extremely popular. In 1805 the manufactories in Rheims produced 3,868 shawls; in 1807 the figure was in excess of 8,000. Despite the economic crises, and the wars with Russia and Spain, which lost Ternaux considerable sums of money, he continued manufacturing. Even the 1830 Revolution, which dealt him a final blow, does not appear to have affected the sale of his shawls. According to one of Balzac's characters: 'I offloaded sixty-two Ternaux cashmere shawls in Orleans. What they will do with them I do not know, upon my honour, unless they put them on the backs of their sheep....'[12]

Ternaux had failed in his attempt to acclimatize a herd of Asiatic goats, and he had also failed in his attempt to wipe out competition by selling good-quality articles at low prices. But ultimately these failures had their benefits: the signatories of the letter of 1823 ushered in a new generation of shawl makers – the likes of Deneirouse, Gaussen, Hébert the elder and others – who would fully exploit the technical potential of the Jacquard mechanism to produce some genuine masterpieces. And people were prepared to pay the prices necessary for these manufacturers to channel their expertise into producing shawls that were greatly superior to Ternaux's mass-produced articles.

Ternaux was involved in many businesses, but he appears to have had a particular affection for shawl making. He was one of the first-ever shawl manufacturers and his name has even found its way into the dictionary, where a 'Cachemire Ternaux' designates a 'cashmere shawl manufactured by the firm founded by Ternaux, in imitation of Indian cashmeres';[13] such a shawl is also referred to simply as 'un Ternaux' ('a Ternaux').

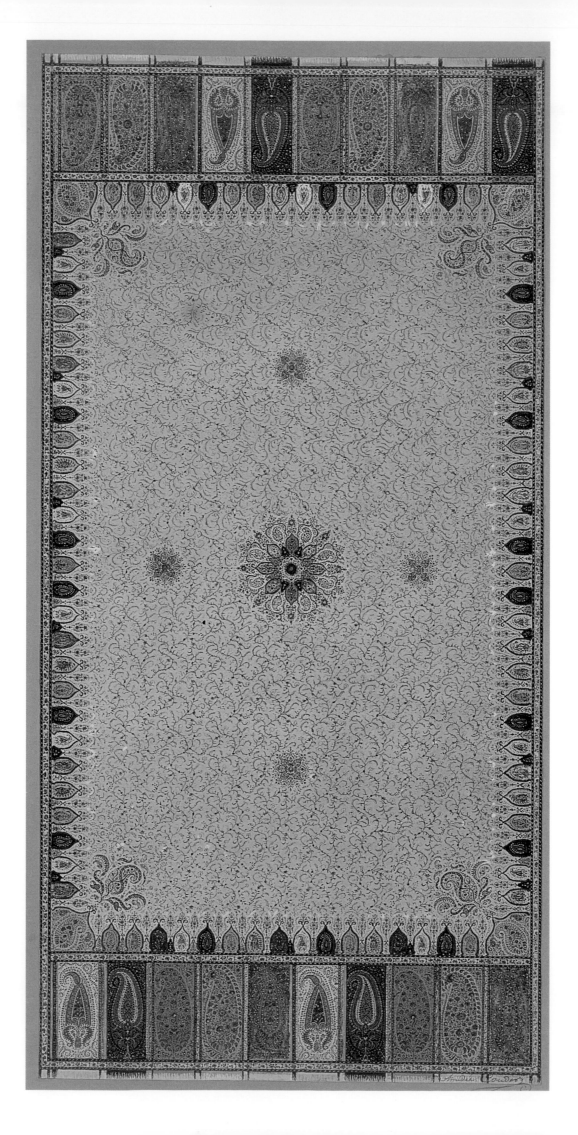

Amédée Couder

Amédée Couder was born in Paris in 1797. His mother was from Marseilles and his father, a designer by trade, was from Santo Domingo. Amédée's elder brother was the painter Louis Charles Auguste Couder. In 1820 Couder founded a combined design studio and school that encompassed all aspects of industrial design for a number of related industries: gold- and silversmithing, cabinetwork, bronze casting and wallpaper, carpet, shawl and silk manufacture. Many of the most outstanding industrial designers of the nineteenth century learnt their craft in his studio. Couder could reasonably be described as a pioneer of industrial design at a time when the word 'industrial' was becoming synonymous with 'mass produced'. The majority of manufacturers had always employed their own designers rather than calling upon the services of freelancers. It was not until 1834 that exhibition juries devoted a section to 'non-exhibitors', which allowed industrial designers such as Couder to see their efforts rewarded. His works are cited repeatedly in the jury reports for exhibitions that were held in Paris and London up to 1862.

Couder was a leading shawl designer whose innovate creations were not only greeted enthusiastically by the public but were also later adopted by the entire profession. Despite this, he did not make a substantial amount of money. He was essentially an idealist who believed in art as a means to 'social perfection', and passed on to his sons the artistic heritage that he had received from his father. Couder died in Paris in 1864.

We will restrict ourselves here to looking at his textile designs. In his *Notices Explicatives*,[1] Couder comments on his 1823 shawl design (opposite) and tells us that the half-finished shawl, woven on a single Jacquard machine with a thousand hooks, was shown at the French exhibition of 1823 by the manufacturer Pierre Fournel, and that the Duchess of Berry was 'enchanted by it'. The Duchess was unfortunately unable to muster the 30,000 francs Fournel wanted if he was to sell her the shawl as a one-off, and it is not known what happened to it subsequently. Couder's shawl design shows a large central field decorated with tiny sprigs and four small medallions surrounding a larger central medallion. A small pine decorated the four corners of the gallery, which was composed of tiny pines set in harlequin compartments. The two ends of the shawl were bordered with a row of ten

OPPOSITE
Design for a harlequin shawl, signed by Amédée Couder. Paris, 1823.
Gouache on paper, 65.6 × 32 cm (25⅞ × 12⅝ in.).
Paris, Musée des Arts et Métiers, CNAM, no. 10.332.
This is the oldest surviving signed and dated shawl design in any Paris collection.

[1] A manuscript that accompanied designs that were exhibited at the Conservatoire Impérial des Arts et Métiers after 1851.

pines in varying shapes and sizes, also enclosed in harlequin compartments, the composition being a free interpretation of the Kashmiri model.

In a pamphlet written in 1834 and entitled *Analyse du Dessin des Cachemires et Moyens de Rendre les Schalls Français Supérieurs à ceux des Indes* (Analysis of Cashmere Shawl Designs and Techniques for Making French Shawls Superior to Indian Ones), Couder explained how the correct *mise en carte* could facilitate the transposition of designs 'whose lines corresponded perfectly to the rounded contours of the oriental forms'. He also indicated that the square *Isfahan* shawl with a green ground (p. 135), together with an orange stole (housed in the Musée de l'Impression sur Étoffes in Mulhouse), both manufactured by Gaussen Aîné & Cie from his own designs, had been submitted for the 1834 French industrial exhibition. In his explanatory note, Couder tells us that the *Isfahan* shawl was named 'after the capital of the country from which he had borrowed the style', while the decorative scheme employed architectural elements in lieu of the traditional pines. The *Isfahan* is one of the first *châles au quart* or quartered shawls, in which the design scheme is repeated in each of the four quarters. The size of the design demonstrates the technical advances that had been made in weaving, thanks to improvements to the Jacquard mechanism (p. 37). Another new feature was that the names of the designer and the manufacturer, the place where the shawl was manufactured and the date it was exhibited were all woven into the design in Arabic script (legible in two places, reversed in two others).

The 1834 jury awarded Couder a silver medal, noting that 'he ranks as one of the foremost designers in his field. He runs a big establishment where the designs themselves are factory produced, so to speak, in such large numbers that the price can be kept low. He generally employs few short of a hundred workers.' Couder's 'establishment' was located at 24 Rue Cadet, in Paris.

Pushing the technical boundaries of the Jacquard mechanism to its absolute limit, for the 1839 exhibition Couder designed and Gaussen the elder manufactured a long shawl with a white ground that required the use of more than 101,000 punched cards. They called it the *Nou-Rouz* (pp. 133 left, 151–55). As Couder explained in his *Notices Explicatives*, 'The *Nou-Rouz* is Persia's most important festival, being at one and the same time the Festival of the Flowers and the first day of their New Year: in the East they are undoubtedly more logical than we Westerners, for they start their new year when nature reawakens.' Later on he commented on the new style of shawl known as the 'renaissance'.[2] This genre signalled the disappearance of any surviving traces of the traditional Kashmir motifs, especially the heavier, irregular shapes: contemporary taste favoured very graceful, clear-cut outlines. The jury 'returned' the gold medal to Gaussen Aîné & Cie,[3] who had been similarly successful in the 1827 and 1834 exhibitions.

Maxime Gaussen was awarded a gold medal in the 1844 exhibition shortly after taking over from his father. Reporting on behalf of the central jury, Deneirouse and Legentil noted that 'Particularly admired were a long white shawl with an original design and a square shawl decorated with two large pines set back to back. These two shawls have only one pattern repeat and are designed to be folded in half so that only one pattern shows.' Jules Burat also observed that Gaussen, 'working from designs by [Monsieur] A. Couder', had created 'a large shawl, of Indian inspiration, with some charming details:

[2] The term simply refers to the revival of the cashmere style and has nothing to do with the Renaissance itself (although the movement was in fact a major influence on the decorative arts of the period).
[3] The word used in the jury reports was *'rappeler'*: it signified that a manufacturer was re-awarded a medal that he had already obtained in a previous exhibition.

instead of those heavy pines with a rounded base, the pattern incorporated a series of lance-shaped leaves each delicately attached to a slender petiole'.[4] These descriptions appear to match the two à pivot shawls pictured on pages 143 and 144–45, which – if the identification is correct – can therefore be attributed to Couder and Gaussen and dated 1844. There are three aspects of the design that are strikingly new and different: first, the fact that a single design occupies the entire width of the fabric and is only repeated once along its length; second, that the harlequin compartments of the shawl ends are now decorated rather than plain; and third, that a handful of decorative motifs overlap the borders of each shawl. These two shawls would appear to be among the earliest à pivot shawls known to us – along with the model conserved in the Metropolitan Museum of Art in New York (no. 22.204), which is identical to the shawl pictured on page 144, except that the background is half white and half yellow. The Metropolitan Museum also has in its collections a square four-seasons shawl with a pivoting design (no. 26.179); its background is composed of four different coloured fields upon which ten segments radiate anti-clockwise. This last shawl may be slightly earlier than the others, judging by the fact that its harlequin shawl ends have plain rather than decorated compartments. It too may have been woven from a design by Couder.

Again according to Burat, Couder designed several shawls that were made by Gaussen Jeune & Maubernard for the same exhibition of 1844. The Musée du Vieux Nîmes owns a square shawl with a white ground (invoice no. 921.154.3) that is typical of Couder's designs of the period and may have been manufactured by Gaussen & Maubernard. The circular composition inscribed within a square is reminiscent of Couder's plan for a Palace of the Arts and Industry, published in 1840.

Two other shawls may be attributed to Couder. One is in the Etro collection (pp. 140–41) and the other at the Kent State University Museum. They are both long and identically patterned, except for the arrangement of the central sections, which are a mirror image of one another. The pattern employs seven basic colours (aside from the central field), with one additional colour (orange) produced by 'marrying' two others (red and yellow).[5] Deneirouse was one of the first exponents of this technique, which enabled the weaver to supplement his colour palette without using additional shuttles. The plain harlequin shawl ends date these two shawls to between 1844 and 1848, so they must have been among the first shawls to have incorporated the new technique (before the term mariage de couleurs was actually coined).

In 1844 the Royal Manufactory of Aubusson, which was owned by Sallandrouze de Larmornaix, showed an elephant tapestry,[6] which recalled the style and decorative motifs of the Nou-Rouz shawl of 1839. The same manufactory also exhibited a Virgin Forest carpet in Savonnerie needlepoint made to a design by Amédée Couder.

The jury report for the 1849 exhibition states that 'Maison Gaussen & Pouzadoux, which manufactures designs by Amédée Couder, is unable to compete because the head of the firm [Maxime Gaussen] is a member of the central jury' – so we have no information for that year.

At the Great Exhibition held in London in 1851 (the first universal exposition) the jury awarded Couder the prize medal for his shawl designs. A design for a long shawl (signed by Couder) with a single central motif flanked by pivoting designs

4 Jules Burat, vol. 1, 3rd part, p. 11.
5 My thanks to Arlene Cooper for having pointed out this 'marriage of colours' in the Kent State University Museum shawl, which I have only seen in a photograph. In Milan I was able to verify that the shawl in the Etro collection presented the same feature.
6 Given to the Musée du Louvre by the Simone & Cino del Duca Foundation in 1995.

(opposite, right) was executed in cashmere for this same exhibition and is now housed in the Musée des Arts et Métiers in Paris. On 22 November 1851 Amédée Couder was made a knight of the Legion of Honour.

At the World's Fair in Paris in 1855, the jury awarded Couder a first-class medal and observed that, 'He is the boldest of all our artists. His *atelier* and school have spawned all manner of creations, from gold and silver articles, bronzes, cabinetwork, carpets and wallpapers to shawls, silks and painted dresses, etc.' However, the article discussing the Gallery of Industrial Designs in *L'Illustration* struck a very different note, referring to 'Amédée Couder...whose current designs..., a table cloth..., two court coats and a shawl decorated with human figures – not a good style for a shawl, this one – leave much, very much, to be desired'.[7] In 1857 Couder applied for a patent for a long shawl known as a *carré double*,[8] which could be either in a cashmere style or a tartan style and where the arrangement of the motifs allowed for sixteen different designs to be shown, depending on the manner in which the shawl was folded. A large shawl also designed by Couder was manufactured by Aubé Nourtier – who took over from Gaussen the younger in 1859 – for the 1862 London Exhibition (the successor to the Great Exhibition of 1851), but it was deemed to be 'a little too eccentric' in the report drawn up by the delegation of designers and shawl weavers.

As well as working as an industrial designer, Couder was busy writing, as is evident from the publication of his pamphlet *Analyse du dessin des cachemires* in 1834. In 1840 he published a short book entitled *L'Architecture et l'industrie comme moyen de perfection sociale* (Architecture and Industry as a Means to Social Perfection), in which he expressed his goal of harnessing the twin forces of art and industry in the interests of social progress – an idea he had entertained since 1820 when he founded his design studio, where work was divided into distinct phases so as to increase productivity. There are fifty-two pages of text in Couder's book, followed by nine plans and detailed views of an architectural project – the Palace of Arts and Industry, which Couder proposed to build in Montmartre, on the site of the Sacré Coeur. In 1845 he submitted two other plans: one for a Royal Academy of Music and the other for an illuminated fountain between the Louvre and the Tuileries. None of Couder's architectural plans was ever adopted.

For nearly forty years, from 1823 to 1862, Couder was one of the foremost designers associated with the decorative arts.[9] A great many very beautiful 'rich' shawls, woven using more than nine weft colours, were manufactured to his designs until 1850 at least. But in contrast with the many shawl designs created by Berrus between 1840 and 1880, and collected in bound albums by his widow, there are only seven extant designs for cashmere shawls signed by Couder. Five of these are in the Musée des Arts et Métiers; one gouache design is in the Musée de la Mode et du Textile, and the design that accompanied Couder's application for a patent is in the INPI. Of these seven designs, only two have been matched up with existing shawls. In the absence of signed works, we have been obliged to rely on descriptions published in the nineteenth century in attributing certain exceptional shawls to Couder.

OPPOSITE LEFT
Design for the Nou-Rouz *shawl, signed by Amédée Couder.*
Paris Exhibition, 1839.
Gouache on paper, 77.5 × 32.5 cm (30½ × 12¼ in.).
Paris, Musée des Arts et Métiers, CNAM, no. 10.333.
As seen in the engraving of this design, the artist gave free rein to his imagination. Note for example the differences between the two central motifs.

OPPOSITE RIGHT
Design for a long shawl, signed by Amédée Couder.
Great Exhibition, London, 1851.
Gouache on card, 158 × 88 cm (62¼ × 34¾ in.).
Paris, Musée des Arts et Métiers, CNAM, no. 10.331.
In this composition the majority of the motifs only appear twice (unlike the 'quartered shawl', where the pattern is repeated in each quarter). The actual shawl would have been twice the size of the design.

[7] *L'Illustration*, 'Exposition universelle de 1855, Galerie des dessins industriels', 17 November 1855, p. 330.
[8] INPI, patent no. 34758, application for fifteen years registered 17 December 1857 by Amédée Couder.
[9] At a public auction (Senlis, 28 March 1998, De Muizon, Le Coënt office, expert: X. Petitcol), the Mobilier National exercised its right to purchase a collection of twenty-six watercolours by Amédée Couder (no. 450E in the catalogue). These rug designs incorporated cashmere motifs that are not dissimilar to Couder's shawl designs and show that he was already interested in polychrome grounds of the 'four seasons' type during the Bourbon Restoration (at least ten years before the appearance of the first four-seasons shawl).

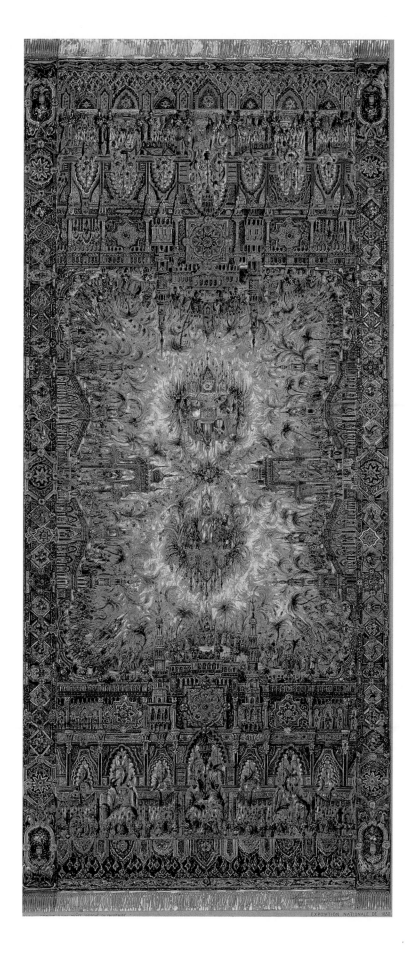

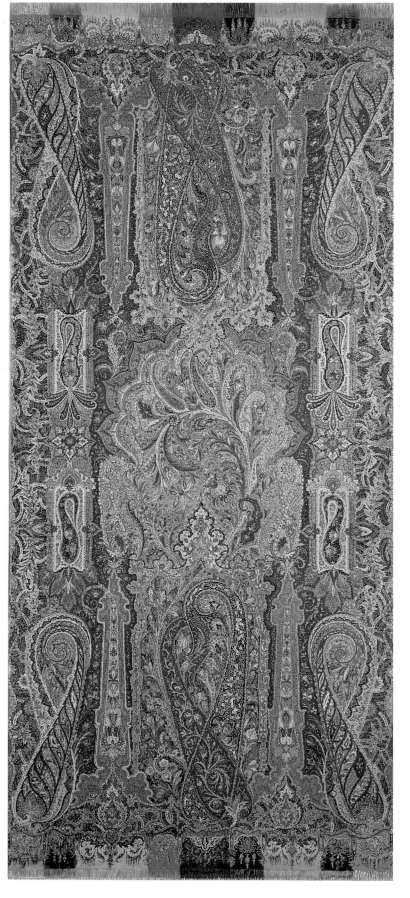

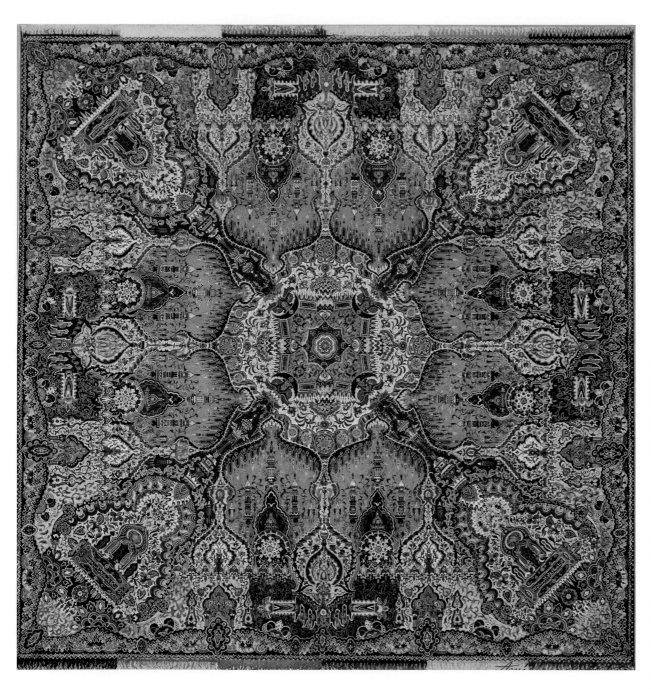

*Design for the Isfahan shawl,
signed by Amédée Couder.
Paris Exhibition, 1834.
Gouache on paper,
33.5 × 32.5 cm (13⅛ × 12¾ in.).
Paris, Musée des Arts et Métiers,
CNAM, no. 10.334.
This is the first known 'quartered
shawl'. The Arabic inscriptions,
enclosed in cartouches, give the
date and place where the shawl
was exhibited – Paris, 1834 –
as well as the names of the designer
(Couder) and the manufacturer
(Gaussen).*

OPPOSITE
*Square shawl, known
as the Isfahan.
Paris, 1834.
Designed by Amédée Couder and
manufactured by Gaussen Aîné
& Cie; signatures, date and place
woven into the design.
Woven au lancé using ten
weft colours, trimmed on back,
cashmere, 183 × 180 cm
(72 × 70⅞ in.).
Milan, Etro collection, no. 274.
The decorative scheme with
its cupolas, minarets and
pennants is very different
from Kashmiri designs.*

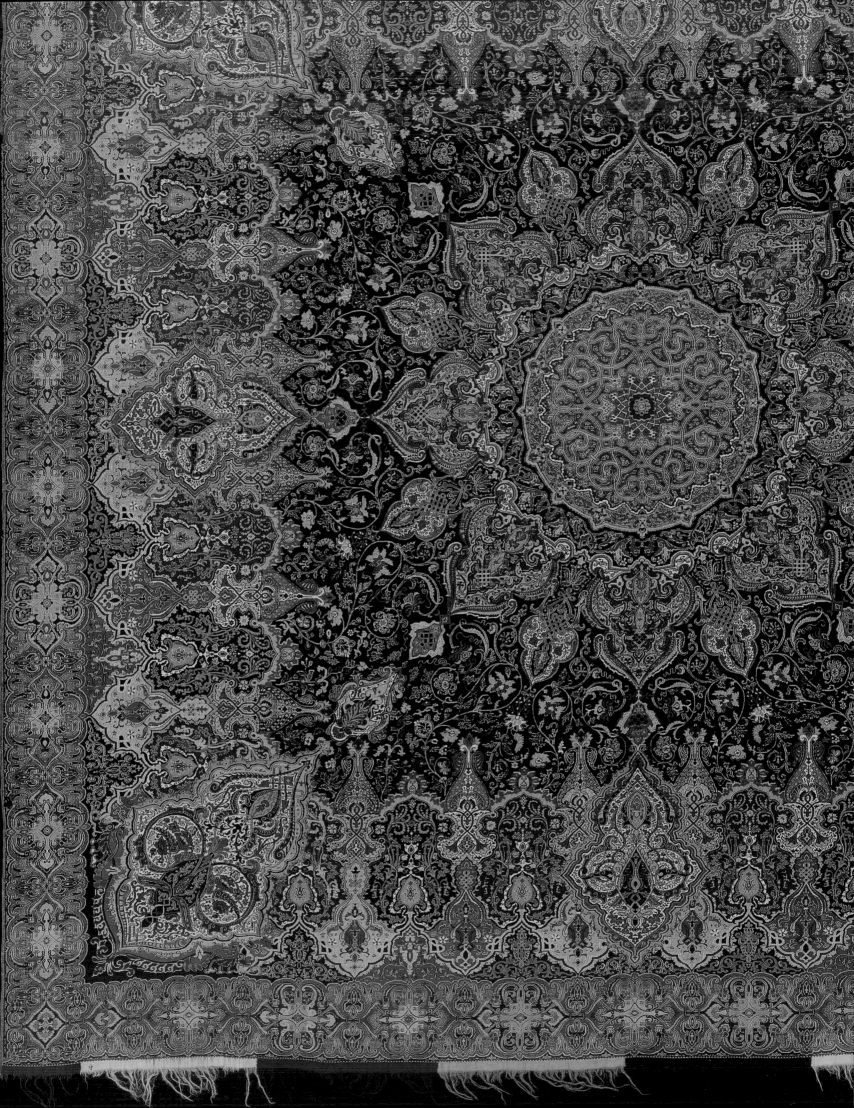

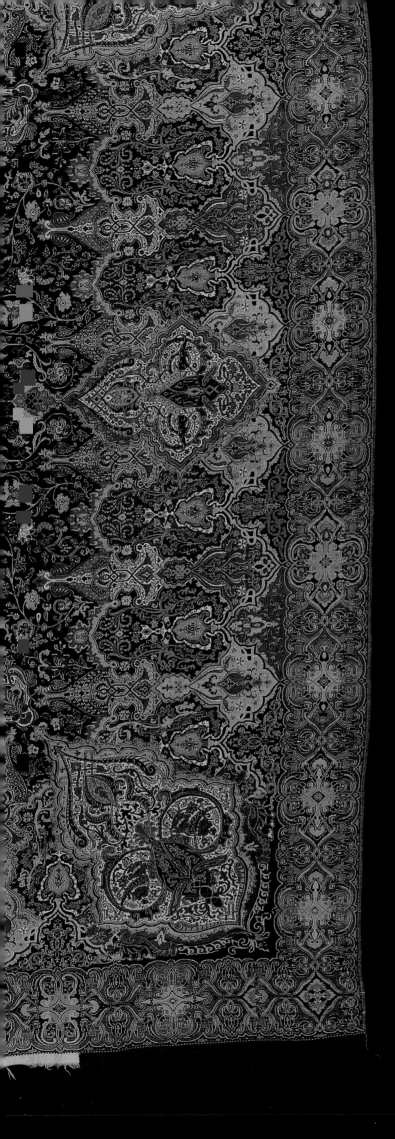

Detail of the invoice reproduced on page 40.
Paris, Debuisson collection.

LEFT *Section of a square shawl.*
Paris, 1835–40.
Woven au lancé using ten weft colours, trimmed on back, cashmere, 194 × 190 cm (76⅜ × 74¾ in.).
Milan, Etro collection, no. 216.
The shawl has a similar pattern to the Isfahan shawl (see p. 135) and may also have been produced by Gaussen the elder to a design by Amédée Couder. The green ground was later painted black.

OVERLEAF *Close-ups of a motif from front and back of the shawl shown left (pp. 136–37).*

PAGES 140–41 *Long 'four seasons' shawl.*
Paris, 1845–48.
Woven au lancé using nine weft colours, trimmed on back, cashmere, 356 × 164 cm (140⅛ × 64⅝ in.).
Milan, Etro collection, no. 252.
This composition is in the végétal or floral style and many of the motifs recall Amédée Couder's designs.

PAGE 142 *Detail of the shawl shown on page 143.*

PAGE 143 *Square 'four seasons' shawl with a large pivoting design.*
Paris, 1844.
Woven au lancé using ten weft colours, trimmed on back, cashmere, 186 × 185 cm (73¼ × 72⅞ in.).
Milan, Etro collection, no. 153.
Probably manufactured by Maxime Gaussen to a design by Couder.

PAGE 144 *Lower section of a long shawl with a large à pivot design.*
Paris, 1844.
Woven au lancé using nine weft colours, trimmed on back, cashmere, 360 × 158 cm (141¾ × 62¼ in.).
Paris, author's collection, no. 40.
Probably made by Maxime Gaussen to a design by Amédée Couder. An astounding technical achievement, given the width of the decorative scheme. This shawl's design is a good example of an artistic compromise between the traditional cashmere style – incorporating pines and making a feature of their curled apices – and the végétal or floral style. The pines are graduated in size and accentuate the diagonal, off-centre effect of an à pivot design.

PAGE 145 *Detail of the shawl shown on page 144.*

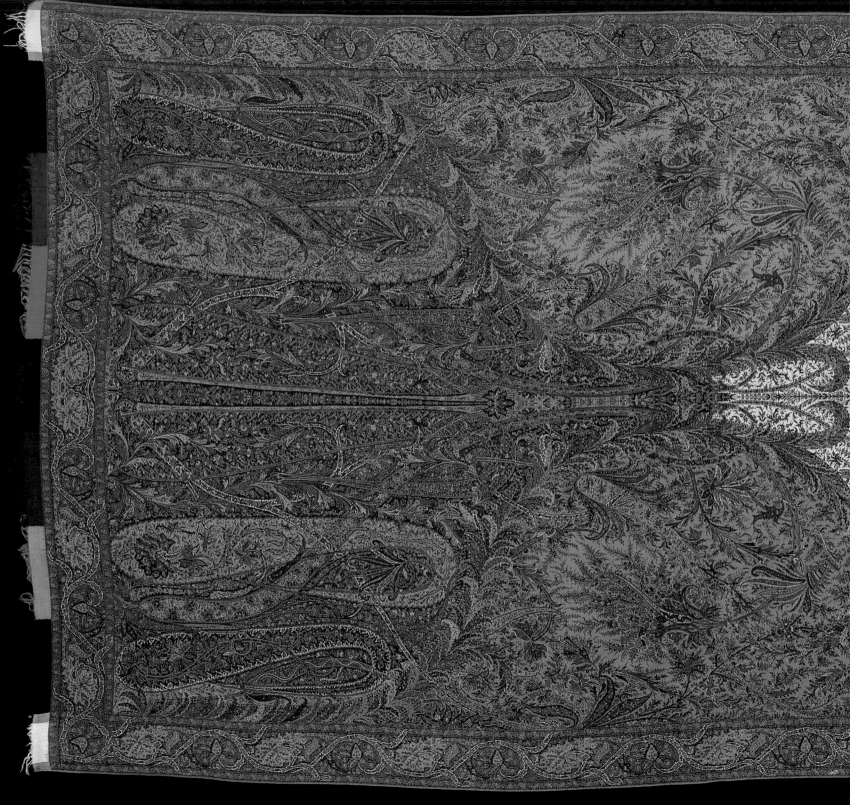

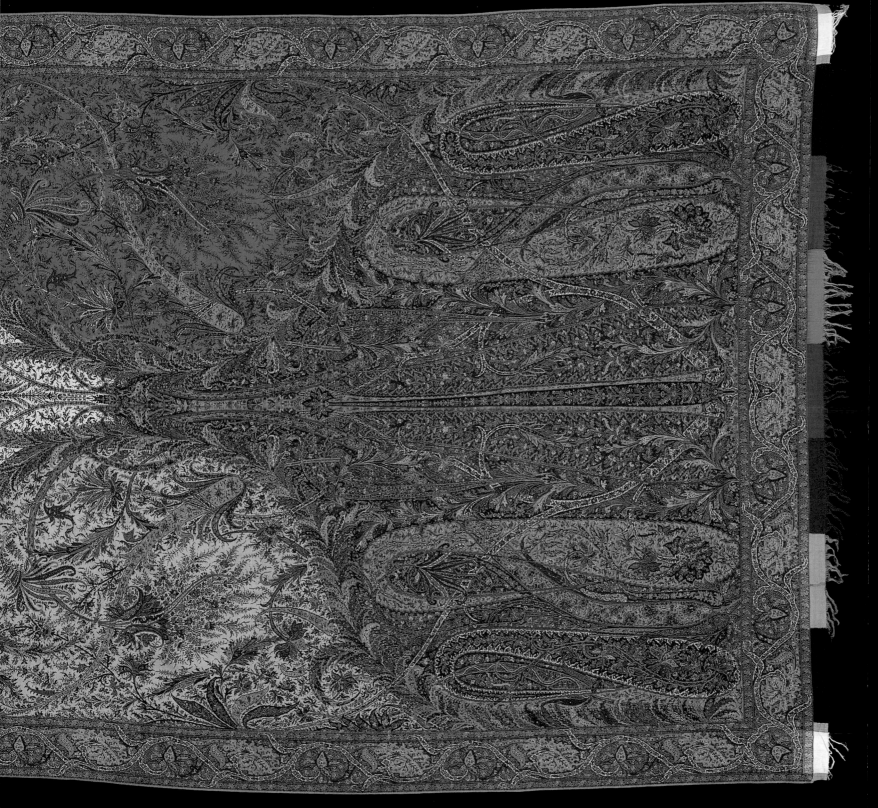

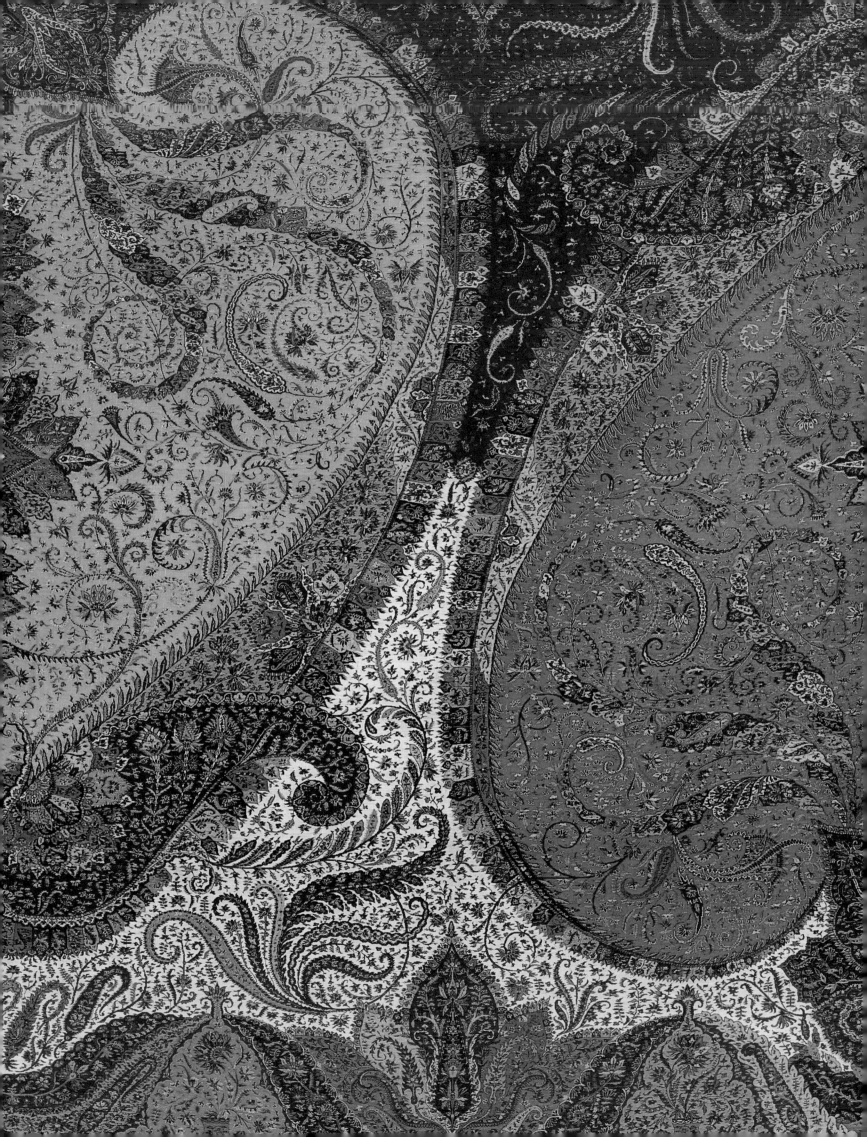

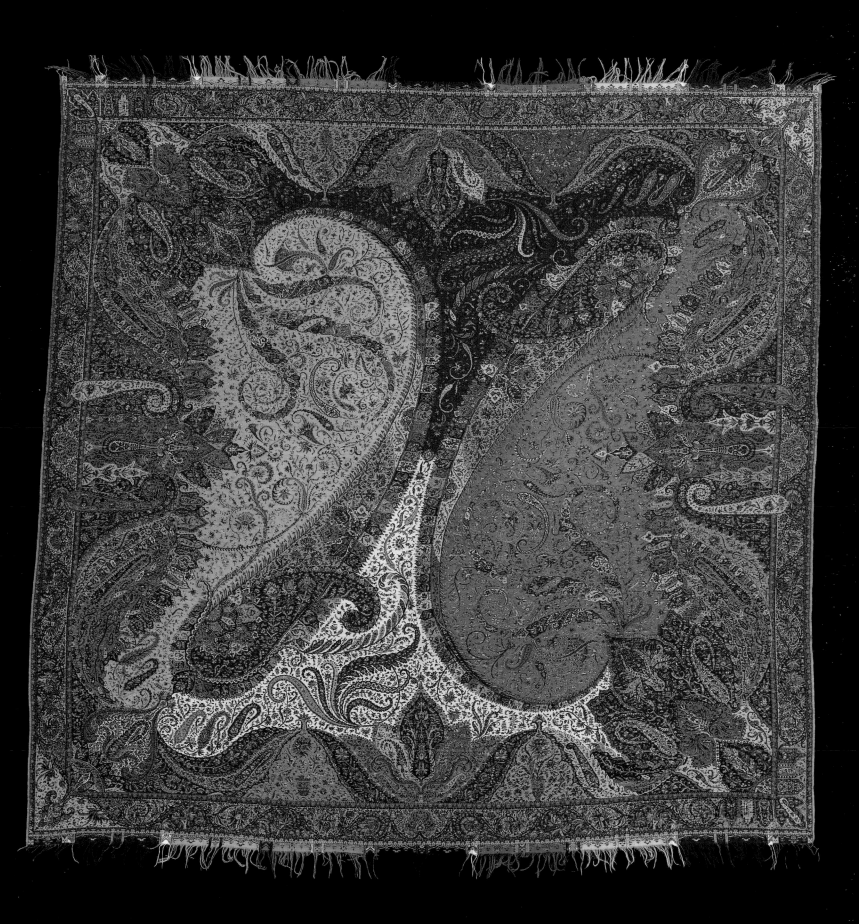

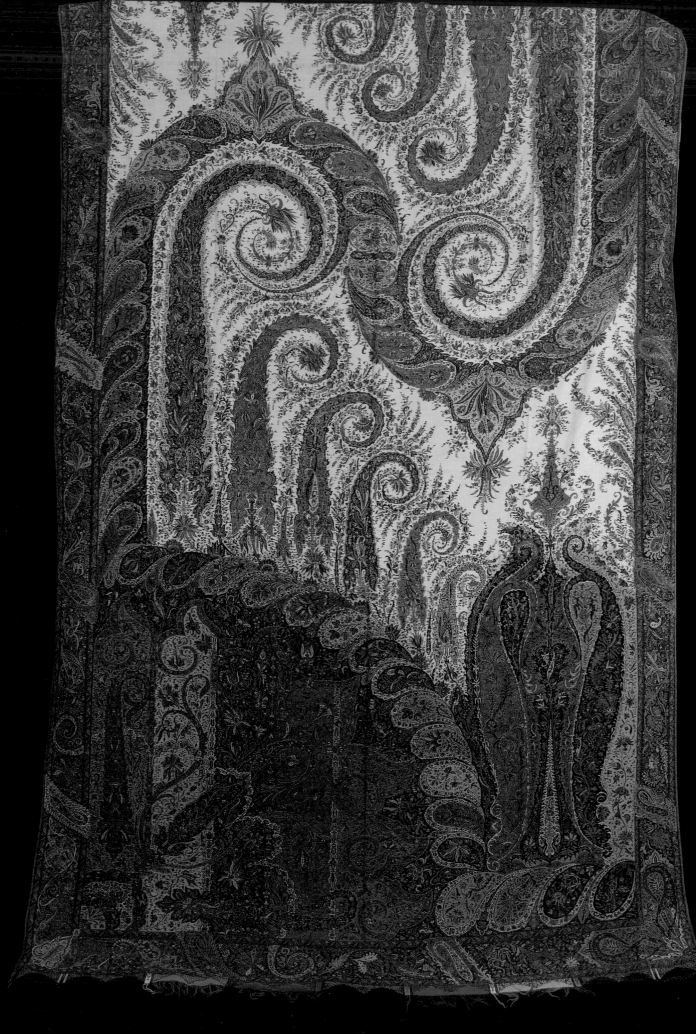

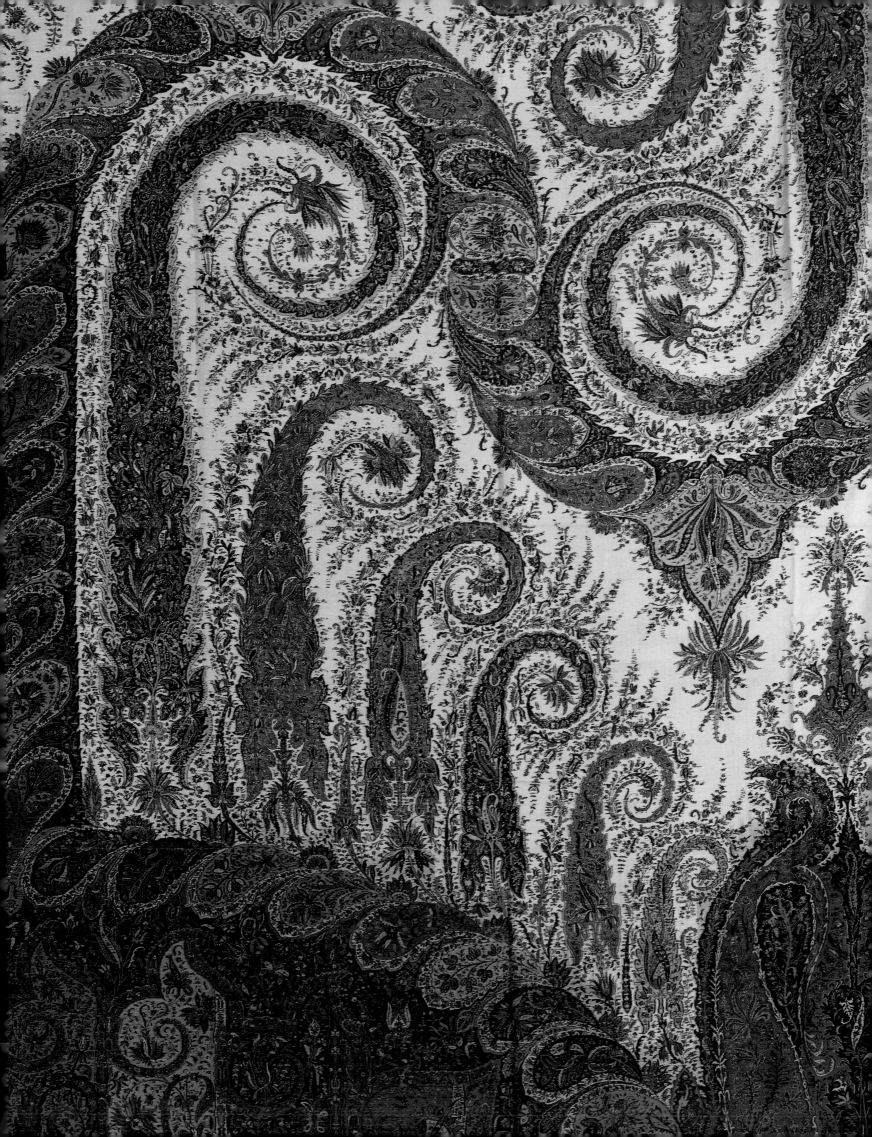

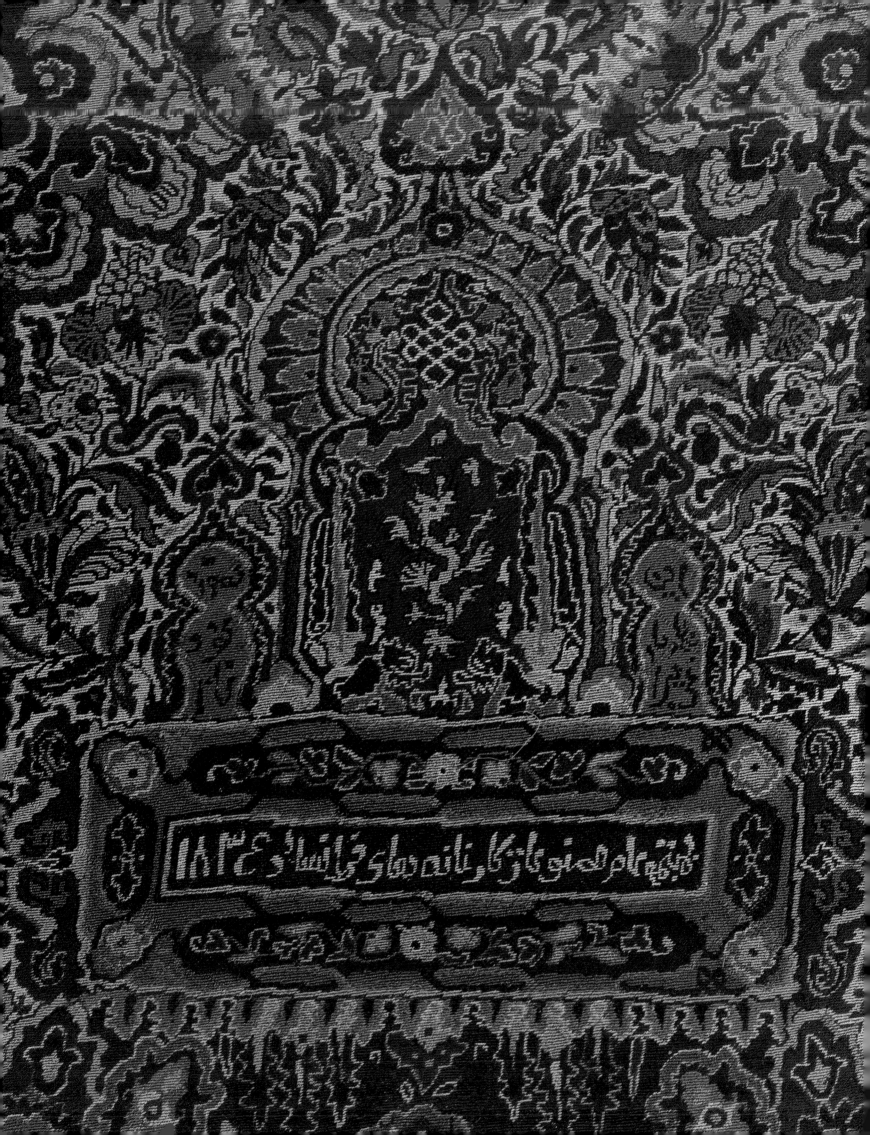

Gaussen the Elder & Gaussen the Younger

Jean Gaussen was born in Nîmes in 1763. He became a silk and stocking manufacturer and married Marie Marguerot, with whom he had five children. Their two sons (both called François) went to live in Paris. The elder son married a Scottish girl, Eugénie Fergusson, in Passy in 1810 and they had three children (see the family tree on pp. 162–63). On 26 January 1821 François Lagorce, who was originally from Nîmes, formed a company in Paris for 'the sale of shawls, in cashmere and wool, for a period of three years, five months and thirteen days, with Jean Deneirouse, Louis Galon, François Gaussen the elder and Julien Juillerat'. They traded under the name Lagorce Aîné & Cie, and François Gaussen the younger was employed as a foreman. The company – which had a manufactory in Corbeil, northeastern France – was awarded a gold medal in the French industrial exhibition of 1823. But the business went into liquidation in 1824 and a new company was formed, for a period of three years. Deneirouse, Galon, Gaussen and Juillerat were partners in the new firm and Lagorce Aîné was a limited partner; they traded under the name Deneirouse, Galon, Gaussen Aîné, successors to Lagorce Aîné & Cie.

So the name of Gaussen was linked publicly with the manufacture of cashmere shawls from 1824. Louis Galon died and Julien Juillerat retired in that same year, and the company was therefore renamed Deneirouse & Gaussen Aîné, successors to Lagorce Aîné & Cie. François Lagorce had supplied 200,000 francs' worth of capital and was just a limited partner in the business; it was Deneirouse and Gaussen who ran the company and they took responsibility for liquidating Lagorce Aîné & Cie.

In 1827 Jean Deneirouse and François Gaussen the elder formed a company for a period of six years under the name Deneirouse & Gaussen Aîné. They were awarded a gold medal at the 1827 industrial exhibition. However, the company was liquidated on 28 March 1829 by mutual agreement; Deneirouse took charge of the liquidation and retained the manufactory in Corbeil (pp. 295–311).

OPPOSITE AND BELOW
Details of the Isfahan *shawl (see p. 135).*
The inscriptions inside the cartouches are in Arabic script. The inscription below reads: 'Isfahan', the one opposite reads: 'Entered for the Exhibition of French Manufactured Products, 1834'.

Gaussen presented examples of his work in the 1834 exhibition under the name Gaussen (François) and the gold medal was 'returned' to him.[1] Reporting on the exhibition in the *Musée Industriel*, Moléon, Cochaud and Paulin-Désormeaux noted that he employed three hundred workers and they made special mention of his *Odalisque* and *Isfahan* shawls: 'There were twenty long shawls, either harlequin or harlequined, with large galleries and garlands, some decorated with a background of pagodas; and twenty 6/4 square shawls [180 cm (70⅞ in.)] with galleries and counter galleries decorated with medallions and a plain or all-over decorated ground. In this last category there was one new type of shawl, in the Persian style. The design was by M. [Monsieur] Couder: it was called *Isfahan* after the capital and the peoples of Persia.'[2]

In 1835 Gaussen the elder formed Gaussen Aîné & Cie with his brother, his son Maxime and the designer Pierre Maubernard. The capital put up for the company was 400,000 francs and its period of operation was fixed for four years. The long shawl known as the *Nou-Rouz*, made by Gaussen Aîné & Cie to a design by Amédée Couder, caused a sensation at the 1839 exhibition (see the description of the shawls designed by Couder and made by Gaussen in the previous chapter) and won them another gold medal. The company was liquidated at the end of that year and François Gaussen the younger and Pierre Maubernard formed another company for a period of four years under the name Gaussen Jeune & Maubernard. According to the jury report on the 1844 exhibition, these two manufacturers became the joint and sole owners of the entire company plant following the death of Gaussen the elder in 1843. On 11 April 1844 they applied for a patent 'for methods of manufacturing woven cloth for shawls' using eight instead of four shafts to control the warp threads. They submitted several shawls designed by Couder to the 1844 exhibition (although Maubernard was in fact a skilful designer in his own right) and were awarded the gold medal. Gaussen Jeune & Maubernard's period of operation was extended by a further four years (making eight in total) and it was finally liquidated in September 1847. Gaussen the younger was named as sole liquidator and immediately went on to form Gaussen Jeune, Fargeton & Cie with Louis Joseph Fargeton and François Devise, his nephew (see family tree, pp. 162–63). The company, which was formed for a period of ten years for the purpose of selling shawls and novelty goods wholesale, won the gold medal again in the 1849 exhibition, and Gaussen the younger was made a knight of the Legion of Honour.

Between 1850 and 1857 shawls woven by Gaussen Jeune, Fargeton & Cie appeared with the manufacturers' initials woven into the corners (around the cross of the Legion of Honour), in line with Laurent Biétry's recommendation to Paris shawl makers anxious to safeguard their designs against potential counterfeiting. Their shawls are therefore readily identifiable, but the identity of the designer during this period is less clear – that it was not Couder can be inferred from the conventionality of the designs, which lack his boldness of approach. At the World's Fair held in Paris in 1855 Gaussen Jeune, Fargeton & Cie were awarded a first-class medal. They stopped trading on 6 March 1857 and Gaussen the younger, who took charge of the liquidation, died on 30 March 1859.

The premises occupied by the firm at 2 Rue Vide-Gousset were taken over by Victor Olivier Aubé and François Hyacinthe Nourtier, shawl manufacturers and merchants, whose company, Aubé, Nourtier & Cie, was formed for nine years from 1 January

[1] See page 130, note 3.
[2] Musée Industriel, pp. 214–19. It is clear from this that *Isfahan* was what was known as a shawl *à fond plein*; in other words, it had an all-over decorated ground.

1858. *L'Almanach du Commerce de Paris* describes them as successors to Gaussen the younger. When the company was wound up early, in 1864, Devise was appointed liquidator.

From a document drawn up in 1844 it is evident that Louis Pouzadoux and Adolphe Duché – the latter brother-in-law to Adèle Gaussen and married to a cousin of Adèle and Maxime – carried on the business of Gaussen Aîné & Cie after the death, in 1843, of Gaussen the elder; they traded separately from Gaussen the younger's new company, under the name Pouzadoux & Duché Jeune. They signed their shawls 'Poux & Dé Je' in Gothic letters. Gaussen Aîné & Cie thus continued in business after Gaussen Jeune & Maubernard had closed (in 1847). A long shawl in the Etro collection (see pp. 156–57), woven in nine weft colours, is signed 'Gen Ané & Cie' (Gaussen Aîné & Cie) in the corners in Gothic lettering. We know that Maxime Gaussen submitted at least two shawls, designed by Couder, to the 1844 exhibition, but without initialling them. This shawl may therefore be of later date, possibly between 1845 and 1847. The 1844 document also contains a promise of association with regard to Maxime Gaussen, which was dissolved in January 1848, 'Maxime Gaussen acting upon his hypothetical right to become an associate, a right which he failed to exercise'. Maxime Gaussen and Louis Pouzadoux were appointed liquidators and went on to form a new company, Gaussen & Pouzadoux, for a period of three years (1 January 1848 to 31 December 1850).

Maxime Gaussen reported for the Shawls section of the central jury at the 1849 exhibition, and was therefore unable to compete; at the Great Exhibition of 1851 held in London he was both a reporter and a jury member. He was made a knight of the Legion of Honour in the same year. Also in 1851 he formed a new company, Gaussen & Cie, with the merchants Théophile Valz and Victor Catherine for a period of five years (1 January 1851 to 31 December 1855).

Maxime Gaussen was reporting again for the 1855 World's Fair, held in Paris, and so was once more unable to compete. He claimed at the time that he was only manufacturing 'rich' shawls, in Paris, where he owned sixty looms, and there is strong evidence to suggest that these beautiful pieces were designed by Amédée Couder.

In 1834 Maxime's father, Gaussen the elder, had signed a stole and a shawl (incorporating his signature in the decoration) and from 1849 to 1857 Maxime's uncle, Gaussen the younger, wove his initials and those of his associate Fargeton in the corners of their shawls. Maxime Gaussen, on the other hand, never left his mark on a shawl as far as we know. He was one of France's most highly respected shawl makers and a member of virtually every exhibition jury. Did he perhaps think his shawls were in some way inimitable, so superior due to the originality of the design and the quality of the weave that it was impossible to confuse them? Whatever his reasoning, the fact remains that we struggle to identify them today.

There is no documentation relating to Gaussen & Cie for the period 1856 to 1858. After this, Victor Catherine and Alfred Legrand took over Gaussen & Cie and filed an application for a patent for 'a type of double shawl'[3] – long, with two dissimilar halves. The company, which owned thirty looms in Paris and its environs and thirty in Fresnoy (Aisne), continued in business until 6 March 1861, when Victor Catherine was appointed as liquidator. Maxime Gaussen was no longer an associate at that time.

[3] INPI, patent no. 53088, application registered on 13 January 1858 by Gaussen & Cie. The application was made barely a month after Amédée Couder applied for a patent relating to a decorative design with the same features.

Frédéric Alphonse Calenge, Jean-Jacques Lhonneur and Constant François Françoise took over the old firm of Gaussen Aîné & Cie at its premises at 1 Rue de la Banque, trading under the new name Calenge, Lhonneur, Françoise & Cie. The term fixed for the company's operations was 1 January 1863 to 31 December 1872. In 1867 it owned twenty looms in Paris and forty five – later sixty five – in Fresnoy (Aisne). An oval label in black taffetas bearing the inscription 'Mon Gen Ané & Cie, C.L.F. Cie Srs' in gold was sewn onto the back of its shawls as confirmation of their provenance. The company was liquidated on 1 October 1871 and Calenge and Mahaut formed a new company, which continued to trade until 1874.

Maxime Gaussen was a jury member again at the World's Fair in Paris in 1878 and wrote a report on 'espoliné, brocaded and au lancé shawls', which traces the history of the shawl industry. He died in Paris in 1890.

OPPOSITE
The last plate in the album Souvenirs de l'Exposition des Produits de l'Industrie Française de 1839, *showing a shawl design by Amédée Couder (see the gouache on the left, p. 133); the shawl was made by the Paris manufacturer Gaussen.*
Paris, Bibliothèque Forney, shelf mark 0161.41 '1839'.
Advances in weaving on the Jacquard loom had made it possible to weave shawls that repeated the design only once lengthwise and once across the width. This meant that a design, which could be up to 90 cm (35⅓ in.) wide was reproduced four times in one shawl. The left-hand half had to be identical to the right-hand half, whether a mirror image or not. This engraving is interesting in that it shows the artist's breadth of inspiration, which the weaver could never hope to reproduce exactly. This shawl was called the Nou-Rouz, *after the Persian New Year or Festival of Flowers. A procession of dignitaries is depicted, mounted on horses, camels and elephants, on their way to pay their solemn respects to their monarch, the Shah. Under the ogival arches, which ornament the shawl's border, a lively celebration involving musicians and dancers is taking place, with exotic birds fluttering overhead.*

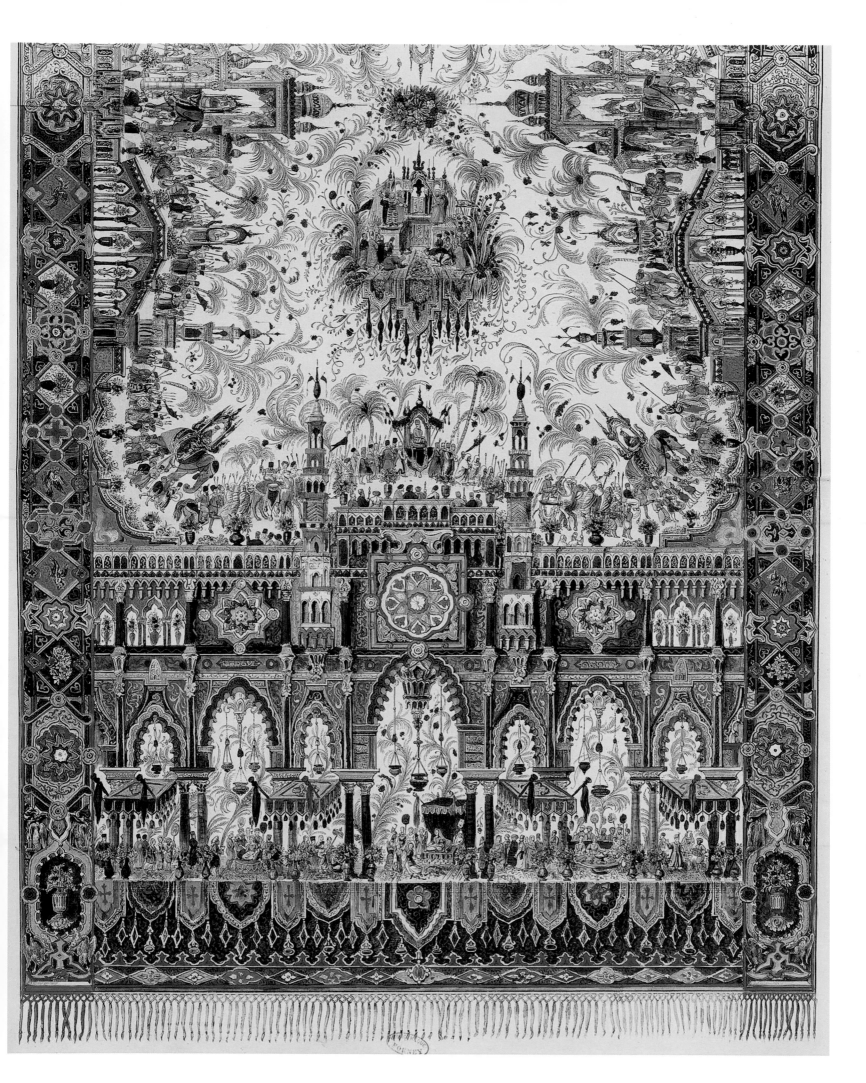

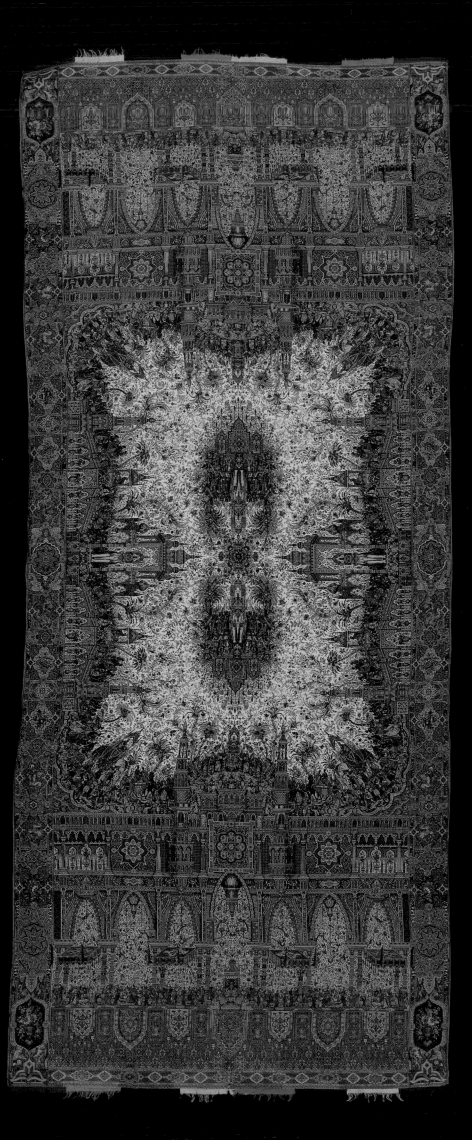

Long shawl known as the Nou-Rouz, woven by
Gaussen Aîné & Cie to Amédée Couder's design.
Paris, 1839.
Woven au lancé using twelve weft colours, trimmed on
back, cashmere, 389 × 165 cm (153⅓ × 65 in.).
Milan, Etro collection, no. 50.
The extremely complicated decorative scheme of this shawl
involved the use of more than 100,000 punched cards.

OPPOSITE
Detail of the Nou-Rouz shawl.

OVERLEAF
Long shawl, known as the Nou-Rouz, designed by Amédée
Couder and made by the successor to Gaussen Aîné & Cie.
Paris, c. 1850.
Woven au lancé using twelve weft colours, trimmed on back,
cashmere, 374 × 161 cm (147¼ × 63⅓ in.).
Milan, Etro collection, no. 198.
Copy of the famous Nou-Rouz shawl (this page and
opposite). Note that the harlequin shawl ends are now decorated
rather than plain (suggesting that the shawl was made around
1850). The colours are still beautifully fresh.

PAGE 156
Lower section of a long shawl with a black central field,
woven by Gaussen Aîné & Cie.
Paris, 1845–48.
Woven au lancé using nine weft colours, trimmed on back,
cashmere, 344 × 158 cm (135½ × 62¼ in.).
Milan, Etro collection, no. 186.
Gaussen Aîné's initials are woven into the four corners in
Gothic script. Gaussen regularly used Amédée Couder's designs
and this is probably one of them.

PAGE 157
Detail of the shawl reproduced on page 156 showing Gaussen's
woven initials.

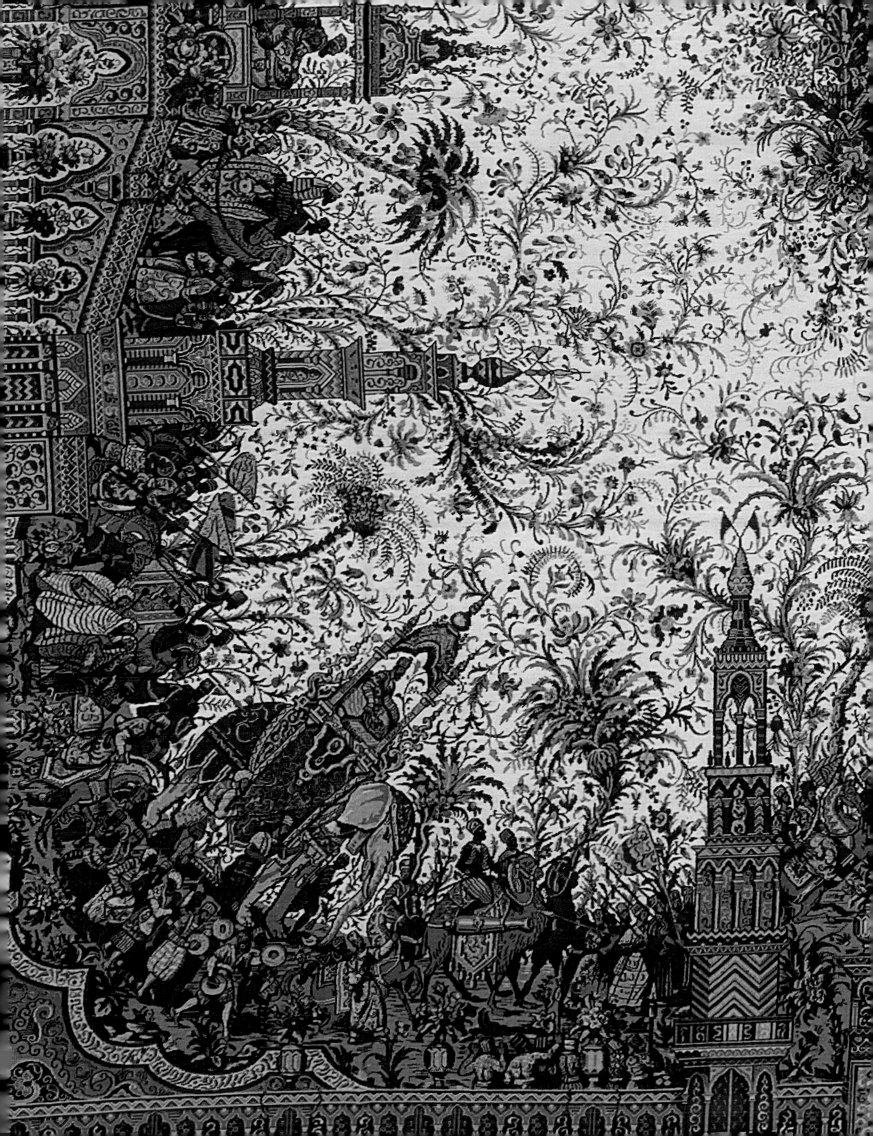

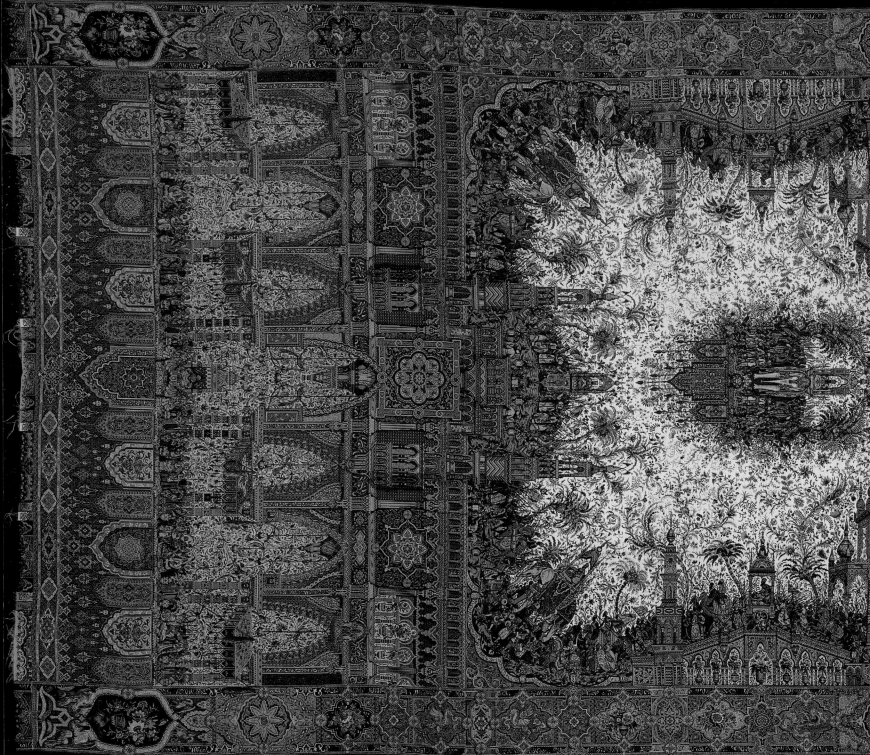

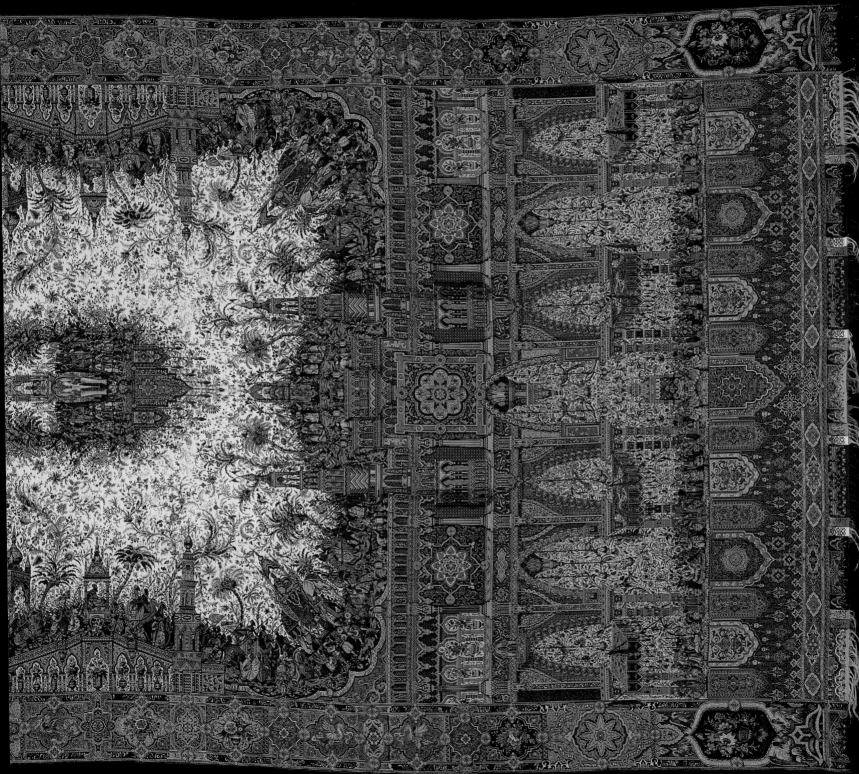

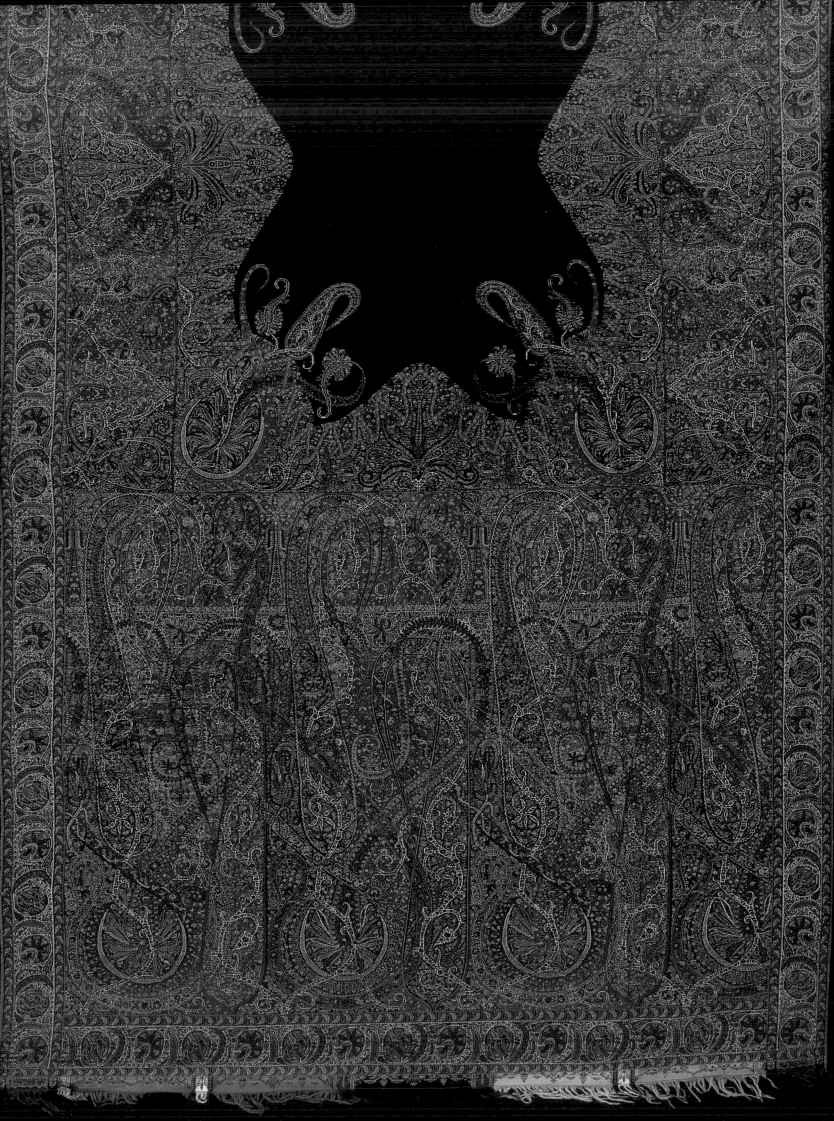

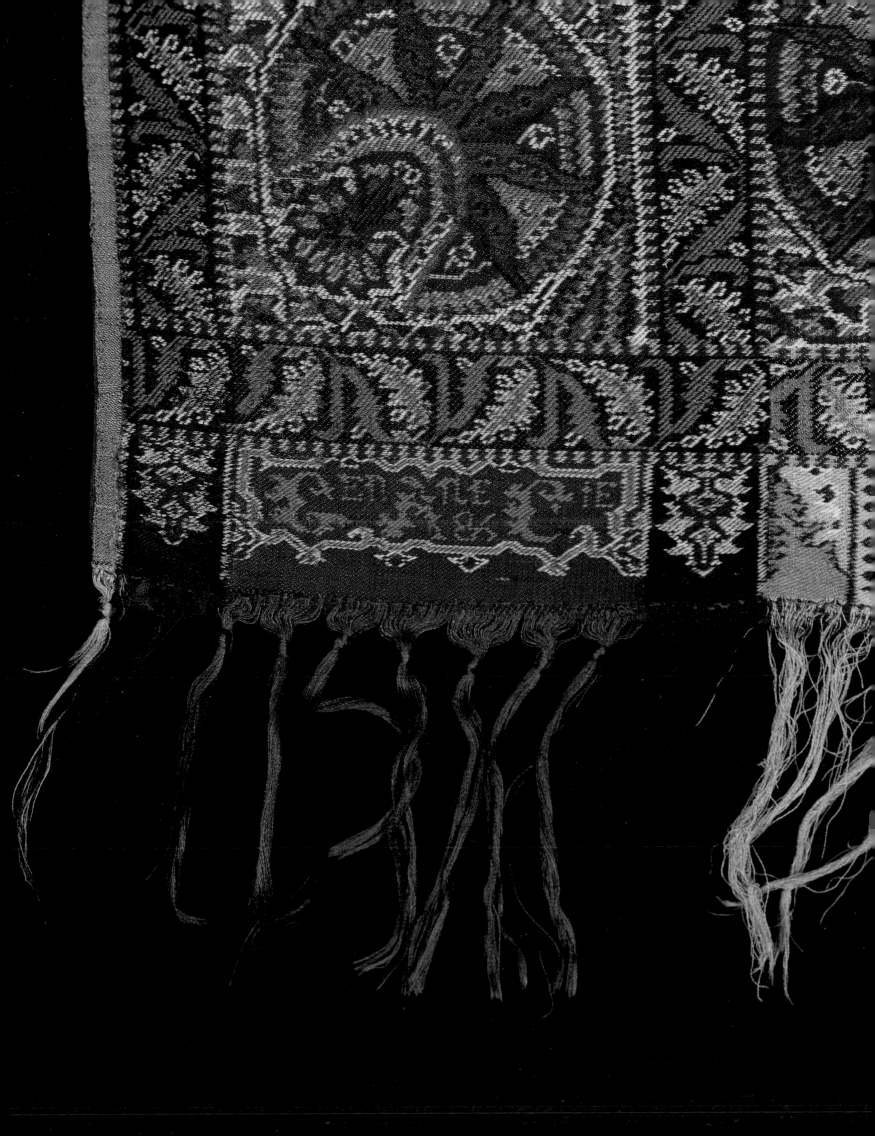

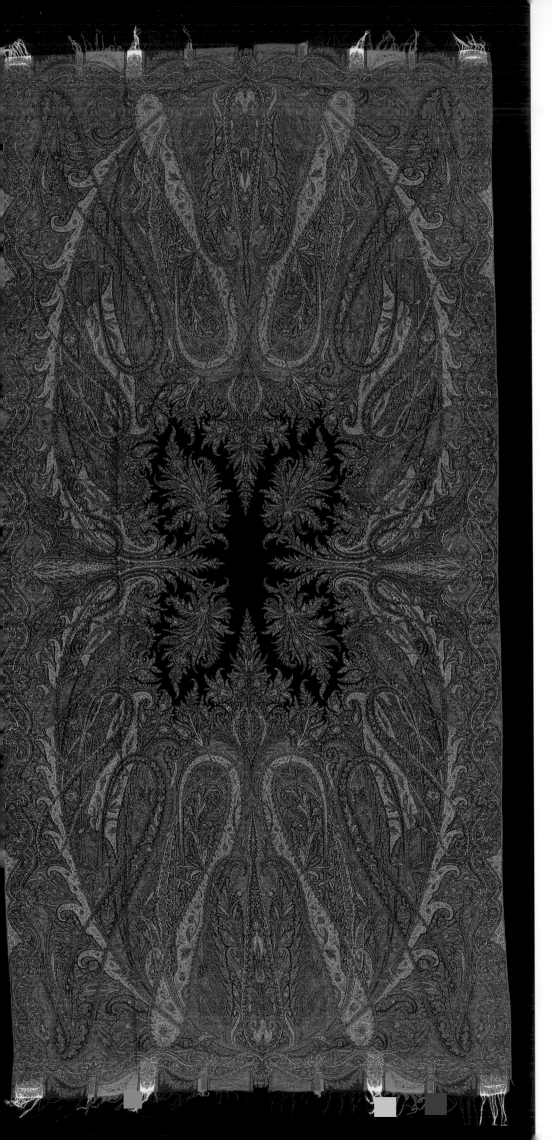

Long shawl with a black central reserve, woven
by Gaussen, Fargeton & Cie, whose initials appear
in the four corners.
Paris, 1847–49.
Woven au lancé, trimmed on back, cashmere,
348 × 164cm (137 × 64⅝ in.).
Milan, Etro collection, no. 187.
The composition is in the style végétal (floral style)
and the black central reserve provides a foil for a
magnificent arrangement of fern leaves.

OPPOSITE *Corner detail of the same shawl showing*
the woven initials.

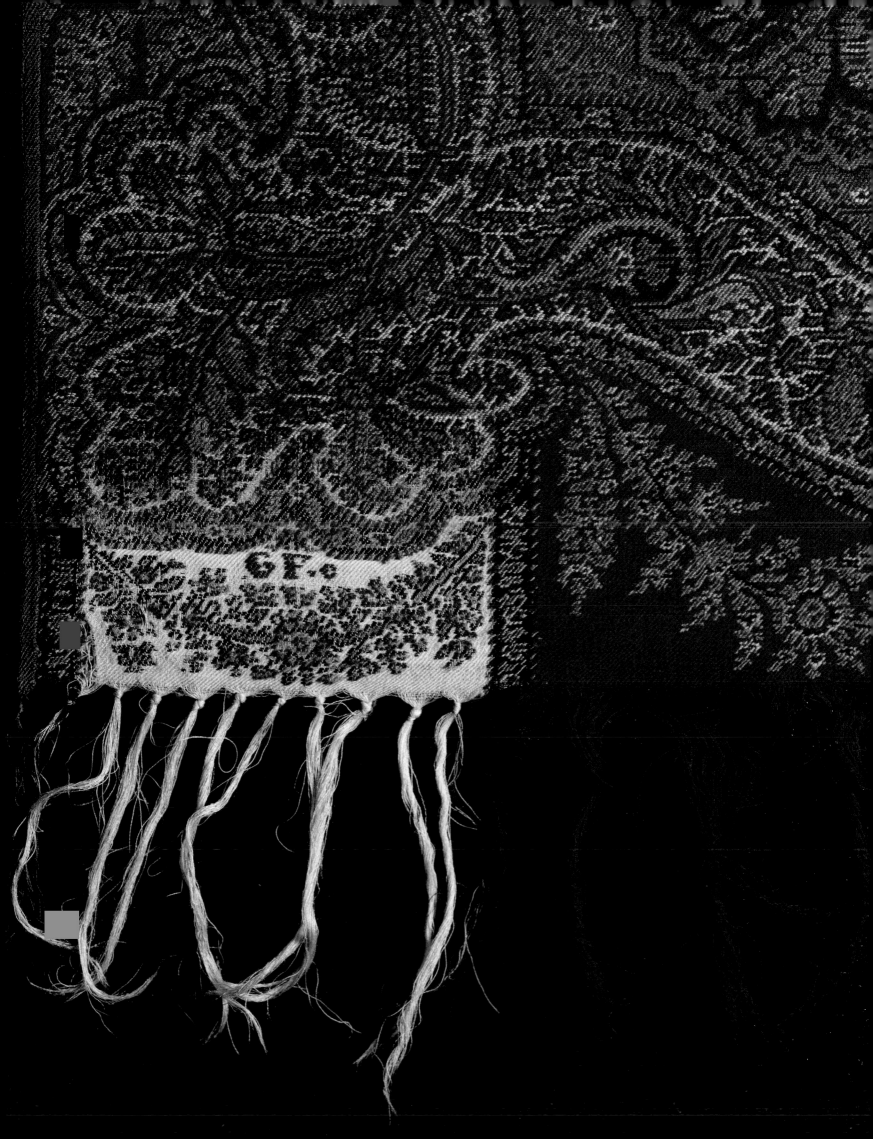

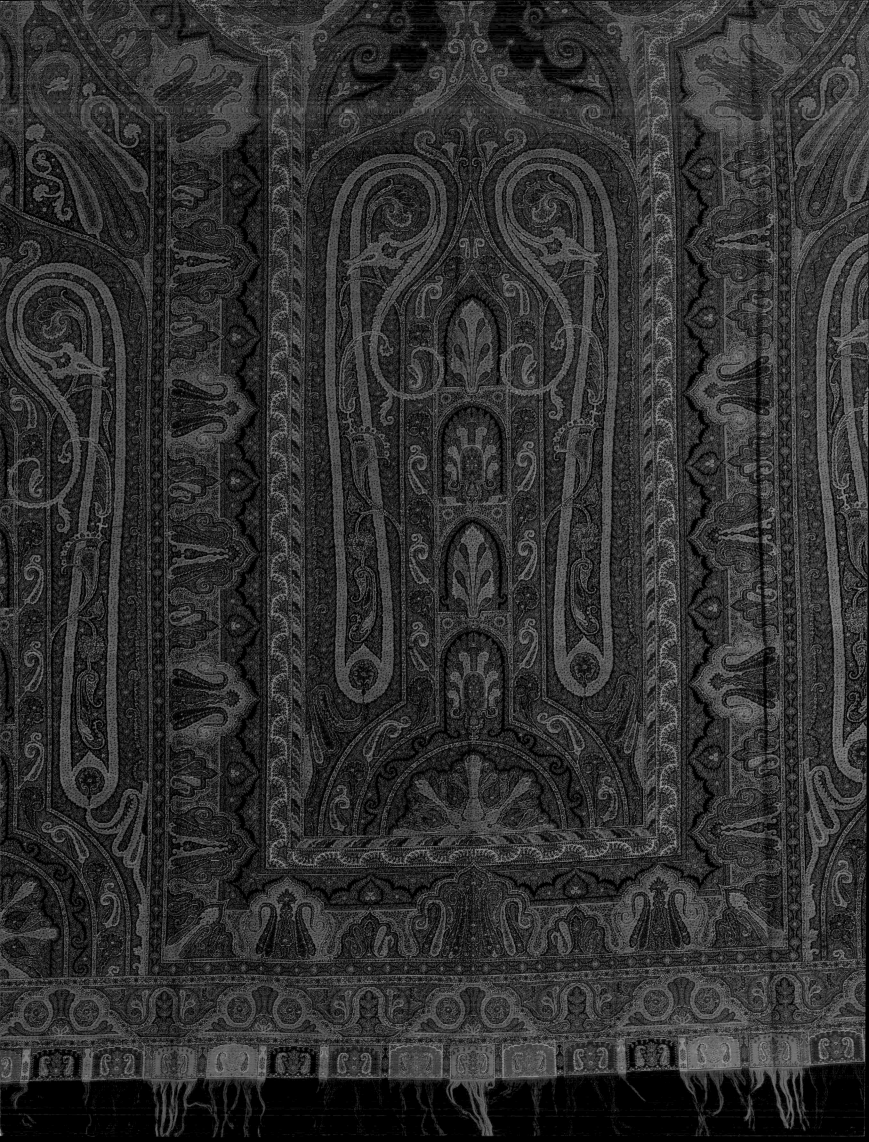

OPPOSITE
*Lower section of a long shawl with a black ground,
woven by Gaussen, Fargeton & Cie, their initials
together with the cross of the Legion of Honour are
woven into the four corners*
*Woven au lancé, trimmed on back, cashmere,
348 × 162 cm (137 × 63¾ in.). Seven colours plus
two* mariages de couleurs *are used for the weft.
Paris, 1855–59, author's collection, no. 161.*

RIGHT
*Corner detail of the shawl opposite, showing the
woven initials.*

Gaussen
Family Tree

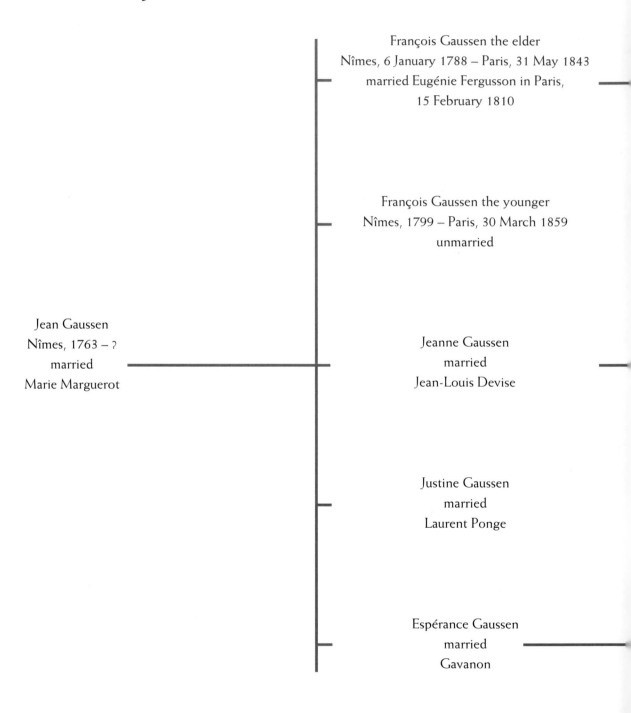

François Gaussen the elder
Nîmes, 6 January 1788 – Paris, 31 May 1843
married Eugénie Fergusson in Paris,
15 February 1810

François Gaussen the younger
Nîmes, 1799 – Paris, 30 March 1859
unmarried

Jean Gaussen
Nîmes, 1763 – ?
married
Marie Marguerot

Jeanne Gaussen
married
Jean-Louis Devise

Justine Gaussen
married
Laurent Ponge

Espérance Gaussen
married
Gavanon

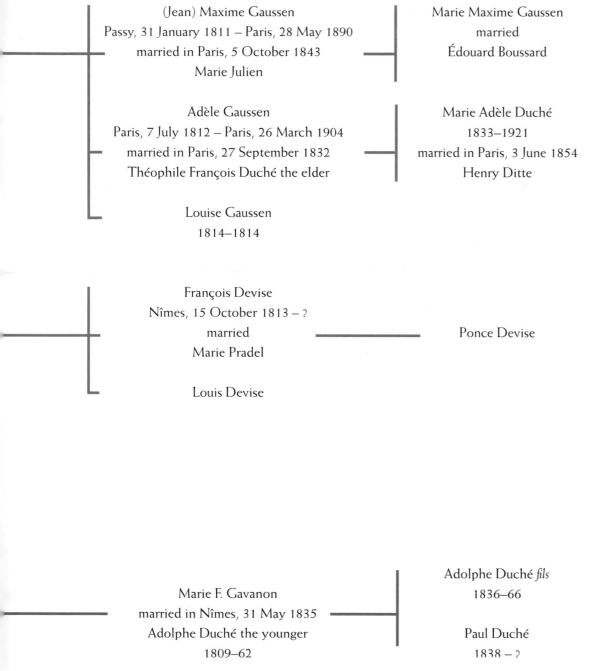

(Jean) Maxime Gaussen
Passy, 31 January 1811 – Paris, 28 May 1890
married in Paris, 5 October 1843
Marie Julien

Marie Maxime Gaussen
married
Édouard Boussard

Adèle Gaussen
Paris, 7 July 1812 – Paris, 26 March 1904
married in Paris, 27 September 1832
Théophile François Duché the elder

Marie Adèle Duché
1833–1921
married in Paris, 3 June 1854
Henry Ditte

Louise Gaussen
1814–1814

François Devise
Nîmes, 15 October 1813 – ?
married
Marie Pradel

Ponce Devise

Louis Devise

Marie F. Gavanon
married in Nîmes, 31 May 1835
Adolphe Duché the younger
1809–62

Adolphe Duché *fils*
1836–66

Paul Duché
1838 – ?

Duché
Family Tree

Théophile François Duché the elder
Leugny, 9 February 1807 – Paris, 29 October 1871
married in Paris, 27 September 1832
Adèle Gaussen
Paris, 7 July 1812 – Paris, 26 March 1904

Adolphe Duché the younger
Leugny, 13 January 1809 – Paris, 6 November 1862
married in Nîmes, 31 May 1835
Marie Françoise Gavanon

Constance Duché
Parly, Yonne, 12 October 1779 – ?
married in Parly, 8 March 1804
Madeleine Adélaïde Lechin
Parly, 21 June 1781 – ?

Émelie Zoé Duché
Chevannes, 29 May 1816 – Paris, 11 March 1888
married in Parly, 22 January 1836
Louis Narcisse Malpas
Paris, 16 June 1811 – Paris, 3 September 1902

Marie Eugénie Duché
Parly, 15 July 1823 – Paris, 21 June 1849
married, April 1844
Pierre Jean-Baptiste Duché
Limoges, 22 June 1813 – Paris, 24 January 1878

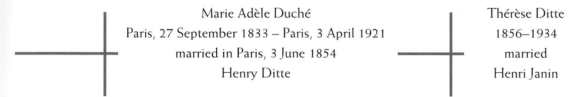

Marie Adèle Duché
Paris, 27 September 1833 – Paris, 3 April 1921
married in Paris, 3 June 1854
Henry Ditte

Thérèse Ditte
1856–1934
married
Henri Janin

Adolphe Duché *fils*
Paris, 3 April 1836 – Paris, 27 July 1866
married, 3 December 1860
Mlle Coste

Paul Duché
Paris, 27 March 1838 – ?
married?

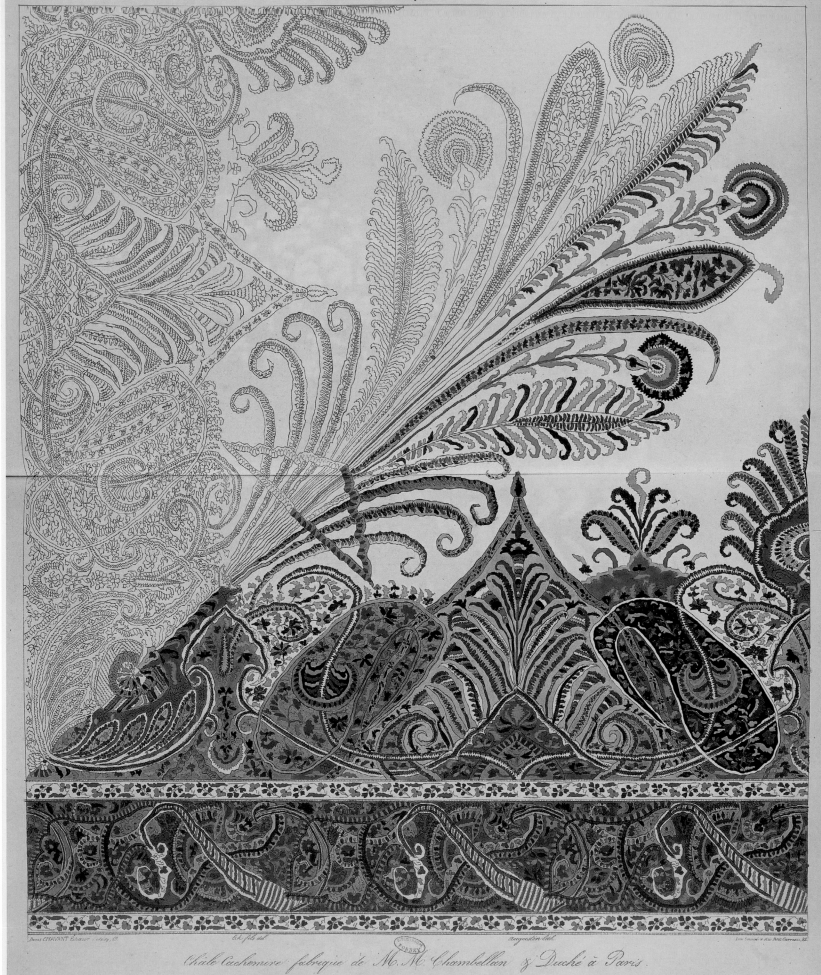

Châle Cachemire fabriqué de M. M. Chambellan & Duché à Paris.

The Duché Family

onstance Duché married Madeleine Adélaïde Lechin in Parly (Yonne) in 1804 and had four children. Their two sons both became shawl manufacturers in Paris. The elder son, Théophile François, married Adèle Gaussen, daughter of François Gaussen the elder; the younger son, Adolphe, married Marie Françoise Gavanon, François Gaussen's niece and Adèle's cousin. The Duché sisters married two future Paris shawl makers (see Gaussen and Duché family trees, pp. 162–65). On 17 November 1831 Nicolas Gratien Chambellan, Théophile François Duché and the designer Pierre Maubernard formed a company 'for the manufacture of shawls and woven stuffs known as cashmere'. The company name was Chambellan & Duché Aîné; its period of operation was fixed for nine years from 1 January 1832 and 120,000 francs were raised in capital.

Chambellan & Duché were awarded a silver medal at the Paris exhibition of 1834; by 1835 Pierre Maubernard had already left to join the newly formed Gaussen Aîné & Cie. At the 1839 exhibition Chambellan & Duché won another silver medal for their two square shawls: one was a 'Hindu' type (with a fancy silk warp and woollen weft) decorated with pagodas and *mihrabs* (prayer niches), the other was a cashmere (warp and weft both in cashmere) decorated with small pines and Indian motifs. The pattern of both shawls is in the album *Souvenir de l'Exposition des Produits de l'Industrie Française de 1839*.

In 1841 Théophile François Duché, his brother-in-law Louis Narcisse Malpas (known as Malpas-Duché, having married Émelie Zoé Duché on 22 January 1836 in Parly) and Denis Clément Doucet (possibly a cousin on his mother's side) formed a company registered at 3 Rue des Petits-Pères under the name Duché Aîné & Cie for a period of twelve years from 1 January 1841; the business capital was 240,000 francs. The firm was awarded a gold medal in the exhibition of 1844.

Adolphe Duché, Théophile François's younger brother, formed a company in 1844 with Louis Pouzadoux that traded under the name Pouzadoux & Duché Jeune until its liquidation a number of years later (p. 149).

The company formed by Duché the elder in 1841 was liquidated at the end of December 1845; Malpas-Duché, Doucet & Cie, the company newly formed by

Round black taffeta label sewn on the back of the shawls made by Duché, Adolphe Duché Jeune, Brière & Cie. Paris, 1858–64.

OPPOSITE
Cashmere Shawl Made by Messrs Chambellan & Duché, Paris, *plate no. 29 from the* Souvenir de l'Exposition des Produits de l'Industrie Française de 1839, *Paris, Bibliothèque Forney, shelf mark* 0161.41 '1839'.

Louis Narcisse Malpas-Duché, Denis Clément Doucet, Pierre Jean Baptiste Duché and Jean François Brière,[1] took charge of the liquidation. Although he was not a liquidator, Duché the elder continued to assist and advise the new company. By marrying Marie Eugénie Duché on 16 April 1844, Pierre Jean Baptiste Duché had become brother-in-law to Théophile and Adolphe Duché; he had the same surname as his wife and may have been related to her in some way.[2] On 15 September 1847 Malpas-Duché & Cie came into existence, from which we may infer that Denis Clément Doucet had retired. On 1 January 1848 Louis Narcisse Malpas-Duché also retired. Théophile François Duché and Adolphe Duché now joined forces and the company name reverted to Duché Aîné & Cie (although only Duché the elder could sign on behalf of the firm); the other partners were Pierre Jean Baptiste Duché, François Victor Malpas[3] and Jean François Brière. At the French exhibition of 1849 the gold medal was 'returned' to Duché Aîné & Cie (see note 2, p. 130), which was said to be the biggest firm of its kind in Paris; it produced 1,200,000 francs worth of goods annually and its 'rich' shawls could cost as much as 1,200 francs.

The company continued trading until 1 January 1854, when it became a limited partnership between P. J. B. Duché, Adolphe Duché the younger, J. F. Brière, F. V. Malpas and two limited partners (one of whom may have been Théophile François Duché[4]). The company was called Duché, A. Duché Jeune, Brière & Cie. The business capital was 720,000 francs, with a further 300,000 francs invested by the limited partners. On 22 October 1858 the company registered its trademark at the Commercial Court in Paris in the form of a round black taffeta label sewn on the back of its shawls that incorporated the company name in gold letters, the medals it had been awarded and the cross of the Legion of Honour (see p. 167). The company continued to trade under the same name after Adolphe Duché, the son of Adolphe Duché the younger, became a new partner in the firm. Adolphe Duché the younger died on 6 November 1862, aged fifty-three.

Jean François Brière was named a knight of the Legion of Honour in 1864 and a new label had to be created, showing two crosses of the Legion of Honour and the medals of the 1851, 1855 and 1862 World's Fairs. The initials of Adolphe Duché the younger still appeared as part of the company name.

On 19 April 1865 the firm was liquidated and Adolphe Duché and Paul Duché, the sons of Adolphe Duché the younger, together with six limited partners (including Jean François Brière), formed a company that traded under the name of Duché Frères.

When Adolphe Duché junior died, on 27 July 1866 (aged just thirty), a third round label bearing the name 'D**** & Cie' in Gothic script was created. In addition to the medals and decorations already present on the 1864 label, the new label also gave the place of manufacture: 'Paris & Vadencourt'.

On 13 December 1866 Paul Duché filed an application for a patent (no. 74096) for fifteen years for 'brocaded shawls without a wrong side'. The shawls were woven in Picardy, but in 1867 Duché dismissed all the firm's long-standing employees – as we gather from a letter written by a designer who had worked for the firm for twenty-seven years.[5] Duché was awarded a silver medal at the World's Fair that same year.

Théophile François Duché died on 29 October 1871, aged sixty-four, and Louis Narcisse Malpas died on 3 September 1902.

[1] Jean François Brière, born 18 March 1820 in La Grange (Eure), was the firm's chief designer from 1840.

[2] Pierre Jean Baptiste Duché and his father were both born in Limoges, in Haute-Vienne; his brothers-in-law and his wife were from the Yonne.

[3] François Victor Malpas, born 9 April 1815 in Paris, was the younger brother of Louis Narcisse Malpas-Duché, who had just retired from the firm.

[4] From 1857 to 1865 he and Louis Narcisse Malpas were both partners in the firm Verdé-Delisle Frères, which owned a shop called La Compagnie des Indes at 80 Rue de Richelieu.

[5] Archives Nationales, shelf mark F12/3111, 'Dessinateurs en châles, Exposition universelle de 1867' folder. Letter from the designer d'Eyssautier to M. Desvernay: '…My colleagues and I have just been dealt a fatal blow and one that I was not in the least anticipating; the firm where I had been working for 27 years has abruptly dismissed its permanent employees, all of them old and of long standing, and has kept on only young new folk engaged in piece work….I don't blame my former employers; however, a young nephew, Paul Duché, a brash and arrogant person, fancied that having lost his elder brother he was himself capable of shouldering the burden and the responsibility of running the leading firm in the shawl industry and one of the largest in the industry….'

In 1906 Paul Duché was still running a company in Vadencourt (Aisne), but he was manufacturing carpets and furnishing fabrics rather than shawls – having channelled his textile expertise in a direction that was less sensitive to the vagaries of fashion.

From 1858 the Duché family sewed a round label on the back of their shawls, but identification is still a problem for shawls that were manufactured prior to this date. In 1836 Théophile François Duché registered a number of shawl designs (on behalf of the company Chambellan, Duché & Cie) with the Prud'hommes Registry (part of the Commercial Court) in Paris for a fixed term at a fixed rate – the idea being that at the end of the fixed term the designs would be destroyed. However, the registration records that are held in the Paris Archives contain descriptions and names that sometimes make it possible for us to identify a shawl.

When he formed Duché Aîné & Cie in 1841, Duché began registering more and more designs to which he gave an actual name. The designs registered on 21 June 1841 (no. 2292) include, among others, a *Jupiter* and a *Phoenix* – examples of both of these shawls are known to us today. They are 'rich' shawls, woven with eight or nine weft colours. In one, the name 'Jupiter', in Greek letters,[6] is woven once into each quarter of the design – the right way round in the left-hand quarters and reversed in the right-hand quarters. Shawls made by Damiron Frères, a Lyons firm, and sold in Paris by Chapusot-Tardiveau & Cie, were part-imitations of this long shawl (pp. 174–75) and of two square shawls, the *Montano* and the *Venus*. Duché Aîné & Cie took both firms to court, but despite certain similarities of detail it was judged 'that these were neither sufficiently numerous nor sufficiently striking to constitute a counterfeit'.

The name 'Phénix' (Phoenix) appears, in Roman letters, in the four borders of a square shawl: twice the right way round and twice back to front. The editor of a contemporary fashion magazine admits to having been 'enchanted by one of those unique shawls aptly described as a *Phénix* and which Brousse alone is fortunate enough to own....'[7] It may not be a total coincidence that Honoré Ditte, the future father-in-law of Théophile François Duché's daughter Marie-Adèle, called the insurance company he founded in 1826 Le Phénix.

In January 1842 Duché registered the design for a square shawl, which he called *Pompadour* (p. 172). The central medallion, quarter-medallions and border are all identical in design to the *Phoenix* (aside from the name of the shawl woven into the border), but the *Pompadour* has a striped ground like the fabrics of the same name,[8] whereas the *Phoenix* has a scattering of small pines.

The jury for the 1844 exhibition devoted almost a page of its report to Duché Aîné & Cie, having awarded the firm its first gold medal. Here is an excerpt from that report: 'This energetic and enterprising manufacturer has succeeded in boosting his output to such an extent that today his firm is the biggest of its kind in Paris.... No one before Duché had dared to use the wefts of the background to produce the motifs or increase the number of picks to sixty per centimetre. Nor is his spirit of enterprise limited to this one article; it encompasses everything, from the 50-franc to the 1,200-franc shawl. Of particular note was a long shawl with a graduated ground in shades of red, green and blue, which it took a hundred and twenty different colours to make.'

[6] It was first spotted by Wendy Hefford, curator at the Victoria and Albert Museum in London.
[7] *Le Petit Courrier des Dames*, 25 July 1842, p. 35. Brousse owned the shop *La Caravane*, at 82 Rue de Richelieu.
[8] Émile Littré (Dictionary): 'POMPADOUR: adj.: Pompadour fabrics.... They can also be striped, the stripes being strewn with bouquets of flowers.'

The reference to graduated colours, or 'colour shading', is significant because it is the first such reference in the description of shawls woven *au lancé*. A long shawl that is currently in the Etro collection (pp. 176–77) has two pines in each *pente** with a colour-shaded ground, ranging from dark red (almost black) at the base, through bright red, orange and pale yellow to white. This is not the shawl described in the jury report since it contains no blue or green, but the use of graduated colours and the style of the design, which is very similar to that of the *Jupiter*, the *Phoenix* and the *Pompadour*, lead us to attribute this shawl to Duché and date it to around 1844.

Describing the brilliant French products on display at London's Great Exhibition in 1851, Maxime Gaussen (a member of the jury) notes 'an *à pivot* shawl by Messrs Duché Aîné & Cie characterized by an extremely fine weave and exquisite workmanship, which it would be difficult to equal and certainly impossible to surpass: this shawl is brocaded with between 100 and 300 picks to the inch. Also much admired in the same exhibition was a charming long white shawl, with a double colour-shaded ground forming a gallery, a very attractive piece that has a great deal of grace and style.' The shawl Gaussen describes here matches a signed Duché model currently in the Etro collection (pp. 178–79), an exuberantly patterned shawl in the *style végétal* (floral style) and the only one known to carry the signature of Duché Aîné & Cie (woven inside a cartouche in the middle of the harlequin border).

The jury at the 1855 World Exhibition in Paris praised the shawls made by Duché, A. Duché, Brière & Cie for the fineness of their weave – a quality we have noted in all the shawls bearing a Duché label. While undeniably elegant, shawl designs in the final period of the firm's manufacturing history lack any real originality.

No overview of the Duché firm is complete without a mention of Jean François Brière. It was not until 1834 that exhibition juries began acknowledging the role of artists who created designs for the decorative arts; and even then they had to be working independently, like Couder or Berrus. If they were attached to a company, any medals and decorations went to the manufacturer, not to them. The case of Jean François Brière consequently rocked the whole profession. On 1 August 1863 a petition drawn up by Joseph Grégoire d'Eyssautier (who had been a designer for the Duché firm for twenty-four years) and signed by three hundred workers in the cashmere shawl industry, addressed to the Minister of Commerce, Agriculture and Public Works, demanded that Brière finally be awarded the Legion of Honour.[9]

In their report on the 1867 World's Fair in Paris, the shawl designers' delegation cited the names of their colleagues and detailed their precise role vis-à-vis the manufacturers. It seemed that the merits of the profession had finally been recognized.

Invoice letterhead.
Paris, Debuisson collection.

OPPOSITE
Detail of the shawl shown on page 173.

9 Archives Nationales, shelf mark F12/5097. The petition was signed by Couder and Berrus and by other designers, *chefs d'atelier*, weavers, dyers and pattern readers. The same bundle contains a 'Note concerning M. [Monsieur] Brière', which says: 'The lynchpin, Monsieur Brière, of whom we have just been speaking, became an associate and head of this same firm [Duché], a position he owes to his skill as a designer; is there not a case today for rewarding Monsieur Brière and according him the distinction that his firm only merited through his good offices?'

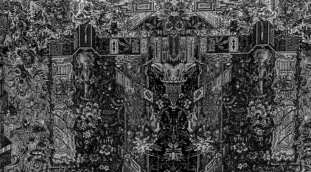

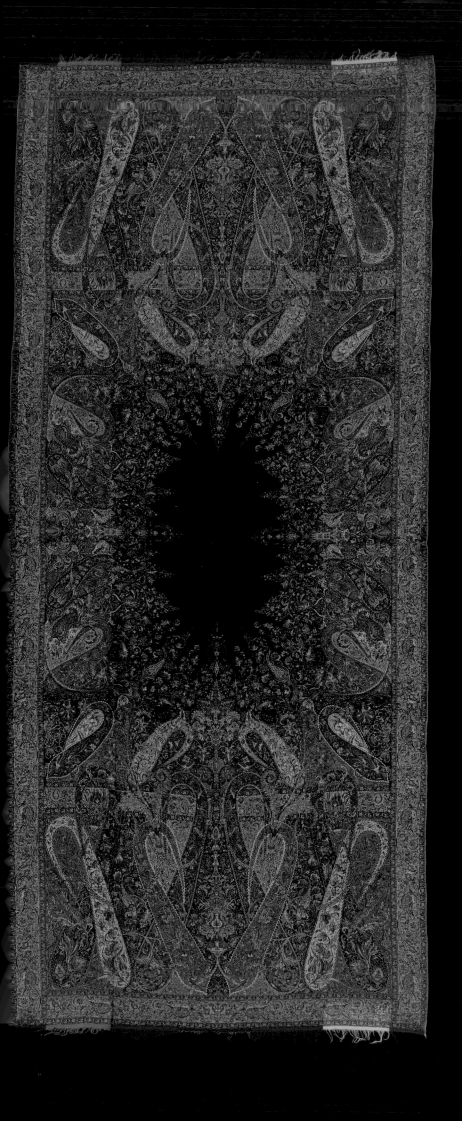

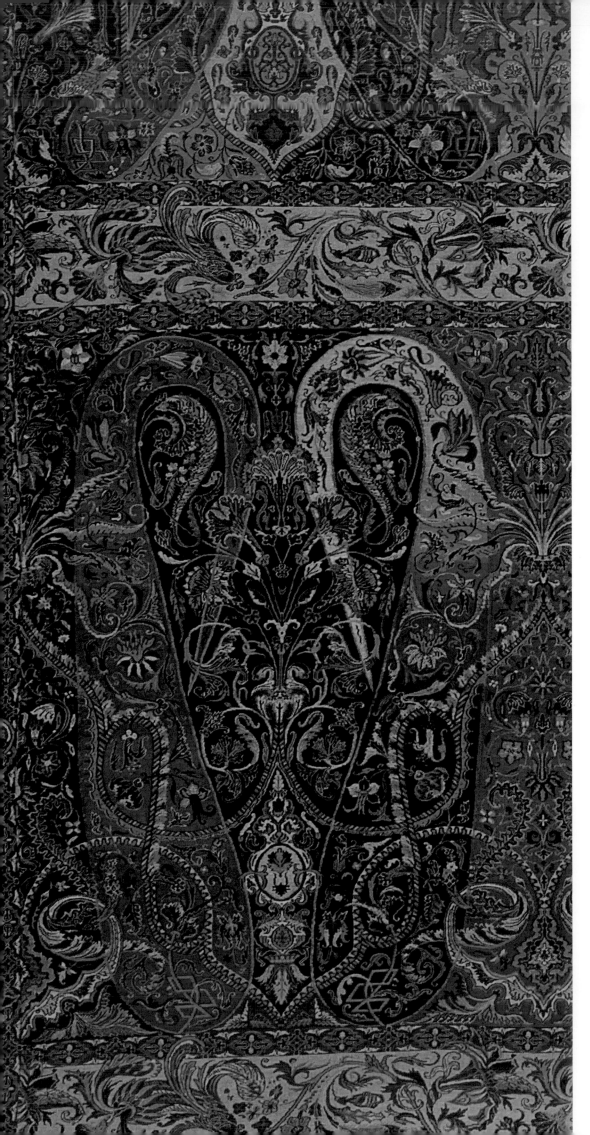

Detail of the shawl reproduced on the opposite page, showing a large colour-shaded pine.

OPPOSITE
Lower section of a long shawl with a white central field, attributed to Duché Aîné & Cie.
Woven au lancé using eleven weft colours, trimmed on back, cashmere, 370 × 162 cm (145⅛ × 63¾ in.).
Milan, Etro collection, no. 249.
Two pines are colour shaded in each of the main borders. The exhibition juries for 1844 and later noted Duché's 'colour-shaded' designs. His graduated palette (black through red and yellow to white) depended on eight basic colours; it was a costly technique and no one else was producing anything like this at the time.

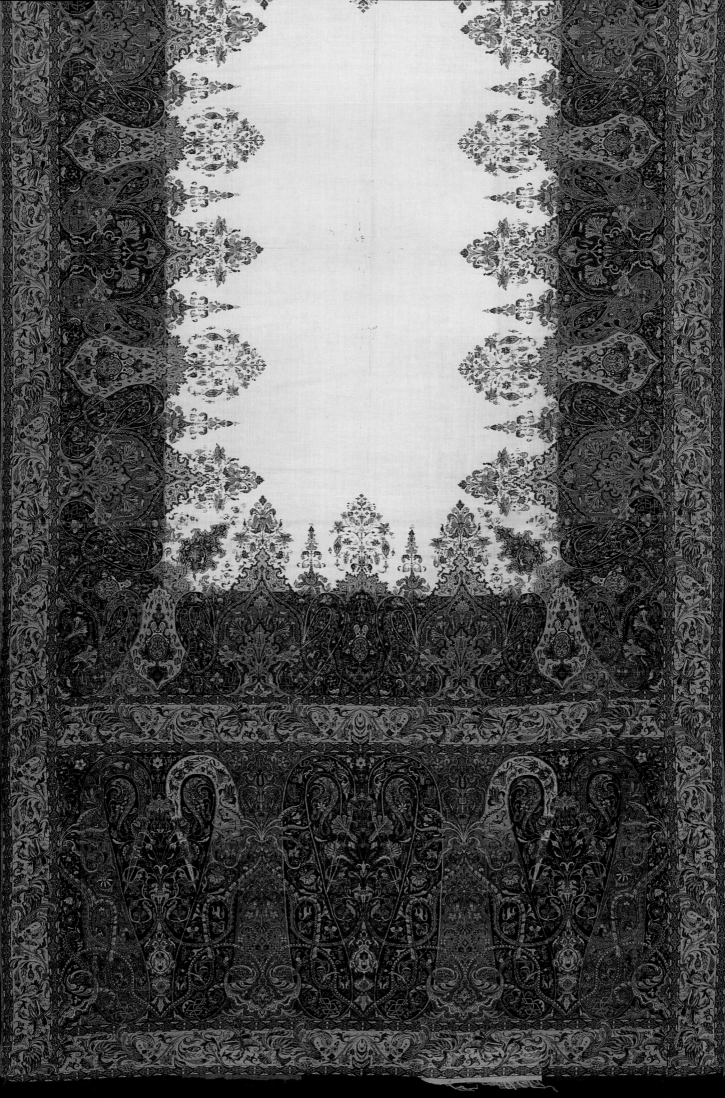

OPPOSITE
Detail of the shawl reproduced on this page,
showing Duché's signature woven into the
shawl end.

RIGHT
Long shawl with a small pivoting design and
colour-shaded ground, manufactured and
signed by Duché Aîné & Cie.
Paris, 1851.
Woven au lancé using more than fifteen weft
colours, trimmed on back, cashmere,
368 × 162 cm (144⅞ × 63¾ in.).
Milan, Etro collection, no. 272.
This shawl in a dazzling style végétal
(floral style) is a technical tour de force, given
its extraordinary colour range. It may well
be the shawl mentioned by the jury for the
Great Exhibition (London, 1851) as having
'a double colour-shaded ground forming
a gallery'.

OVERLEAF
Detail showing the centre of the shawl that is
reproduced here, right.

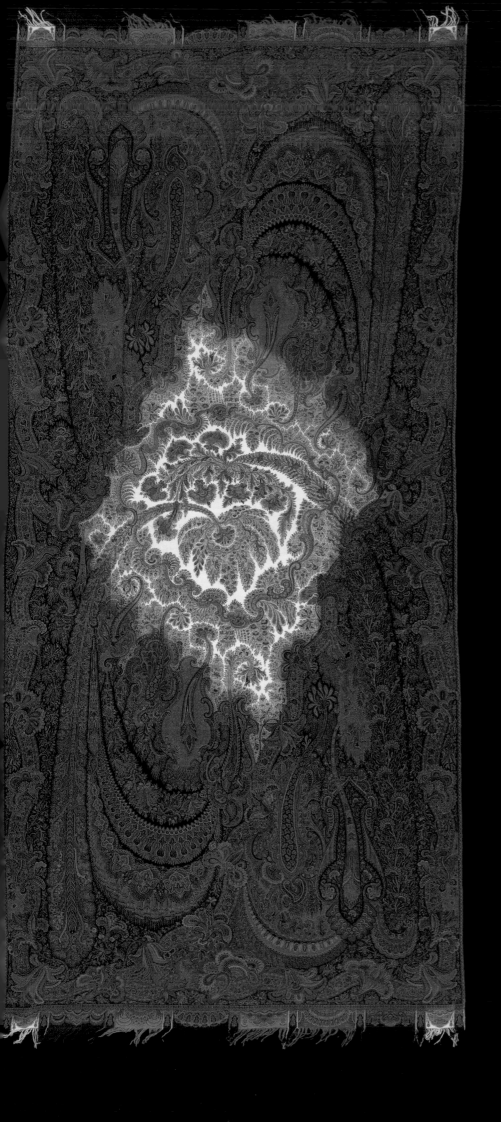

*Long shawl with a large pivoting design and a single
central motif on a white ground.
Paris, c. 1851.
Woven au lancé using nine weft colours, trimmed
on back, cashmere, 360 × 163 cm (141¾ × 64⅛ in.).
Milan, Etro collection, no. 139.
The jury report for the Great Exhibition in 1851
refers to 'an à pivot shawl by Messrs Duché Aîné
& Cie characterized by an extremely fine weave and
exquisite workmanship which it would be difficult to
equal'. This may have been the shawl in question.*

OPPOSITE
Central detail of the shawl shown on this page.

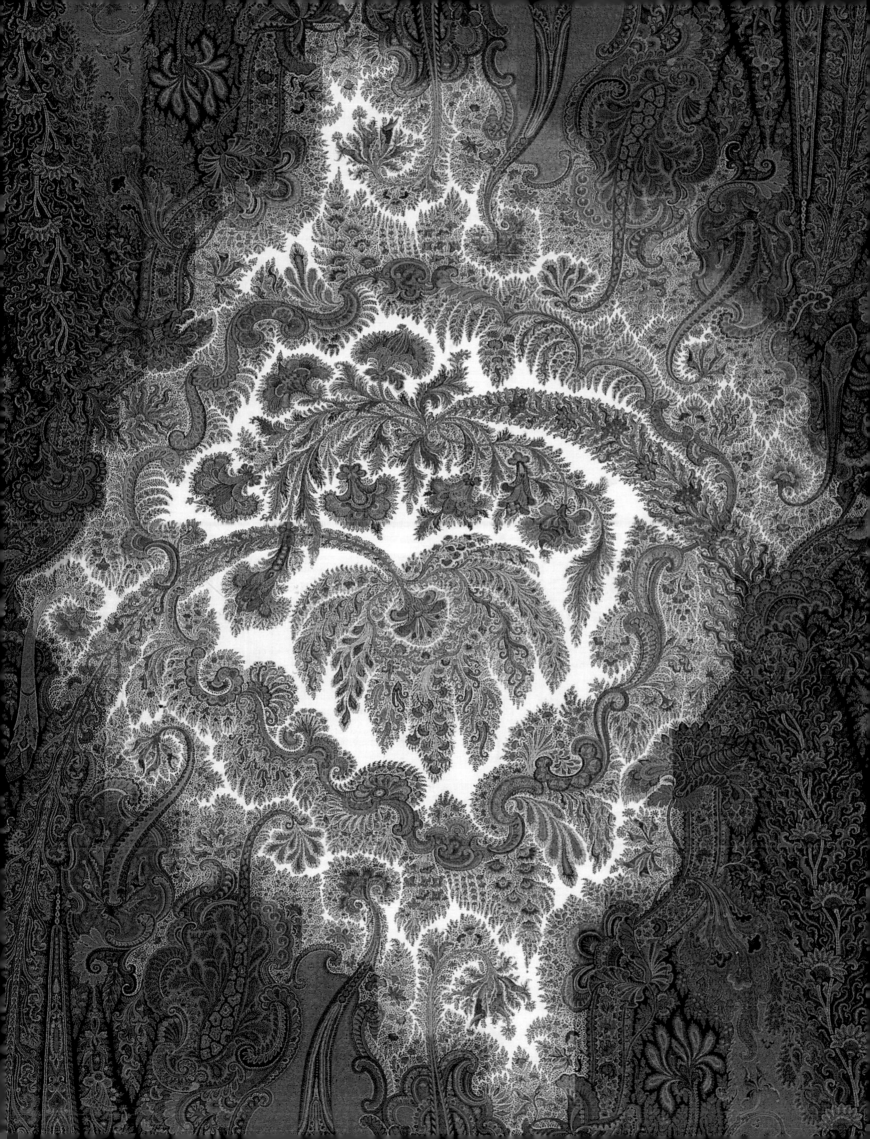

Fortier & Maillard

Pierre Thomas Pascal Fortier (born 15 April 1800) married Marie Catherine Eugénie Johnson; their daughter, Eugénie Fortier, married Pierre Honoré Maillard on 19 July 1849. Fortier died in Louviers on 25 September 1860.

On 3 April 1830 Denis Carteron Gallimard and Fortier, both shawl manufacturers, formed a company for a term of six years and four months. The company name was Carteron Gallimard & Fortier and its address was 36 Rue Neuve-Saint-Eustache.

The company was modified on 1 August 1833 and was henceforth known as Carteron & Fortier; it was liquidated on 1 July 1837. In a circular letter dated 30 June 1837, Cartier and Fortier informed their correspondents that 'since M. [Monsieur] Carteron wishes to give up his business interests, M. [Monsieur] Fortier remains sole proprietor of the firm and assumes responsibility for its liquidation. As a token of his affection for M. Fortier, M. Carteron intends to leave him all the necessary funds to enable him to run the new Firm on the same footing as the old.'

At the French exhibition of 1839, where he exhibited for the first time,[1] the jury awarded Fortier a gold medal, commenting as follows:

> He is the first to have succeeded in making the Hindu shawl more generally affordable by reducing the number of colours used without significantly altering the effect.[2] It is thanks to his perfect grasp of manufacturing processes and his intelligent combination of colours that he has achieved this result, and he is therefore able to sell for between 50 and 55 francs shawls whose price previously never fell below 100 to 120 francs. His example has been imitated by the entire industry and his market outlets have greatly increased as a consequence.
>
> M. [Monsieur] Fortier has also continued to manufacture rich shawls which sell for 150 to 200 francs, and which are a testament to his skill and unerring sense of beauty.
>
> He is the inventor of what he calls the palatin,[3] a shawl with a novel shape which features among his exhibits and which he is confident will soon become fashionable.
>
> ...In consideration of his products taken as a whole, the impetus he has given to the entire industry, and the reduction in prices which he has ushered in, the jury award M. Fortier the gold medal.

Detail of the shawl reproduced on the opposite page, showing the woven initials and embroidered numbers.

OPPOSITE *Detail of a long 'four seasons' shawl manufactured by Fortier & Maillard.*
Paris, 1852.
Woven au lancé using nine weft colours, trimmed on back, wool, 332 × 159 cm (130¾ × 62⅝ in.).
Milan, Etro collection, no. 174.
Manufacturers' initials woven into the corners.
Embroidered numbers: 86857 735 5.
Fortier & Maillard registered design no. 735 with the Prud'hommes Registry in August 1852.

[1] The 1834 exhibition reports do not mention Fortier.
[2] The 1839 jury-report notes that the woollen Hindu shawl has the same warp as the cashmere Hindu shawl, 'two fancy silk yarns twisted together'; but 'the weft and the *lancé* are in wool of varying fineness'.
[3] He received a patent for this shawl the previous year but had not named it when he applied for the patent.

LEFT
*Patent registered by Fortier in 1838.
Paris, INPI.*

RIGHT
*Design for the châle palatin (see note 11, p. 88),
which Fortier attached to his patent application.*

The jury for the 1844 exhibition awarded Fortier another gold medal and praised the skilful construction of his work and his sense of economy:

Goods that are well made and at the same time inexpensive should be the goal which every manufacturer seeks to achieve, and no one solves this economic problem more convincingly than this exhibitor, who is offering for sale today at 35 and 40 francs shawls which five years ago would have cost 50 and 55 francs.

He excels equally in the manufacture of richer shawls, priced between 100 and 150 francs.

M. [Monsieur] Fortier has had the ingenious idea of creating three long shawls, all of them white and in a particularly rich and complex pattern, using the same design but different materials....

One is pure cashmere; the second is in Dresden wool and the third in wool from the herd belonging to M. Graux de Mauchamps.... In terms of suppleness and softness the de Mauchamps wool, as it is known, was superior to the Dresden wool and very like the pure cashmere.

In his report on the shawls in the 1844 exhibition, Jules Burat wrote:[4]

One of the most beautiful shawls and one of the most interesting in the Exhibition was a shawl by M. [Monsieur] Fortier. Designed by M. Lurtier, it was decorated with garlands of the most delicate flowers, but its most conspicuous feature was the material. It was made from a variety of wool obtained by M. Graux de Mauchamps from a new breed of sheep which he has been responsible

[4] Jules Burat, p. 41.

for discovering and breeding himself.... This beautiful wool-silk, of superb length, maybe less soft and downy but lighter than cashmere, was spun by M. Biétry, according to whom it is easier to spin than cashmere, while M. Fortier for his part insists that it is also easier to weave. This wool is currently 30 per cent cheaper than cashmere wool, and the price is likely to fall.

The jury awarded him a third gold medal in the 1849 exhibition, noting:

He was the first to manufacture a Hindu shawl in Paris and it must be said that hitherto he has been very successful and deservedly so. Today M. [Monsieur] Fortier is focusing his efforts on manufacturing shawls with a woollen warp and he is without question one of the leading manufacturers of this particular article. Among his exhibits there are woollen warps which rival the most beautiful cashmeres for softness and delicacy of weave. The materials which M. Fortier employs are always of the finest quality and cannot be faulted; while his prices remain hard to match, he has never cut corners where the quality of either the yarn or the weave is concerned. Of particular note among this reputable manufacturer's submissions are what he terms his 'shawl rugs'. Originality of conception, superb workmanship and beautiful simplicity in respect of the design combine to make this article unquestionably the best of its kind.

On 18 April 1851 Fortier registered a new company, Fortier & Maillard, formed in association with his son-in-law Pierre Honoré Maillard, for a fifteen-year term (from 1 December 1850 to 1 December 1865) in order to carry on his shawl manufacturing operations. The company continued to be located at 36 Rue Neuve-Saint-Eustache.

There is no mention of the company in the jury reports for the Great Exhibition held in London in 1851, but the jury at the Paris World's Fair four years later awarded Fortier & Maillard a first-class medal and commented that:

These skilful manufacturers, whose firm has been in business for a great many years, are still the most outstanding producers of striped shawls, shawl rugs, fonds pleins [shawls with an all-over decorated ground] and small-pine designs. Messrs Fortier & Maillard's workmanship is remarkable for its regularity and they are perfectionists in terms of their attention to detail.... No one is as adept at manufacturing a woollen warp, and their shawls are distinguished by their exceptional texture and feel, which are due primarily to the beauty of the yarn they employ.

Fortier & Maillard was liquidated on 1 May 1859 and Maillard was appointed liquidator. Fortier died the following year.[5]

On 21 February 1862 Pierre Honoré Maillard and Ernest Eugène Bréant registered a new company at the address on Rue Neuve-Saint-Eustache for a term of eight years (from 1 December 1861 to 1 December 1869), and in 1865 Maillard & Cie, as it was known, filed an application for a fifteen-year patent for 'the manufacture of shawls with four fringes',[6] described as follows:

We assert our claim to be identified with the production of a new article – namely a shawl which has been fringed on all four sides during the course of weaving and brocading. This process essentially relies on replacing the cotton liage [binder] yarn in what is known as the mignonette border (near the edges of the shawl) with a warp yarn that is extended horizontally to form the side fringes.[7]

5 The notification of transfer by death (no. 240) held in the Paris Archives mentions that at the time of his death 'M. [Monsieur] Fortier was barred and M. Maillard had power of attorney'. The judgment was passed on 1 May 1859, at which time Fortier was hospitalized in Dr Baillarger's clinic in Ivry-sur-Seine.
6 INPI, patent no. 69279, granted 22 December 1865.
7 The term *mignonette* referred to the fringed harlequin shawl end.

The jury for the Great Exhibition in London in 1862 makes no mention of Maillard & Cie, but five years later the *Rapport des Dessinateurs en Châles* for the 1867 World's Fair gives the following description of the shawls manufactured by Maillard & Bréant:[8]

> *These Gentlemen are great lovers of colour and have achieved superb results with their large à pivot shawl, which is in a much less fine weave than the last shawls which they exhibited and yet has a quality all its own. The row of light-coloured brocaded double-grounds simply outlined with simple black cord is an unusual feature in this beautiful piece, which is copied from an Indian original but is vastly superior to it. This shawl is complete, ingeniously worked in all its details.*
>
> *These Gentlemen are showing two very finely woven shawls which are said to be tours de force in manufacturing terms. We like these less. Their design is not as strong. Although the colours are very beautiful, the pattern in both cases is too repetitive and the detail is overly simple. Of twelve shawls exhibited, eight were designed by M. Henry Vichy, whose style is perfectly suited to the type of shawls made by Messrs Maillard and Bréant, both great admirers of Kashmiri compositions.*

The *Almanach du Commerce* for 1869 refers to the firm of Maillard & Bréant, but from 1870 the company name is followed by 'Bréant successeur'. At the World's Fair held in Paris in 1878, Bréant was the only exhibitor to be awarded a gold medal.

Carteron & Fortier registered twenty-eight shawl patterns with the Prud'hommes Registry in Paris on 10 January 1837 and seventeen on 14 April (numbered between 211 and 299) for a period of three years. The two manufacturers parted company in June. The following year Fortier applied for a ten-year patent for a new type of shawl which he described as follows:[9] 'The four ends which form the corners of shawls currently in use are rounded in the exhibitor's shawl; the sides are no longer straight but elliptical, curving inwards towards the centre of the shawl.' Fortier attached a drawing (p. 186) by way of elucidation. The decorative part of the shawl was woven to shape, which was not uncommon in the eighteenth century for jacket and waistcoat fronts, pocket flaps and button-covers in men's clothing. The model in a fashion plate from 1839 is wearing a shawl of this type (p. 190).[10] The plate, which gives the name of the stockist but not the manufacturer, describes the shawl as a *châle palatin*,[11] the same name that was given to it by the jury for the 1839 exhibition.

The Smithsonian Institution in Washington DC has a *châle palatin* in its textile collection (p. 191) that is very similar in design to the one shown in the fashion plate. Fortier registered two designs for *châles palatins* (nos. 416 and 417) with the Prud'hommes Registry on 28 September 1838 for a period of ten years and three other designs for similar shawls (nos. 334, 336 and 337) on 5 February 1839, also for a period of ten years. However, for reasons that are not clear to us, Fortier did not register any more designs throughout the course of the next ten years.

Between 1849 and 1851 (and before he and Maillard became partners in April 1851) Fortier began weaving his initial into the four corners of his shawls and embroidering a number into one of the left-hand corners, alongside his initial, in white silk. After Fortier and Maillard joined forces they initialled the corners of their shawls with their joint initials (F. M.) and continued to embroider the shawl number in a left-hand corner. The numbers are in two parts: the left-hand number (never more than five digits) probably

8 The company name appears to have changed in 1865; their new address was 60 Rue d'Aboukir.
9 INPI, patent no. 8736, granted 4 July 1838.
10 *Le Follet, Courrier des Salons*. The caption reads: '*Châle palatin* from Magasins Séguier, 2 Place des Victoires'.
11 Probably by analogy with *palatine*: 'Fur worn by women around the neck and shoulders in winter' (Littré). It was the Princess Palatine (1652–1722), Louis XIV's sister-in-law, who set a fashion for wearing these stoles.

corresponds to the number of the shawl; the right-hand number (never more than three digits) was the number of the template or design. These numbers help us to date shawls.[12]

Most other manufacturers numbered their shawls by sewing a piece of tape in a corner on the back of the shawl with the number written in ink. Between 1855 and 1859 Fortier & Maillard switched to this practice – which is a shame because the bits of tape tended not to stay in place (and in many cases the owner of the shawl may have deliberately unpicked them because they were unsightly). Fortier appears to have been the only manufacturer to have embroidered his shawl numbers, for a few years at least. In addition to their initials woven into the corners, from around 1855 Fortier and Maillard also began weaving a white signature in the small black central reserve.

The registrations, the patent, the woven initials and embroidered numbers were all a means of protecting against counterfeiting. On 7 June 1850,[13] the Commercial Court passed a judgment against Jabely & Cie,[14] manufacturers of printed shawls, for copying several of Fortier's shawl designs. The judgment seems exemplary and demonstrates the usefulness of registering designs with the Prud'hommes Registry.

Fortier's speciality was shawls with a small design ratio such as stripes and *fonds pleins* (with an all-over pattern and no central field). A small design ratio meant that minimal time was invested in working out the design on point paper* – the process known as *mise en carte* – and thus created the possibility of offering good quality at a reasonable price. Even Fortier's 'quartered shawls' used repeat patterns as a way of keeping down the cost and it is not surprising that there appear to be no pivoting designs attributable to him.

Fortier's innovation was the *châle palatin* with its novel shape; in his choice of patterns, on the other hand, he always adopted a classical approach. He wove 'rich' shawls but limited himself to using nine colours, being primarily concerned with the quality of his materials (beautiful wools, though not necessarily cashmere) and of the spinning (which he entrusted to Biétry) and the weaving. Although his workmanship and finishing were always of the best quality, his prices were affordable.

12 Two 'four seasons' shawls made to the same design – a long shawl labelled FM 86857 735 (Etro collection, no. 174) and a square shawl labelled FM 89417 735 (Susan Meller collection, New York) – provide confirmation that the three right-hand digits (in this case, 735) refer to the design. There are several points to note regarding the numbering of shawls made by Fortier and Fortier & Maillard:
– All the designs are numbered but not all of them are registered.
– A shawl might be numbered without being initialled. It is possible that the initials were omitted in the case of more modest shawls, such as certain striped shawls. The shawl number was embroidered in a very distinctive style, in itself sufficient for the purposes of identification.
– Assuming Fortier began numbering his shawl designs from the start of his partnership with Carteron in 1830, by 1855 he would have produced more than 1,000 models.
– The oldest number embroidered by Fortier known to us is F 74582 521. The design corresponds to the registration dated 23 August 1850. A shawl made in 1856 carries the embroidered number FM 96409 34 and a shawl dated 1858 carries the number FM 7295 27: we are looking, therefore, at a second series of shawls (following the first 100,000) and a second series of designs (following the first 1,000).
13 Judgment recorded 25 June 1850, conserved in the Paris Archives, shelf mark D2 U3/2196.
14 Jabely & Cie, 3 Rue du Sentier, Paris. To protect themselves against counterfeiting (and prevent the kind of damage they had inflicted on Fortier), Jabely & Cie applied for a fifteen-year patent, which they were granted on 20 September 1853: INPI, patent no. 17219 'for a type of square, both brocaded and printed shawl, known as a *châle Hortense*, imitating long and asymmetric shawls'.

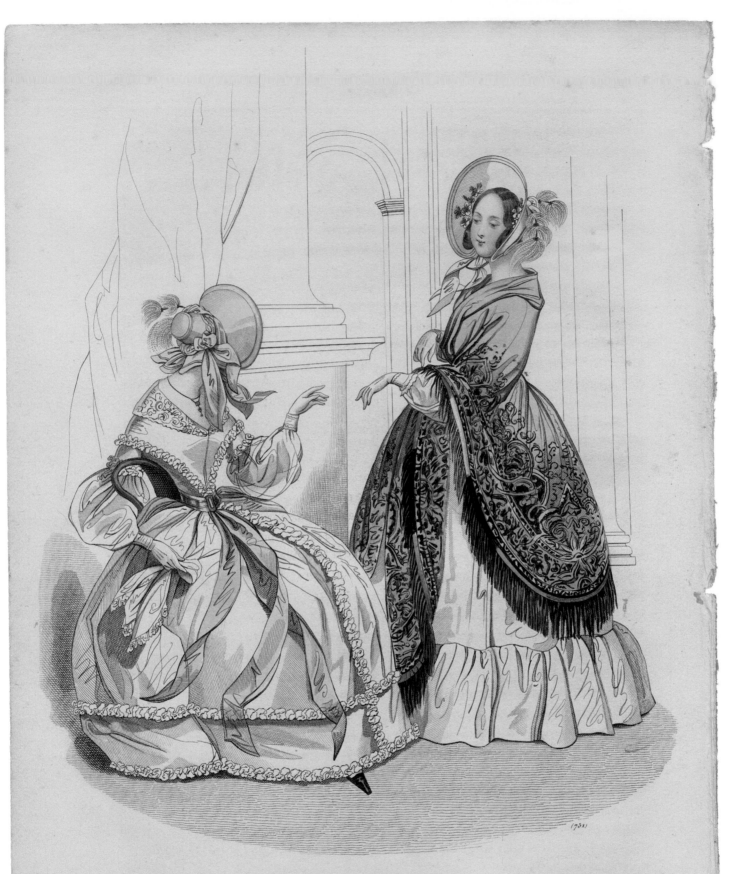

LE FOLLET
Courrier des Salons
Boulevart St. Martin, 61.

Chale palatin des Mmes Séguier, Pl. des Victoires N.º 2 — Chapeau des Salons Maxence, r. Vivienne, 16, au 1.er
Redingote, mousseline, ruchée en pareil de Mme Larcher, C.re de la Reine, r. Vivienne, 8.

Court Magazine, N.º 11. Carey street Lincoln's Inn London.

1839

OPPOSITE *Fashion plate.*
Paris, 1839.
The model on the right is wearing a châle palatin.
Paris, da Silvera collection.

ABOVE Châle palatin, *woven to shape.*
Manufactured by Fortier.
Paris, 1839.
Woven au lancé, trimmed on back, cashmere,
180 × 198 cm (70⅞ × 78 in.).
Washington DC, Smithsonian Institution, inv. no. T.5889.
Embroidered numbers: 16420 417.
The pattern is roughly identical to that of the shawl
in the fashion plate opposite.

PAGE 192 *Section of a striped square shawl*
manufactured by Fortier & Maillard.
Paris, 1855.
Woven au lancé, trimmed on back, wool,
180 × 178 cm (70⅞ × 70⅛ in.).
Paris, author's collection, no. 18.
Initials woven into each corner.
Embroidered numbers: 93442 970.

PAGE 193, ABOVE *Initials and embroidered numbers*
in the corner of the shawl shown opposite.
BELOW *Detail of the shawl reproduced on pages 194–95*
showing the white initials woven in the centre.

PAGES 194–95
Long shawl with a black central reserve
manufactured by Fortier & Maillard.
Paris, 1855–59.
Woven au lancé, trimmed on back, cashmere,
358 × 152 cm (141 × 59⅞ in.).
Milan, Etro collection, no. 189.

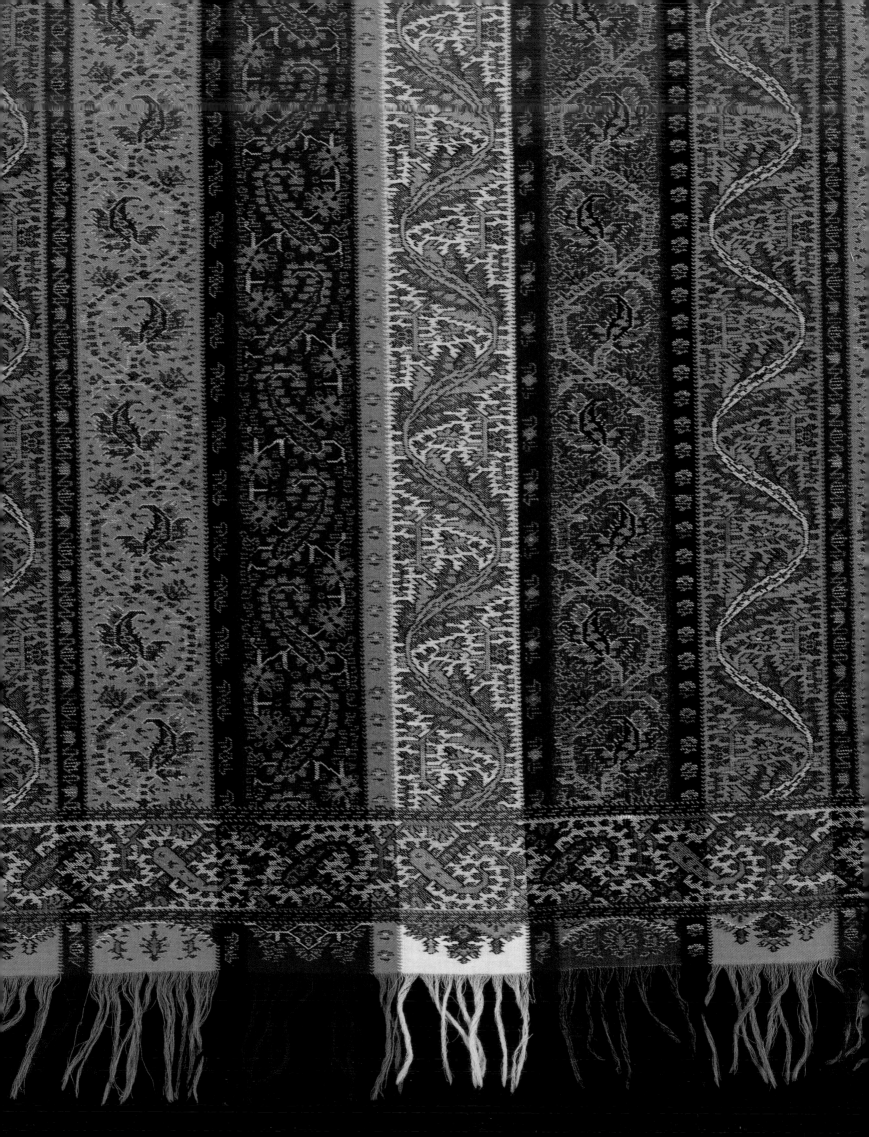

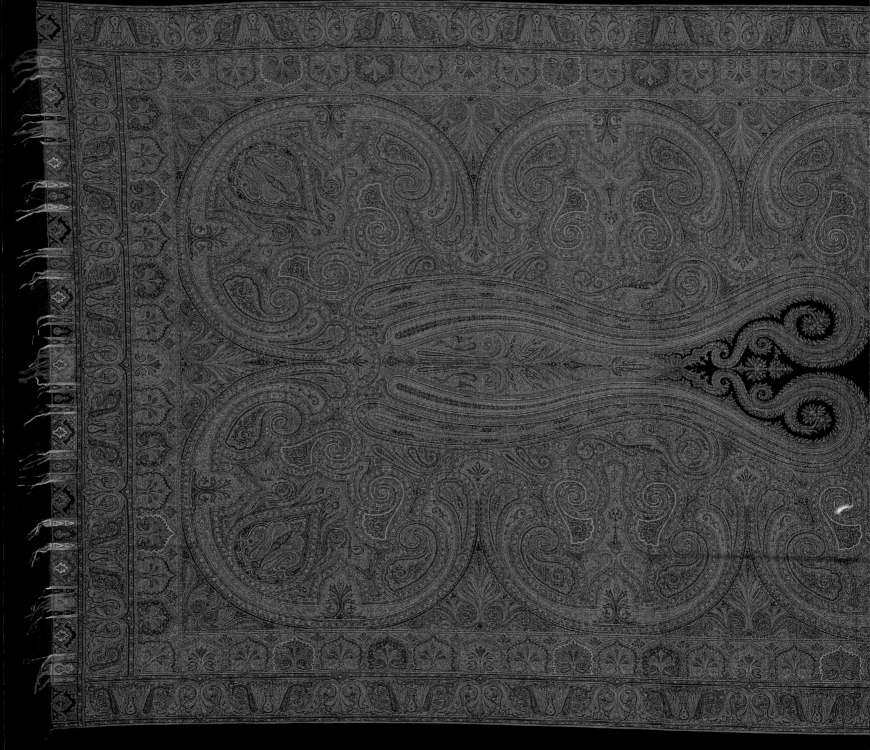

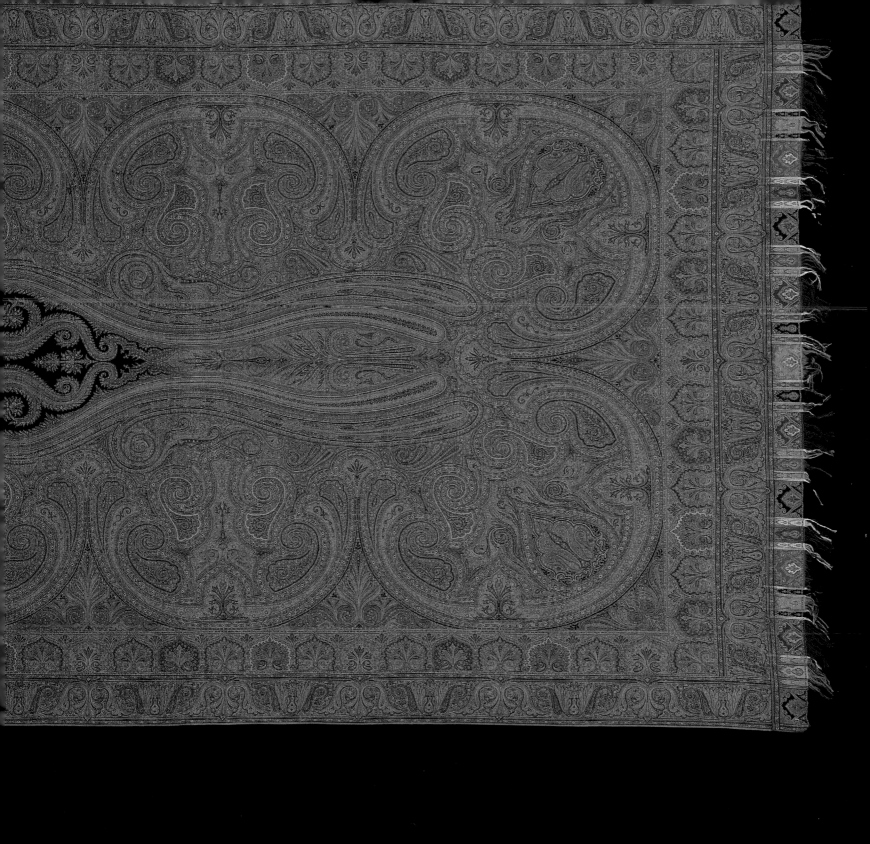

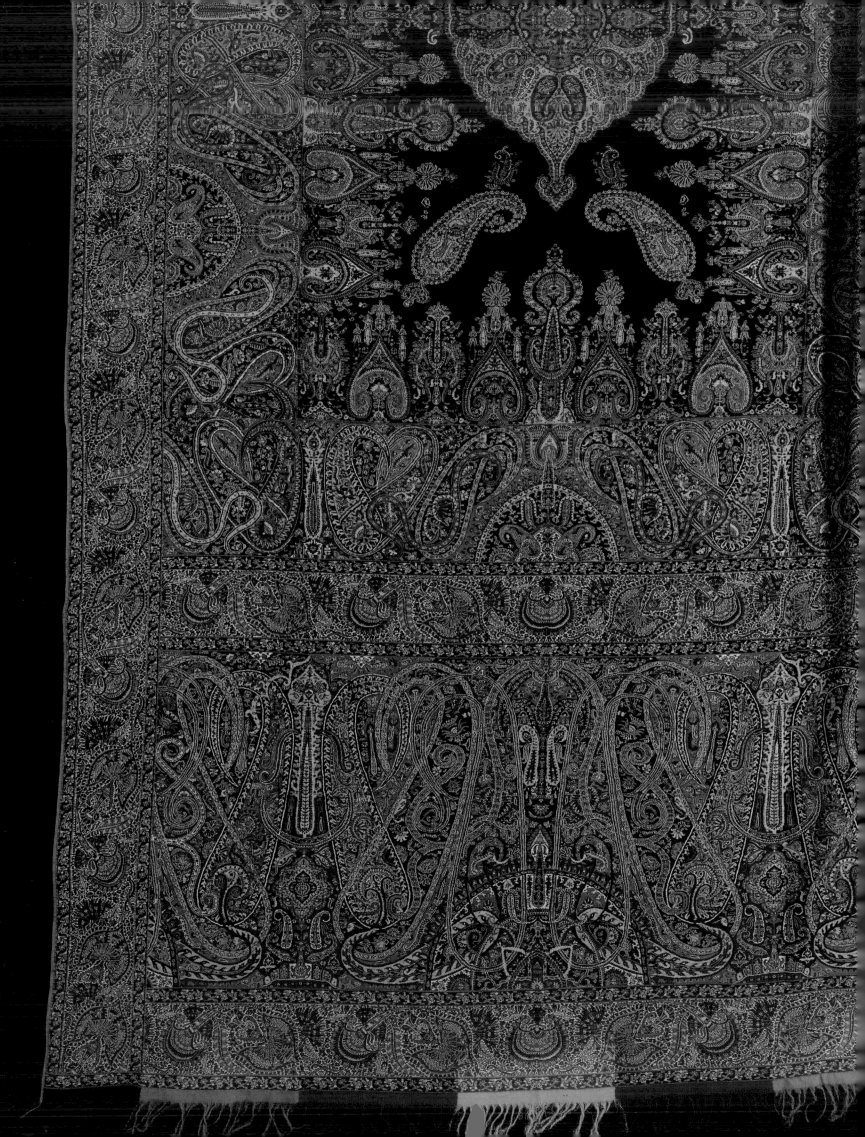

Hébert
& Fils

Nicolas Frédéric Hébert was born on 29 October 1784 in Rouen. In 1817 he married Adèle Pougin and the couple had two children: Adèle (future wife of the designer Adolphe Isidore Parguez) and Émile Frédéric (born 24 January 1824), who joined his father in the family firm and took it over in 1855.

With a view to obtaining the Legion of Honour – which was awarded to him on 8 May 1840 – Frédéric Hébert compiled a dossier in 1840 (now in the National Archives)[1] that gives a first-hand account of his professional life between 1811 and 1840. The principal passages are given below:

In 1814, on my return from Italy, where I had been responsible since 1811 for overseeing the Service of War Provisions in the fortified town of Pisa and its coastal region, and also the Civil Prisons Service, I was appointed temporary auditor at the Reserve Army's Accounts Office in Paris.

In 1815, when those duties had come to an end, following the advice of friends – who also provided me with financial assistance – I decided to form a company under the name of Frédéric Hébert & Cie for the purpose of manufacturing shawls. By 1817 I had already had some success manufacturing French cashmeres and since that time I have channelled all my efforts in that particular direction.

In 1819 I was awarded a bronze medal in the exhibition. Encouraged by this initial success to extend my French cashmere operations, I entered into a partnership – registered in Paris on 3 December 1822 – with the firm of Rey, whose capital and commercial relations promised more extensive outlets for my business activities. According to my agreement with M. [Monsieur] Rey I was to initiate and oversee the manufacturing of French cashmeres for the firm, which had no specialist experience in that field.

I was delighted to see my associate awarded the gold medal in the 1823 exhibition. Since my name was not part of the company name, all I gained personally was the satisfaction of having contributed to that success by taking charge of cashmere manufacturing.

My association with M. Rey came to an end in 1824. I formed a limited joint stock company and continued producing my French cashmeres without interruption, and at the 1827 exhibition I won a silver medal.

[1] Archives Nationales, shelf mark LH/1275/37.

In 1834 I was awarded the gold medal. Independently of their assessment of my products, the jury recognized that in the course of seventeen years' work I had actively contributed to the most significant advances in the manufacture of French cashmeres.

Up until 1825 this manufacturing process was based on an irregular mise en carte system. M. [Monsieur] Eck, my then designer, had been using a mise en carte for his twill-tapestry weave shawls exhibited in 1823 under the name Isot & Eck, and he now applied the same system to the manufacture of French shawls. I bought the patent from M. Eck and manufactured the first cashmere shawls using this system, which was then adopted by the industry as a whole. . . .

Hébert goes on to describe other improvements that he was responsible for introducing into French shawl manufacturing. Some of the facts mentioned by him are documented in the corresponding company records.[2] Thus, on 19 October 1815, Hébert formed Frédéric Hébert & Cie with two limited partners for a period of five years. Their registered address was 374 Passage Saint-Chaumont, Rue Saint-Denis, and the company capital was 40,000 francs, of which 8,000 francs was contributed by Hébert 'in cash and equipment'. Frédéric Hébert & Cie was liquidated on 11 June 1819.

At the 1819 exhibition Hébert was personally awarded a bronze medal (since the company no longer existed). The jury noted that:

The raw material used to make M. [Monsieur] Hébert's shawls comes from India through the good offices of Messrs Ternaux of Paris and is spun by Messrs Jobert & Lucas of Rheims. This type of shawl looks in every respect like a Cashmere shawl but can be sold. . .for a quarter of the price of an Indian shawl. . . . Messrs Hébert & Cie make some 600 shawls of this type a year and they are distributed throughout France and in Germany and Italy.

I have been unable to trace the document registered, according to Hébert, on 3 December 1822 and confirming his association with Jean Rey (see p. 197).

[2] The extracts were consulted in the Paris Archives and the records themselves in the Central Registry at the National Archives.

Jean Rey is the author of a highly informative book about the history of shawl manufacturing in France and was one of the best-known Paris shawl makers.[3] In awarding him a gold medal, the jury for the 1823 exhibition noted that his shawls replaced Indian ornamentation with 'a very precise imitation of real flowers whose brilliant colours are often enhanced by the felicitous use of gold embroidery'. The jury also noted the coloured shawl ends in *espoliné* or twill-tapestry weave – their first appearance in shawls manufactured by Jean Rey.

After the break with Jean Rey, Frédéric Hébert formed a new limited partnership on 12 July 1824 under his old name, Frédéric Hébert & Cie. The company was registered at 9 Rue de Cléry and Hébert's new associates were the shawl merchants and manufacturers Chapeaux & Paroissien, the printer and bookseller Charles Panckoucke (Madame Hébert's cousin) and a property owner called Grégoire Bénier. The company capital was fifteen shares worth 10,000 francs each. The responsibility for the day-to-day running of the firm lay with Hébert and its period of operation was fixed for six years.

This period may have been extended. In a biographical note he added to his dossier of 1840 (p. 197) Hébert made no mention of any changes to his company (and I have found no documentation concerning its liquidation). Either way, Hébert formed a new company, Frédéric Hébert & Cie, with his son Émile on 26 February 1851. Their registered office was at 13 Rue du Mail. The company capital, provisionally fixed at 136,000 francs, was gradually raised to 200,000 francs: Hébert senior contributed his business funds, including designs, furniture, equipment and the right to the use of the premises (at a total estimate of 35,000 francs), plus 65,000 francs in cash, monies owing, raw materials and manufactured goods; Hébert junior contributed 36,000 in cash, this stake being raised to 100,000 francs, since all profits eventually owing to him were compulsorily withheld. Both father and son had the right to sign. Frédéric Hébert retired and his son Émile took over the business around the time of the 1855 World's Fair.

In 1869 the business was taken over by a company called Tresca, successor to Hébert, which occupied the same premises, at 13 Rue du Mail.

In another note in the dossier of 1840, Frédéric Hébert described the various improvements made to the Jacquard mechanism between 1823 and 1828 that facilitated the weaving of French cashmeres. These were the new *mise en carte* invented by Eck, from whom Hébert claimed to have acquired the patent; the *mécanique à retour* invented by Rostaing, and the *double griffe* invented by Bosche and David – each of which was an improvement on the previous mechanism insofar as it reduced the number of punched cards required – and, finally, the *mécanique brisée* invented by Boillé, which replaced all of the previous mechanisms and which Hébert's company was one of the first to have adopted.

While acknowledging the authors of inventions that were to benefit the entire shawl-making industry, Hébert's exposé creates the impression that he was the first manufacturer to have ventured into the new territory. In the section of his brochure devoted to French cashmeres, Jean Deneirouse likewise claimed to be the first manufacturer to have adopted the new methods.[4]

Reporting for the jury for the 1839 exhibition – where another gold medal was awarded to Jean Deneirouse and Frédéric Hébert – Legentil and Bosquillon noted with reference to Hébert that:

[3] Jean Rey, *Études pour Servir à l'Histoire des Châles*, 1823.
[4] Jean Deneirouse, 1851, pp. 20–22 (see the chapter on him, pp. 295–311).

This is the manufacturer who put his money into and was the first to put into practice the two most important discoveries in shawl manufacturing: the return mechanism, invented by a person by the name of Rostaing, and squared point paper, the invention of M. [Monsieur] Eck, then designer to the same F. Hébert. Both these procedures greatly advanced the manufacturing of French shawls once the industry became familiar with them.

The assertion that Hébert had been 'the first to put into practice the two most important discoveries in shawl manufacturing' aroused protest from Jean Deneirouse. The jury for the 1844 exhibition – which included Deneirouse, who was reporting for the Shawls section along with Legentil – corrected the error, while nevertheless awarding Hébert and Deneirouse's successors the gold medal.

If the most competent judges of the time had difficulty deciding on the respective merits of their eminent colleagues, it is easy to see how much harder the task is for us today. One hundred and seventy years on, it is tempting to think that both manufacturers genuinely believed they were right and that they had invested a great deal of time and money in applying the inventions of Eck, Isot, Rostaing, Bosche and others: their parallel efforts, far from leading to a collaboration, turned them into rivals.

Here are some extracts from the reports drawn up by juries and journalists concerning Hébert's exhibits. The jury for the 1849 exhibition, with Gaussen and Roux Carbonnel reporting for the Shawls section, awarded Frédéric Hébert another gold medal, commenting as follows:

M. [Monsieur] Hébert continues to imitate the Indian model with both precision and intelligence, remaining faithful to a style which has brought him such extraordinary success. M. Hébert's workmanship is always flawless, and his materials and dyes cannot be faulted. Despite the vagaries of fashion and the caprices of the purchasing public, M. Hébert believes in confining his loyalties to the Indian shawl and sticks to his industrial guns with remarkable steadfastness. And one thing is certain: at various times the industry as a whole has come back to M. Hébert's way of thinking, but M. Hébert has never wavered for a single moment.

At the Great Exhibition of 1851, held in London's Crystal Palace, Hébert & Fils was awarded a prize medal. The jury singled out for special mention a long shawl with a four-colour ground, which may be the shawl held at the Musée de la Mode et du Textile in Paris. A French journalist reporting on the exhibition remarked:

M. [Monsieur] Hébert is the antipodes of M. Deneirouse and the classical manufacturer par excellence. Never for a moment has he been seen to depart from the pure Indian style. If he did so he would feel he was violating the laws of a beautiful and time-honoured craft endorsed by centuries of use and by the entire world....[5]

At the World's Fair in Paris in 1855, Émile F. Hébert junior was awarded the medal of honour (Hébert senior had just retired). Justifying its choice, the jury noted:

The goods produced by this young manufacturer are flawless; the texture and the quality of his fabric leave nothing to be desired. Without being exact copies of their Indian models, his shawls have the same restrained and magisterial beauty...his choice of colours is both simple and felicitous.

[5] Émile Bérès, 'Exposition Universelle de Londres', L'Illustration, 20 September 1851, p. 190.

In his dictionary published in 1859, Jean Bezon welcomed the invention of a completely new type of shawl:[6]

What we needed was to find a means of executing espoliné *weave using a brocading batten that operated all the bobbins in a single row simultaneously, enabling us to produce Indian woven fabric at less cost than in the countries from which it originated.... Given the superiority of French manufacturing over that of other European countries, there was every reason to believe that if the difficulty were ever to be overcome, it would be France that enjoyed the glory of the discovery.*

The gap in the industry was still waiting to be filled, therefore, but now this situation has been remedied. In 1856 M. [Monsieur] Voisin successfully applied his method for the mechanical production of satin-stitch embroidery to the manufacture of cashmere shawls. From the earliest attempts M. Voisin's machine, although highly imperfect, and made of wood, carried six bobbins or shuttles to every five centimetres [two inches] and produced reasonably good results. Voisin was only steps away from perfecting his technique, but his success depended on the active collaboration of one of the manufacturing firms. Such assistance was forthcoming from M. Frédéric Hébert, who is well known in the shawl industry, and with this manufacturer's help Voisin succeeded in manufacturing a new precision machine in iron, copper and steel equipped with seven bobbins, or shuttles if you will, to every five centimetres [two inches]....

Once again, Frédéric Hébert had helped to fine-tune a new technique, the fruits of which his son displayed at the Great Exhibition in London in 1862.

The representatives of the shawl designers and weavers, who reported on the exhibition, concluded their remarks concerning the Hébert company by saying that their machine-made twill-tapestry weave shawls still left room for improvement:[7]

...Turning now to their Indian shawls, we have to confess that we are not especially struck by them. We find them too curly on the back, and this results in their being thick and heavy, to say nothing of the thin patches that appear every 15 millimetres from one end of the shawl to the other, and the imperfections visible on the right side. We ought, nevertheless, to congratulate M. Hébert for having encouraged and supported an inventor who has been seeking to perfect a system that hitherto has encountered so many obstacles.

Maxime Gaussen, reporting on the Shawls section, was less severe:

No previous efforts had given rise to such optimism as these recent attempts to imitate, by mechanical means, what has come to be known as Indian work.

Frédéric Hébert died a few months later. His son Émile does not appear to have continued producing machine-made *espoliné*, or twill-tapestry weave, shawls, although other manufacturers did. Lecoq, Gruyer & Cie won a first-class medal for their 'Indian shawls' at the World's Fair in 1867, but there were none among Hébert's submissions. Here is what the shawl designers' delegation had to say about his large pivoting design:

Maison Hébert has always held its own in industrial competitions.... But at previous exhibitions we have seen...shawls of superior design to the châle à grand pivot *exhibited here...the design is too heavy.*

6 Jean Bezon, vol. IV, pp. 365–67.
7 *Rapports des Délégués Tisseurs en Nouveautés Publiés par la Commission Ouvrière*, Paris, 1863. National Archives, shelf mark F12/5097.

The Musée Galliera has in its collections a *châle à grand pivot* (an identical shawl is shown on p. 234), signed by Hébert and dating from around this time; it is possible that the report is referring to the same model. Since he was reporting for the jury at this same exhibition (the World's Fair of 1867), Hébert was not able to compete. He was named a knight of the Legion of Honour in 1863 and retired from business shortly before 1870. Émile Hébert had always been a staunch realist in his style of management and it should therefore not surprise us if he was able to foresee the commercial demise of the 'rich' shawl or that he chose to abandon the profession at such a young age. When Tresca took over as successor to the Hébert firm, Émile Hébert was pursuing a very different career as a judge at the Commercial Court in Paris.[8]

Hébert had its own design studio, which was run in the 1850s and 1860s by a Monsieur Claverie – what is not certain is whether it was Claverie or his employers who should be thanked for the house style. Many Hébert shawls woven between 1850 and 1869 and signed are still in existence, so it is possible to identify certain common characteristics. The jury reports had good reason to commend their excellent manufacture: Hébert designs are balanced compositions with a restrained, classical elegance; their detailing is sophisticated and they are beautifully and finely woven. It is worth noting that certain motifs are sometimes repeated as many as sixteen times – to reduce the costs of the *mise en carte* and keep the price down – but without detracting from the overall design. The jury reports of 1815 tell us nothing more about the first shawls made by Frédéric Hébert other than that they are faithful imitations of their Indian prototypes. But Adolphe Blanqui, reporting on the shawls submitted to the 1827 exhibition,[9] mentions 'two black shawls with columns in the background and a third, resembling a rainbow, with wide borders and five columns in the background'.

The jury for the 1834 exhibition awarded Hébert the gold medal, justifying its choice in the following terms: 'An unerring sense of beauty, not without boldness, which in copying Indian shawls discerns clearly which elements to borrow and which to abandon; a rare understanding of colour, a profound knowledge of manufacturing techniques – these are the qualities that put this exhibitor on a par with his most adept rivals.'

The first reproductions of Hébert's designs are to be found in the album entitled *Souvenir de l'Exposition des Produits de l'Industrie Française de 1839*.[10] They include the border of a long shawl decorated with alternating adorsed and confronted pines (p. 8) and a motif in the form of a lyre bird appearing against the green ground of a square shawl (p. 207). The lyre-bird design is strongly reminiscent of Indian shawl designs of the 1840s; the only Hébert design *not* inspired by Indian models was the shawl known as *The Dendera*.

It was through the minutes of a lawsuit conserved in the Paris Archives,[11] to which the head curator Brigitte Lainé drew my attention, that I learnt that Hébert had produced a square shawl called *The Dendera* – named after the zodiac in the Dendera temple complex in Egypt. Having marketed his shawl in 1841, Hébert discovered that it had been copied by a manufacturer from Lyons and sold in Paris; he filed a claim and won. There are two versions of the shawl: one with a blue ground (pp. 216–17) in the collections of the Royal Ontario Museum in Toronto; the other, with a green ground, is in the Antonio Ratti collection, in the Italian city of Como.

[8] Paris Archives, notification of transfers by death no. 1382, dated 5 September 1894.
[9] Adolphe Blanqui, p. 106.
[10] Fleury Chavant, *Souvenir de l'Exposition des Produits de l'Industrie Française de 1839*, plates 4 and 41.
[11] Paris Archives, shelf mark D2U3/2065, 'Minutes of a judgment in the Commercial Court relating to a case of counterfeiting: Hébert being the plaintiff and Damiron Frères and Chapusot & Tardiveau the defendants', 14 June 1843.

The choice of motifs reminds us of the *Nou-Rouz* shawl (p. 152), made by Gaussen to a design by Amédée Couder, which caused such a stir at the Paris exhibition in 1839. The central medallion motif, the medallion borders and the elephants all have an oriental flavour, although the inspiration here is Egyptian rather than Persian.

Dendera is a village in Upper Egypt, situated on the left bank of the Nile, north of Thebes. It was constructed on the ruins of a temple to the goddess Hathor. This temple, built on ruins dating from the sixth dynasty (*c.* 2345–2181 BC), was started at the end of the time of the Ptolemies (305–30 BC) and completed under the Roman occupation (1st century BC to 1st century AD). During Napoleon's Egyptian campaign in 1798, General Desaix discovered a sandstone sculpture at Dendera representing a circular zodiac inscribed inside a square measuring approximately 2.5 m (8 ft 2½ in.) and supported by twelve figures with arms outstretched. The zodiac was in the ceiling of a chapel dedicated to Osiris (built on the temple roof). In 1821 a Frenchman by the name of Claude Lelorrain was commissioned to remove the zodiac, which he achieved with the help of a powder gun – even though it broke in two in the process. The zodiac reached Paris after six months in transit, and Louis XVIII acquired it for the phenomenal sum of 150,000 gold francs. It was exhibited for a year in the Louvre and then installed in the Royal Library (today's Bibliothèque Nationale de France), where it remained until 1919, when it was returned once more to the Louvre to grace the ceiling of Osiris's crypt. *La Grande Encyclopédie* (The Great Encyclopedia) traces the history of the Dendera zodiac, noting that this ancient bas-relief, on display since 1822, 'has served as fuel for the most unreasonable imaginations'.[12]

The large medallion in each of the shawl's four quarters represents a stylized version of the famous Dendera zodiac (p. 215), with its four standing female figures representing the four main points of the compass, and the four groups composed of two kneeling falcon-headed spirits with their raised arms interlinked, which are repeated on either side of the zodiac, beneath the motif of the man fighting a dragon.

The hieroglyphs in the centre of the zodiac have been replaced by a Hindu statue representing the god Brahma with his four crowned heads and four arms: in one of his left hands he holds the Hindu sacred texts, the Vedas, and in the other a flask of water from the Ganges; in his right hands he holds a lustral spoon and a rosary. The motif of Brahma appears four times, twice facing the same way as the model, twice facing the opposite way – confirming my hypothesis that the two left quarters of a shawl always reproduce the design of the *mise en carte*, while the two right quarters present a mirror image of the design.

The shawl is almost 2 m (6 ft 6¾in.) square. It would have been folded diagonally and draped evenly across the shoulders, so that the Dendera zodiac was shown to best advantage. It is tempting to speculate on what was in Hébert's mind when he created his zodiac shawl. We can imagine him visiting the 1839 exhibition, seeing the *Nou-Rouz* with its new type of decoration incorporating figures and architectural structures, and registering the impact it made. If the public wanted exoticism, that was what he would provide, and he would show that he too was capable of producing a masterpiece. As a companion piece to Gaussen's shawl representing the Persian New Year, Hébert would reproduce the Egyptian zodiac depicting the yearly voyage of the sun around the earth.

12 André Berthelot (ed.), *La Grande Encyclopédie*, Société anonyme de La Grande Encyclopédie, Paris, 1885–1903, vol. 14, pp. 96–97.

Hébert's offices in Rue du Mail were a stone's throw away from the Royal Library where, for the past sixteen years, the public had come to admire the famous Dendera zodiac. Around the zodiac, Hébert depicted other marvels that were to be found in the same library. The white elephants (p. 214) abutting the quarter-medallions in the corners of the shawl are inspired by two chess pieces (corresponding to our bishops) that form part of the Trésor de Saint-Denis exhibited – in 1840 as it still is today – in the Medals Room at the Bibliothèque Nationale. The elephants, each carrying two mahouts (elephant riders), are in ivory with traces of gilding; they are approximately 12 cm (4¾ in.) tall, date from the end of the eleventh century and are thought to be from Salerno, in southern Italy. The similarity between the woven elephants and their ivory originals is striking. Note in particular the mahouts' crook, the diagonally checked saddle-cloth with its beaded edging and the knee cap that protects the front leg of the white elephant.

The designer also drew inspiration from other Egyptian antiquities, reproducing one of the Colossi of Memnon (p. 212) from an illustration in Antoine Jean Letronne's book *La Statue Vocale de Memnon* (The Vocal Statue of Memnon), published in Paris in 1833. These 20 m (65 ft 7½ in.) high statues stand on the Theban plain, across the River Nile from the modern city of Luxor. One of them was partially destroyed by an earthquake in 27 BC and reconstructed by the Roman emperor Septimius Severus at the end of the second century AD. Instead of being made in a single piece, the reconstructed colossus (from the waist up) had five tiers of stone, and the *mise en carte* for the shawl design clearly indicates the joins. While still in its damaged state, the statue was said to emit musical sounds at dawn and the 'Vocal Memnon' became the subject of legend.

The shawl design incorporates other exotic elements drawn from the pages of the weekly magazine *Le Magasin Pittoresque* (first published in 1833), such as the model of the elephant designed as a centrepiece for the Place de la Bastille (p. 214) and the procession of figures (p. 216) decorating an Etruscan situla (or bucket-shaped vessel) in gilded silver that is conserved in the Archaeological Museum in Florence.

In 1842 Hébert sued Damiron Frères and Chapusot & Tardiveau for (respectively) counterfeiting his design and selling the counterfeit goods. Damiron and Chapusot appealed repeatedly and some of the judgments pronounced against them between 1842 and 1844 are still extant. The transcript of the proceedings for 14 June 1843 provides the following information:

> ...*in as much as, in early June 1841, Hébert offered for sale a square French cashmere shawl...which he called the Dendera model....*
>
> ...*in as much as, during the course of 1842, Damiron Frères offered for sale a square shawl in Tibet weave and that the design presents the most striking similarities with the Hébert shawl....*
>
> ...*in as much as it [the injury] should be calculated to include the full extent of the damage experienced, and the Damiron shawl, being manufactured in much more common material, involving less complicated workmanship and being of smaller dimensions, was offered for sale at a price differential of almost ¼ less than the Hébert shawl...and there resulted from this an injury to the manufacturer the figure for which the court is now able to determine and which it fixes at 6,000 francs....*

...the court, in view of the expert's report,...jointly and severally orders Damiron Frères and Chapusot & Cie...to pay Hébert each the sum of 3,000 francs by way of damages and interest, and prohibits them from ever in the future selling the said shawl, either directly or indirectly, a fine of 100 francs being levied for each shawl sold in contravention of this ban...orders Damiron Frères, Chapusot & Cie to pay all the costs including the sum of 105 francs disbursed for the acquisition of the counterfeit shawl....

Thanks to these minutes, we know that Hébert's *Dendera* shawl dates from June 1841 and was a 'French cashmere shawl'; in other words, that it had a cashmere warp (the cashmere wool was generally wound around a central silk strand). We also learn that the Damiron shawl was in 'Tibet weave' – that is, woven using yarn made from silk and wool (or even cotton) waste, as was common practice among shawl makers from Lyons. And finally we are told that the Damiron shawl cost 105 francs and that its price was 'almost ¾ less than the Hébert shawl'. So, the Hébert shawl must have cost in the region of 420 francs, which corresponds to the standard prices for the time, as listed by the jury report for 1839 in the chapter devoted to 'Cashmere Shawls and their Imitations': 'The majority of these shawls are square and measure between 180 and 195 cm (70⅞ and 76¾ in.). The prices vary between 220 and 500 francs. Rarely are fewer than eight colours used....'

Before they started signing their shawls, Frédéric and Émile Hébert sometimes wove the words 'pure cashmere' in the central reserve of a shawl. They appear to have been the only manufacturers to have adopted this practice. A long shawl in the Etro collection (pp. 222–23) bears an inscription of this type. On 25 August 1852, Frédéric Hébert & Fils registered the trademark 'H. Cachemire Pur' with the Prud'hommes Registry in Paris.[13] The 'H' appears under a *mihrab* (prayer niche) and the graphic style is Italianate. Although the 'H' remained clearly legible, as time went on the letters of 'Cachemire Pur' became more and more stylized; by the 1860s only the capital 'C' and 'P' remained, followed by a series of small 'o's under a curving line. When Tresca took over the business, he kept the same inscription, simply replacing the 'H' under its *mihrab* with a 'T'.

From 1828 onwards, as a matter of course, Frédéric Hébert registered his shawl designs, sketched on a *vernis*, with the Prud'hommes Registry. From 1849 to 1862 the Hébert firm registered designs bearing both a number and a name, often that of a flower or a tree. A trademark was registered for fifteen years, but the designs only lasted five: when the five years were up, they were destroyed; so we have to rely on the registrations for details. Eight designs (no. 963) registered on 19 May 1853 include a long shawl (design no. 57) called *The Palm Tree*. There are several copies of a long shawl dating from around this time (p. 227), and it could be this shawl that is referred to here. Two palm trees of different heights are outlined against the central black field; framed by a *mihrab*, the taller of the two leans down towards the smaller tree like a father leaning towards his child. The composition and the treatment of details are reminiscent of Hébert, but the shawl is unsigned. Possibly the *mihrab* itself is the signature. Alternatively, the trunks of the palm trees stand for the uprights in the letter 'H'. The number '55' woven into the harlequin shawl ends may refer to the year 1855, which was when Frédéric Hébert passed the reins to his son Émile. A square shawl decorated with lyre birds (pp. 208–9) – very similar to the ones on the Frédéric Hébert

13 Paris Archives, Designs and Models Registered with the Prud'hommes Registry in Paris, Fabrics Section, registration no. 815, for a period of fifteen years.

Louis Hersent (1777–1860),
Portrait of an Unknown Woman, *1846.*
Initialled in the right-hand corner.
33 × 25 cm (13 × 9⅞ in.).
Paris, author's collection.
The woman's shawl is decorated with motifs similar to those on the shawl by Frédéric Hébert reproduced opposite.

OPPOSITE
Shawl in Cashmere, Manufactured by Frédéric Hébert & Co., Paris, *plate no. 41 from the* Souvenir de l'Exposition des Produits de l'Industrie Française de 1839.
Paris, Bibliothèque Forney.

shawl reproduced in *Souvenir de l'Exposition des Produits de l'Industrie Française de 1839* (p. 207) – also features a *mihrab* (housing a miniature temple) in each corner.

On 6 March 1856, Émile Frédéric Hébert, who had now taken the business over from his father, registered a half-moon stamp bearing the inscription 'Seule Médaille d'Honneur 1855 E. F. H. Cachemire Pur' printed in gold letters, which appeared on the back of his shawls.[14]

Following his nomination as knight of the Legion of Honour in 1863, Émile Hébert replaced the old half-moon stamp with a new one bearing, in gold letters, the inscription: 'Seule Médaille d'Honneur, 1840 E. F. H. 1863'. The monogram 'E. F. H.' was flanked by two crosses with, beneath them, the dates on which father and son were awarded the Legion of Honour.

Frédéric Hébert was undoubtedly one of the great pioneers of the shawl industry. He was responsible for promoting a number of technical innovations relating to the *mise en carte*, the Jacquard mechanism and mechanical twill-tapestry weaving. On an artistic level he showed great discernment in his choice of colours and the motifs that he transposed from his Indian models.

Émile Hébert managed the firm with great assurance after his father retired, and it is indeed to him that we owe the detailed account of the life of a Paris shawl weaver, published in a book about European workers (pp. 84–87).[15] He ignored the challenge of producing twill-tapestry weave mechanically and only started creating pivoting designs some twenty years or more after Maxime Gaussen and Jean Deneirouse. The Héberts were in business from 1815 to 1867 and can be classed among the top three or four Parisian shawl makers.

14 *Ibid.*, registration no. 1712, in perpetuity.
15 Émile Frédéric Hébert and Ernest Delbet, 'Tisseur en Châles de Paris', in Frédéric Le Play, *Les Ouvriers Européens* (The European Workers), Paris, 1887.

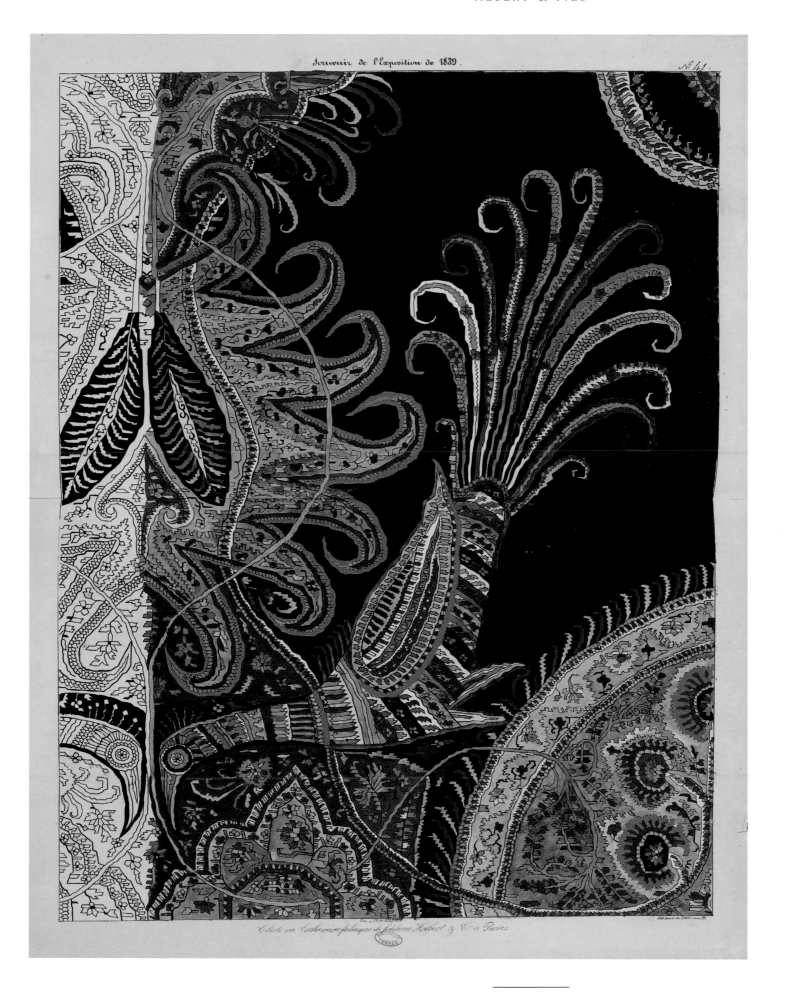

Souvenir de l'Exposition de 1839.

Nᵒ 41.

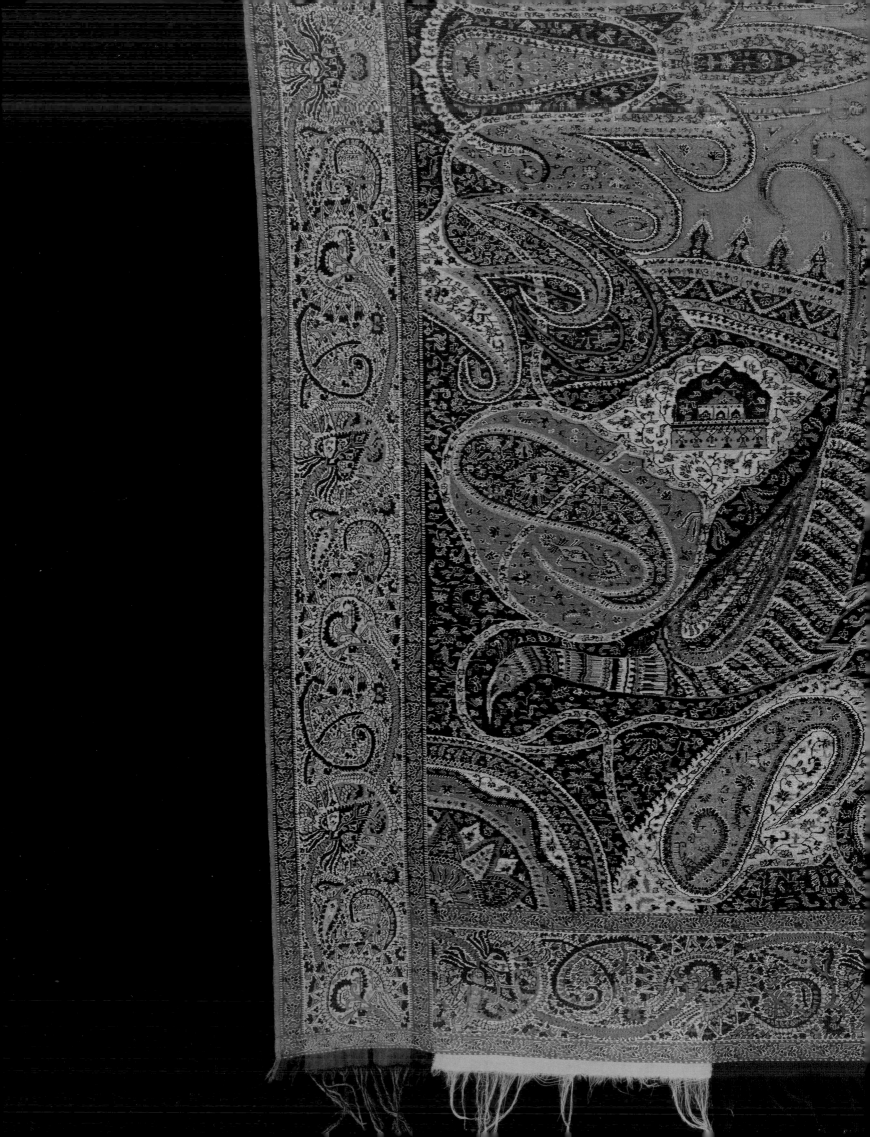

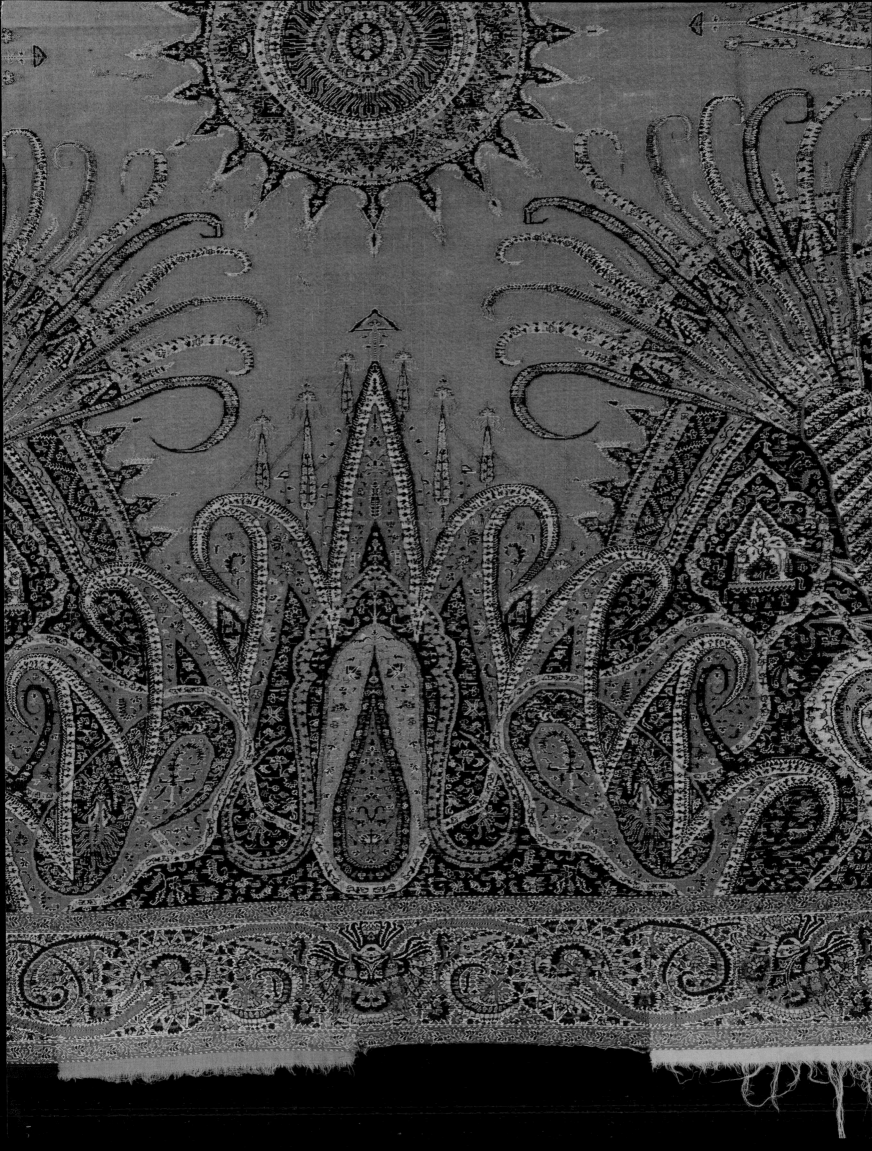

TORESQUE.

ceux-ci, quoique grossier, n'est pas dépourvu d'énergie e
d'un certain sentiment du vrai.

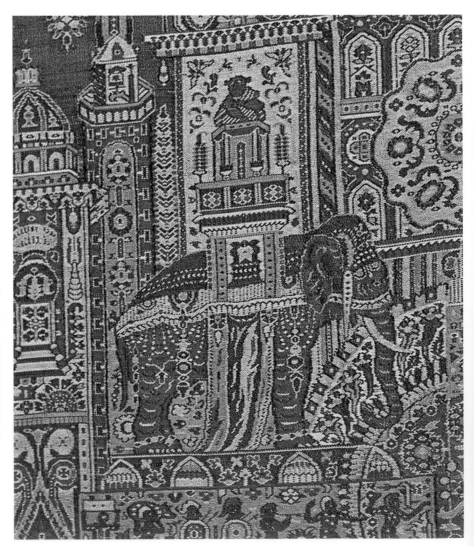

A la mort de M. Célerier, M. Alavoine, son inspecteur, lui succéda dans la direction des travaux; et c'est d'après les dessins de ce dernier architecte, que s'exécuta le modèle de l'éléphant que représente notre gravure.

Ce modèle en charpente, armé de fer, recouvert en plâtre, a été exécuté, quant à la sculpture, par M. Bridan, statuaire. La machine hydraulique destinée à alimenter la fontaine aurait été établie dans la tour que portait l'ani-

(Modèle de l'éléphant qui devait orner la place de la Bastille.)

ANTIQUITÉS ÉGYPTIENNES.
ZODIAQUE CIRCULAIRE DE DENDERAH.

PREVIOUS PAGES
Details of the shawl reproduced on pages 216–17.
The reconstructed Colossus of Memnon seen in profile (top);
frontal view of the same (bottom).
Description de l'Égypte, *vol. 2, Paris, 1809.*

Quarter section of the shawl reproduced on pages 216–17.

OPPOSITE
Details of the shawl reproduced on pages 216–17.
Two plates published in Le Magasin Pittoresque,
1834, nos. 2 and 20.

ABOVE *Elephant ridden by two mahouts, ivory chess*
piece (equivalent of a bishop), Salerno, 11th century,
part of Charlemagne's Chess Set.
Paris, Bibliothèque Nationale, Cabinet des Médailles.

BELOW *Model of the huge ornamental elephant that*
was intended for the Place de la Bastille in Paris.

ABOVE RIGHT
The Dendera Zodiac, illustration in Le Magasin
Pittoresque, *1833, no. 40.*

BELOW RIGHT
Detail of the Dendera shawl, which is reproduced
on pages 216–17.
The designer has replaced the hieroglyphs at the centre
of the zodiac with an image of the Hindu god Brahma.

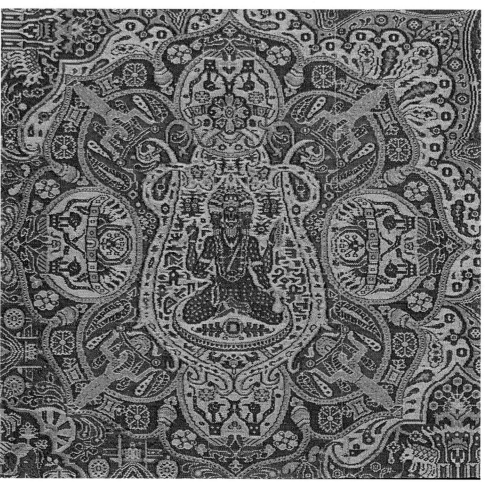

MAGASIN PITTORESQUE. 255

TABLEAU HISTORIQUE DE L'ART CHEZ LES ÉTRUSQUES.

(Style étrusque ancien. — Premières périodes.)

Detail of the shawl reproduced opposite and (below) an
illustration from Le Magasin Pittoresque, 1834, no. 31.
The decorative frieze is engraved on an Etruscan situla made
of gilded silver and dates from the 7th century BC.

OPPOSITE
Square shawl with a blue ground, manufactured
by Frédéric Hébert and known as Le Dendera.
Paris, 1841.
Woven au lancé using nine weft colours, trimmed on back,
cashmere, 200 × 195 cm (78¾ × 76¾ in.).
Toronto, Royal Ontario Museum.
ROM, no. Inv 986.87.1.
The harlequin shawl ends have been doubled over, top and bottom.
Hébert's response to the Nou-Rouz, which created a sensation
in 1839, Le Dendera is the only Hébert shawl to differ
significantly in design from the Kashmiri model.

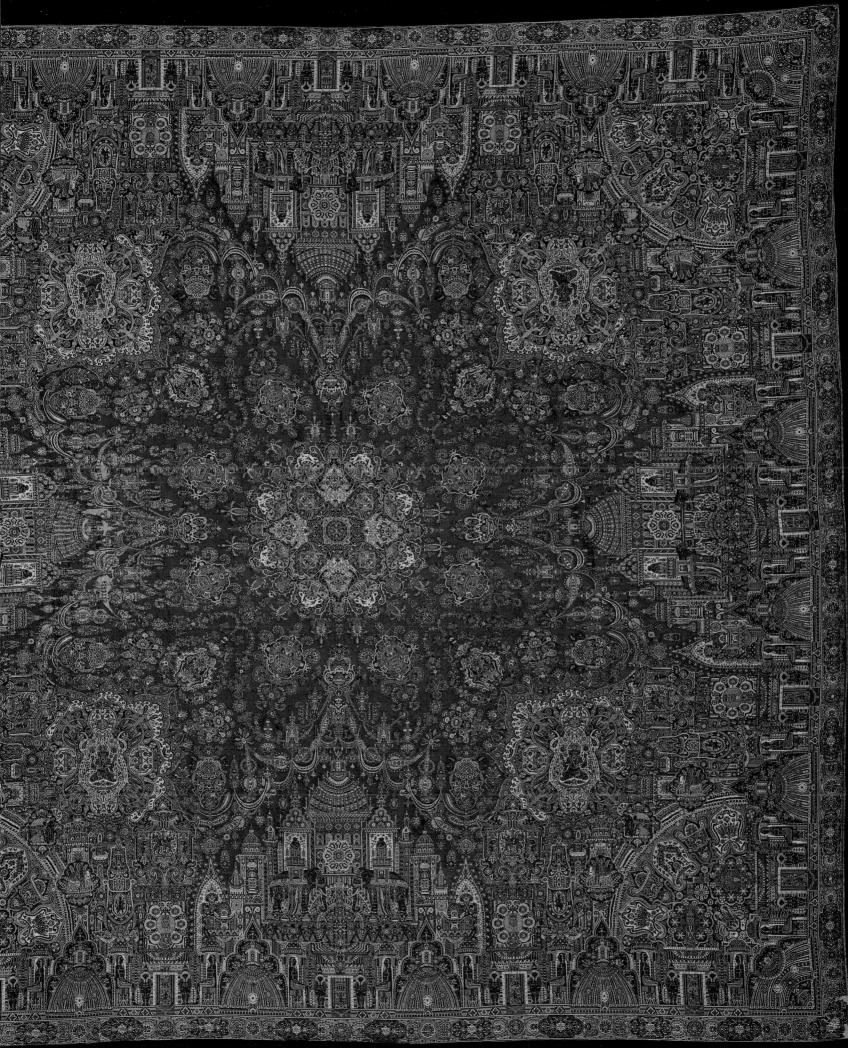

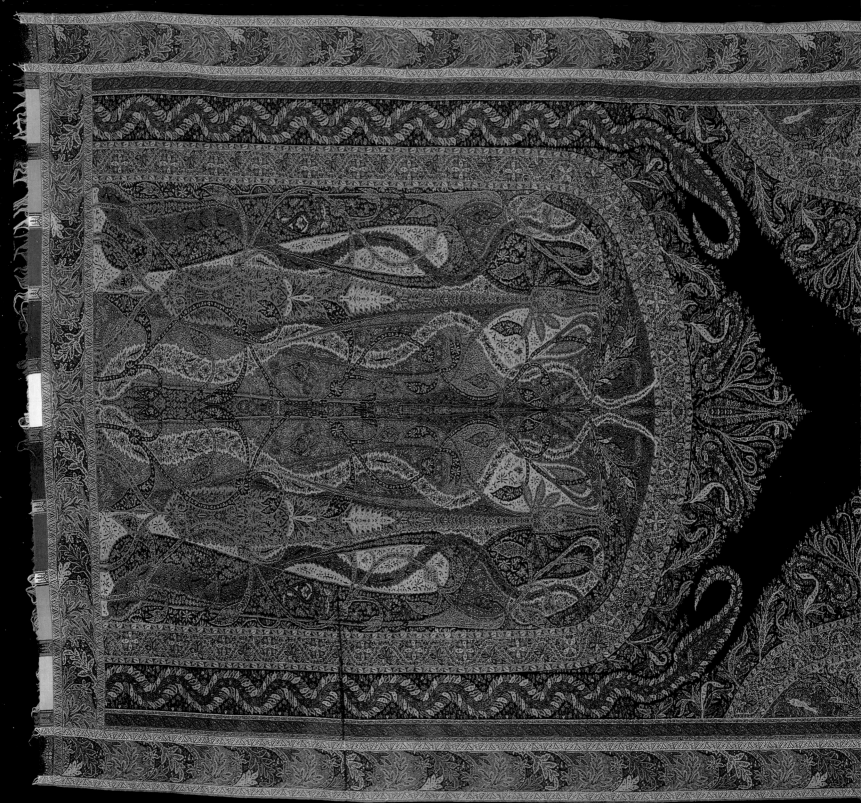

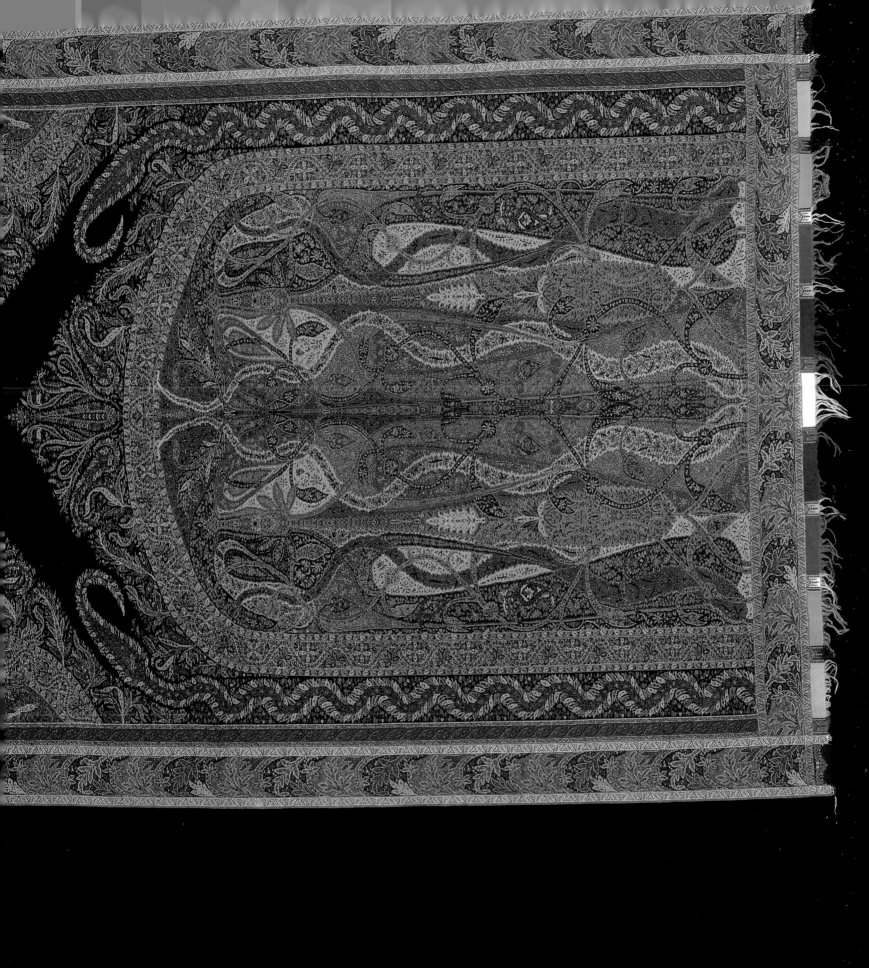

Detail of the shawl shown opposite.

OPPOSITE
Detail of a square shawl with a black ground,
manufactured by Frédéric Hébert.
Paris, 1850–52.
Woven au lancé using nine weft colours, trimmed on back,
cashmere, 188 × 188 cm (74 × 74 in.).
Paris, author's collection, no. 22.
The words 'Cachemire Pur' are woven in white on the black central
reserve – a practice Hébert adopted for several months before adding his
initial 'H' under a mihrab (prayer niche) and, in 1852, registering it
as his trademark.

PREVIOUS PAGES
Long shawl with a black ground. Paris, c. 1845.
Woven au lancé using nine weft colours, trimmed on back,
cashmere, 348 × 156 cm (137 × 61⅓ in.).
Milan, Etro collection, no. 182.
Note the ogee motif of the vertical borders. The small borders of the
shawl reproduced on page 230 – and signed Hébert – show the same
motif; it therefore seems likely that this shawl is also one of Hébert's.

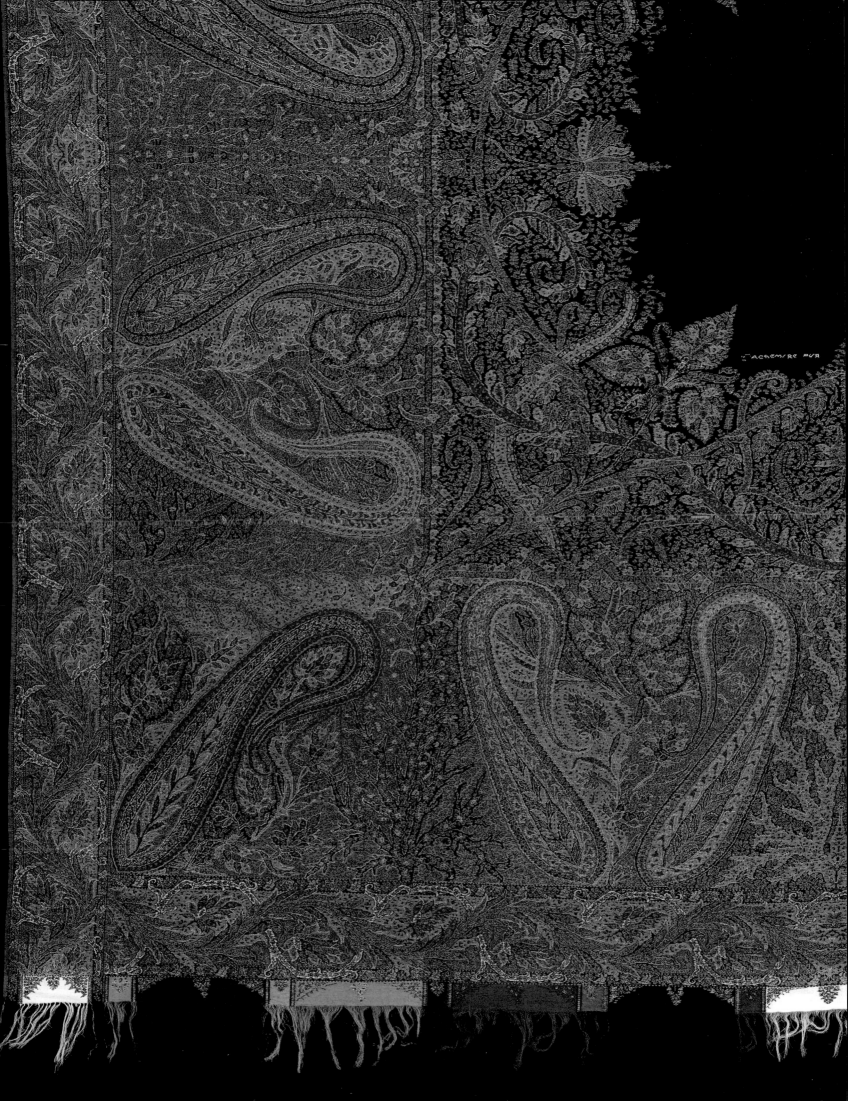

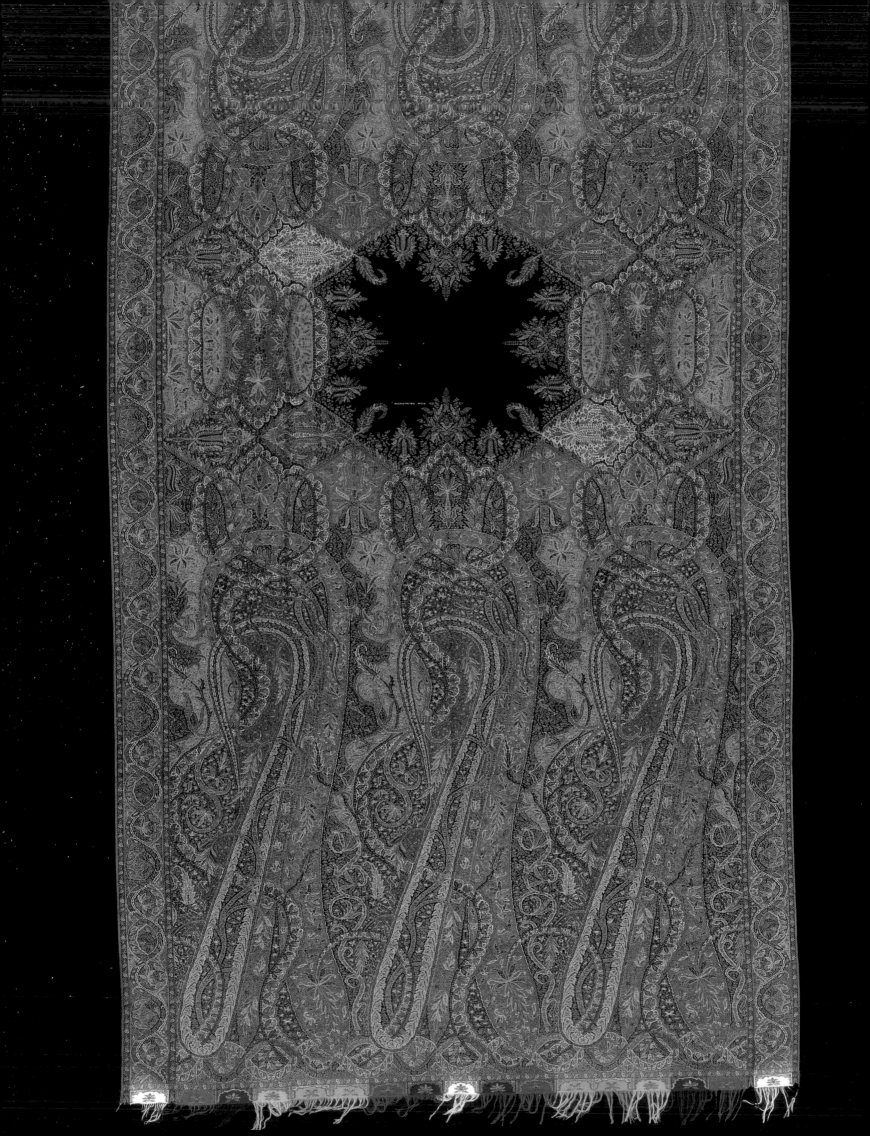

Detail of the shawl shown opposite.

OPPOSITE
Lower section of a long shawl with a black central reserve.
Paris, manufactured by Frédéric Hébert & Son, c. 1850.
Woven au lancé *using nine weft colours, trimmed on back,*
cashmere, 352 × 160 cm (138¼ × 63 in.).
Milan, Etro collection, no. 251.
As in the case of the shawl shown on page 221, the
inscription 'Cachemire Pur' *is woven in white*
on the black central reserve.

PAGE 224
Detail of the shawl reproduced on page 225, showing the
inscription woven in white in the left-hand corner of the
central reserve. In 1852 Hébert began weaving his initial
under a mihrab *in front of the words* 'Cachemire Pur'.

PAGE 225
Section of a square shawl with a black central reserve.
Paris, manufactured by Frédéric Hébert & Son, c. 1855
Woven au lancé *using nine weft colours, trimmed on*
back, cashmere, 190 × 188 cm (74¾ × 74 in.).
Paris, author's collection, no. 39.
The motifs framing the central reserve have differently
coloured grounds.

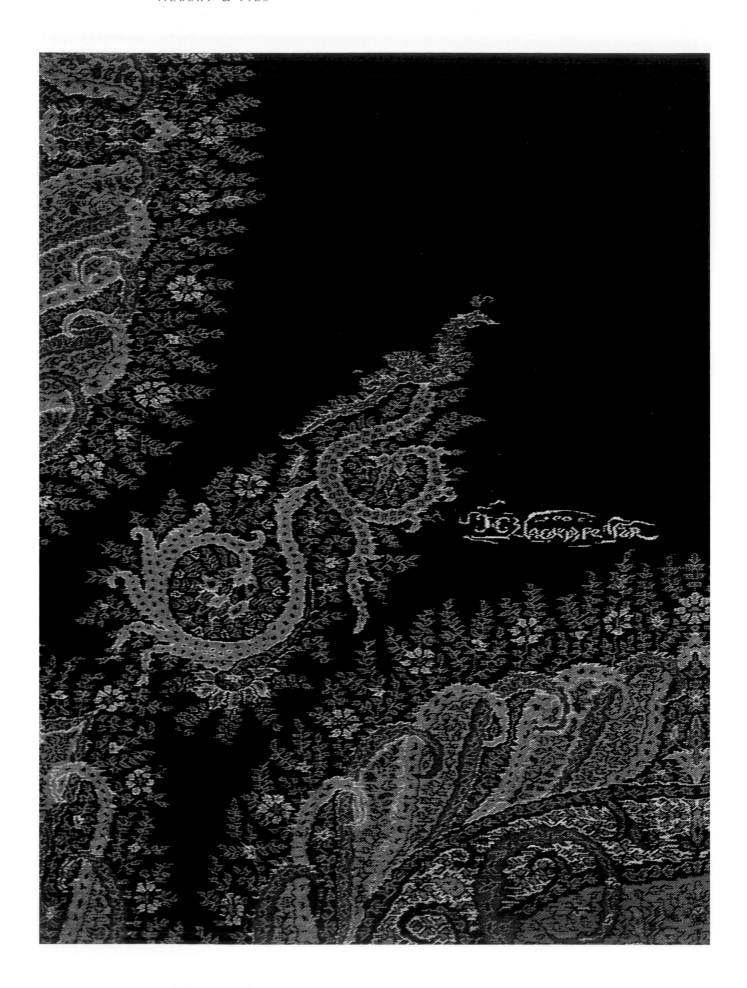

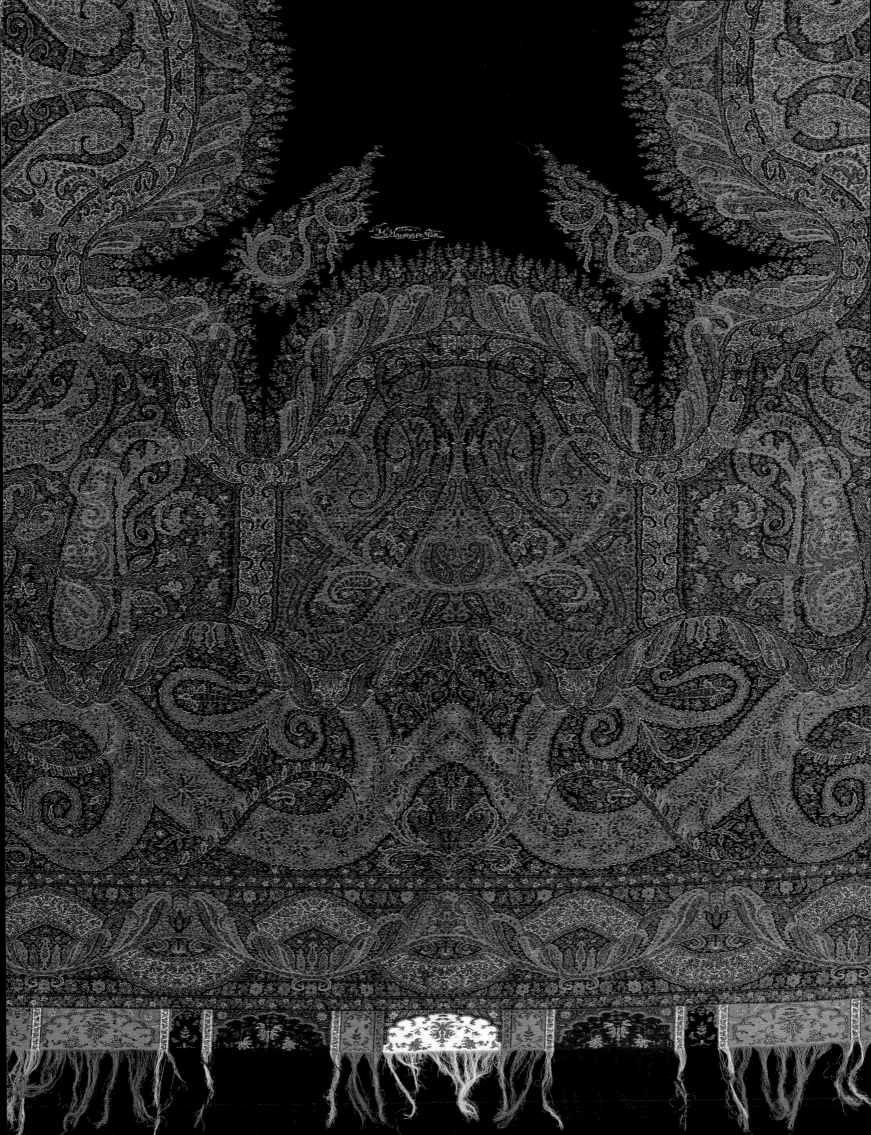

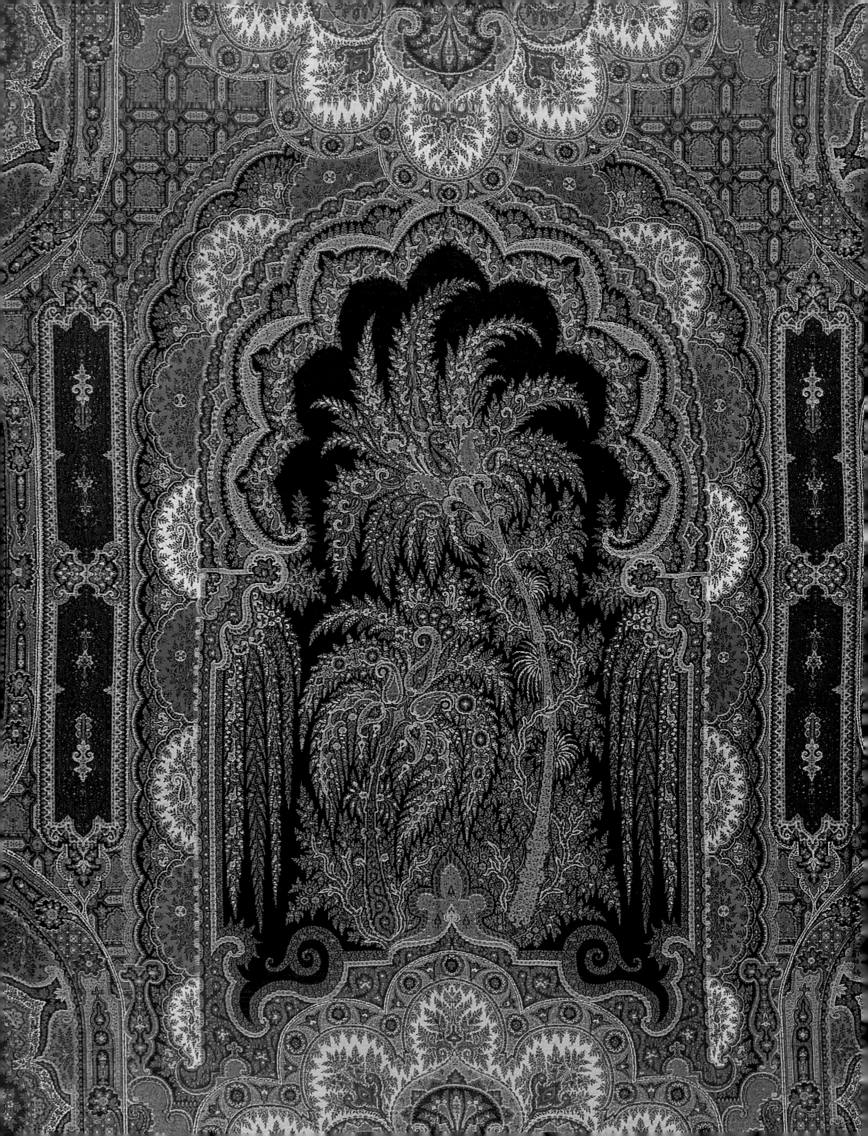

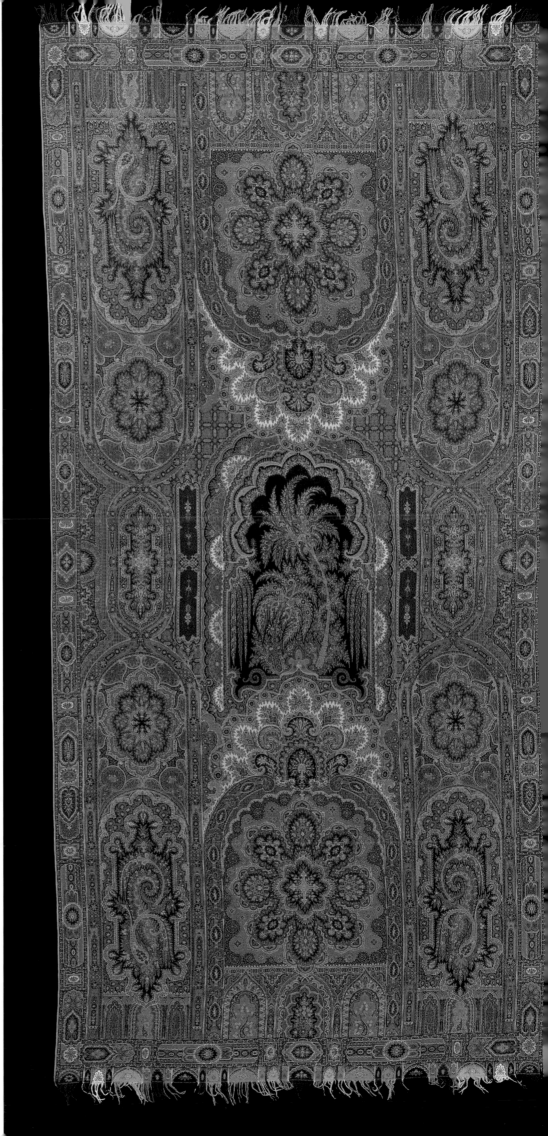

Detail of a long shawl known as
The Palm Tree.
*Paris, manufactured by Frédéric Hébert
& Fils, 1855.*
*Woven au lancé using eleven weft
colours, trimmed on back, cashmere,
315 × 160 cm (135⅞ × 63 in.).*
Milan, Etro collection, no. 134.
*The number 55, woven in the harlequin shawl
end, probably refers to the year 1855 – when
the World's Fair was held in Paris, and also
the year Frédéric Hébert handed over the
business to his son Émile. In 1853 Hébert
registered eight shawl designs, including one
with the name Le Palmier (The Palm Tree).
The tall tree framed by a mihrab and leaning
over the small tree at the centre of the shawl
may symbolize the father handing over the
family company to his son.*

*Long shawl known as The Palm Tree seen
in its entirety.*

Detail of the centre of the shawl shown opposite.

OPPOSITE
*Section of a long shawl with a black centre,
known as* The Circle.
*Paris, manufactured by Émile F. Hébert, c. 1855.
Woven au* lancé *using seven weft colours plus two*
mariages de couleurs, *trimmed on back, cashmere,
346 × 144 cm (136¼ × 56¼ in.).
Milan, Etro collection, no. 256; formerly in the
Nureyev collection.
Records held at the Prud'hommes Registry show that
Émile Hébert registered a design called* Le Cercle *on
20 September 1855.*

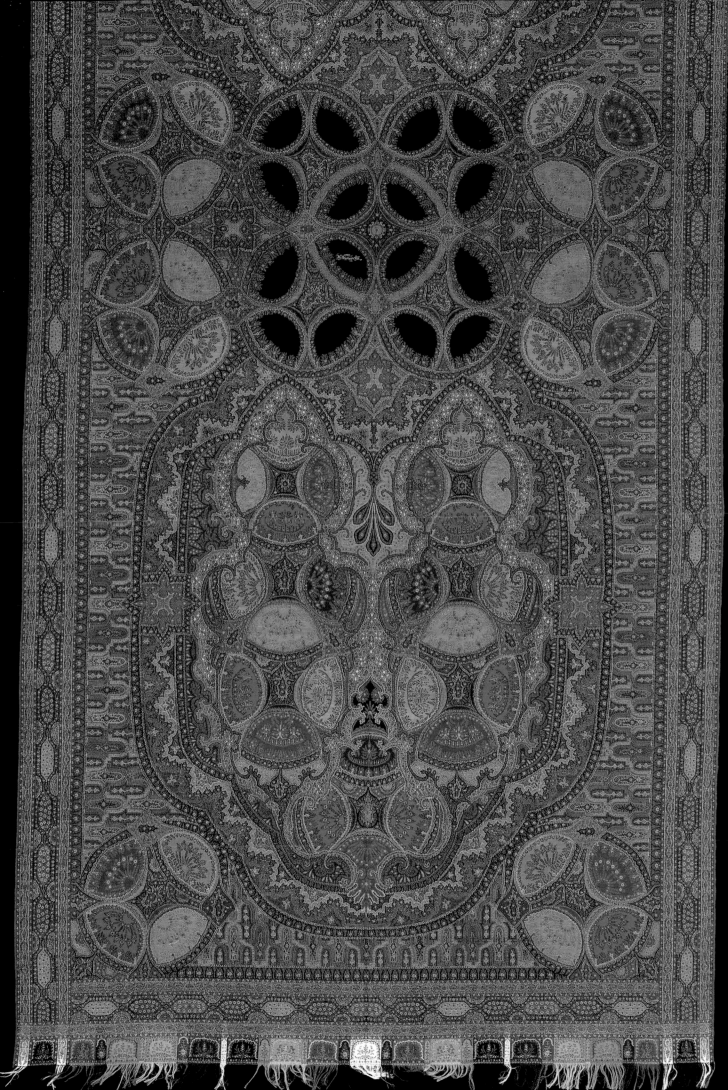

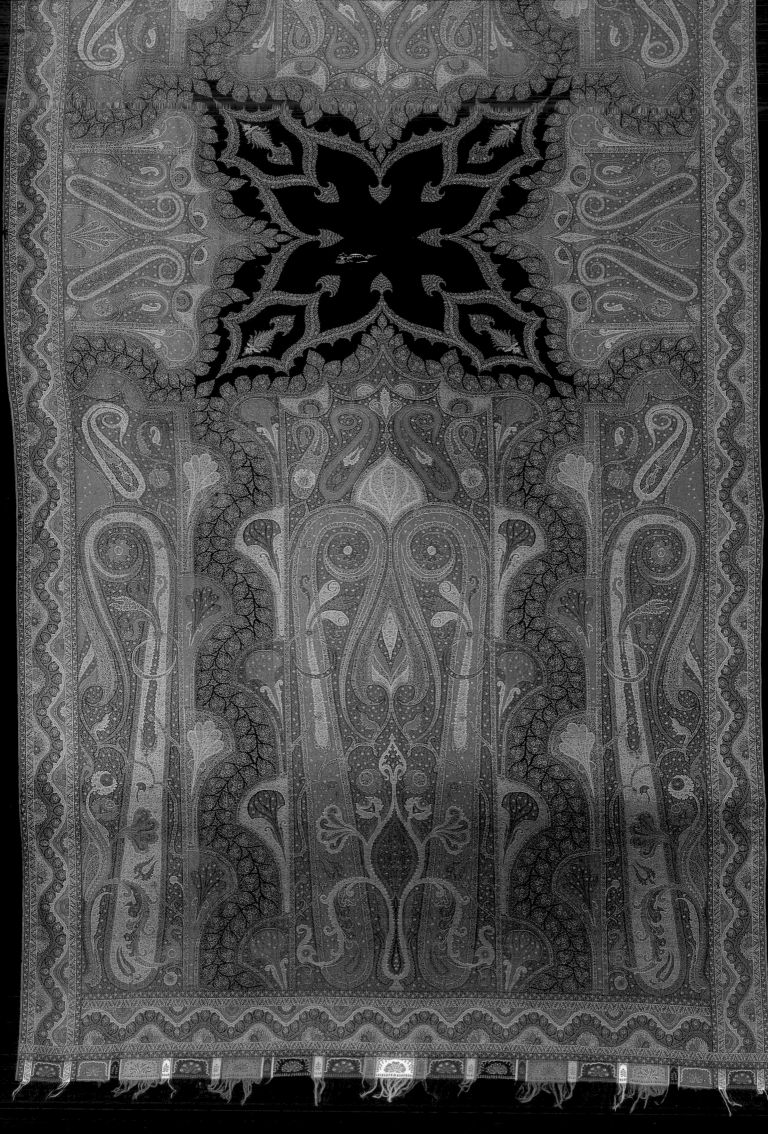

Lower section of a long shawl with a black central reserve.
Paris, manufactured by Émile F. Hébert, 1856–63.
Woven au lancé, *trimmed on back, cashmere, 340 × 156 cm* (133⅞ × 61⅜ in.).
Milan, Etro collection, no. 190.

Details of the shawl shown opposite.
ABOVE *In the signature woven in the centre, only the 'H' is legible.*
BELOW *A half-moon stamp in a corner on the back of the shawl indicates that Emile F. Hébert was awarded the only medal of honour at the World's Fair in Paris, 1855.*

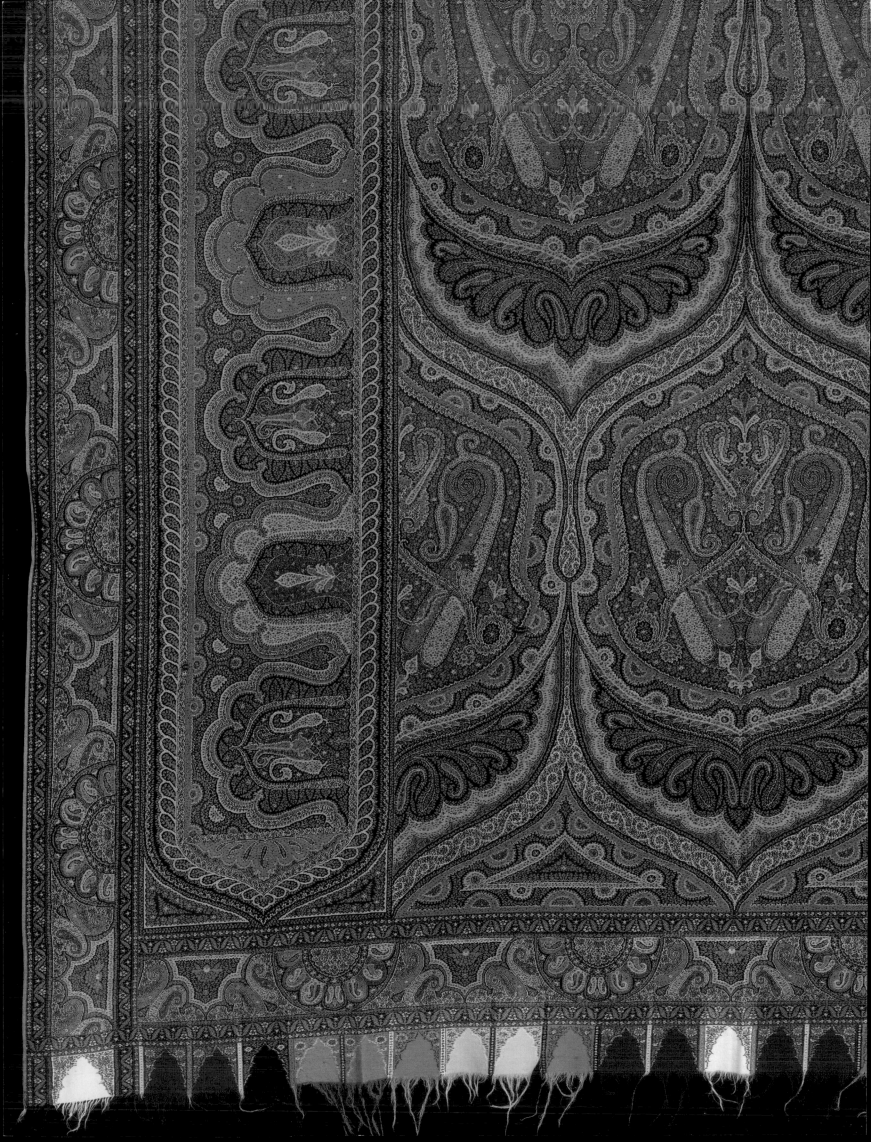

OPPOSITE
Corner of a long shawl with a black central reserve.
Paris, manufactured by Émile F. Hébert, 1856–63.
Woven au lancé using seven weft colours plus two
mariages de couleurs, *trimmed on back, cashmere.*
Paris, author's collection, no. 158.

RIGHT
Detail of the shawl partially reproduced on the opposite
page, showing the signature woven on the black central
reserve. Only the 'H' is legible.

PAGE 234
Lower section of a long shawl with a large pivoting
design and a black central reserve.
Paris, manufactured by Émile F. Hébert, c. 1867.
Woven au lancé using six weft colours plus three
mariages de couleurs, *trimmed on back, cashmere.*
Paris, private collection.
Châles à grand pivot *are technical tours de force.*
Émile F. Hébert showed one – possibly this particular
design – at the World's Fair in Paris in 1867.

PAGE 235
Detail of the shawl reproduced on page 234, showing
the signature against the black central reserve.

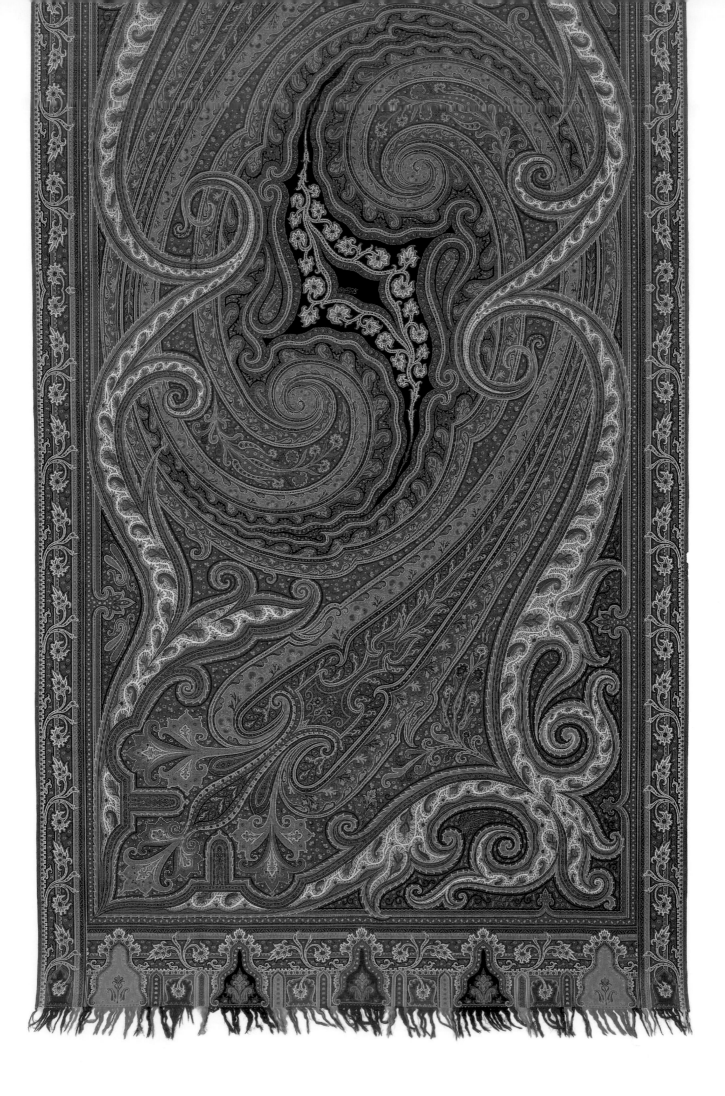

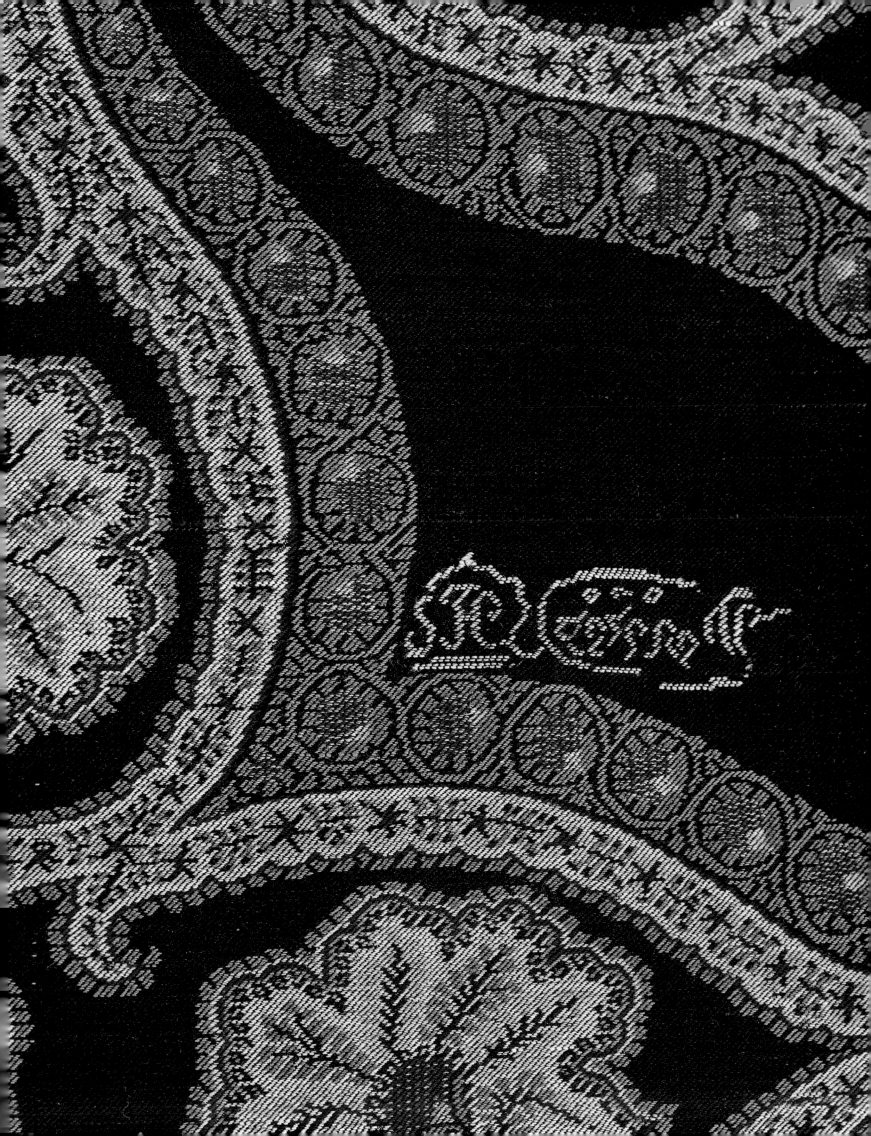

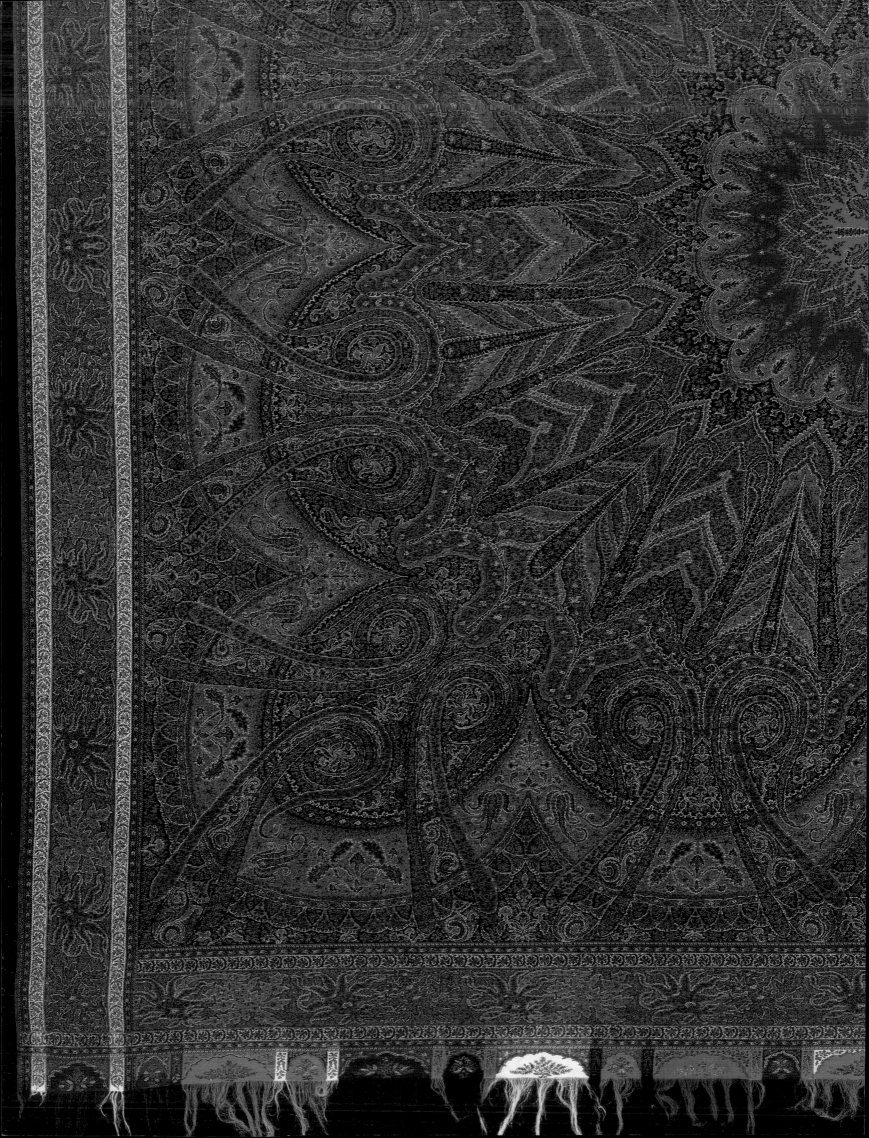

*Quarter of a square shawl with a sun
pattern radiating from the central medallion.
Paris, 1850–53.
Woven* au lancé *using seven weft colours
plus two* mariages de couleurs, *trimmed
on back, cashmere, 190 × 188 cm
(74¾ × 74 in.).
Paris, author's collection, no. 157.
The pattern of the harlequin borders and of the
shawl as a whole are in Hébert's style, but there
is no signature (the central motif leaving little
space for one).*

*Two half-moon stamps in gold lettering.
The top one was registered on 6 March 1856.
The other commemorates the respective years
(1840 and 1863) when Frédéric Hébert and
his son received the Legion of Honour.*

Signature woven in the centre of the shawl shown
on the opposite page.
The initial 'T' under the mihrab (prayer niche)
refers to Tresca, Émile F. Hébert's successor, who
took over the company in 1869.

OPPOSITE
Section of a long shawl with a black central reserve.
Paris, manufactured by Hébert's successor, Tresca, 1869–78.
Woven au lancé using seven weft colours plus two
mariages de couleurs, trimmed on back, cashmere,
322 × 151 cm (126¼ × 59½ in.).
Milan, Etro collection, no. 241.
By keeping the mihrab trademark, Hébert's successor, Tresca,
indicated his intention of remaining loyal to the house style.

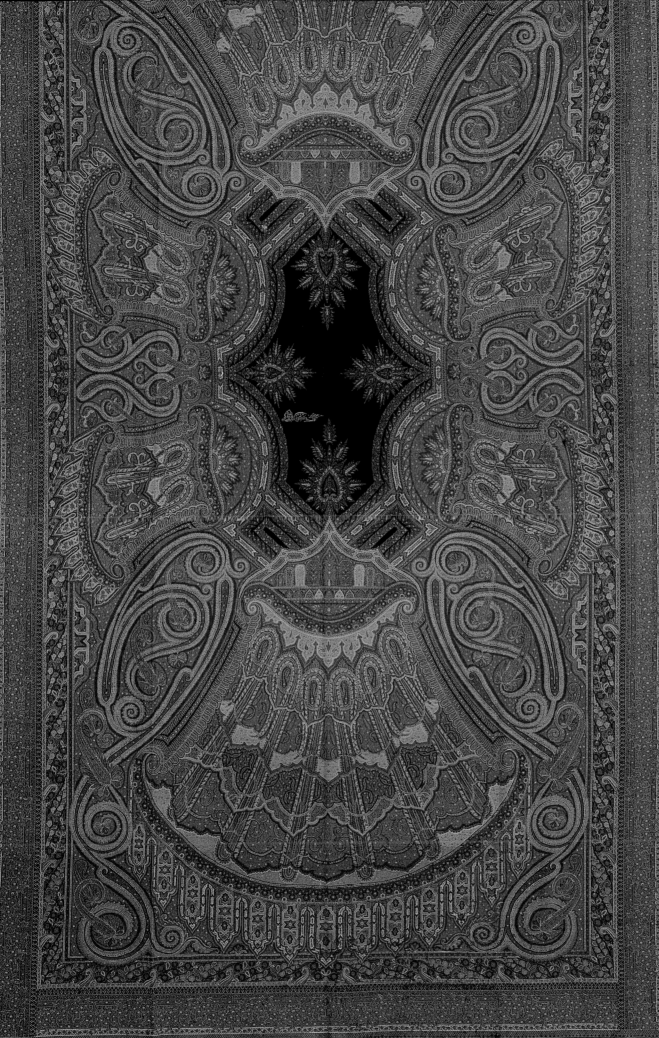

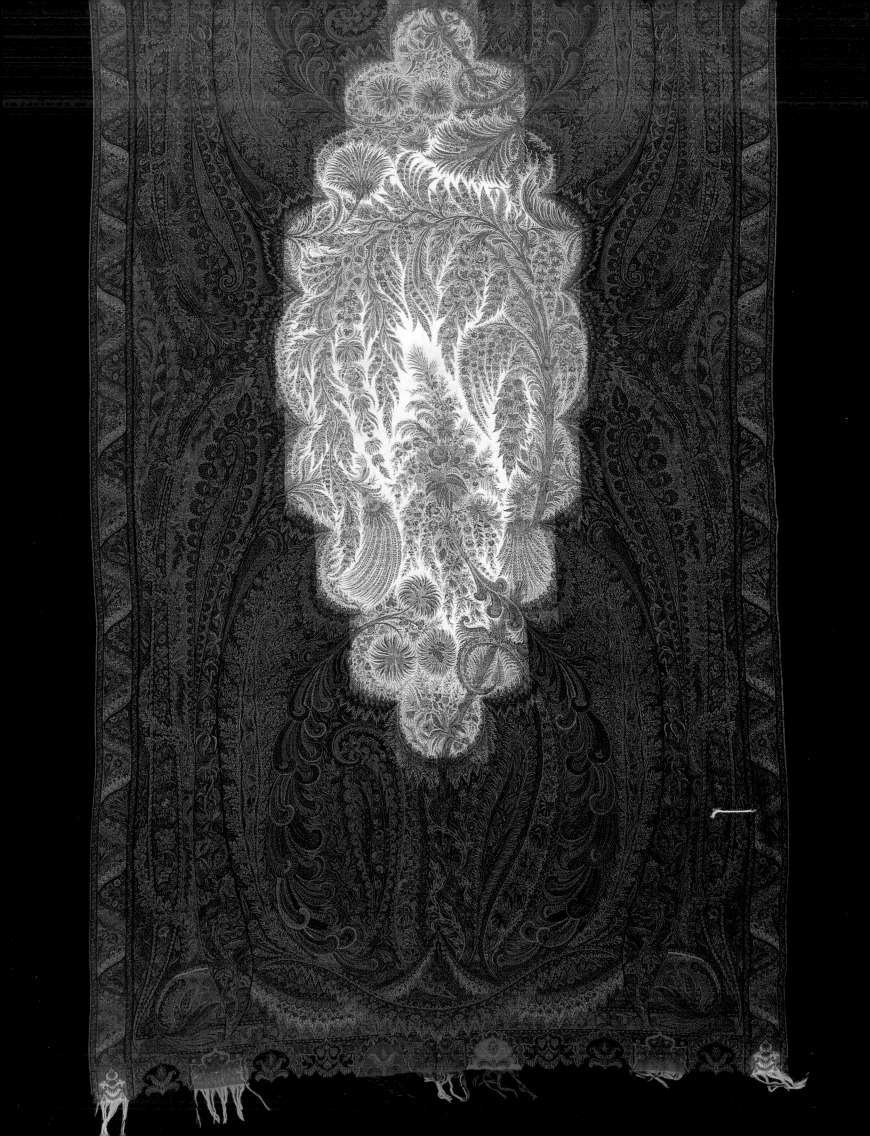

Antony Berrus

Antoine Berrus (who later changed his name to Antony) was born in Nîmes on 16 June 1815. He was the son of Barthélemy Berrus, a shoemaker, and Marie Espérandieu.[1] Antoine studied at the School of Fine Art in Nîmes and was later hired as a designer in a carpet manufactory, where his real training in textile design began. In around 1838 he was invited to work as a designer with the shawl manufacturer Gélot, who had just moved his business from Nîmes to Lyons.

In 1841 Berrus formed a company – T. Gélot, A. Berrus Fils & Cie – with T. Gélot (possibly the same Gélot for whom he had worked in Lyons) for six years. The intention was for it to become a 'design studio' that would 'encompass all areas of manufacturing'. The company was registered in Paris at 22 Rue d'Enghien; Berrus's private address was 11 Rue Cadet.[2]

On 30 November 1843, when he was twenty-eight, Berrus married Marie Chabrol at the Saint-Merry church in Paris.[3] The jury for the 1844 exhibition awarded Gélot & Berrus an honourable mention. In about 1846 Berrus and his younger brother, Émile, formed a company, Berrus Frères & Cie, whose registered address was 73 Rue Montmartre.[4] They were awarded a silver medal in the exhibition of 1849.

The earliest of Berrus's square shawl designs that are known to us date from 1847,[5] and the earliest long ones date from 1848. It was around this time that the *style végétal*, or floral style, was really coming into its own, allowing the young designer to give his imagination free rein and the public a taste of his extraordinary talent. In 1850 Berrus was still only thirty-five. His gouache designs from this period are exquisite: intricately detailed and representing a luxuriant array of gracefully undulating stems, leaves and imaginary flowers. The shawls woven according to his designs convey a magical charm.

Berrus's efforts were crowned with almost instantaneous success. His designs, executed on sheets of paper approximately 40 × 20 cm (15¾ × 7⅞), were scaled up five or six times to produce the finished article, without the composition losing any of its coherence or the detail any of its delicacy. Berrus Frères & Cie continued in business for forty years, employed as many as one hundred, possibly even two hundred, designers and

OPPOSITE
Section of a long shawl with a white central reserve, designed by Berrus.
Europe (United Kingdom?), c. 1860.
Woven au lancé using eight weft colours, trimmed on back, wool, 312 × 154 cm (122⅞ × 60⅝ in.).
Milan, Etro collection, no. 255, formerly in the Nureyev collection.
The design for this shawl is in Berrus's album XX47/3, conserved in the Cabinet des Dessins, Musée des Arts Décoratifs, Paris, no. CD5273.3.
This design is a good example of the technique known as chinage à la branche,* *in which the warp is tie-dyed prior to weaving. The warp threads forming the ground for the central pattern have been tightly bound (in 'branches') to keep them white, shielding them from the red dye used for the remainder of the warp.*

1 Gard Archives, register of birth.
2 Paris Archives, *Actes de société*, no. 1641, dated 20 November 1841.
3 Paris Archives, register of Paris marriages.
4 *Almanach du Commerce de Paris*, Bottin, 1846.
5 They can be found in one of the forty-five collections of sketches of shawls by Berrus that are conserved in the Cabinet des Dessins at the Musée des Arts Décoratifs in Paris. There are ten other such collections: one in the United States, four at the Fondazione Antonio Ratti, in Como, and five in the Etro collection, in Milan. Each album has about five hundred folios. Consequently, there are more than eight thousand shawl designs, many of them dated and carrying Berrus's stamp, now bound in book form by his widow.

only ever produced designs for shawls. This gives us an indication not only of how special-ized the company was, but also of the depth of Berrus's technical skill in this specialist area. In comparing the shawls woven from Berrus's designs (and we have examined around thirty) with other European shawls, it is impossible not to be impressed by the harmony of the colours and the technical skill involved.

Berrus's first designs for shawls *à grand pivot* (at least five in all) were sub-mitted to the 1849 exhibition; however, we only know of four such shawls that were woven to his designs from this period.

The jury for the Great Exhibition in London in 1851 awarded its prize medal to Berrus Frères & Cie, but did not approve of 'the introduction of landscapes into the design of their shawls'. They were referring to small vignettes and oriental structures incorporated into the composition of designs that were a foretaste of Berrus's projects in 1855. Indeed, the 1855 World's Fair, held in Paris, witnessed a broadening of the *style végétal*, or floral style, to encompass more than just plant motifs: Berrus's designs mixed pines with architectural features – steps, pavilions, arches and columns – of Persian, Turkish, Chinese and even Egyptian inspiration, while the plant elements themselves were becoming more stylized. Some of the designs were for shawls *à grand pivot*; in others, the central motif spilled into other areas of the composition. We know of at least eight shawls made to designs by Berrus dating from 1855. Those that carry a maker's mark were woven by Biétry. Some of the shawls attributable to Biétry also carry the inscription 'Cachemire' in two corners, as well as the coat of arms of the shawl's recipient (pp. 287 and 288). The latter was a practice borrowed from the world of tapestry weaving; Biétry is, to our knowledge, the only shawl maker to have adopted it, and then only in 1855.

The jury for the 1855 World's Fair awarded Berrus a first-class medal. We learn from its report that: the company employed more than one hundred people to interpret the designs and to transfer them to point paper, the process known as the *mise en carte*; the artists' annual salary varied between 1,200 and 3,500 francs; and the firm's annual turnover was between 225,000 and 250,000 francs. Antony Berrus was made a knight of the Legion of Honour in the wake of the exhibition: he was forty years old and had reached the highpoint of his career.

From 1857 onwards the Paris shawl manufacturers Bourgeois Frères, Joseph Chanel and Gérard & Cantigny were all making shawls designed by Berrus, and in 1867 we find Berrus shawls carrying the Bourgeois Frères and Mahaut labels. We also know that the Lyons manufacturers Grillet & Pin bought Berrus designs (in 1857), as did the Parisian company Dachès & Duverger (in 1862) and Dachès Père & Fils (in 1867), in addi-tion to a number of other French shawl makers who did not have their own house designer. Some manufacturers from Paisley and Vienna also bought Berrus designs.

The report drawn up for the Great Exhibition in London in 1862 by the delegation of shawl designers and weavers devoted more than two pages to Berrus Frères, describing the firm as 'the most important industrial design house there is…. It employs… 60 to 80 designers, in a guild where the total number is at most 300 to 350.' After praising Berrus's prolific output, his colleagues note that 'he has his own particular style and never imitates Indian shawls', but that his designs are 'always made with the potential purchaser

in mind', adding: 'Their one weakness, we feel, is their lack of variation. The strongest evidence we have for making this assertion is that Berrus is much more successful at the cheaper end of the market than with the rich style of shawl.' The report then describes the division of labour within Berrus's company. In other design studios the employees fell into one of three categories, depending on whether their function was to draw the design, transfer it to point paper or fill in the colours. Berrus Frères, on the other hand, employed someone to do each of the following: '1. draw the design; 2. make the *maquette* [scale model]; 3. enlarge this on the cards; 4. neaten the lines; 5. *guilloche* the contours [a form of ornamentation resembling braided or interlaced ribbons]; 6. draw the details; 7. transfer the design to point paper; and 8. fill in the design.' In the view of those reporting on the exhibition, such a system – although providing significant economic advantages – was disadvantageous to the employees, making them over-specialized and obliging them to work in a somewhat mechanical fashion, with the result that Berrus designs tended to look too uniform, as if they had all been made by the same person.

The designs that Berrus submitted for the Great Exhibition of 1862 introduced several new decorative features. Draperies, for one, created an element of relief, giving the illusion of real folds of cloth and replacing the effect of depth produced by the architectural perspectives. Certain important motifs were also enclosed within a ribbon decorated with a Greek key pattern, and one design incorporated a verse from the Koran in Arabic characters (p. 254, below) – possibly in an attempt to please an oriental clientele.

The shawl designers' report for the following World's Fair, held in Paris in 1867, praised Berrus for his great service to the shawl industry, and in particular for having created an 'affordable style' that had helped to boost French trade. They also admired the superb shawls with flamboyant central motifs spilling into other areas of the composition and those in which the central decoration was inscribed inside Louis XV-style medallions inspired by wood and silver mouldings – in other words, the 'rich' shawls aimed at a well-heeled clientele. And, once again, Berrus was awarded the first-class medal.

By 1870 fashionable Paris was already losing interest in cashmere shawls, but Antony Berrus continued designing them regardless, and in 1873 he submitted a great many new designs to the World's Fair in Vienna. His last four known albums, dating from 1875, contain hundreds of designs that were never used. Berrus was just sixty. We can imagine what he must have felt – a man once at the top of his profession, now abandoned by his customers and forced to lay off his staff and put away his pencils. Some of his fellow designers who had specialized less put their skills to use in related fields such as furnishings – but not Berrus. He died on 27 March 1883.

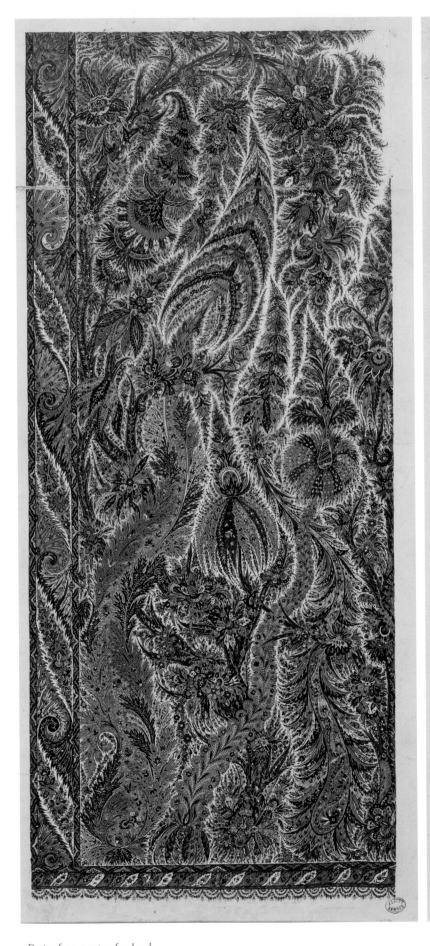

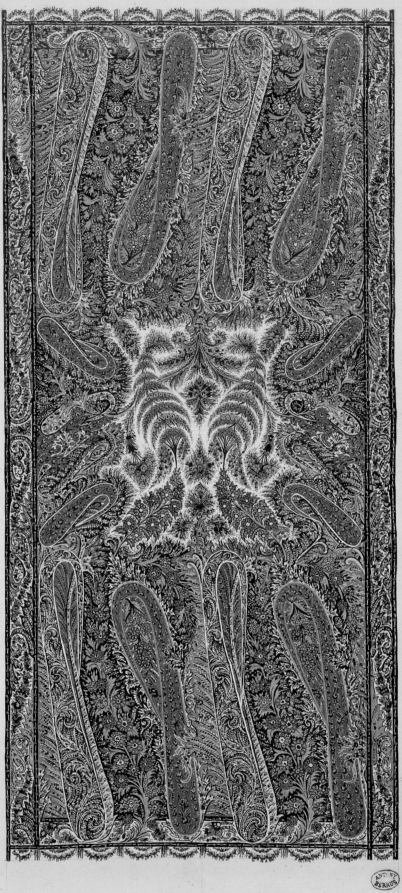

Design for a quarter of a shawl.
Folio no. 1 of Berrus's album XX48/2, dated 1848–50.
Gouache on paper, 48.4 × 23 cm (19 × 9 in.).
Paris, Musée des Arts Décoratifs, Cabinet des Dessins, no. CD5275, F.1.

Design for a shawl.
Folio no. 2 of Berrus's album XX48/2, dated 1848–50.
Gouache on paper, 38.5 × 23 cm (15⅛ × 9 in.).
Paris, Musée des Arts Décoratifs, Cabinet des Dessins, no. CD5275, F.2.
This exuberant design has made use of plants as well as classic pine motifs of varying sizes around the central decoration. The large pines break into the horizontal borders. The two halves of the central section are mirror images of one another along a vertical axis, while the large pines at each end are also repeated along the same axis but not as a mirror image.

244

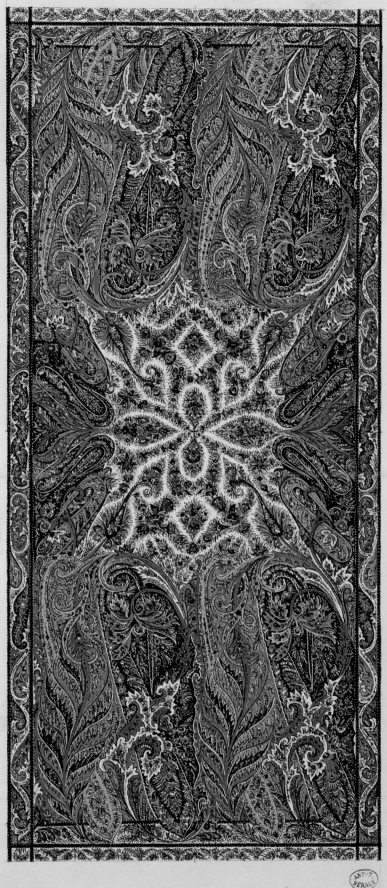

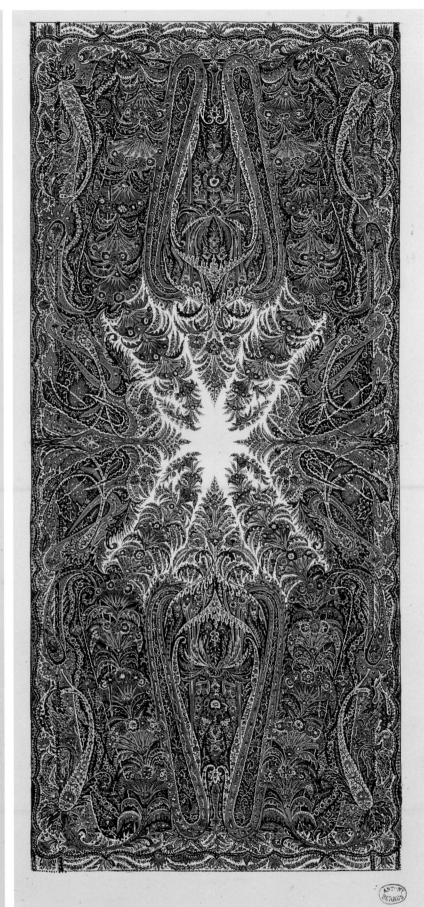

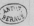

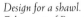

Design for a shawl.
Folio no. 3 of Berrus's album XX48/2, dated 1848–50.
Gouache on paper, 38.5 × 23 cm (15⅛ × 9 in.).
Paris, Musée des Arts Décoratifs, Cabinet des Dessins, no. CD5275, F.3.
This shawl owes its effect to a double contrast. The border motifs stand out against a white ground, while in the centre section the floral ornamentation forms the background on which the white ground seems to create a tracery. This centre section is symmetrical in relation to the two axes, while the large pine motif is repeated, but not as a mirror image, along the vertical axis.

Design for a shawl.
Folio no. 4 of Berrus's album XX48/2, dated 1848–50.
Gouache on paper, 38.5 × 23 cm (15⅛ × 9 in.).
Paris, Musée des Arts Décoratifs, Cabinet des Dessins, no. CD5275, F.4.
Here the pattern is repeated as a whole in mirror image along the vertical and horizontal axes. The flowering branches that stretch towards the centre form a modified X. The horizontal and vertical borders have almost disappeared, replaced by a black ribbon that meanders along the edge as a framework for the decoration.

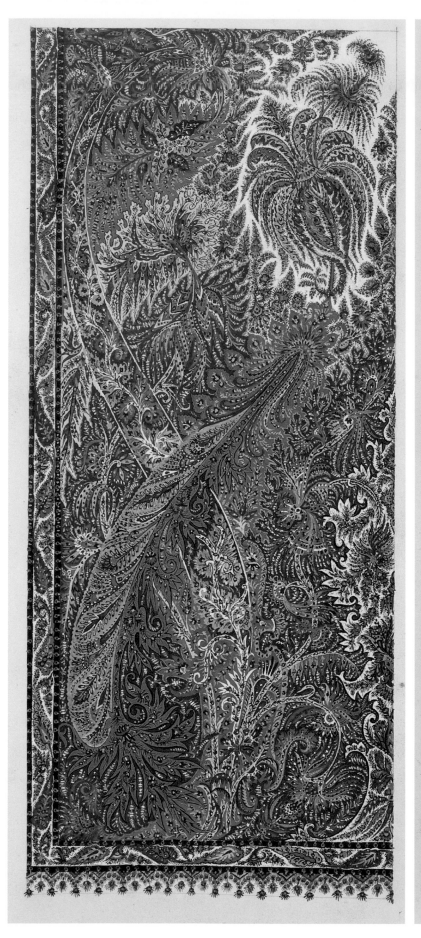

Design for a quarter of a shawl.
Folio no. 5 of Berrus's album XX48/2, dated 1848–50.
Gouache on paper, 38.5 × 23 cm (15⅛ × 9 in.).
Paris, Musée des Arts Décoratifs, Cabinet des Dessins, no. CD5275, F.5.
Berrus has organized his design so that the decorative motif is repeated symmetrically along the two axes.

Design for a shawl.
Folio no. 6 of Berrus's album XX48/2, dated 1848–50.
Gouache on paper, 38.5 × 23 cm (15⅛ × 9 in.).
Paris, Musée des Arts Décoratifs, Cabinet des Dessins, no. CD5275, F.6.
The designs in Berrus's album (the first six of which are reproduced on these pages) illustrate his style végétal – luxuriant arrangements of plant life, either single or combined with the pine motif. The composition here is symmetrical across the vertical axis. Only the area between the central field and the borders is reflected as a mirror image along the horizontal axis. A lush meander of leaves garlands the edge of the shawl and takes the place of both vertical and horizontal borders.

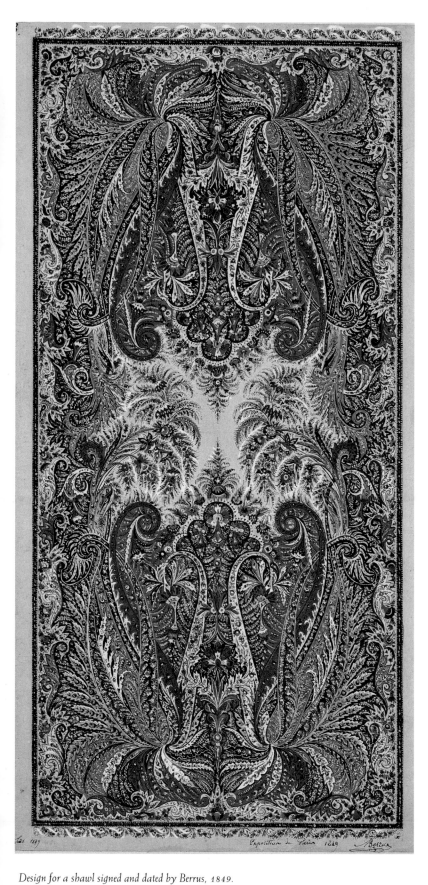

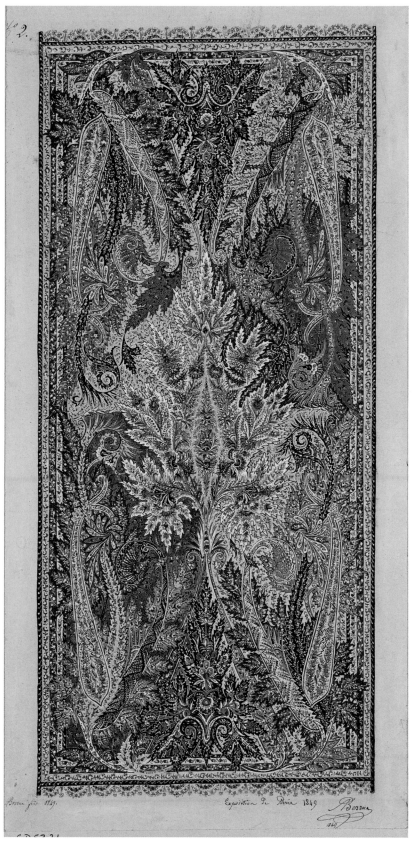

Design for a shawl signed and dated by Berrus, 1849.
Paris Exhibition, 1849.
Gouache on paper, 32.2 × 17.3 cm (12⅝ × 6¾ in.).
Paris, Musée des Arts Décoratifs, Cabinet des Dessins, no. CD5320.
The ornamentation on this shawl is symmetrical in relation to the vertical axis.
Only the main areas of decoration on either end are in mirror image about the
horizontal axis. The borders have been eliminated and the pines are mixed in with
the vegetation.

Design for a shawl signed and dated by Berrus, 1849.
Paris Exhibition, 1849.
Gouache on paper, 35.2 × 17 cm (13⅞ × 6¾ in.).
Paris, Musée des Arts Décoratifs, Cabinet des Dessins, no. CD5321.
The slim and sinuous pines surround a tree of life that is set against four differently coloured
fields. The tree has only vertical symmetry while the remainder of the decoration is mirrored in
relation to both axes. The varying background colours give the impression of a great diversity
of ornamentation; on close examination the motifs on these fields are revealed as identical.

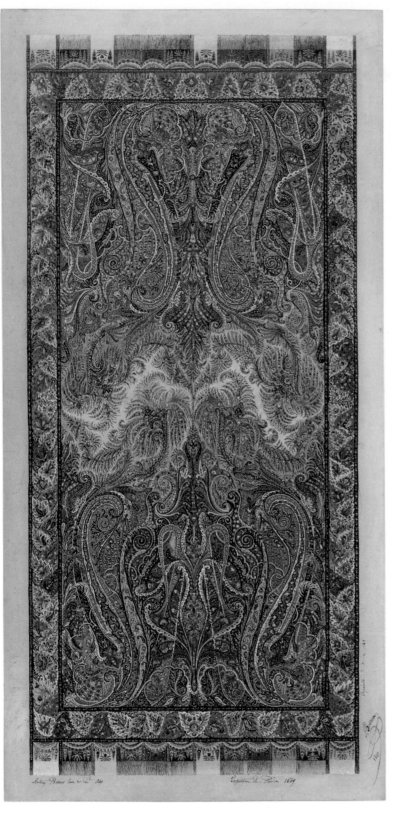

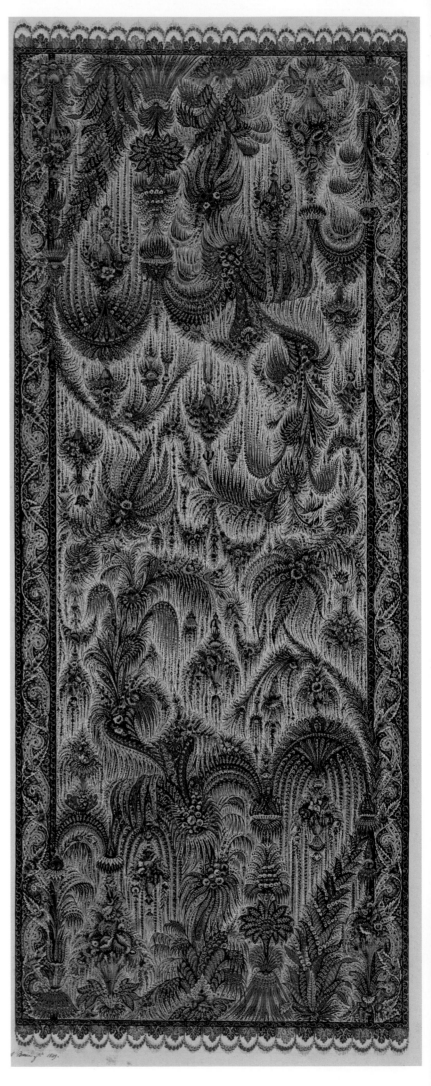

ABOVE *Signed and dated design for a double à pivot shawl by Berrus, 1849.*
Paris Exhibition, 1849.
Gouache on paper, 49.2 × 24.3 cm (19⅛ × 9½ in.).
Paris, Musée des Arts Décoratifs, Cabinet des Dessins, no. CD5322.
The left-hand and the right-hand sides are à pivot designs and give a mirror image
of each other. In the centre section the decorative motifs stand out against fields of three
contrasting colours. As in the Berrus designs shown on previous pages, the fringed shawl
ends have festoon motifs. But here, by contrast, these motifs appear against harlequin
backgrounds, prompting the thought that this shawl may signal a turning point in Berrus's
designs, when he abandoned his former avoidance of harlequin shawl ends and succumbed
to the prevailing fashion. His subsequent shawl designs all had polychrome fringes.

RIGHT *Signed and dated design for an à pivot shawl by Berrus, 1849.*
Gouache on paper, 66.4 × 30.2 cm (26⅛ × 11⅞ in.).
Paris, Musée des Arts Décoratifs, Cabinet des Dessins, no. CD5436.3.
This shawl is decorated exclusively with plant forms with bold stylization that was well
in advance of its time. The horizontal borders have vanished. Some plants have encroached
on the vertical border.

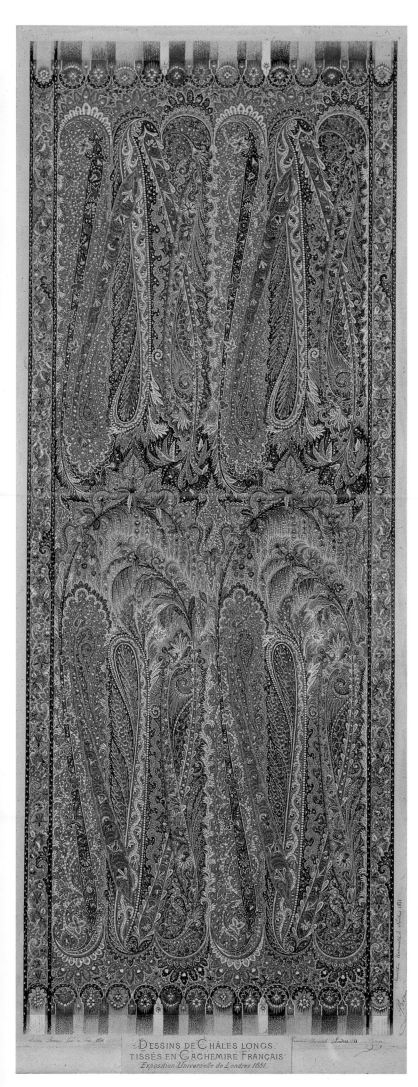

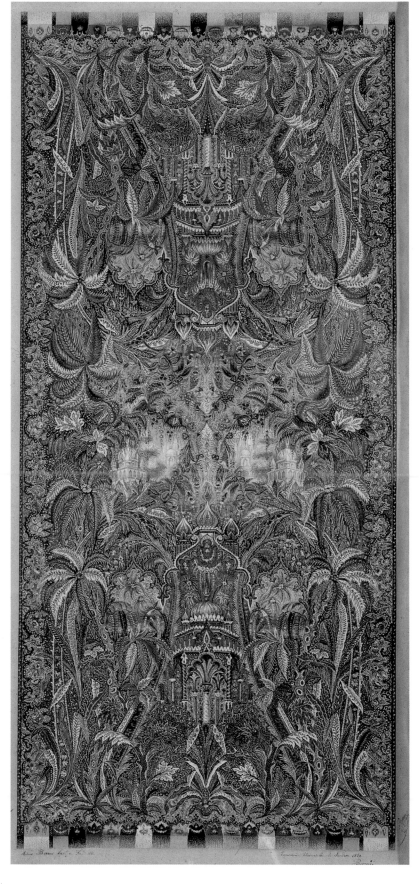

ABOVE *Design for a shawl signed by Berrus.*
Great Exhibition, London, 1851.
Gouache on paper, 75 × 35 cm (29½ × 13¾ in.).
Paris, Musée des Arts et Métiers, CNAM, no. 08797.
Instead of pines, architectural motifs make a discreet appearance here.

LEFT *Design for a shawl signed by Berrus.*
Great Exhibition, London, 1851.
Gouache on paper, 79 × 30.5 cm (31⅛ × 12 in.).
Paris, Musée des Arts et Métiers, CNAM, no. 08797.
In the centre of the shawl, architectural motifs appear timidly in the midst of the vegetation.

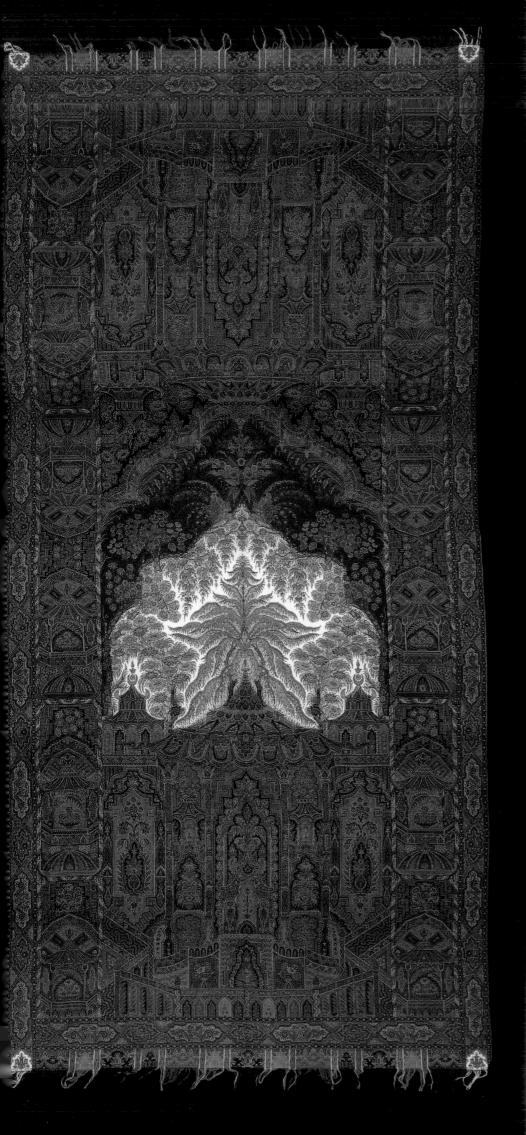

Long shawl with a three-colour field decorated
with a cedar tree, designed by Berrus.
(The design is shown on p. 258, right.)
Paris, 1855.
Woven au lancé, trimmed on back, cashmere,
350 × 166 cm (137¾ × 65⅛ in.).
Milan, Etro collection, no. 112.
Architectural motifs surround the flowers
and vegetation in the centre of the design.

OPPOSITE
Detail of the centre of the shawl shown
on this page.

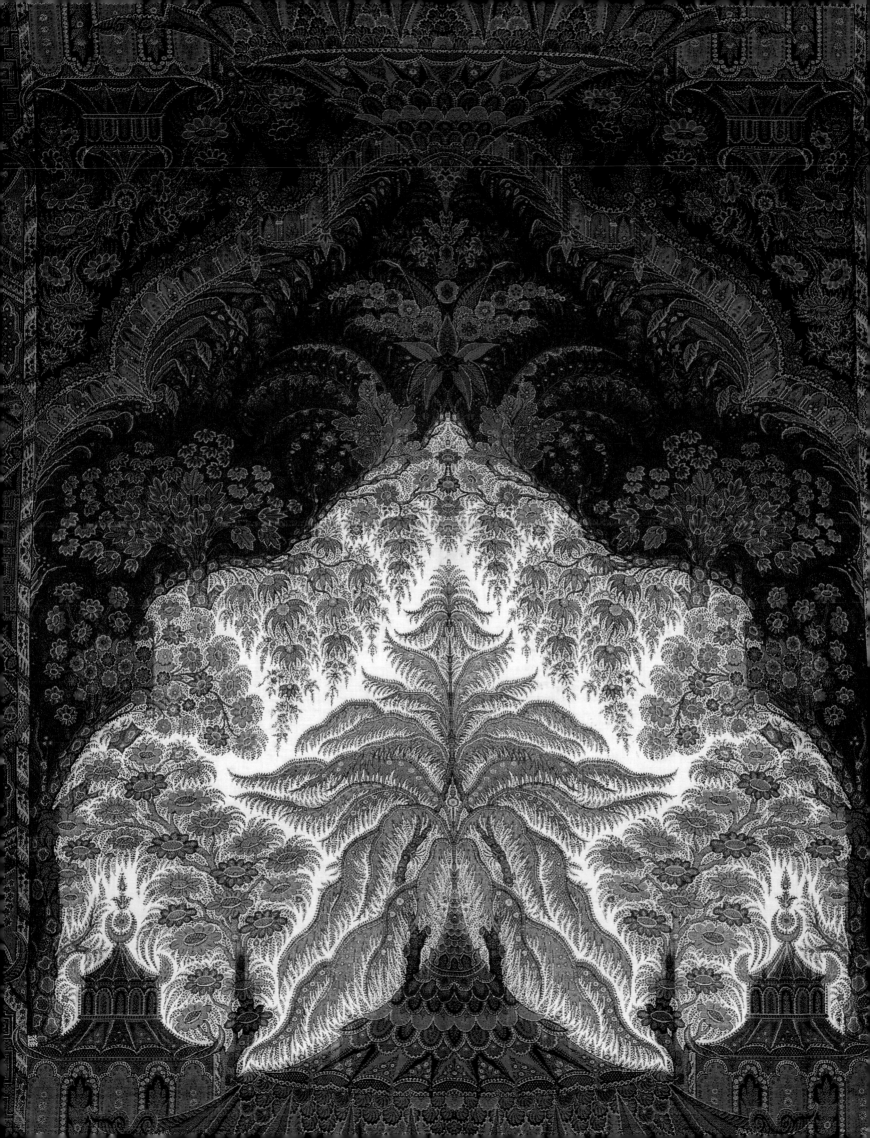

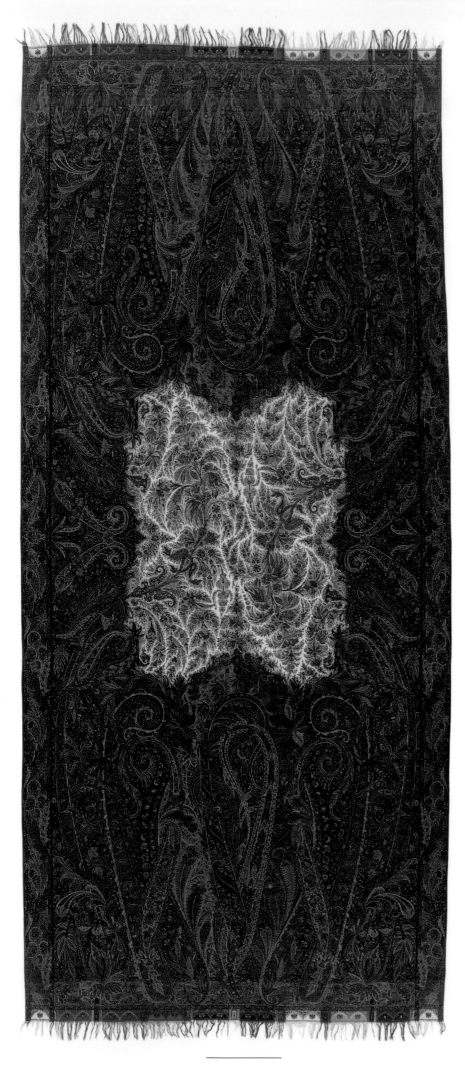

Long shawl with a small pivoting composition
in the centre of a white ground, designed by Berrus.
Paris, 1848–50.
The design for this shawl is in Berrus's album
XX48/2 (dated 1848–50), folio 141.
Paris, Musée des Arts Décoratifs, Cabinet des Dessins,
no. CD5275.
Woven au lancé using ten weft colours, trimmed on back,
cashmere, 360 × 158 cm (141¾ × 62¼ in.).
Paris, Musée Galliera, inv. no. 1989.2.9.
This shawl is a glorious example of the style végétal
or floral style. The fineness of the weave suggests that it
was woven by Biétry.

OPPOSITE
Long 'four seasons' shawl designed by Berrus.
Paris, c. 1850.
The design for this shawl is in Berrus's album
XX48/2 (dated 1848–50), folio 141.
Paris, Musée des Arts Décoratifs, Cabinet des Dessins,
no. CD5275.
Woven au lancé using ten weft colours, trimmed on back,
cashmere, 360 × 160 cm (141¾ × 63 in.).
Milan, Etro collection, no. 109.
Apart from the central motif, the shawl is identical in
design to the one shown on this page. It was probably
manufactured by Biétry.

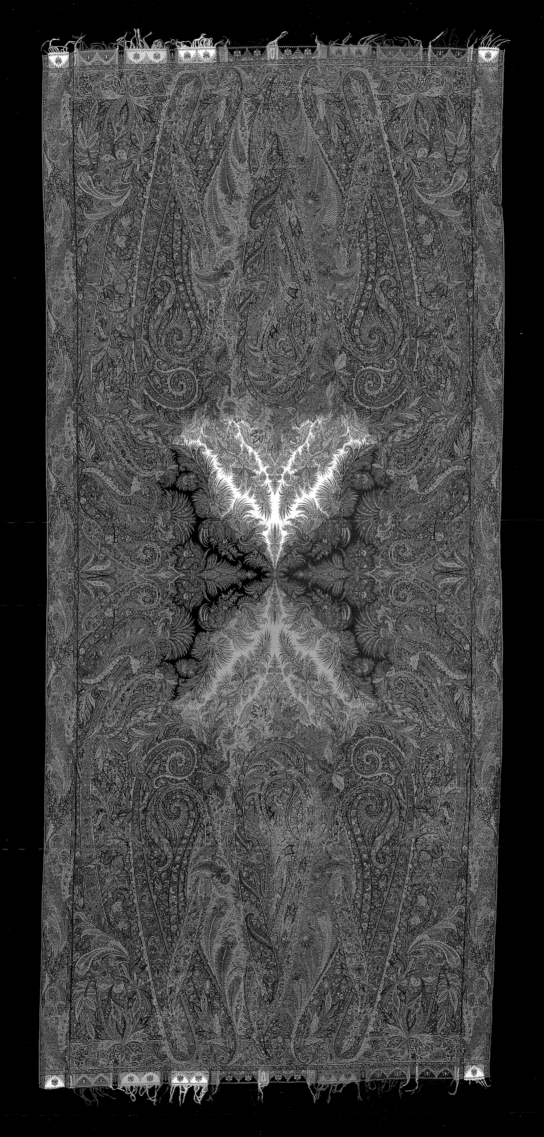

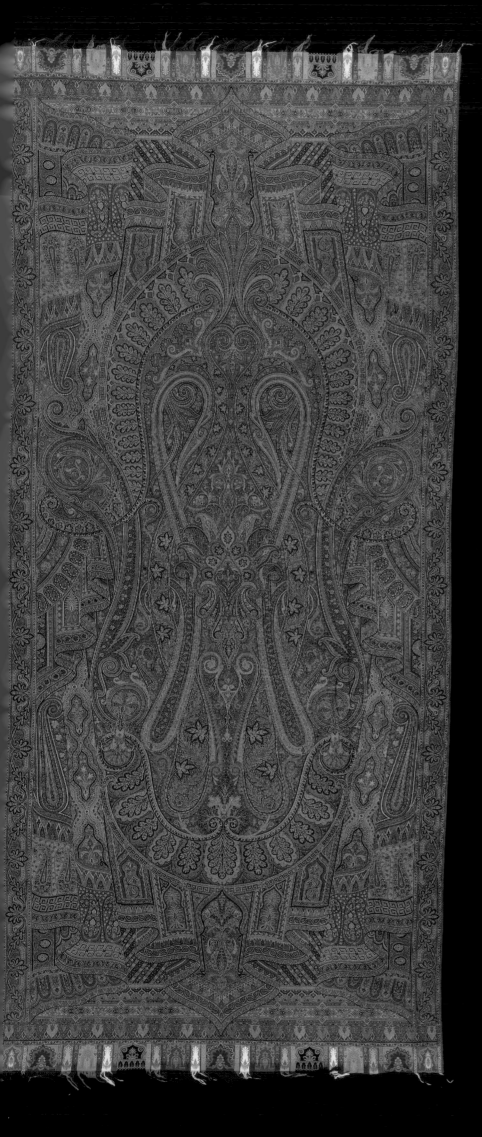

OPPOSITE
Long shawl with a small black central reserve, designed by Berrus.
Paris, 1862.
The design for this shawl is in Berrus's album XX47/3 (dated 1861–64), folio 3.
Paris, Musée des Arts Décoratifs, Cabinet des Dessins, no. CD5273.
Woven au lancé using seven weft colours plus two mariages de couleurs, trimmed on back, cashmere, 360 × 160 cm (141¾ × 63 in.).
Milan, Etro collection, no. 130.
Apart from the central motif, the shawl is identical in design to the one shown on this page. The two shawls may have been made by Bourgeois Frères, who submitted a 'shawl with drapery motifs' – probably of the design shown here – to the Great Exhibition in 1862.

LEFT
Long shawl with no central field, designed by Berrus.
Paris, 1862.
The design for this shawl is in Berrus's album XX47/3 (dated 1861–64), folio 3.
Paris, Musée des Arts Décoratifs, Cabinet des Dessins, no. CD5273.
Woven au lancé using seven weft colours plus two mariages de couleurs, trimmed on back, cashmere, 365 × 162 cm (143¾ × 63¾ in.).
Milan, Etro collection, no. 232.

BELOW
The shawls shown opposite and above both have the inscription 'God is the only God' woven in Arabic letters in the upper part of their horizontal borders.

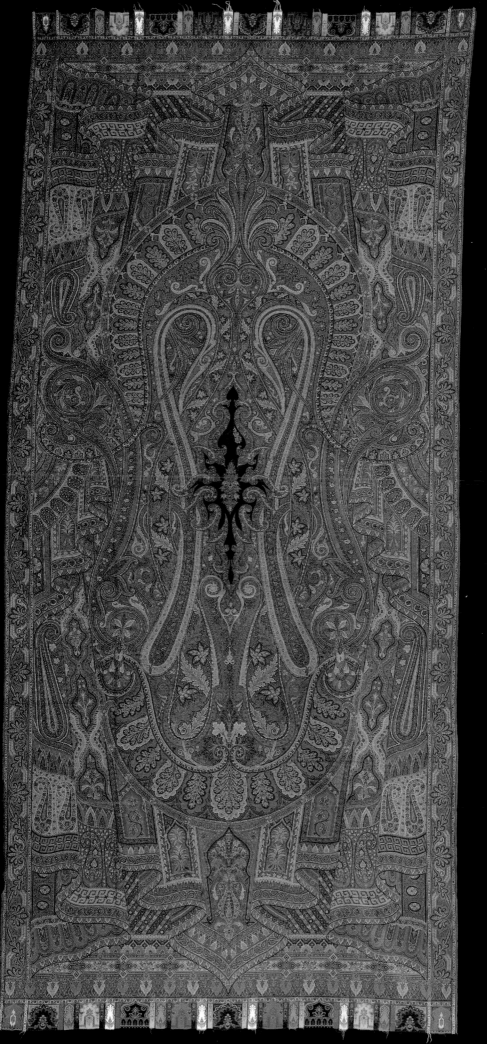

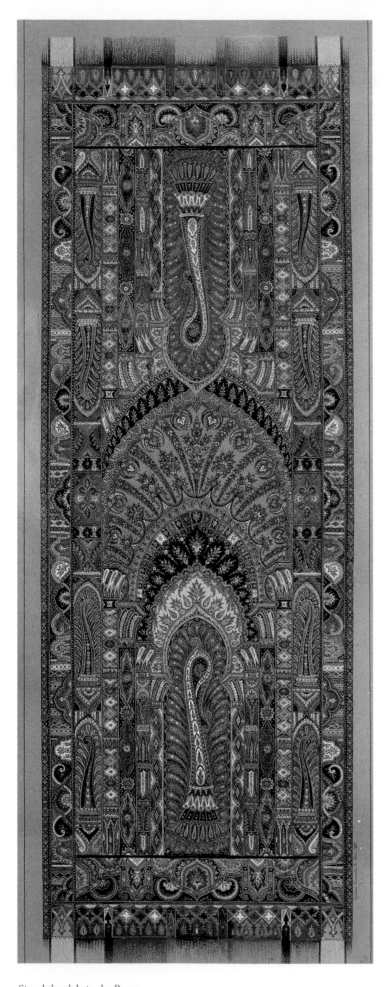

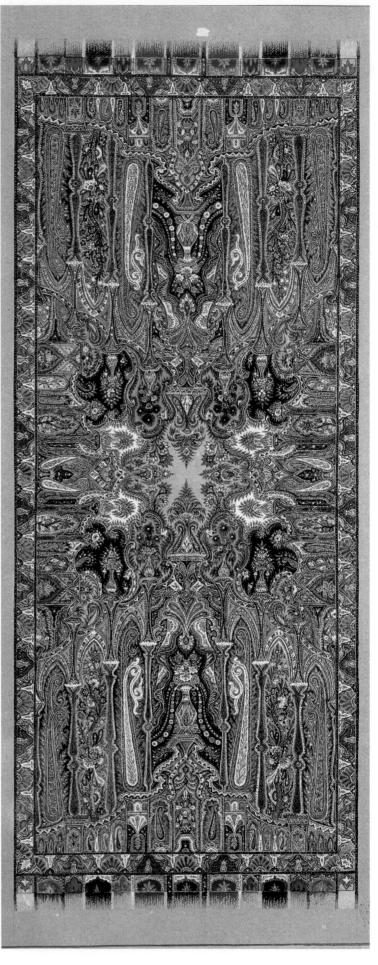

Signed shawl design by Berrus.
World's Fair, Paris, 1855.
Gouache on paper, 87.5 × 32.5 cm (34½ × 12¾ in.).
Paris, Musée des Arts et Métiers, CNAM, no.08800.0001.
There is a strong architectural feel to this design. Pines are set in mihrabs, endowing
them with the status of sacred objects.

Signed shawl design by Berrus.
World's Fair, Paris, 1855.
Gouache on paper, 44 × 20.5 cm (17¼ × 8⅛ in.).
Paris, Musée des Arts et Métiers, CNAM, no.08800.0001.
An intriguing synthesis has been achieved between floral and architectural motifs
in this shawl. On either side of an altar-like construction are three graduated arches.

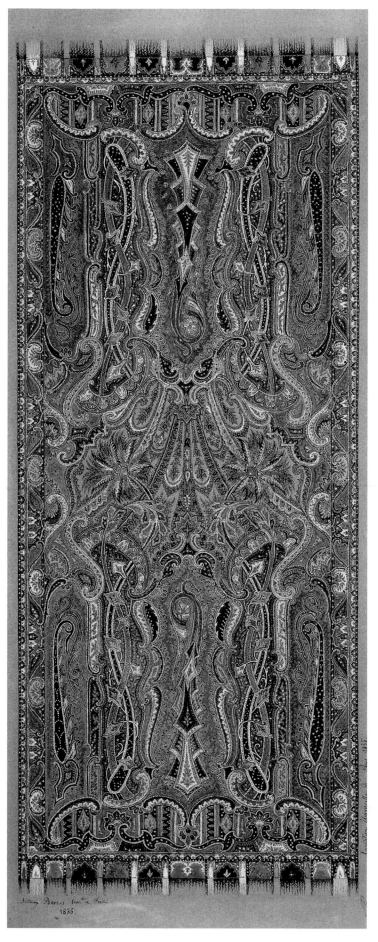

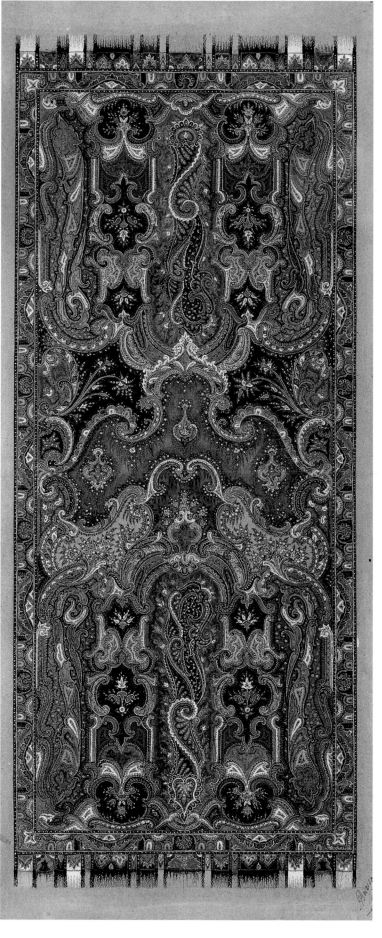

Signed shawl design by Berrus.
World's Fair, Paris, 1855.
Gouache on paper, 43.5 × 21 cm (17⅛ × 8¼ in.).
Paris, Musée des Arts et Métiers, CNAM, no.08800.0002.
A series of highly stylized pines, combined with plant motifs, are arranged
above a rococo-style base. In the centre a niche encloses a central pine with
what appears to be a number of pendants suspended from it.

Signed shawl design by Berrus.
World's Fair, Paris, 1855.
Gouache on paper, 44 × 20.5 cm (17⅛ × 8¼ in.).
Paris, Musée des Arts et Métiers, CNAM, no.08800.0001.
Decoration reminiscent of carved wall panelling and rococo bronzes.

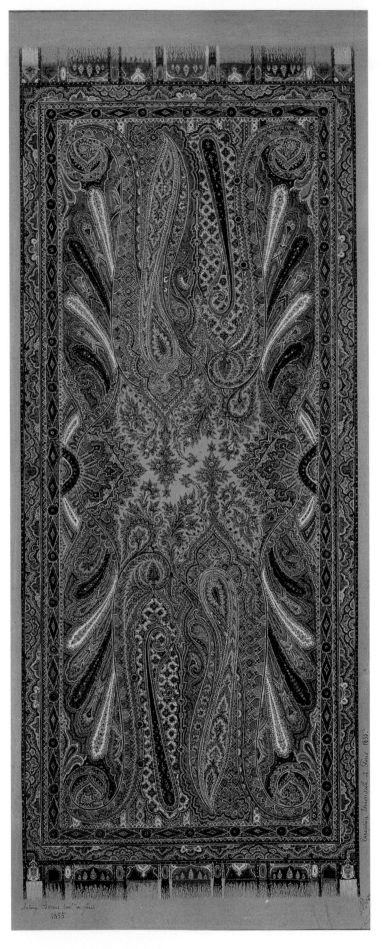

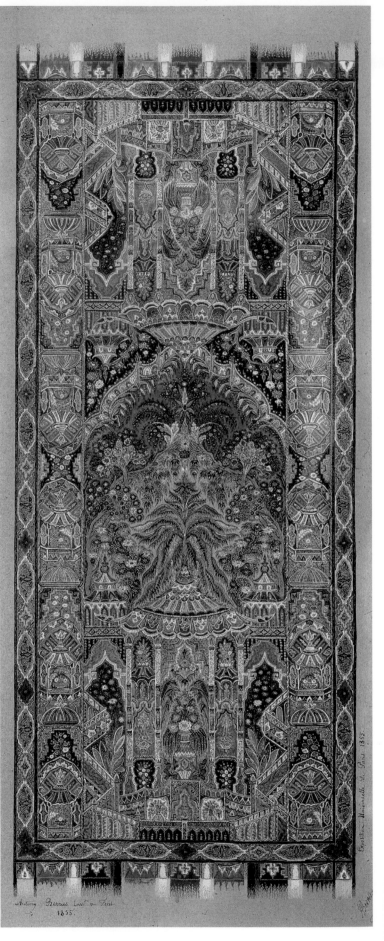

An à pivot shawl design signed by Berrus.
World's Fair, Paris, 1855.
Gouache on paper, 43.5 × 20.5 cm (17⅛ × 8⅛ in.).
Paris, Musée des Arts et Métiers, CNAM, no.08800.0002
Four pines confronted in pairs, with bases scrolling in the corners of the shawl,
are flanked by groups of smaller sloping pines. In the centre the decoration
consists of a delicate floral motif.

Signed shawl design by Berrus.
World's Fair, Paris, 1855.
Gouache on paper, 43.5 × 21 cm (17⅛ × 8¼ in.).
Paris, Musée des Arts et Métiers, CNAM, no.08800.0002.
In the midst of Persian motifs, a panel in the shape of a mihrab shows a Turkish pavilion;
behind it a cedar is flanked by trees in blossom. On either side are two pagodas: their tip-tilted
eaves, although reminiscent of China, are topped by Islamic-style crescent moons.

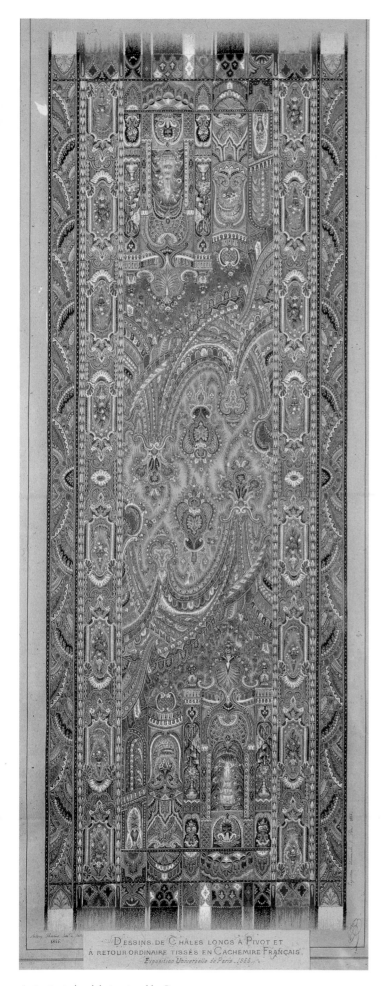

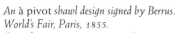

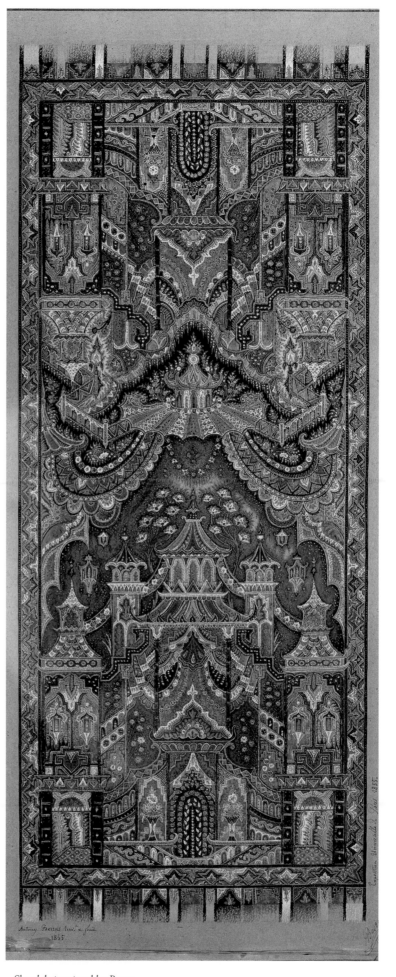

An à pivot shawl design signed by Berrus.
World's Fair, Paris, 1855.
Gouache on paper, 87 × 33 cm (34¼ × 13 in.).
Paris, Musée des Arts et Métiers, CNAM, no.08800.0002.
This à pivot design has resulted in the large central motif being diagonal; the sweeps of drapery complement the fantastical and baroque architectural features of the end sections.

Shawl design signed by Berrus.
World's Fair, Paris, 1855.
Gouache on paper, 43.5 × 20.5 cm (17¼ × 8¼ in.).
Paris, Musée des Arts et Métiers, CNAM, no.08800.0002.
This design incorporates a mihrab-shaped panel that contains a strange building, part Chinese, part Islamic in style.

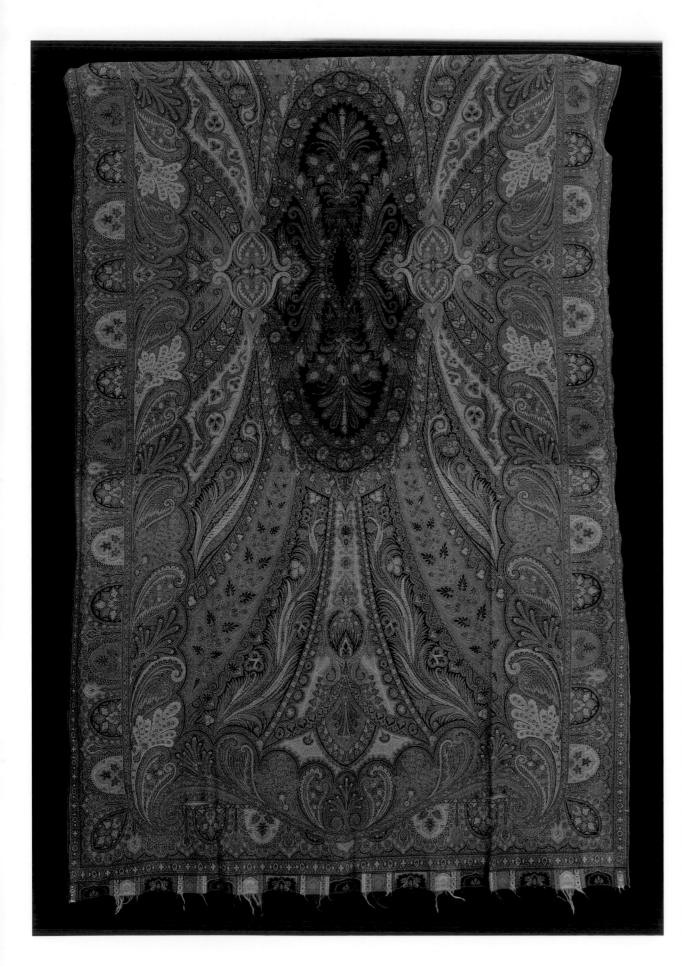

*Lower section of a long shawl
with a black central reserve.
Paris, 1857.
Manufactured by Bourgeois Frères
to a design by Berrus (no. 662,
dated 14 October 1857); conserved
in a Berrus album in the Etro
collection, Milan.
Woven au lancé using seven
weft colours plus two mariages
de couleurs, trimmed on back,
cashmere, 334 × 156cm
(131½ × 61¾ in.).
Paris, author's collection, no. 162.
The initials 'B. F.' are woven into
the four corners.*

OPPOSITE
*Detail of the shawl shown on this
page (central reserve).*

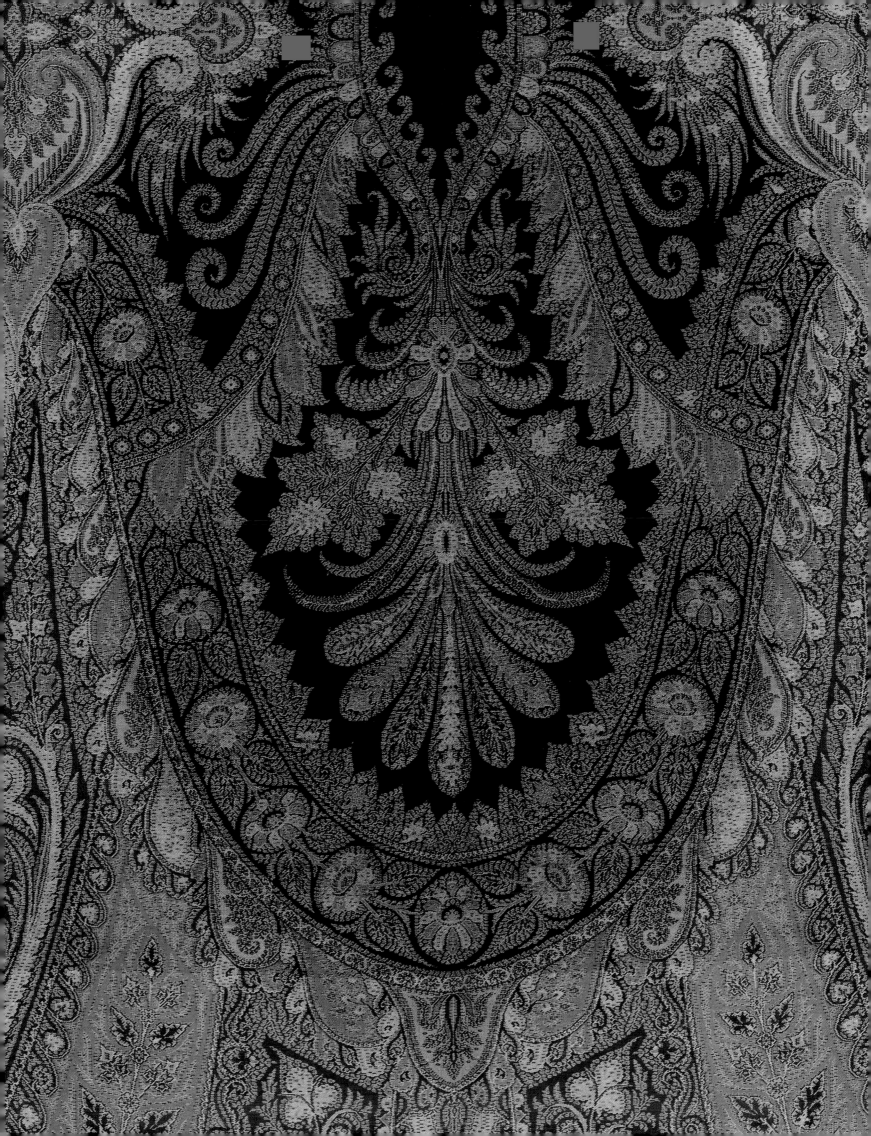

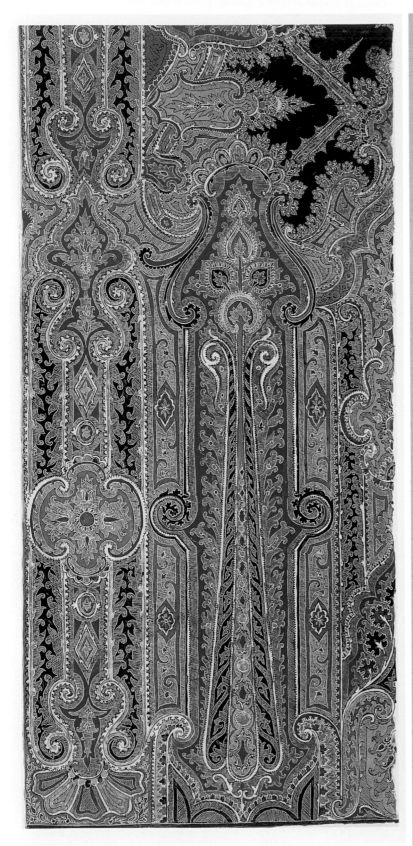

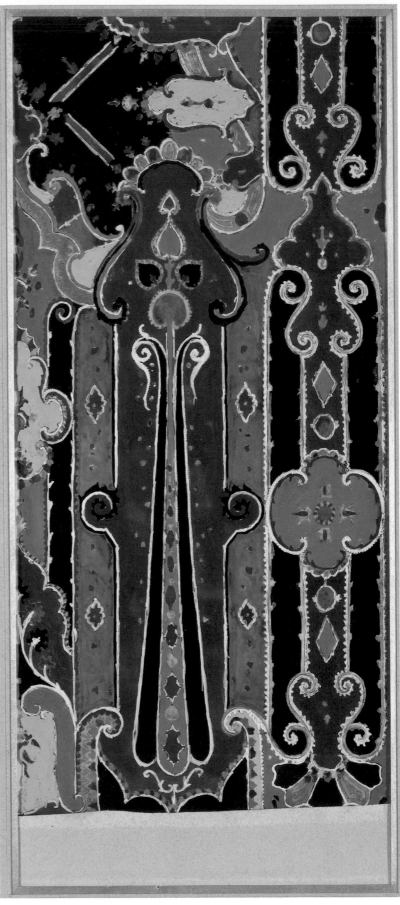

*Design for a quarter of a long shawl with Antony Berrus's stamp,
not signed, c. 1855–60. Right side, showing the design.
Gouache on gelatin, 41.8 × 32 cm (16½ × 12⅝ in.).
Paris, Musée des Arts Décoratifs, Cabinet des Dessins, no. CD5436.13.
The geometrically inspired decorative composition runs along parallel
lines. Berrus has conjured up a design reminiscent of a mosaic or another
architectural embellishment.*

Reverse of the same design, showing the plain areas of colour.

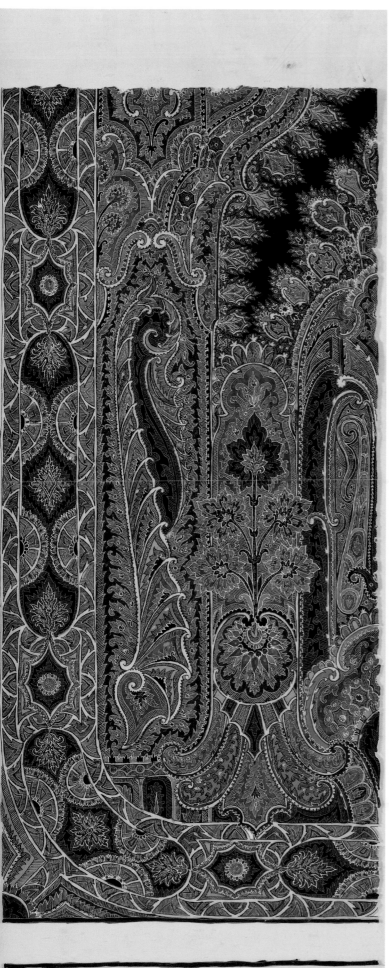

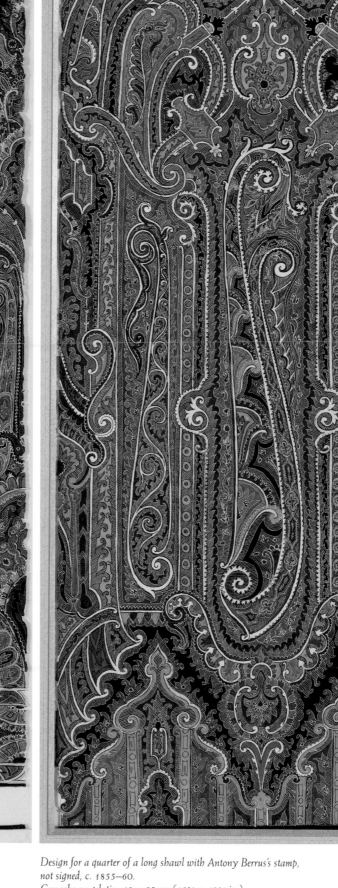

Design for a quarter of a long shawl with Antony Berrus's stamp,
not signed, c. 1855–60.
Gouache on gelatin, 45.4 × 24 cm (17⅞ × 9½ in.).
Paris, Musée des Arts Décoratifs, Cabinet des Dessins, no. CD5436.16.

Design for a quarter of a long shawl with Antony Berrus's stamp,
not signed, c. 1855–60.
Gouache on gelatin, 48 × 32 cm (18⅞ × 12⅝ in.).
Paris, Musée des Arts Décoratifs, Cabinet des Dessins, no. CD5436.17.

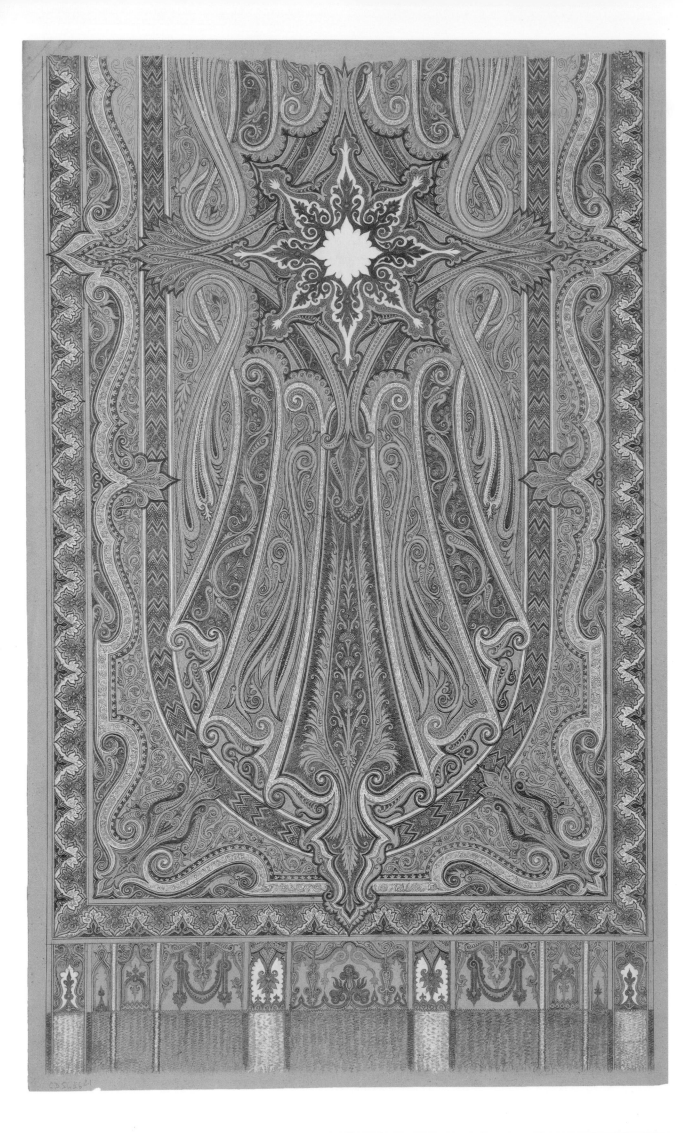

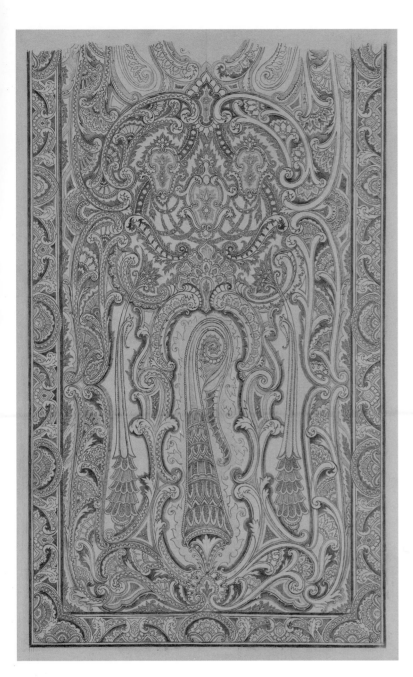

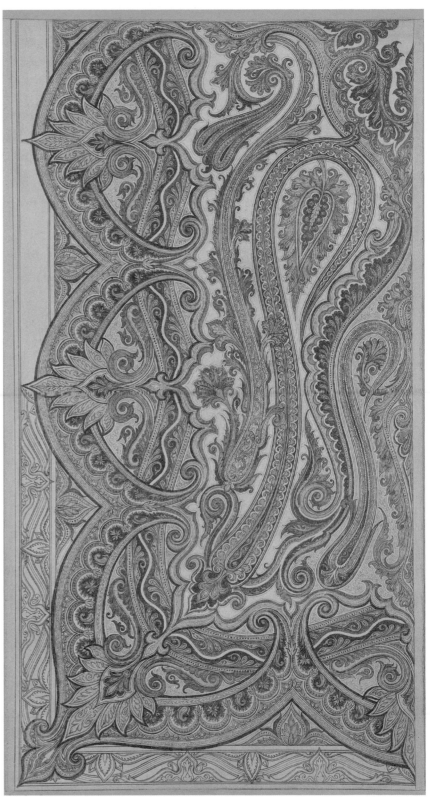

Design for a long shawl by Berrus, not signed or dated.
Pencil on paper, 58 × 46.8 cm (22⅞ × 18⅜ in.).
Paris, Musée des Arts Décoratifs, Cabinet des Dessins, no. CD5436.23.
The central decoration is inspired by the French Regency (1715–23) and is
supported by two rocaille-style columns enclosing a three-dimensional figured pine
with a conical end. Some features are reminiscent of designs prepared for the 1855
World's Fair in Paris.

OPPOSITE
Design for a long shawl by Berrus, not signed or dated.
Pencil and white gouache on paper, 58.2 × 35.8 cm (22⅞ × 14⅛ in.).
Paris, Musée des Arts Décoratifs, Cabinet des Dessins, no. CD5436.21.
This composition is contained within an elongated oval shape; in the centre is
a white, eight-pointed star-shaped reserve, forming the focal point for groups
of pines that snake towards it.

Design for a quarter of a long shawl by Berrus, not signed or dated.
Pencil on paper, 73 × 47 cm (28¾ × 18½ in.).
Paris, Musée des Arts Décoratifs, Cabinet des Dessins, no. CD5436.26.
The most noticeable feature of this quarter detail is the giant festoon ornamentation,
inside which are other, smaller festoons surrounding the decorative motif.

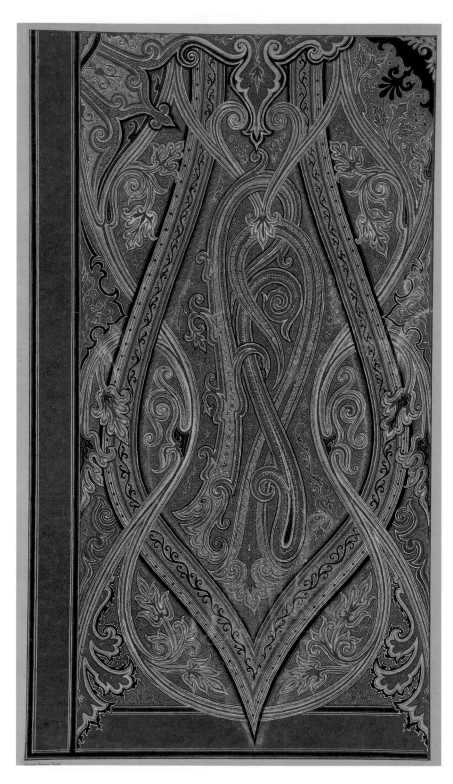

Design for a quarter of a long shawl by Berrus, not signed or dated.
Ink and gouache on blue paper, 73.7 × 50 cm (29 × 19⅝ in.).
Paris, Musée des Arts Décoratifs, Cabinet des Dessins, no. CD5436.39.
A bold spearhead motif points downwards and is entwined with plants tracing
arabesques, reminiscent of traditional Celtic illuminations in old Irish manuscripts.
There are three slender, interlaced pines in the centre of the motif.

Design for a quarter of a long shawl by Berrus, not signed or dated.
Ink and gouache on blue paper, 74 × 50 cm (29⅛ × 19⅝ in.)
Paris, Musée des Arts Décoratifs, Cabinet des Dessins, no. CD5436.40
The effectiveness of this design owes much to the bold festoon that surrounds a shield
motif. In the centre of the latter, a stylized tree of life can be discerned on the field
between two pairs of intertwined pines. The grid plan is visible – this made it possible to
reproduce the design on a large sheet of paper, ready for the mise en carte process when
the design was transferred to point paper.

Design for a long shawl by Berrus, not signed or dated.
Ink and white gouache on blue paper, 64.5 × 35.4 cm (25⅜ × 14 in.).
Paris, Musée des Arts Décoratifs, Cabinet des Dessins, no. CD 5436.42.
Pleated ornamental drapery directs the eye towards a large pedestal that encloses,
among other decorative motifs, two confronted pines with split apices.

RIGHT *Design for a long shawl signed by Berrus.*
Great Exhibition, London, 1862.
Gouache on paper, 49 × 20 cm (19¼ × 7⅞ in.).
Paris, Musée des Arts et Métiers, CNAM, no. 08799.0001.

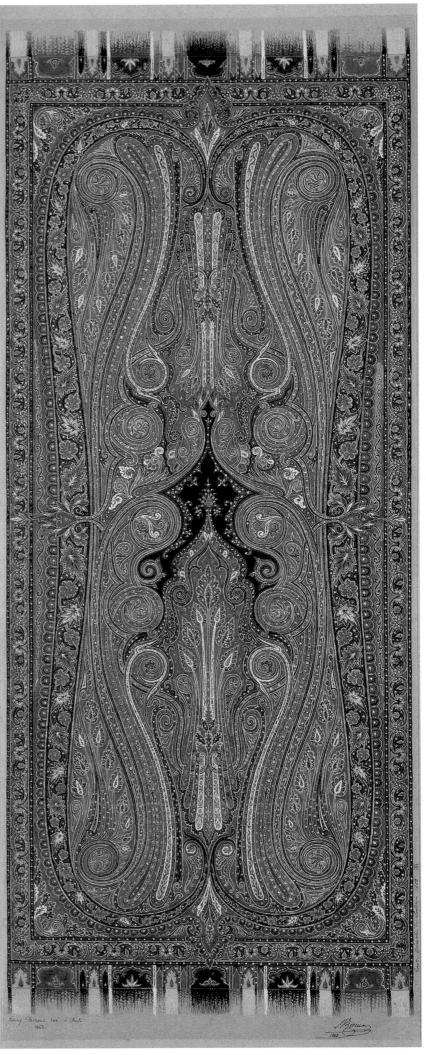

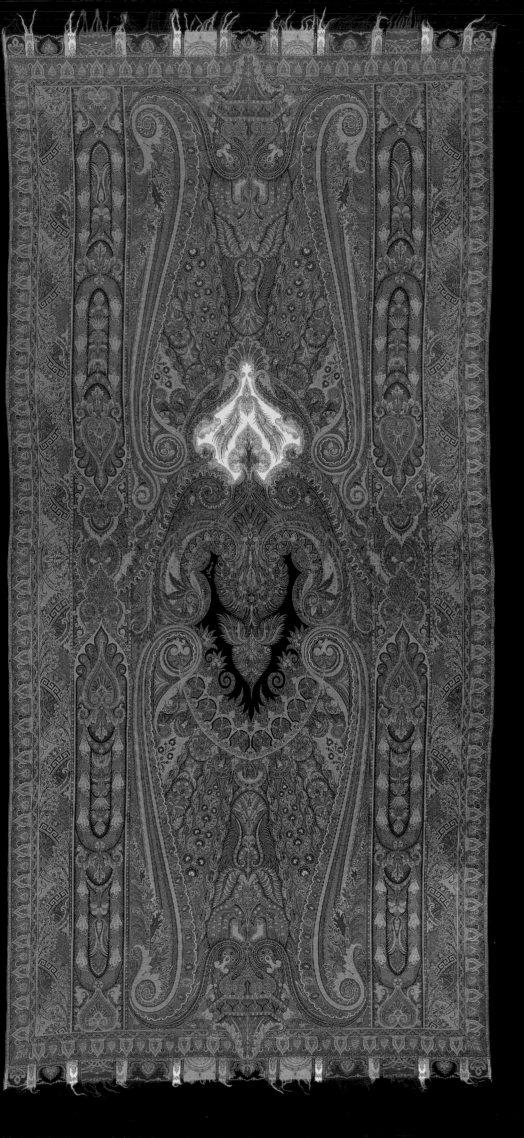

Long shawl with two different central reserves,
designed by Berrus.
Paris, c. 1862.
The design for this shawl is in Berrus's album XX47/3
(1861–64), folio 71, conserved in the Cabinet des
Dessins, Musée des Arts Décoratifs, Paris, no.
CD5273.
Woven au lancé using seven weft colours plus
two mariages de couleurs, trimmed on back,
cashmere, 346 × 162 cm (136¼ × 63¾ in.).
Milan, Etro collection, no. 208.
Signature woven in white on the black ground,
but illegible.

OPPOSITE
Long shawl with a black central reserve, designed
by Berrus and manufactured by J. Chanel.
Paris, 1861–62.
The design for this shawl is in Berrus's album
XX47 (1861–62), folio 179, conserved in the
Cabinet des Dessins, Musée des Arts Décoratifs,
Paris, no. CD5273.2.
Woven au lancé using seven weft colours plus two
mariages de couleurs, trimmed on back, cashmere,
334 × 162 cm (131½ × 63¾ in.).
Milan, Etro collection, no. 181.
The initials 'J C' are woven into the four corners.
The signature is woven in white on the black
central reserve.

Both these shawls and those shown on pages 254
and 255 have horizontal borders decorated with
a Greek key pattern.

OVERLEAF
Long shawl with a black central reserve,
designed by Berrus.
France, 1866.
Design conserved in the Cabinet des Dessins at the
Musée des Arts Décoratifs, Paris, no. CD5273.4.
Woven au lancé using seven weft colours plus two
mariages de couleurs, trimmed on back, cashmere,
352 × 161 cm (138⅜ × 63⅜ in.).
Milan, Etro collection, no. 158.
One of the exhibits at the World's Fair in
Paris (1867) was a shawl woven by the Lyons
manufacturer Rivoiron from a Berrus design
incorporating 'Louis XV-style medallions'.
It may quite possibly have been this shawl.

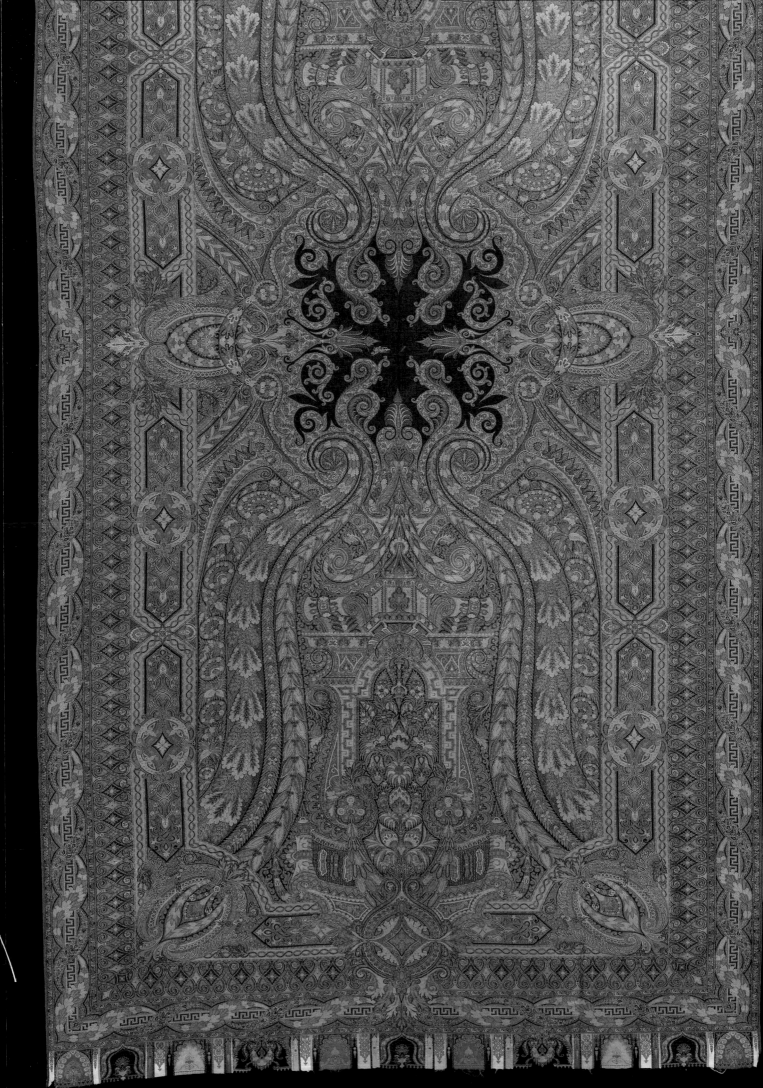

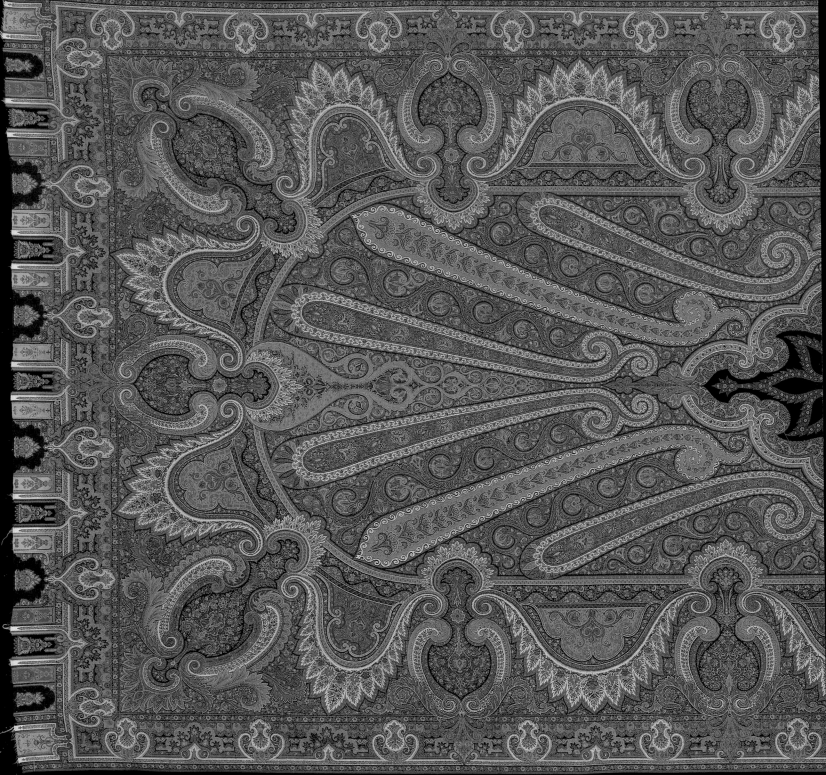

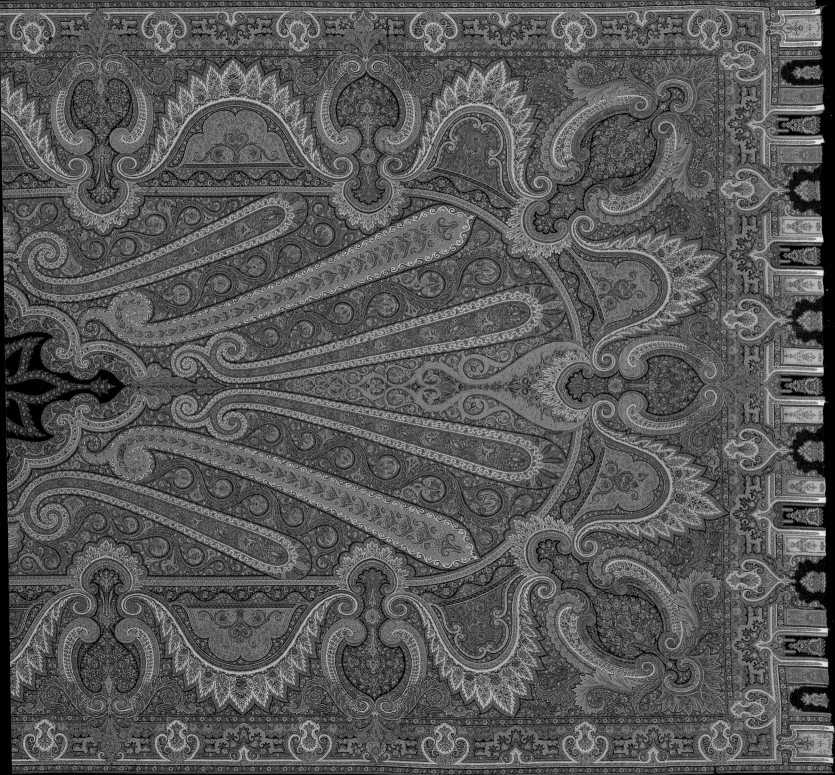

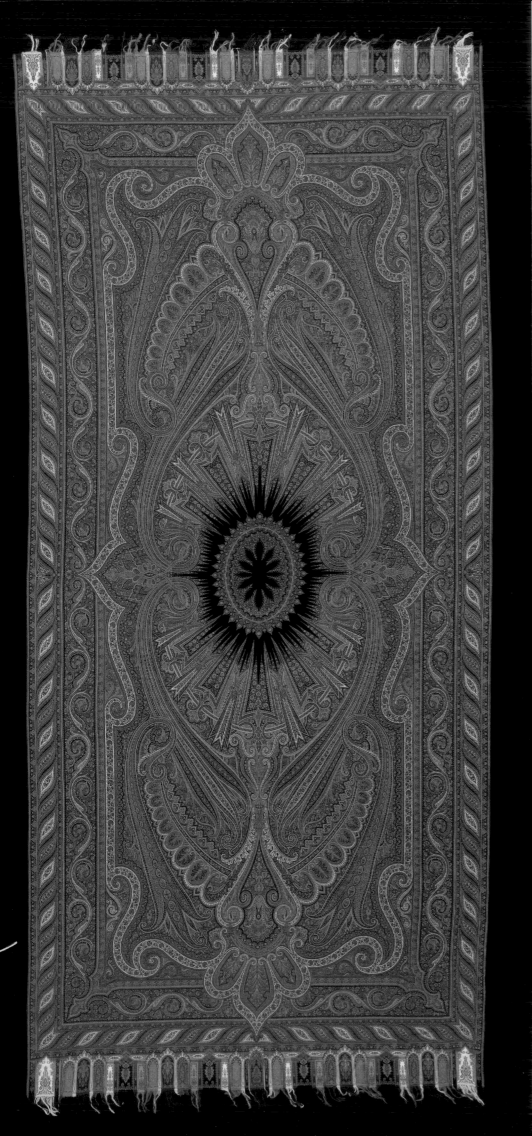

Long shawl with a black central reserve,
known as the Sun Shawl.
Paris, 1867.
Manufactured by Bourgeois & Mahaut from a design
by Berrus published in the Rapport des Délégations
Ouvrières de l'Exposition Universelle de Paris,
1867, in the chapter devoted to shawl designers.
Paris, library of the Musée des Arts Décoratifs.
Woven au lancé *using seven weft colours plus three*
mariages de couleurs, *double warp, trimmed on*
back, cashmere, 355 × 158cm (139¾ × 62¼ in.).
Milan, Etro collection, no. 275.

OPPOSITE
Central motif of the shawl shown on this page.

Design for an à pivot long shawl (detail),
signed by Berrus.
World's Fair, Paris, 1867.
Pencil and white gouache on paper,
95 × 44.5 cm (37⅜ × 17½ in.).
Paris, Musée des Arts Décoratifs,
Cabinet des Dessins, no. CD5436.30.
Sinuous pines twine around each other in this à pivot
design, in the middle of which is a small white reserve.
The borders surrounding this decoration look like a carved
wooden frame.

OPPOSITE LEFT
Long shawl design signed by Berrus.
World's Fair, Paris, 1867.
Gouache on paper, 54.8 × 26.9 cm (21⅝ × 10⅝ in.).
Paris, Musée des Arts Décoratifs, Cabinet des Dessins,
no. CD5305.
This design is completely symmetrical in relation to both
axes. The black reserve is lozenge-shaped and its points
end in an ornamental motif shaped like a lily. The pines
have become so misshapen in this composition that they
are almost unrecognizable as such, contained within a frame
of sweeping festoons.

OPPOSITE RIGHT
Long shawl design signed by Berrus.
World's Fair, Paris, 1867.
Gouache on paper, 54.4 × 26.6 cm (21⅜ × 10½ in.).
Paris, Musée des Arts Décoratifs, Cabinet des Dessins,
no. CD5306.
From 1867 onwards the outline of decorative motifs was
sometimes emphasized by narrow white tracery. This design
is also completely symmetrical in relation to both axes.
A bold fusiform ornament stands out against a rectangular
background, in its centre is a medallion, towards which twelve
small pines with curled tops converge in groups of three.

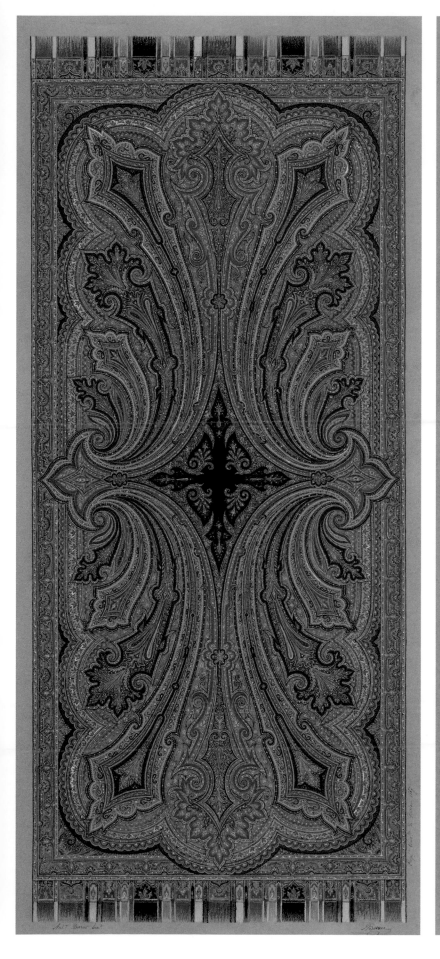

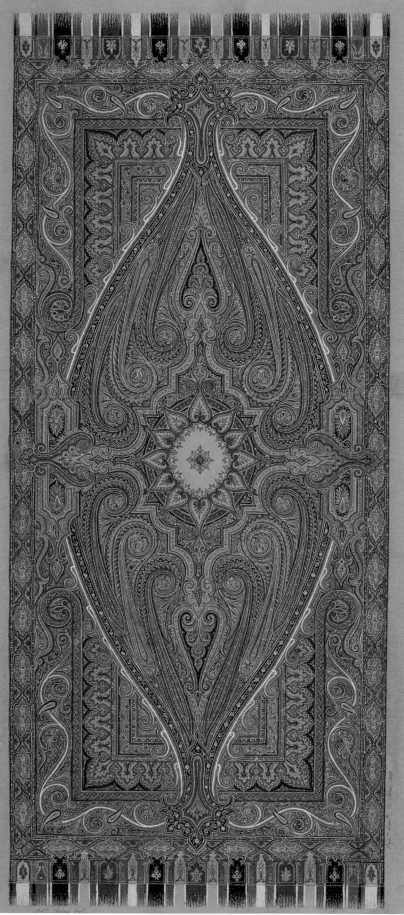

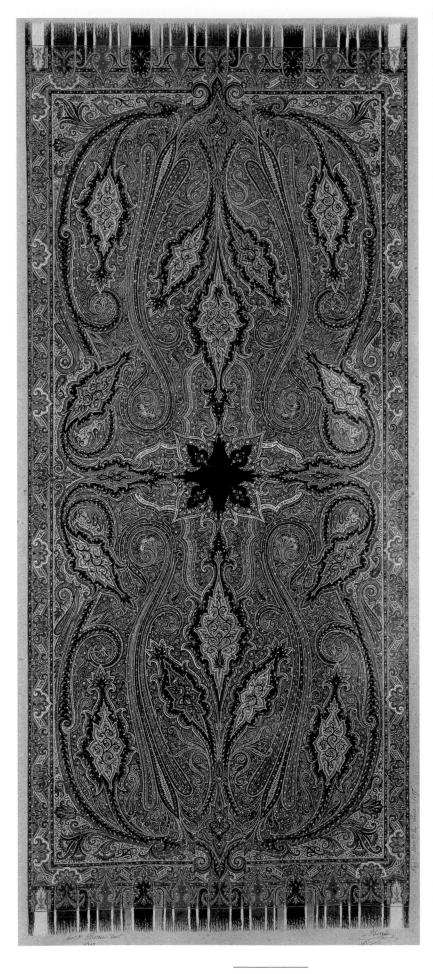

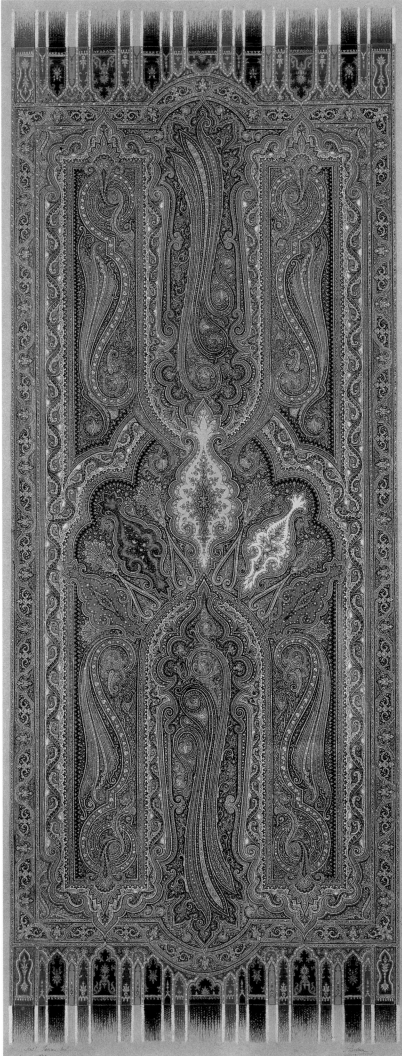

OPPOSITE LEFT
Long shawl design signed by Berrus.
World's Fair, Paris, 1867.
Gouache on paper, 50 × 23.5 cm (19⅝ × 9¼ in.).
Paris, Musée des Arts et Métiers, CNAM, no. 08799.0002.
The composition of this shawl design has been developed
symmetrically around both axes. Backing on to both sides
of a highly stylized tree of life is a pine with a base consisting
of three segments and a curled tip ending in a flower motif.
The small black reserve is contained within a cruciform motif.

OPPOSITE RIGHT
Long shawl design signed by Berrus.
Great Exhibition, London, 1862.
Gouache on paper, 88 × 36 cm (34⅝ × 14⅛ in.).
Paris, Musée des Arts et Métiers, CNAM, no. 08799.0001.
The triple pine placed in the centre of one half of the shawl
is repeated in the other half by a rotation of 180 degrees,
using the technique adopted for à pivot designs. The first
niche is placed under a multifoil arch with three different
ground colours.

RIGHT
Design for an à pivot shawl signed by Berrus.
World's Fair, Paris, 1867.
Gouache on paper, 97 × 40 cm (38⅛ × 15¾ in.).
Paris, Musée des Arts Décoratifs, Cabinet des Dessins,
no. CD5314.
This à pivot design comprises two pairs of pines, placed
head to tail, occupying the whole length of the figured field.
These S-shapes, which take the place of pines, cross a small
black central reserve which is also S-shaped. A black edging
traces the outline of the motif and is in turn surrounded by
a festooned border.

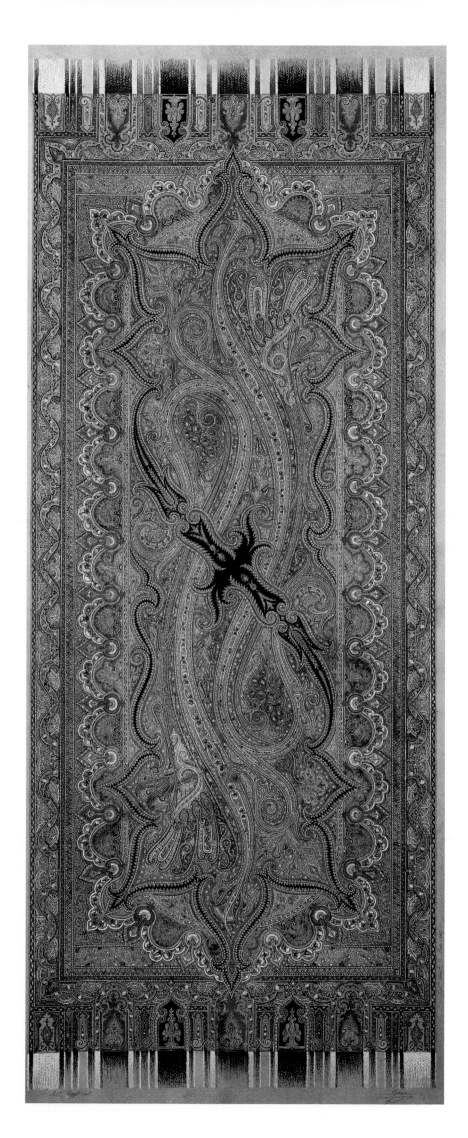

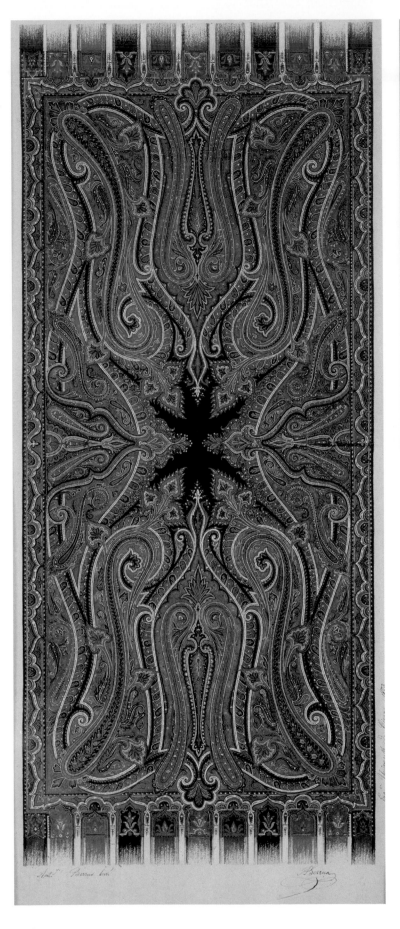

Signed shawl design by Berrus.
World's Fair, Vienna, 1873.
Gouache on paper, 51 × 22.5 cm (20⅛ × 8⅞ in.).
Paris, Musée des Arts et Métiers, CNAM, no. 08798.
An arabesque of white outlines with floral motifs encircles pines
that face each other across a motif topped by a lily.

278

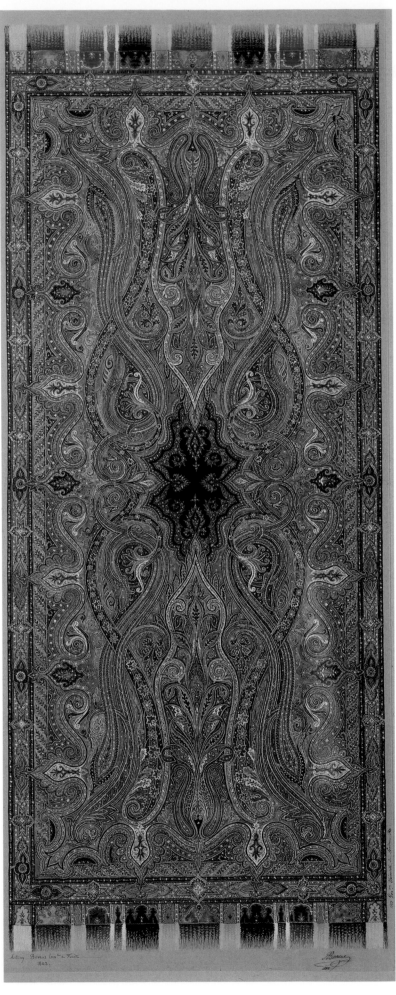

Signed shawl design by Berrus.
Great Exhibition, London, 1862.
Gouache on paper, 51 × 24 cm (20⅛ × 9½ in.).
Paris, Musée des Arts et Métiers, CNAM, no. 08799.0001.

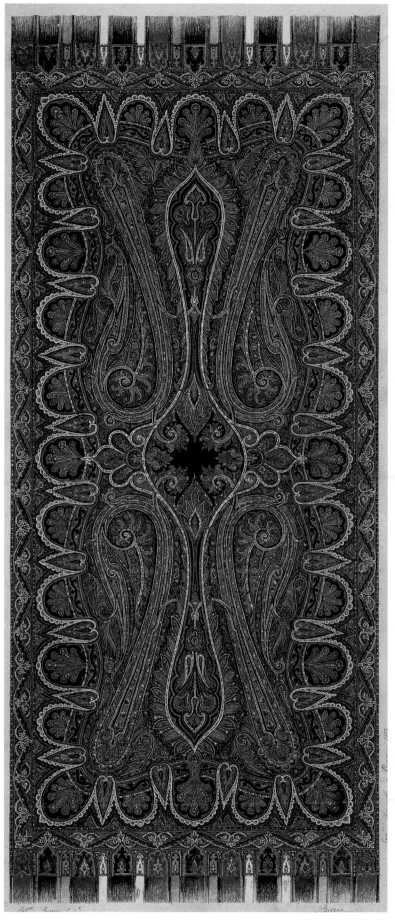

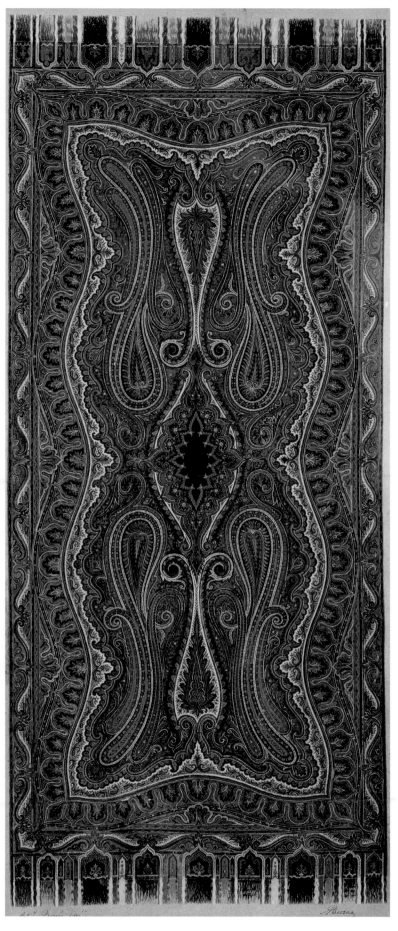

Signed shawl design by Berrus.
World's Fair, Vienna, 1873.
Gouache on paper, 59.7 × 31.5 cm (23½ × 12⅜ in.).
Paris, Musée des Arts Décoratifs, Cabinet des Dessins, no. CD5312.
The design is symmetrically arranged around both axes. The surround has a white
festoon edging; the deep end (pentes) section is decorated with two pines arranged
back to back on either side of a spear-shaped motif containing a flowery ornament.

Signed shawl design by Berrus.
World's Fair, Vienna, 1873.
Gouache on paper, 51 × 22.5 cm (20⅛ × 8⅞ in.).
Paris, Musée des Arts et Métiers, CNAM, no. 08798.

279

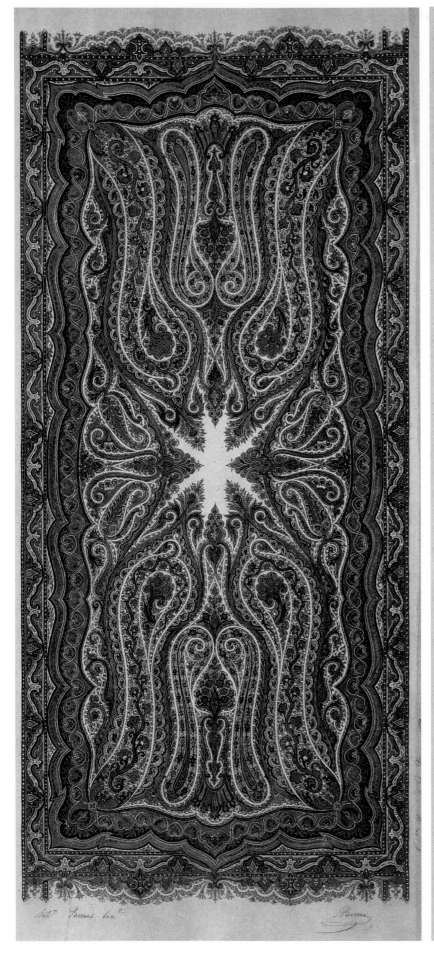

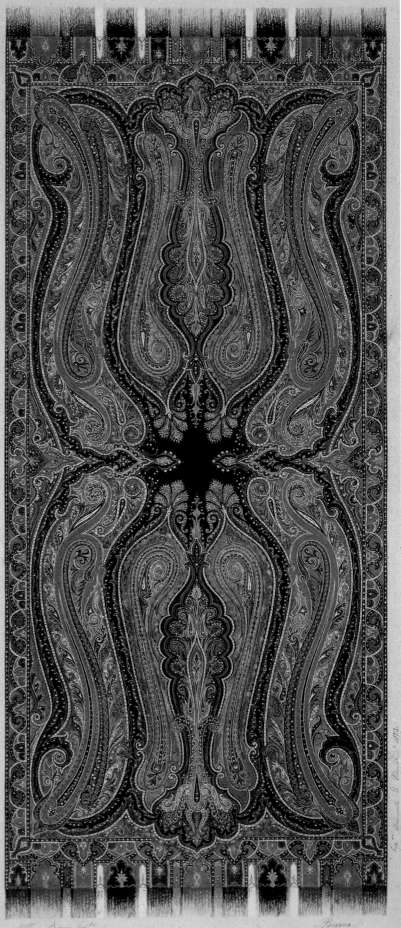

OPPOSITE LEFT
Signed shawl design by Berrus.
World's Fair, Vienna, 1873.
Gouache on paper, 51 × 22.5 cm (20⅛ × 8⅞ in.).
Paris, Musée des Arts et Métiers, CNAM, no. 08798.

OPPOSITE RIGHT
Signed shawl design by Berrus.
World's Fair, Vienna, 1873.
Gouache on paper, 51 × 22.5 cm (20⅛ × 8⅞ in.).
Paris, Musée des Arts et Métiers, CNAM, no. 08798.

RIGHT
Signed shawl design by Berrus.
World's Fair, Vienna, 1873.
Gouache on paper, 87 × 34 cm (34¼ × 13⅜ in.).
Paris, Musée des Arts et Métiers, CNAM, no. 08798.
The lobes that radiate outwards from the central motif are
in contrasting colours.

La question des Cachemires, caricatures par Cham.

(Un duel à la lettre. — Affaire Cuthbert et Biétry.)

(J'aimerais bien mieux que ces messieurs m'écrivissent directement par la poste, ça ne me coûterait que 3 sous, au lieu de m'écrire par mon journal, qui me coûte 60 francs par an.)

(Le Constitutionnel écrasé par la correspondance Cuthbert et Biétry.)

(M. Biétry traduisant le Grand-Colbert en police correctionnelle.)

(M. Cuthbert prouvant qu'il est Frrrrrrrrrrrrançais.)

(Vérification d'un cachemire. — Madame, j'ai effilé tout votre châle, et j'ai trouvé trois fils de coton.)

(Étiquette de cachemire proposée par M. Biétry.)

(Nouvelle marque de fabrique pour les cachemires. — Voir le Constitutionnel du 1er décembre.)

(Le meilleur moyen de s'assurer que l'on porte un véritable cachemire.)

Laurent Biétry

Ambroise Laurent Biétry, the son of a farmer, was born on 4 October 1799 in Bagnolet (Seine-Saint-Denis). In 1810 he became an apprentice at Richard-Lenoir's works, which was France's first cotton mill.

Biétry formed a company with a Monsieur Belleville and the two associates exhibited as spinners at the Paris exhibition in 1823, where they were awarded an honourable mention for the quality of their cashmere yarn. In the same year Biétry acquired his own spinning mill in Villepreux (Yvelines), on the banks of the Gally, and the works soon acquired a reputation for the quality and fineness of the yarn it manufactured. Between 1827 and 1839 there were as many as six or seven spinning mills in the Paris region.

The jury for the 1827 exhibition awarded Biétry a silver medal. By this date, in addition to spinning, he was also producing woven cashmere fabric. In 1831 his mill had 10 spinning looms equipped with between 120 and 130 spindles and it employed 50 workers.[1] By the time of the 1834 exhibition – where he was awarded a gold medal – Biétry was manufacturing plain fabrics on more than 100 looms in addition to spinning superior quality cashmere yarn. His mill now employed 85 workers and produced between 6,000 and 7,000 pounds of cashmere yarn annually.[2] Biétry was awarded another gold medal at the 1839 exhibition and was made a knight of the Legion of Honour at the same time; in 1844 he was awarded a gold medal for the third time.

On 1 May 1846, Biétry formed Laurent Biétry & Fils with his son Louis Joseph for a period of twelve years for the production of cashmere and woollen yarn; they also made and sold woven fabrics. By 1848 the Biétry mill was equipped with 2,308 spindles.[3] On 15 March 1847 Auxence Marcel joined the company (see the chapter on Deneirouse, pp. 295–311).[4] Biétry Père, Fils & Cie were retailers of cashmere shawls and cashmere fabric and their shop was located at 102 Rue de Richelieu. The jury report for the 1849 exhibition noted that the firm had recently begun manufacturing, as well as selling, cashmere shawls. In 1852 the firm acquired a limited partner but kept the original name. Biétry was made an officer of the Legion of Honour in the same year. Two years later, Louis Joseph died and Laurent Biétry and Auxence Marcel liquidated the company.

OPPOSITE
Cartoon by Cham in L'Illustration (*12 December 1846*) *caricaturing Biétry's attempts to stamp out fraud.*

[1] 'General state of manufactures, factories and industrial establishments and businesses in the commune of Villepreux'. Yvelines Departmental Archives, shelf mark 15M.5. These data were collected by the Mayor of Villepreux, on 13 December 1831. In the 'observations' column he writes regarding Biétry's cashmere spinning works: 'this establishment has been operating for a very short time. It is likely to undergo a substantial increase in size.'
[2] Response by the Mayor of Villepreux (dated 27 August 1834) to a circular letter from the prefect for the Seine-et-Oise department. Yvelines Departmental Archives, shelf mark 15M.6, item no. 439.
[3] Bailly tax records for the Villepreux commune, information dated 22 June 1848 concerning the Laurent Biétry woollen mill. Yvelines Departmental Archives, shelf mark 15M.2..
[4] Auxence Marcel had joined Deneirouse & Cie on 30 April 1839 and following Deneirouse's retirement he and Eugène Pierre Louis Aimé Heuzey had formed Heuzey & Marcel, which was liquidated on 21 December 1846.

In 1854 Biétry became president of the Fabrics section at the Prud'hommes Registry, a post he retained until 1866 while continuing to manage his spinning mill and manufacture shawls and fabric, which he sold from his new outlet at 41 Boulevard des Capucines.

As if exercising his official duties and running a full-time business were not enough, Biétry was also busy defending his professional activities in court. In 1833 he came into conflict with the Mayor of Villepreux and a wallpaper manufacturer by the name of Cartier when his efforts to increase the water supply to his factory affected levels in the vicinity. And in 1846 he became involved in another dispute with a Monsieur Cuthbert, owner of the shop *Le Grand Colbert*,[5] when the latter began advertising pure cashmere shawls at prices that undercut the competition (p. 282). Biétry reacted by publishing a letter in *Le Charivari* denouncing Cuthbert's assertions as fraudulent and arguing that the shawls could not be pure cashmere at the prices advertised but must be mixed with silk waste, sheep's wool and possibly even cotton. Cuthbert replied that if he was in a position to offer pure cashmere shawls for such a modest price it was thanks to buying in bulk at very low rates. The harsh exchanges continued and we learn that Biétry had just opened an office for 'the verification of cashmere shawls' at 8 Rue de La Vrillière, in the heart of the 'shawl district'. A former manufacturer by the name of Girard ran this establishment, which offered certificates free of charge confirming whether shawls were genuine or imitation cashmere. Biétry and Cuthbert went to court over the matter, but a judgment was not reached. What is clear, however, is that rivalries in the Parisian market were fuelled by the increasingly low prices fetched by Indian shawls (which were also becoming increasingly crude).

In 1849 Biétry published a pamphlet entitled *Réponse à une Brochure d'un Fabricant de Châles*.[6] The manufacturer in question (whom Biétry does not name) was asking for government protection of the French shawl industry against the importation of Indian goods. What he and his colleagues wished to see was the introduction of a tax on all Indian shawls coming into France, the suggested figure being 500 francs for every square shawl and 1,000 francs for long ones – a demand that the Chamber of Deputies had already rejected in February 1841. While approving the manufacturer's demand, Biétry criticized him for underestimating the level of the fraud involved – 'this disloyally cheap competition', as he described it, 'which had killed off the French cashmere industry'. And he insisted that 'no protection and no improvement will be safe and effective without a trademark…the guarantee of the thing sold'.

Biétry was therefore one of the first to demand (in 1849) that manufacturers should label their shawls. Gaussen the elder, and following him Pouzadoux & Duché, had already been weaving their name or their initials at the bottom of some of their shawls. But it was only from 1850 that the practice became widespread. Biétry himself either wove or embroidered his name and the word 'Cachemire' in the corner of some of his shawls. Sometimes he also incorporated the recipient's coat of arms.

The shawls he had been selling in his shop since 1847 – not all of them necessarily manufactured by him – carried a round white taffeta label sewn on the back (p. 104) with the company name and address on it ('Biétry Pére, Fils & Cie, Rue de Richelieu, 102, Paris') and an indication of whether the shawl as a whole or only the warp was made

5 I would like to thank Piedade da Silveira, who has written about the history of the Parisian department stores and brought these particular facts to my attention.

6 *Réponse à une Brochure d'un Fabricant de Châles. Le Châle Cachemire Français, le Châle des Indes et la Marque de Fabrique, par Biétry, Fabricant de Cachemire, Membre de la Légion d'Honneur.* Bibliothèque Nationale de France, shelf mark VP-6925..

of cashmere. From 1855 an oval label in ivory silk bearing the inscription 'Châle Biétry, Boulevart [sic] des Capucines, 41' also included Biétry's medals and decoration, and the fact that he had a patent from their Imperial Majesties, but no longer indicated the cashmere content (p. 291). Later, and certainly in 1862, Biétry printed a half-moon stamp on the back of his shawls bearing the inscription 'Biétry à Paris Châles Cachemires' in gold letters. His manufacturer's guarantee thus appeared on the front of a shawl, whereas his retailer's guarantee appeared on the back.

We know of eight shawls that were actually manufactured by Biétry. Four are reproduced here, including one that carries his label (p. 291, right). Biétry's first shawls were in an exuberant *style végétal*, or floral style, and had a typical French elegance, combin-

ing Berrus's brilliant design work with a top-quality yarn and weave. The shawl made for the Empress Eugénie presented two new features that gave it a particularly Indian feel: one, the hand-embroidered harlequin shawl ends and, two, a slightly uneven texture due to the use of twisted yarns.[7]

All the shawls signed by Biétry were woven from designs by Berrus, to whom Biétry appears to have turned for the vast majority of his shawl designs. The two men would have felt a keen sympathy for one another. They both loved things that were well made and the fine Biétry's yarns was a perfect match for Berrus's intricate designs. And they were both commercial realists (a characteristic not universally shared by their colleagues).

We might wonder why there are no Biétry shawls signed in the corners after 1857, given that he was exhibiting 'French cashmere shawls' in London in 1862 and that up until 1869 he continued to describe himself as a spinner and manufacturer of cashmeres in the *Almanachs du Commerce*. It is possible that, like the majority of shawl manufacturers after 1860, he used a mark woven in white in the black central reserve of his shawls, which we have so far been unable to identify. Equally, his son's early death may have led to a reduction in his activities. Laurent Biétry himself died in Chatou (Yvelines) in 1870.

A box lid showing Biétry's stamp.
Paris, 1855. Cardboard.
Paris, Debuisson collection.

7 See Laurent Biétry, *Lettre Adressée à Messieurs les Membres de Jury de XXe Classe (Tissus) à l'Exposition Universelle de 1855.* Bibliothèque Nationale de France, shelf mark VP-13011.

Detail of the shawl shown opposite. The imperial arms
are woven in the left-hand corner of the harlequin shawl
end, within a framework of embroidered flowers; the name
'Biétry' has been embroidered beneath them.

OPPOSITE
Lower section of a long shawl with a cruciform central reserve, woven by
Biétry from a design by Berrus.
Paris, c. 1855.
Berrus's design is in the Cabinet des Dessins at the Musée des Arts Décoratifs,
Paris.
Woven au lancé using eight weft colours plus one mariage de couleurs,
trimmed on back, cashmere, 337 × 162 cm (132⅛ × 63¾ in.).
Milan, Etro collection, no. 172.
The imperial arms are woven into all four corners of the shawl, which was
clearly commissioned by the Court, probably for the Empress Eugénie. The
name 'Biétry' is embroidered in two corners and also in the centre of the shawl.

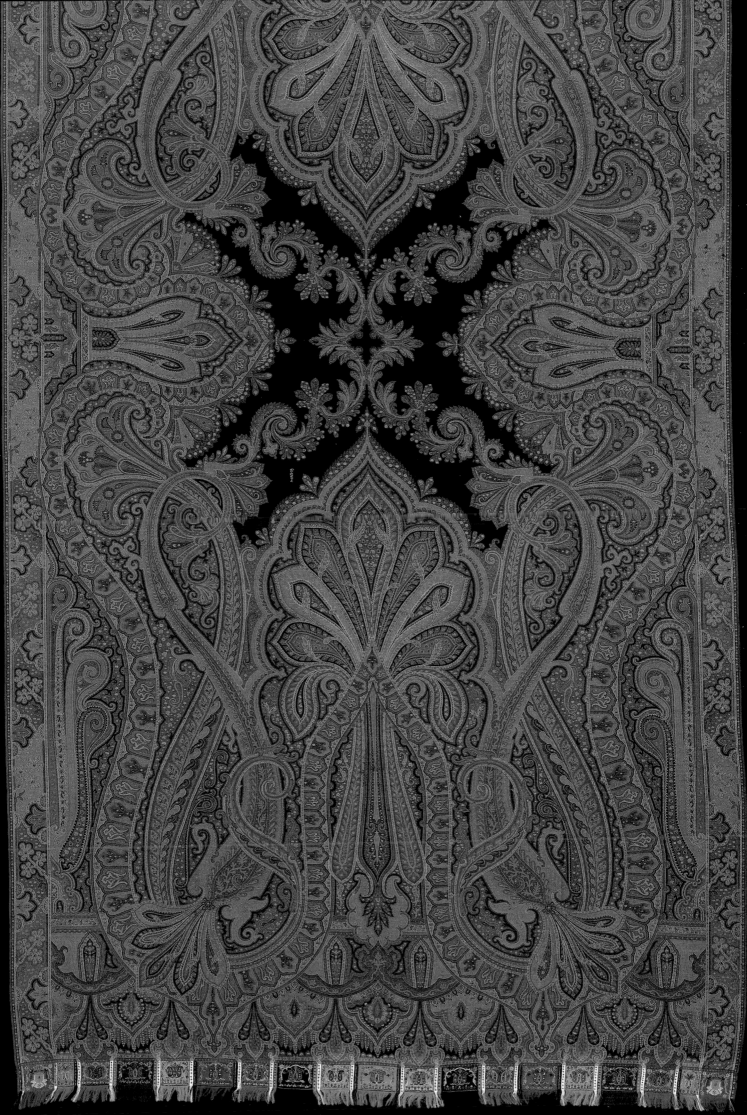

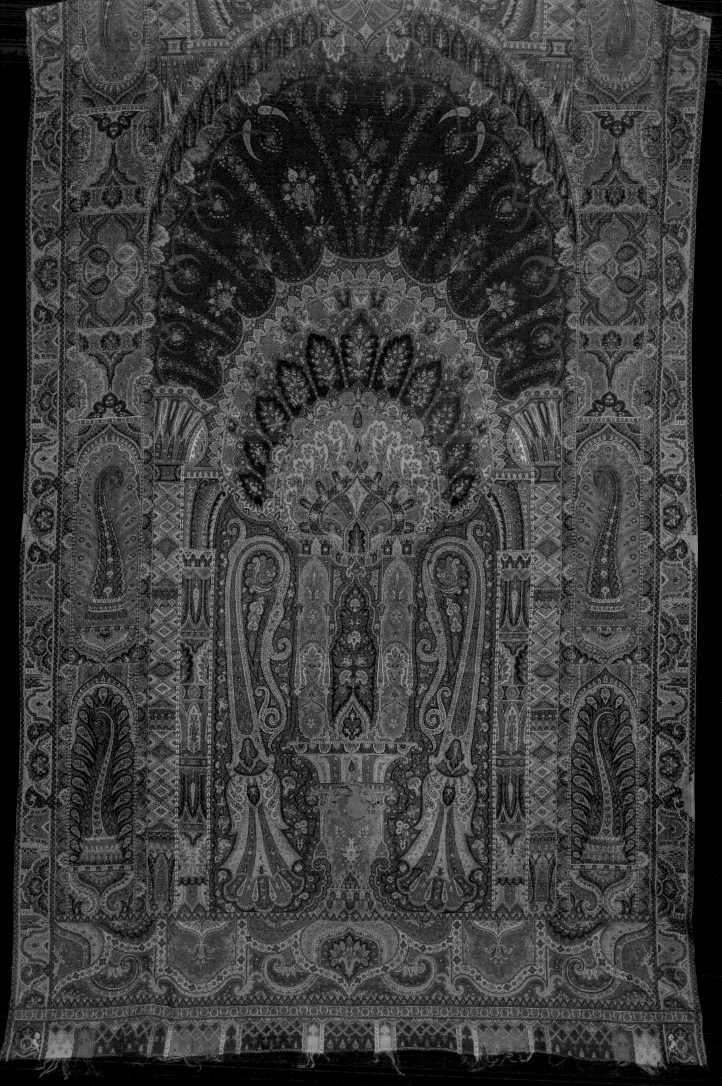

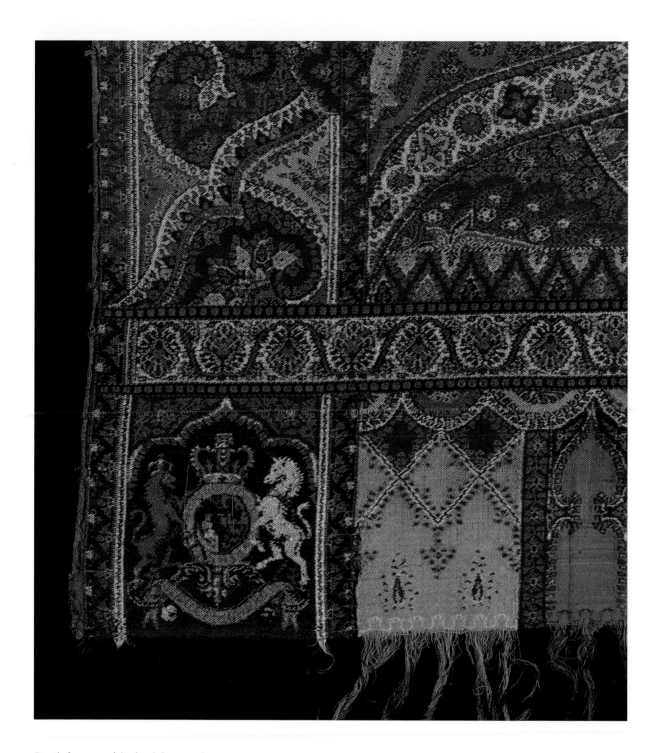

Detail of a corner of the shawl shown on the opposite page.

OPPOSITE
Long shawl (lower half) with a red reserve, woven by Biétry from a design by Berrus.
Paris, 1855.
Berrus's design is in the Musée des Arts et Métiers, CNAM, no. 08800.0001 (see p. 256, left).
The Arms of England are woven into the corners of this shawl, which was probably commissioned
by a member of the Royal Family. The sky-blue ribbon beneath the arms tells us that the shawl
was made by Biétry (who incorporated a similar ribbon bearing his name in the design of other
shawls). The pines in their niches have a statuesque quality in keeping with the architectural style
of the composition.

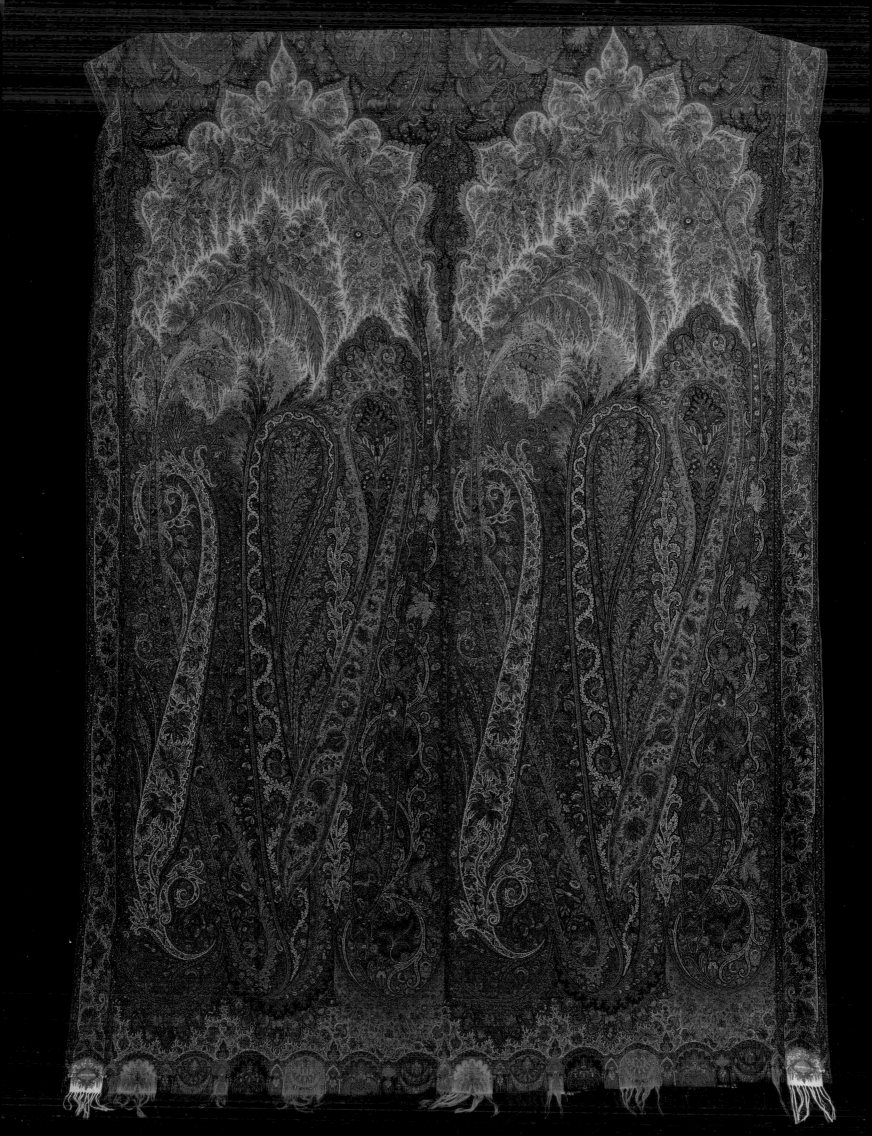

OPPOSITE
Lower section of a long shawl with green reserves,
woven by Biétry from a design by Berrus.
Paris, 1851.
Berrus's design is in the Musée des Arts et Métiers,
CNAM, no. 08797 (see p. 249, left).
Woven au lancé using nine weft colours, trimmed
on back, cashmere, 378 × 163.5 cm (148⅞ × 64⅛ in.).
Paris, author's collection, no. 154.
The patterning of this shawl – which only has one
central repeat across its width – reflects the style végétal*,*
or floral style, at its most flamboyant.

RIGHT
Oval label used by Biétry (in his retail capacity) from 1855.

BELOW
Two corners of the shawl shown on the opposite page; in one
we see the woven inscription 'Cachemire', in the other 'Biétry'.

Detail of a corner of the shawl shown on the opposite page. The cross of the Legion of Honour dangles from a sky-blue ribbon carrying the woven inscription 'Cachemire'; the same ribbon at the other end of the shawl carries the inscription 'Biétry'.

OPPOSITE

Long shawl (lower section) with a black central reserve, woven by Biétry from several designs by Berrus. Paris, 1852–54. Berrus's designs are in the Cabinet des Dessins at the Musée des Arts Décoratifs, Paris, no. CD5277.4.
Woven au lancé using eight weft colours plus one mariage de couleurs, trimmed on back, cashmere, 357 × 162 cm (140½ × 63¾ in.).
Paris, author's collection, no. 159.
While creating an original effect, the multiple repetitions of this design stem from a desire to minimize the work involved in the mise en carte (and thereby reduce costs).

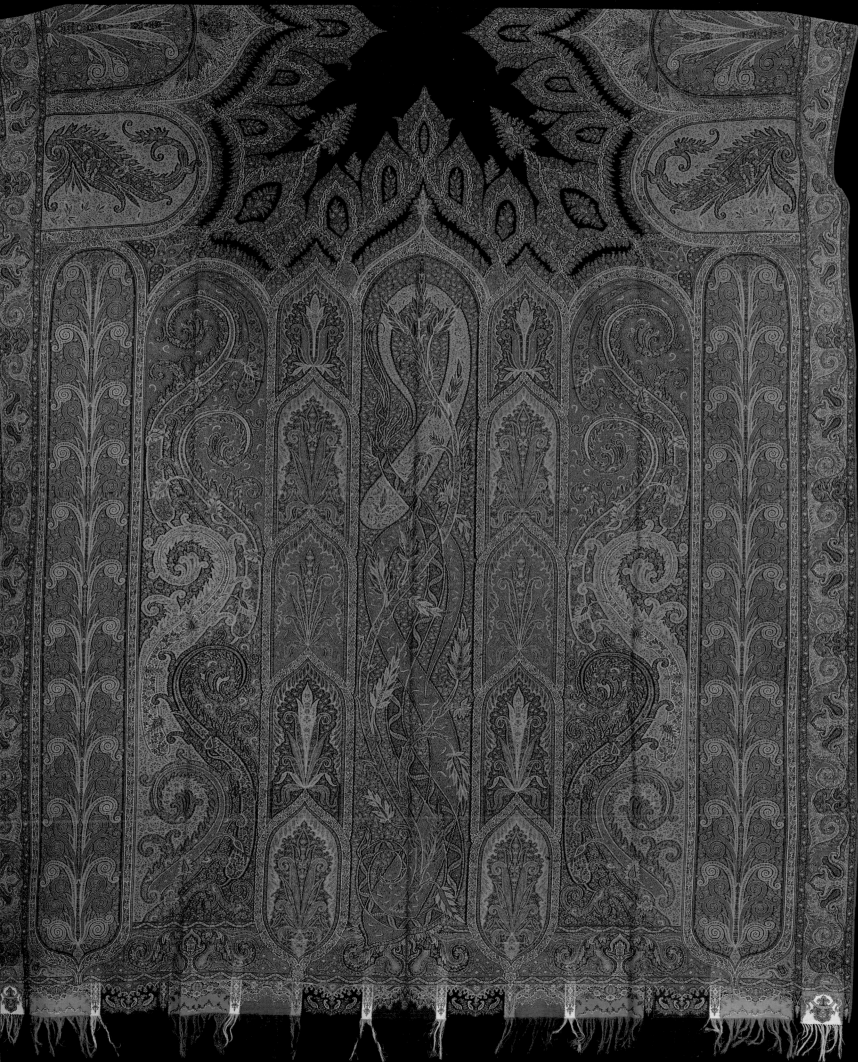

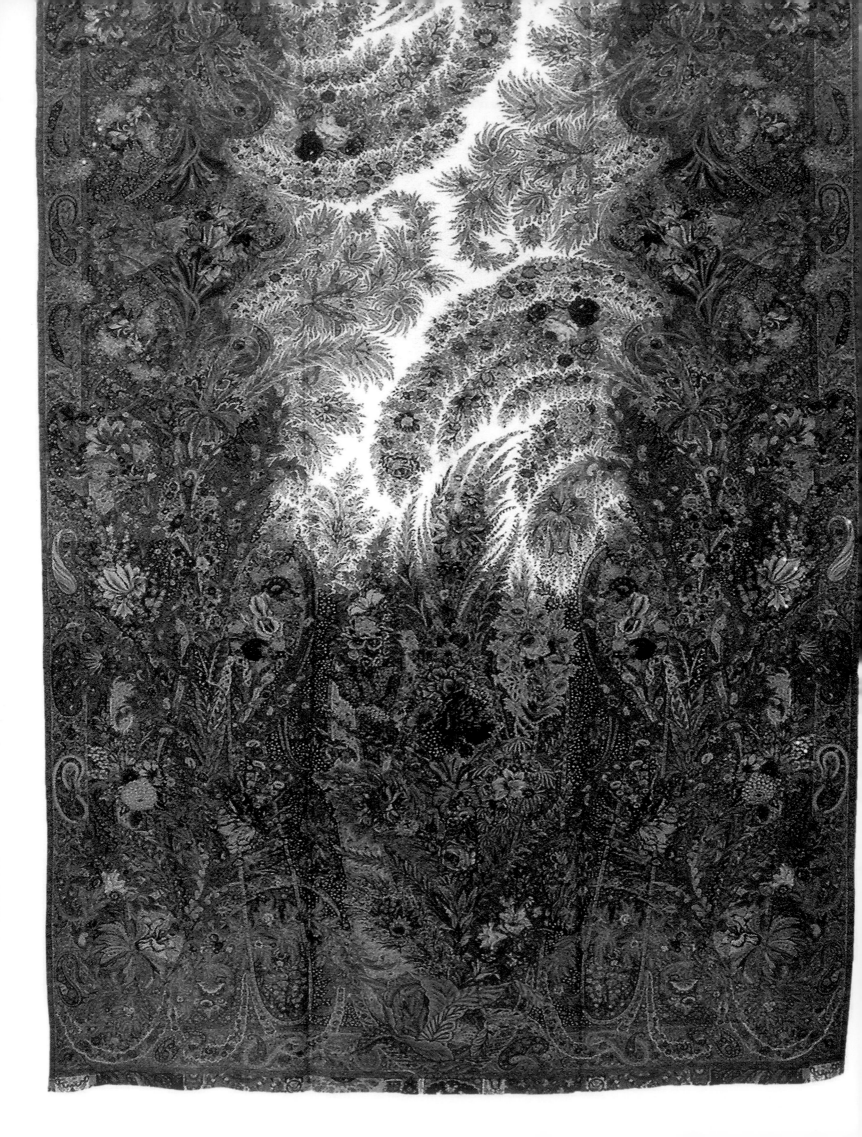

Jean Deneirouse

The book *Cachemires Parisiens 1810–1880* (Parisian Cashmeres),[1] which I published in 1998, includes chapters on six of the most famous shawl manufacturers in Paris. Unfortunately, it includes nothing on Jean Deneirouse, one of the masters of the profession, since we had none of his shawls to show in the exhibition that was held to coincide with publication of the book. But in December 2003 a particularly beautiful shawl signed by Deneirouse and his associate Eugène Boisglavy appeared on the market and its owner allowed us to photograph it (see opposite).

Like François Lagorce and the two Gaussen brothers (three other great Parisian shawl manufacturers), Jean Deneirouse was born in Nîmes – on 5 December 1787. His father was a weaver.[2] Deneirouse records that in 1805 his then employer, Lagorce (who had a manufactory in Nîmes), sent him to Lyons to learn the 'theory of fabrics'.[3] One of the two notebooks that Deneirouse donated to the Musée des Arts Décoratifs de Paris (currently held at the Musée de la Mode et du Textile[4]) opens with *'First principles of the manufacture of silk stuffs and all types of gilding composed by M. Laselve, professor at the Conservatoire des Arts de la Ville de Lyon'*. It would appear that Deneirouse spent at least two years in Lyons studying weaving and industrial design.[5] Then, in 1809, Lagorce summoned Deneirouse to Paris, where he wanted him to start up a shawl manufactory.[6]

Deneirouse married Marie Joséphine Audussant (at a date unknown to us) and the couple had two daughters: Laure Sophie Joséphine, born on 17 March 1814, and Henriette Eugénie (known as Eugénie), born in Passy on 6 May 1827. On 2 February 1833 Laure Joséphine Deneirouse married Charles Léopold Heuzey.

The letterhead of an invoice informs us that in 1828 Deneirouse was manufacturing shawls in Corbeil.[7] He acquired some land and property in the region in 1836, at Quai de l'Apport-Paris, and it was probably around this time that he moved his parents there. His mother died in Corbeil in 1840 and his father in 1841.

In 1846 the population census for Corbeil indicates that Jean Deneirouse, his wife Marie Joséphine and his younger daughter Eugénie were still living together at Quai de l'Apport-Paris. The 1851 census reveals that although Deneirouse (who

OPPOSITE
Lower section of a long shawl with a pivoting design, manufactured by Deneirouse, Boisglavy & Cie. Paris, 1849.
Woven au lancé using ten weft colours, trimmed on back, cashmere, 366 × 161 cm (144⅛ × 63⅜ in.). Milan, private collection.
We probably owe the design of this shawl to Deneirouse, who was a designer as well as a manufacturer.

1 Monique Lévi-Strauss, 1998.
2 Jean Deneirouse, 1863, p. 1.
3 *Ibid.*
4 Inventory no. UCAD ГО 18, reg. 1143: two handwritten notebooks (no page numbers), with samples, entitled 'Description de l'ourdissage, lissage et armure des étoffes de soie composée d'après des échantillons de soieries par Deneirouse en l'année 1805'. The author would like to thank Jean-Paul Leclercq, then curator of the Musée de la Mode et du Textile, in Paris, for showing her these two notebooks in 1996.
5 In their report for the Great Exhibition in London in 1862, the designers and weavers of shawls refer to Deneirouse, 'whom we have heard boast on more than one occasion, and with very good reason, that he had worked as a weaver and thrown a shuttle, and who later became a designer, drawing with a point on *papier verni'*.
6 Jean Deneirouse, 1851, pp. 3–4.
7 Essonne Departmental Archives, shelf mark 79J. Philippe Oulment was kind enough to send me a photocopy of this invoice.

described himself as Catholic) was still at the same address, Marie Joséphine and Eugénie were no longer living there. However, Léontine Petit, the daughter of a wine grower, born in Saint-Germain-lès-Corbeil on 13 July 1819, and her two children are recorded as living at the same address as Deneirouse. The situation was the same in 1855. On 15 August 1859 Marie Joséphine Audussant, the legally separated wife of Jean Deneirouse, died in Paris, where she was living at 69 Rue des Vieux-Augustins; and on 14 September 1859 Deneirouse married Léontine Petit. He died in Corbeil, at Quai de l'Apport-Paris, on 9 May 1869 and his real estate was sold in Corbeil in 1870.[8]

On 26 January 1821, Deneirouse formed a company with his former employer François Lagorce the elder and with three other shawl manufacturers: Louis Galon, François Gaussen the elder (see 'Gaussen the Elder and Gaussen the Younger', pp. 146–63) and Julien Juillerat. Lagorce Aîné & Cie was formed 'for the sale of shawls in both cashmere and wool' and from 1 July 1824 was registered at 16 Rue des Fossés-Montmartre, Paris. The document that contains this information also reveals that another company was formed by the same people, for the same purpose, for a period of three years, dating from the expiration of the first company, 1 July 1824, and ending on 1 January 1827. Deneirouse, Galon, Gaussen and Juillerat were to be associates in the new firm and Lagorce was to be a limited partner. The new company name was to be Deneirouse, Galon, Gaussen Aîné, successors to Lagorce Aîné. In the meantime, however, and before the first company reached the end of its term, Louis Galon died and Julien Juillerat retired. The new company was therefore known as Deneirouse & Gaussen Aîné, successors to Lagorce Aîné & Cie, and Deneirouse and Gaussen were the joint managers from July 1824.

When this second company reached the end of *its* term, on 30 March 1827, Deneirouse and Gaussen formed Deneirouse and Gaussen Aîné. The company was registered at the same address, 16 Rue des Fossés-Montmartre, and was liquidated, with the agreement of both parties, on 28 March 1829; Deneirouse oversaw the liquidation. The collaboration between Deneirouse and Gaussen the elder had lasted a total of eight years.

On 28 January 1832 the sub-prefect of Corbeil sent a letter to the prefect of Seine-et-Oise on the subject of 'the State of the factories in the main town of the arrondissement', observing that:[9]

> *Shawl manufactories have suffered a great deal since the July Revolution. The manufactory run by M. Saillet & Cie produces goods for both home and abroad, but its sales have been considerably affected in both markets. The efforts of these manufacturers to keep on their workforce have placed them in serious difficulties. However, business has been picking up since the month of September.*
>
> *The Deneirouse manufactory (previously Lagorce & Cie) sells ⅓ of its production in France and the other ⅓ abroad, ⅔ in Germany and England and the remainder in Italy and Spain. This factory has also made great sacrifices in order to keep on its workforce. Its looms have only been in operation again since September. Both firms are working speculatively and only manufacturing cheap shawls at the moment, there being no market for luxury products.*

We learn from this letter that two shawl manufactories were operating in Corbeil. A report on the factories in Corbeil dated 19 October 1832[10] indicates that by 31 October 1831 the two factories were between them employing 94 workmen on 63

8 The information relating to Deneirouse's presence in Corbeil was taken from the Essonne Departmental Archives. I am extremely grateful to Olivier Gorse for pointing me in the right direction.

9 The abstract of this document, and all those that follow, was consulted at the Paris Archives, shelf mark D31U3.

10 Yvelines Departmental Archives, shelf mark 15M.5.

looms, and that by 15 September 1832 the number of workmen had risen to 146.[11] On 14 May 1833, Deneirouse formed a new company with his son-in-law Charles Léopold Heuzey.[12] Deneirouse & Cie was registered for five years, from 1 July 1833 to 1 July 1838, at the old address, 16 Rue des Fossés-Montmartre.

By 1834 the fortunes of Corbeil's two shawl manufactories had revived and the Mayor of Corbeil, responding to a questionnaire from the prefect of Seine-et-Oise, stated that the Deneirouse shawl factory employed 200 workmen and produced 1,200 shawls annually with a value of 200,000 francs, destined for the major cities of Europe, and that the Saillet & Junot factory employed 30 workmen and produced 400 shawls valued at 100,000 francs and destined for the Paris market.[13]

Deneirouse worked until 1863 on the expansion of the property in Quai de l'Apport-Paris, Corbeil, which he had bought in 1836. As well as making his home there, he also installed a shawl factory on the premises; indeed, it is possible that his former factory may have been rented at this address.

On 13 May 1839, Jean Deneirouse, Eugène Pierre Louis Aimé Heuzey (possibly the younger brother of Deneirouse's son-in-law) and Auxence Marcel formed a new company 'for the manufacture and sale of cashmere shawls following the practices of the former Deneirouse firm'. The business was to be run 'from the shops and other rooms forming the first floor of a house located on Rue des Fossés-Montmartre, no. 16, and in Corbeil, in the factory of the former Deneirouse firm'. Deneirouse planned to retire on 1 January 1844 and until that time the company would continue to be known as Deneirouse & Cie; it was subsequently named after the other two associates, Heuzey and Marcel, who would be entitled to describe themselves as 'successors' to Deneirouse until 1 January 1851. However, the two companies were liquidated on 21 December 1846.[14]

Before this, on 20 October 1846, Deneirouse formed a new company with his son-in-law Charles Léopold Heuzey, which traded under the name Deneirouse & Léopold Heuzey and was liquidated on 6 November 1847. The same day he created another company with Eugène Pierre François Boisglavy and a limited partner (possibly his son-in-law Charles Léopold Heuzey) 'for the manufacture and sale of shawls, in both cashmere and wool and in *espoliné*, following the Indian style'. The company – Deneirouse, Eugène Boisglavy & Cie – was formed for a period of eight years, from 1 November 1847 to 31 December 1855, and remained at 16 Rue des Fossés-Montmartre.

On 14 January 1856 a new company was formed, this time without Jean Deneirouse, between Charles Léopold Heuzey-Deneirouse and Eugène Pierre François Boisglavy, 'for the manufacture and sale of shawls, in both cashmere and wool and in *espoliné*, following the Indian style', for a period of six years, from 1 January 1856 to 1 January 1862, at the same address and under the name Heuzey-Deneirouse & Boisglavy. When it reached the end of its term, the company gained a new associate in the person of Édouard Heuzey,

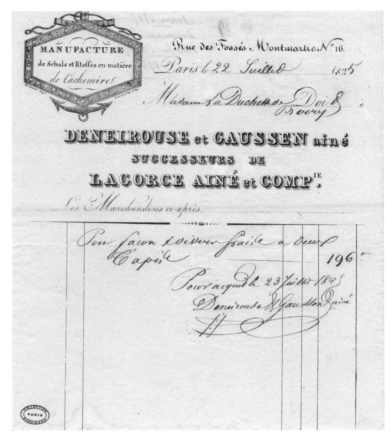

Invoice made out to the Duchess of Berry. Paris, Debuisson collection.

11 *Ibid*
12 Charles Léopold Heuzey married Laure Deneirouse in Paris on 2 February 1833; he later changed his name to Heuzey-Deneirouse. The couple's son, Édouard Heuzey, was born in Paris on 19 December 1833.
13 Yvelines Departmental Archives, shelf mark 15M.6, item no. 86.
14 On 15 March 1847 Auxence Marcel formed a company with Biétry, Père & Fils, another famous shawl manufacturer; the company was known as Biétry, Père, Fils & Cie.

then aged twenty-eight and the son of Charles Léopold Heuzey-Deneirouse (so Jean Deneirouse's grandson). Its address and business aims remained the same, and the company name became Heuzey-Deneirouse Père, Fils & Boisglavy. It was formed for the period from 1 January 1862 to 1 January 1870, as confirmed by the company adverts in the annual business almanacs (Didot-Bottin) for those years. Although their business address remained the same, in 1865 Rue des Fossés-Montmartre changed its name to Rue d'Aboukir. From 1872 to 1887 the company name given in the almanacs was Heuzey-Deneirouse Fils, manufacturer of shawls and novelties. So the Deneirouse family's connection with the Paris shawl industry spanned three generations and a period of nearly eighty years.

The following is a record of Jean Deneirouse's involvement in the French industrial exhibitions and world's fairs.

Exhibition of 1819: Lagorce, Jean Deneirouse's employer, exhibited alone and was awarded a silver medal.

Exhibition of 1823: Deneirouse was now an associate of Lagorce Aîné & Cie. The jury awarded the company a gold medal and was lavish in its praise:

> *This firm, which already enjoyed a very good reputation, has surpassed itself through its choice of materials for both warp and weft, and by the exquisite finish of all the products it exhibited.*

Commenting on the exhibition, one magazine noted that these manufacturers exhibited 'a shawl worked in the Indian style' and had an establishment in Corbeil.[15]

Exhibition of 1827: exhibiting for the first time under their own names, Deneirouse & Gaussen Aîné were awarded a gold medal. The jury commented on their presentation as follows:

> *Messrs Deneirouse & Gaussen have applied to the manufacture of au lancé shawls an improvement in the* mise en carte *process practised, in 1823, by Messrs Isot & Eck in the manufacture of espoliné shawls. This method has the advantage of exactly matching up the design with the croisé [twill],[16] and offering a perfect imitation of the ribbed texture of Indian shawls; it is known as new weave. All the best manufactories in Paris, Lyons and Nîmes have adopted it and it will soon become universal. Two espoliné shawls, one of them striped and reversible, were among the most beautiful pieces shown by Messrs Deneirouse & Gaussen. They also showed a type of loom for making reversible shawls.*

Reporting on the exhibition, Adolphe Blanqui,[17] after commenting that 'Indian cashmeres are a public necessity today in the same way as coffee, tobacco, pepper and cinnamon', describes the products of the French shawl industry and mentions a wall hanging 'commissioned from Messrs Deneirouse & Gaussen by Her Ladyship, which has only one pattern repeat in the whole of its length of 5/4 [of an ell]'[18] and, with reference to the same firm, 'harlequin shawls with a double warp combined in such a way that the ground warp, which is in a single colour, is skilfully woven together with that of the pines'.

Exhibition of 1834: Deneirouse exhibited alone for the first time and was awarded the gold medal (having won it as an associate in the two previous exhibitions). The jury referred to the significant manufacturing improvements that had already been introduced into the shawl industry and mentioned:

15 *Bazar Parisien*, Paris, 1824.
16 The reference is to a twill-weave fabric, in which the weft yarns are worked around two or more warp yarns to produce an effect of parallel diagonal lines or ribs.
17 Adolphe Blanqui, pp. 105–6.
18 5/4 of an ell (an obsolete measurement); in other words approximately 150 cm (59 in.).

The diagonal effect is produced by a technique allowing an even better imitation of Indian work. Since even the thickest yarn can be brocaded in this way, considerable cost savings can be made.

It is also worth quoting the following commendation, which is taken from a contemporary fashion journal:[19]

There are magnificent shawls from those manufacturing giants Messrs Deneirouse & Gaussen. One cannot but admire the quality of the weave, the choice of patterns and the brilliance of the colours: they are dazzlingly beautiful.

A book about the exhibition goes into greater detail and gives us a clear impression of the tremendous interest that was aroused by Deneirouse's work:

Among the cashmere shawls and fabrics shown by M. [Monsieur] Deneirouse there was a green shawl with a complex all-over pattern; it was noted by the Queen and purchased at her request. The experts were even more interested in the card next to the shawl showing the design on which it was based. The shawl and the card merely represented the application and development of techniques devised in 1825 by Messrs Deneirouse & Gaussen, when they were still associates, and which were known as new weave or new work.... Thanks to one of the authors of this discovery developing the technique further...it is now easy to quadruple the size of a design and to create designs of great richness on shawls that sell for the most modest prices. The design can occupy a quarter or half of the fabric, and even the whole width, as we saw with the green shawl exhibited. And what is no less laudable in M. Deneirouse, and ought to stir a feeling of gratitude in his colleagues, is that he is willing to place his improvements at their disposal, as they have requested.[20]

Exhibition of 1839: this was the first year that the jury members reporting on 'Cashmere Shawls and their Imitations' actually signed their report. The reporters were Legentil and Bosquillon, who were among the leading shawl manufacturers in Paris. In their introduction they mention (without naming him) that 'One of our most skilful manufacturers claims to have discovered a technique for using the card in the Jacquard mechanism three times rather than twice, which new work [the same term had already been used by Moléon, Cochaud and Paulin-Désormeaux in their book about the exhibition – see the quote above] has enabled him to produce a finer weave while reducing the reading for the composition of the design by a third.'

Later, having awarded Deneirouse another gold medal, the reporters note that 'he has created a school, as part of his establishment, where young brocade weavers receive a moral education and learn reading, writing and arithmetic.' They continue: 'In addition to submitting numerous other products, these manufacturers exhibited a shawl worked in a new fashion: thanks to this piece, made specifically for the exhibition, the manufacturers are hopeful that they will be able to cut by a third the work involved in manufacturing their designs according to existing techniques.' It is clear from this that it was Deneirouse's new method to which the writers were referring in their introduction. Following the exhibition, Deneirouse was made a knight of the Legion of Honour.

Exhibition of 1844: the reporters on this occasion were Deneirouse and Legentil. Deneirouse could no longer compete since he had retired on 1 January 1844, but his successors, Heuzey & Marcel, received another gold medal. The report indicates

19 *La Toilette de Psyché*, no. 4, first year, 3 July 1834. The article was entitled 'Cachemires' and signed '(Vert-Vert)'.

20 Moléon, Cochaud, Paulin-Désormeaux, vol. 1.

that they remained the sole owners of the factory in Corbeil and that they continued to receive assistance from Deneirouse for some of their more complex designs. They mention in particular a striped twill-tapestry shawl of a type Heuzey & Marcel exported to one of the major cities in the Orient, as well as a long white shawl and a striped stole, also twill-tapestry but reversible.

Jules Burat, describing the booth (or 'stand' as it was soon to be called) belonging to Heuzey Jeune & Marcel, comments on one shawl in particular: a brocaded, all-white, pure cashmere reversible shawl. He writes:

> *Two things characterize this sample piece: firstly the way it is woven makes it reversible, the warp being enveloped so as to produce a relief effect that imparts a luminosity to the colours imitating the velvety texture created by a twill ground; secondly the design – different from typically Indian designs with crochets, leaf patterns and the unavoidable pines – reproduces beautiful bouquets such as nature lays before our eyes. The appearance of this shawl marks a real turning point.*[21]

Exhibition of 1849: Maxime Gaussen – the son of François Gaussen, a former associate of Jean Deneirouse – and Roux Carbonnel were the reporters for 1849 and commented on Deneirouse & Boisglavy's factory in Corbeil:

> *M. [Monsieur] Deneirouse, the natural head of this new company, is back in business today after having received every industrial award available to him, and is competing in association with M. [Monsieur] Eugène Boisglavy. The jury wishes to say at once that Deneirouse & Boisglavy's display is magnificent. It was a long white shawl in India work that first caught its eye, and provoked intense interest among the general public.*
>
> *This piece is the most perfect example of its type and proves beyond any shadow of doubt that we can make shawls in France that are both richer and more beautiful than Indian ones.*
>
> *The design of this magnificent shawl is markedly superior to the most notable and the best pieces to have found their way here from the Orient. It combines French flowers and cashmere details, the roses, dahlias and carnations arrayed in all their fresh beauty over a fabric of flawless weave. This shawl has everything – subtle colours, fineness of weave and exquisite workmanship. We should congratulate M. Deneirouse in particular on his splendid achievement and give him his full due for being perhaps the only one among all his colleagues never to have despaired of the twill-tapestry weave shawl. Indeed, think of the enormous benefits of creating a splendid new industry in France providing easy work for a whole host of women and children! We have good reason to be hopeful because today we can say – at the risk of upsetting French ladies with their idées fixes – that the days of the Indian shawl are over: indeed, next to the Deneirouse shawl, what lady would dare to wear one of those beautiful and much-envied cashmeres?*
>
> *The design which M. Deneirouse and M. E. Boisglavy are showing is in twill-tapestry weave, but they are also showing it in au lancé, and for the first time it is possible to compare the effect of Indian work and French work. The latter seems to us to withstand the comparison completely. In truth, what difference is there really between them?*
>
> *The two shawls look the same; the only difference is the manner in which they have been woven. But one costs 5,000 francs, the other between 1,000 and 2,000....*

[21] Jules Burat, vol. 1, part 3, 'Tissus'.

The jury has decided to award Deneirouse and E. Boisglavy the gold medal in recognition of the important position which the firm occupies within the shawl industry

Great Exhibition, London, 1851: Maxime Gaussen was that year's reporter for the 'Shawl and Mixed Fabrics Industry' section. In his introduction he notes:

Never before, perhaps, have French shawls combined such richness of design with such perfect weaving....Out of the dozen or so exhibitors representing this splendid industry in the Crystal Palace, we have been awarded a grand medal – the only one to be awarded to a weaver – and seven prize medals.

It was Deneirouse, E. Boisglavy & Cie who were awarded the famous council medal (Gaussen's 'grand medal') for a long white twill-tapestry weave shawl with a flower pattern and for the introduction of a new technique designed to be used in conjunction with the Jacquard mechanism. Known as the *mariage* or *mélange des couleurs*, this technique enabled the weaver to extend his colour palette by combining two different weft colours. According to one French writer, reporting on the Great Exhibition at Crystal Palace:

In 1849 M. [Monsieur] Deneirouse showed us his famous flower shawl: he was told at the time, and we also took the liberty of observing to him, that such a bold move required the sanction of time. It is not clear whether this sanction has been granted quite as emphatically as one would have hoped; but this clever manufacturer has come up with a new idea that is no less novel and which involves human figures, brilliantly coloured birds, trees, pavilions, etc.[22]

World's Fair, Paris, 1855: Deneirouse, E. Boisglavy & Cie obtained a first-class medal. The international jury report mentions the new colour combinations whose popularity the firm has helped to establish and notes:

The head of this firm, which is one of the oldest in the industry, has always been very clever in his efforts to discover an economical method of producing twill-tapestry weave.

Great Exhibition, London, 1862: Maxime Gaussen was the reporter once again. Heuzey & Boisglavy had taken over from Deneirouse, E. Boisglavy & Cie and did not exhibit.

World's Fair, Paris, 1867: Heuzey-Deneirouse Père & Fils & Boisglavy exhibited a large shawl with an unusual pattern, in addition to *impératrice* (empress) cloaks and tapestry-ground cloaks, and were rewarded with a silver medal.

Deneirouse was convinced that the Jacquard mechanism had the potential to transform the industry and continued to investigate ways of using it to produce larger patterns. One problem, in its early days, was that it required too many punch cards:

...the huge cost of which deterred even the most stalwart manufacturers, with the result that the mechanism could only really be used for small patterns. I invented [a new kind of] point paper, which the jury for 1827 incorrectly described as new weave (perhaps because of its connection with the fabric), the old system of mise en carte was completely overturned and Jacquard mechanisms replaced the use of the drawloom.

22 Émile Bérès, *L'Illustration*, 'Exposition universelle de Londres' (8th article), Paris, 20 September 1851, p. 190.

The new point paper is such a useful device that the designer can draw flowers, right, left and centre, knowing that he is designing the actual twill weave of the cloth....Moreover, I noticed that in Indian shawls two identical sheds could be repeated by using the return mechanism. It is a matter of changing the order of the ground weft with the help of the special heddles.[23]

Deneirouse was applying the same principle that Ysot and Eck had applied to the *mise en carte* for twill-tapestry weave shawls, but in this case for shawls woven *au lancé*. Using *briqueté* point paper, he had already managed to reduce the number of punched cards required to one in every four, and thanks to the return mechanism he was able to reduce the overall number by half again. From 1827 the two mechanisms combined enabled him to produce designs that were eight times larger than had been possible previously. Soon thereafter a shawl weaver by the name of Bosche introduced another important improvement by adding a *double griffe* to the mechanism.

Today, thanks to these two mechanisms, a workman can move 6,400 warp threads and execute a design 175 centimetres [68⅞ inches] wide with the greatest of ease, just by using his foot, whereas with a drawloom and a drawboy it was only possible to produce patterns that were 15 centimetres [5⅞ inches] wide, and eight of the original Jacquard mechanisms would need to be attached to the loom to achieve the same result, which would be impracticable.[24]

Aside from his brilliant contributions to *au lancé* weaving, Deneirouse was constantly looking for ways to produce twill-tapestry weave shawls that matched Indian ones for quality while keeping the costs down. One way forward was to use mechanical devices to help the weaver select the appropriate warp threads for the wefts to pass through and so speed up the weaving process; another was to hire women and children to do the same work but for lower wages. By submitting a twill-tapestry shawl and an *au lancé* shawl, both woven to the same design, to the 1849 exhibition (p. 294), where he hung them side by side, Deneirouse was keen to demonstrate the supremacy of the French technique in an area previously monopolized by Indian weavers.

After a conference held in Washington DC in November 1986,[25] I had the opportunity to examine the cashmere shawls held at New York's Metropolitan Museum of Art.[26] My attention was caught by a twill-tapestry shawl in 2/2 twill whose flower pattern struck me as typically French. Closer analysis revealed that the warp threads were cashmere with a silk core – a combination used in France but not in India. The shawl was composed of ten woven rectangles sewn together, the joins being invisible on the right side. It measured 366 × 152 cm (144⅛ × 59⅞ in.) and carried an illegible signature in Arabic letters embroidered in pink silk in the white central reserve. The composition of its central section was *à pivot*: the pattern of one half was reproduced in the other half after having been rotated through 180 degrees. The side sections were reproduced as mirror images of one another, the pattern thus appearing four times in total. Around the white central reserve an exuberant array of flowers with colour-shaded petals and leaves included dahlias, irises, poppies, roses and various other identifiable species. There was a border at either end made up of harlequin segments decorated with garland motifs and terminated with harlequin fringes. There were no initials or maker's name in the corners, but flanking the central rectangles were

23 Jean Deneirouse, 1851, pp. 13–16.
24 *Ibid.*, p. 17.
25 'Symposium on Kashmir and Related Shawls', The Textile Museum, Washington DC.
26 In 1986 Mrs Nobuko Kajitani was in charge of textile restoration at the museum; it was her idea that we should examine each of the museum's cashmere shawls in turn by spreading them out on her work surface. I am extremely grateful to her for this opportunity.

two emblems: Mercury's staff (or caduceus) and a beaded medallion enclosing a majestic bird with muscly thighs and outstretched wings rising up from a pile of firebrands. Another distinctive 'signature' was the little bee, in each half of the shawl, clinging to a peony petal next to five droplets. The height of the harlequin shawl ends, approximately 4 cm (1⅝ in.), dated the shawl to the 1850s.[27]

I was reminded of the descriptions of the exceptional shawls patterned with 'colour-shaded flowers' submitted by Paris manufacturers to the French exhibitions. This particular shawl evoked the description of the two identical shawls presented by Jean Deneirouse and Eugène Boisglavy at the 1849 exhibition – but whether this was one of them had yet to be determined.

In December 2003 an antique dealer specializing in old textiles showed me a shawl that was woven *au lancé* and signed in two corners 'Deneirouse, Boisglavy et Cie' (the two other corners showed the letters in reverse).[28] I compared it with photographs of the shawl in New York and saw that the pattern was identical. In addition to the manufacturers' names given in the corners, the inscriptions 'Paris' and 'Corbeil' were woven into parts of the harlequin border.

The shawl had been woven in a single piece, *au lancé* and in 3/1 twill. Its warp threads were in cashmere with a silk core and had been dyed prior to weaving. The background to the many flowers – themselves in colours corresponding to the harlequin border segments – was dyed red, while the warp for the central section was left white. Using a thread-counter, I was able to establish that there were forty-six warp threads and fifty-six picks to the centimetre – which gives an idea of the fineness of the weave. Ten different colours were used for the wefts.[29] As in the case of the twill-tapestry shawl held in New York, the weft threads were cashmere. The *au lancé* shawl was 366 cm (144⅛ in.) long, like the other shawl, but 9 cm (3½ in.) wider (161 cm [63⅜ in.]). The two shawls corresponded so closely to the description given by the reporters of the 1849 jury that they were clearly either copies of the shawls exhibited by Deneirouse or the actual models themselves. At that time *au lancé* long shawls were woven on a warp a little less than 25 m (82 ft) long; this meant that six shawls could be woven in succession, which reduced the costs in terms of preparatory work (design, *mise en carte*, punched cards, and so on). We can be certain therefore that the manufacturers would not have limited themselves to weaving a single shawl. And the same is true for the twill-tapestry weave shawl, which was probably woven on two or three looms where the mechanisms had been installed for that particular design.

The names of the artists who collaborated with the other leading shawl manufacturers are known to us. However, documents describing the business activities of Jean Deneirouse and his associates make no mention of a designer – and from this we can assume that Deneirouse designed his own shawls. The shawl designer's report for the Great Exhibition in London in 1862 notes that he regarded himself as a designer (see note 5, p. 295). Lyons was famous for its floral patterns and it was there, no doubt, that Deneirouse learnt to draw flower motifs destined to be incorporated in a *mise en carte*. If it was indeed Deneirouse who designed these particular models, what meaning was he attempting to convey through his inclusion of the bee, the five droplets, the staff and the majestic bird?

27 The Metropolitan Museum of Art (New York), Rogers Fund, Textile Study Room, inv. no. 65.91.2. Mrs Arlene Cooper, who was on an internship in the department, drew my attention to the bee motif. She later very kindly sent me a series of slides of the shawl and I am extremely grateful to her. To my knowledge, the only time this particular shawl has been shown in public was in 1975 at Yale University Art Gallery, New Haven (Connecticut), in an exhibition entitled 'The Kashmir Shawl'; it is reproduced as no. 28 in the exhibition catalogue.

28 Madame Virginie David at *Les Indiennes* gallery, Paris, went to great lengths to show me anything unusual and I am very grateful to her.

29 Ten colours plus a ground weft: for each pick the weaver had to throw eleven shuttles; in other words 56 x 11 = 616 shuttles per centimetre.

The 1849 exhibition opened at the Carré Marigny in Paris on 1 May. It took a minimum of six months to weave one of the more spectacular shawls and manufacturers would have been preparing feverishly for this day since the previous autumn. Paris had just witnessed a revolution; Louis-Philippe had abdicated in February 1848 and the Second Republic had been proclaimed. In December 1848 Napoleon's nephew Louis Napoleon was triumphantly elected president of the new republic. The majestic bird inside the medallion, perched on top of a pile of firebrands with its wings outspread, is probably a phoenix and an allusion to the Empire reborn from its ashes. Similarly, the bee with the droplets (of honey?) may represent the first Empire. The Emperor had helped to revive the fortunes of France's ailing silk industry by commissioning wall hangings and curtains to cover the walls and furniture of the imperial palace. In 1805, while he was undergoing his training in Lyons, Deneirouse would have been in a prime position to appreciate his support for local textiles and at the end of his life Deneirouse referred to Napoleon's 'profound genius'.[30]

The other emblem included in the shawl design – Mercury's staff – is easy enough to explain. The caduceus is traditionally associated with trade and commerce and it appears on Deneirouse's letterhead.

Mentioning the boost to French shawl manufacturing resulting from technical advances in weaving, Deneirouse reports that the jury for the 1827 exhibition estimated that 30 million francs' worth of shawls were being produced annually.[31] In 1851 he noted that France was importing three to four million francs' worth of shawls from India.[32] A little later, in 1857, Frédéric Le Play noted that 'French shawl manufacturing turns out 50 million francs' worth of products each year; of this figure, half is to be attributed to Parisian manufacture and the remainder is shared between Lyons and Nîmes'.[33] As we have already seen, the two shawl manufactories in Corbeil suffered as a result of the July Revolution but by 1832 were beginning to operate normally again. In 1834 the Deneirouse manufactory employed 200 workers and produced 1,200 shawls a year at a value of 200,000 francs.

Deneirouse had been planning to retire in 1844 but changed his mind, finally retiring in 1855, at the age of sixty-eight. During the thirty years that he ran the Corbeil manufactory, his shawl production remained a small-scale affair. His shawls sold for very high prices: the twill-tapestry weaves (manufactured in very small numbers) cost between 2,000 and 5,000 francs; the au lancé models, known as 'French cashmeres', fetched between 50 francs and 800 francs, although the top of the range, the French cashmeres remarked upon at the exhibitions, could be as much as 2,000 francs, as the report for the 1849 exhibition informs us. Today, the best French shawls from that period fetch in the region of 30,000 euros at public auction.

The importation of shawls from India was hugely detrimental to the French shawl industry. Jean Deneirouse's answer was to develop more advanced mechanisms for espoliné or twill-tapestry weaving, but to do this he needed government support. So in November 1859 he sent a letter to the Minister of State[34] requesting that a room at the Gobelins manufactory should be set aside for the weaving of espoliné shawls and proposing, in addition, that a studio be opened at the Conservatoire des Arts et Métiers, with a view to designing new and better looms for twill-tapestry weaving. The letter was referred to the Minister for Agriculture, Trade and Public Works, who vetoed Deneirouse's proposals.

[30] Jean Deneirouse, 1863, p. 69.
[31] Jean Deneirouse, 1851, p. 12.
[32] Ibid., p. 61.
[33] Frédéric Le Play, 1887, p. 342.
[34] National Archives, shelf mark F21 670, file no. 1860.

It is evident from the title of a pamphlet he published in 1863 – *Notice sur la Nécessité de Remplacer par un Tissage Mécanique les Brochés à la Main* (Note on the Need to Replace Hand Brocading by a Weaving Mechanism) – that Deneirouse (who had retired several years earlier) continued to push for his utopian vision of the shawl industry. What he had not anticipated, however, was that the fashion for cashmere shawls – which could not be worn satisfactorily in combination with a bustle – would soon be a thing of the past.

Deneirouse's death in 1869 meant that he did not witness the demise of the shawl industry. Improvements to the Jacquard mechanism (which brought benefits to the textile industry as a whole) owe much to the efforts and imagination of Paris shawl makers – foremost among them, Jean Deneirouse.

Invoice.
Paris, Debuisson collection.

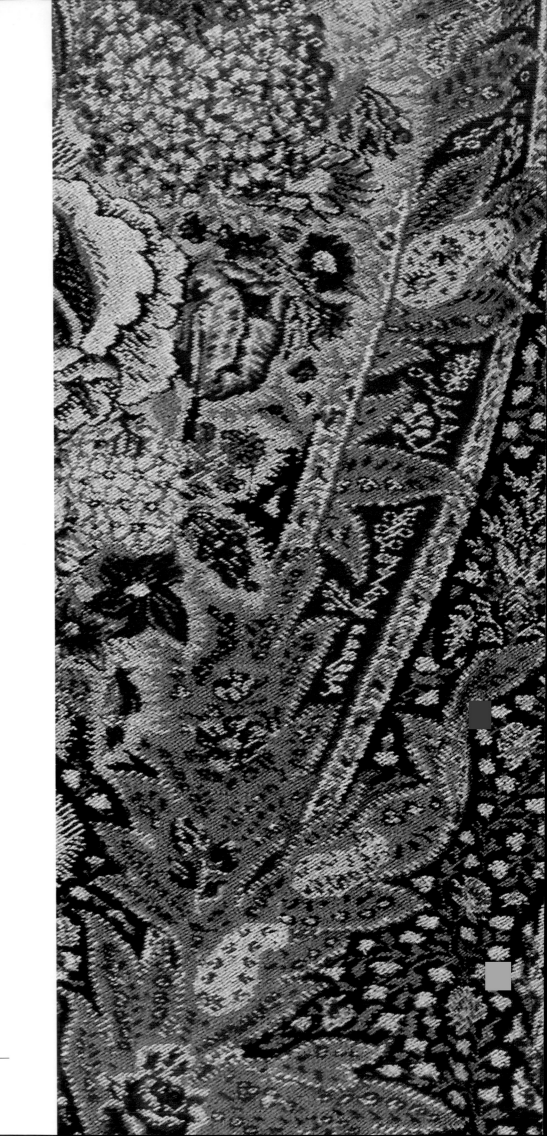

Details of the shawl shown on page 294.
Note (far right) the bee on the peony petal and the droplets
(four and one) on the two adjacent petals — possibly an
allusion to the first Empire (see p. 304).

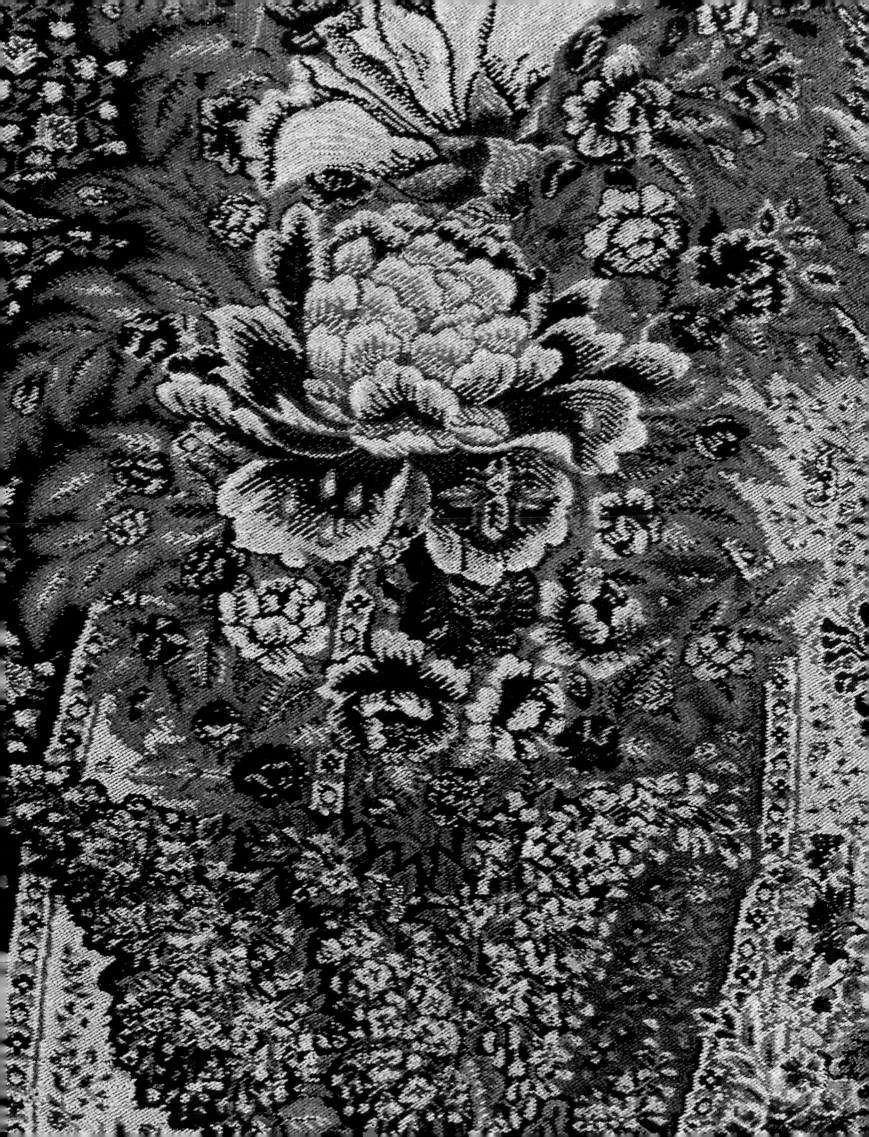

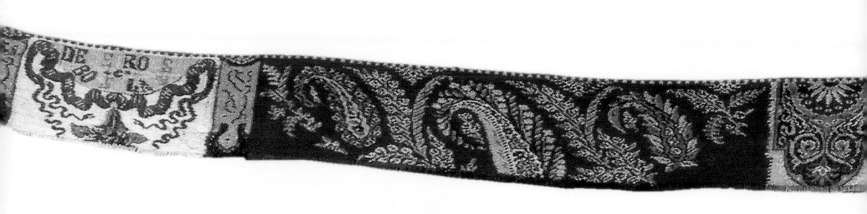

Details of the shawl shown on page 294.

ABOVE AND BELOW *Part of the harlequin border.*

LEFT ABOVE
Segment of the harlequin border.
The names of the manufacturers, 'Deneirouse, Boisglavy & Cie',
are woven above a ribbon.

LEFT BELOW
Mercury's staff or caduceus, a symbol of trade and commerce.

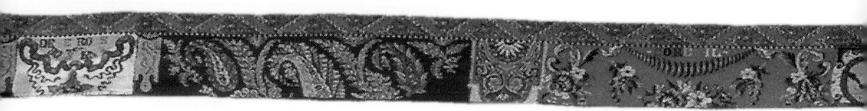

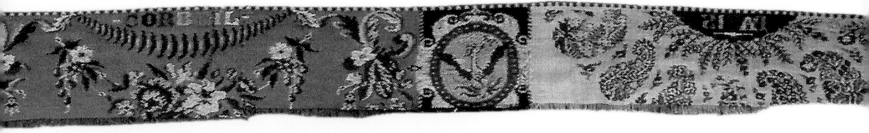

ABOVE
The bird rising from the firebrands.

LEFT ABOVE
Woven letters forming the name 'Paris' (the company's registered address).

LEFT BELOW
Woven letters forming the name 'Corbeil' (where the shawl was manufactured).

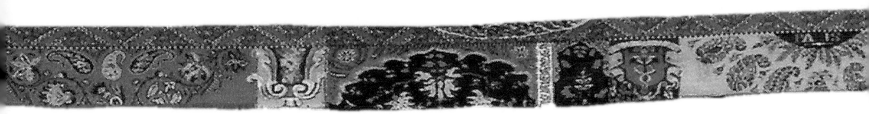

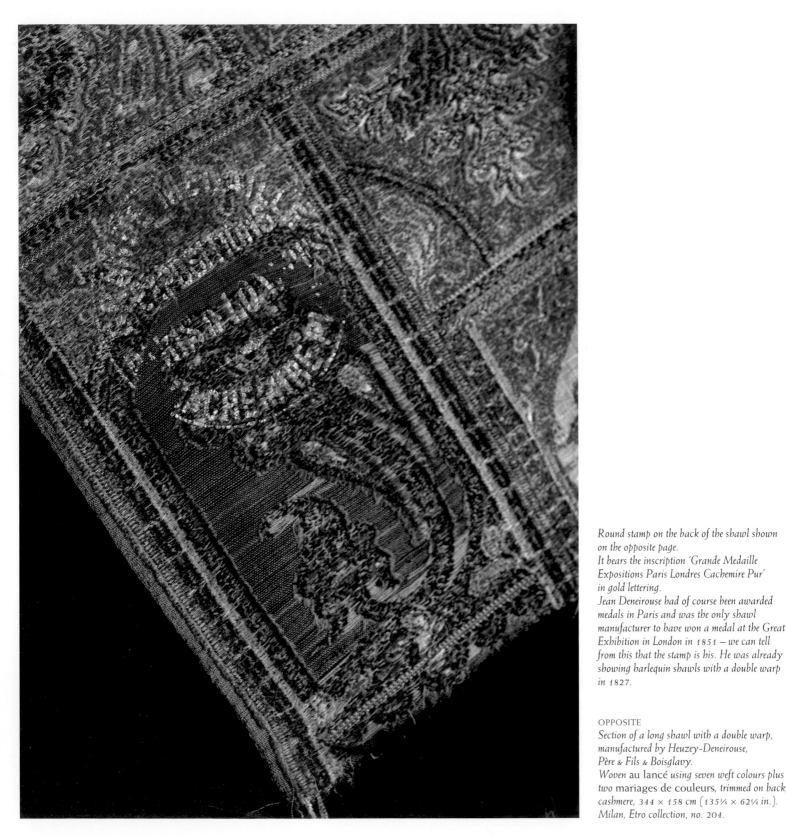

Round stamp on the back of the shawl shown
on the opposite page.
It bears the inscription 'Grande Medaille
Expositions Paris Londres Cachemire Pur'
in gold lettering.
Jean Deneirouse had of course been awarded
medals in Paris and was the only shawl
manufacturer to have won a medal at the Great
Exhibition in London in 1851 – we can tell
from this that the stamp is his. He was already
showing harlequin shawls with a double warp
in 1827.

OPPOSITE
Section of a long shawl with a double warp,
manufactured by Heuzey-Deneirouse,
Père & Fils & Boisglavy.
Woven au lancé using seven weft colours plus
two mariages de couleurs, trimmed on back,
cashmere, 344 × 158 cm (135⅜ × 62¼ in.).
Milan, Etro collection, no. 204.

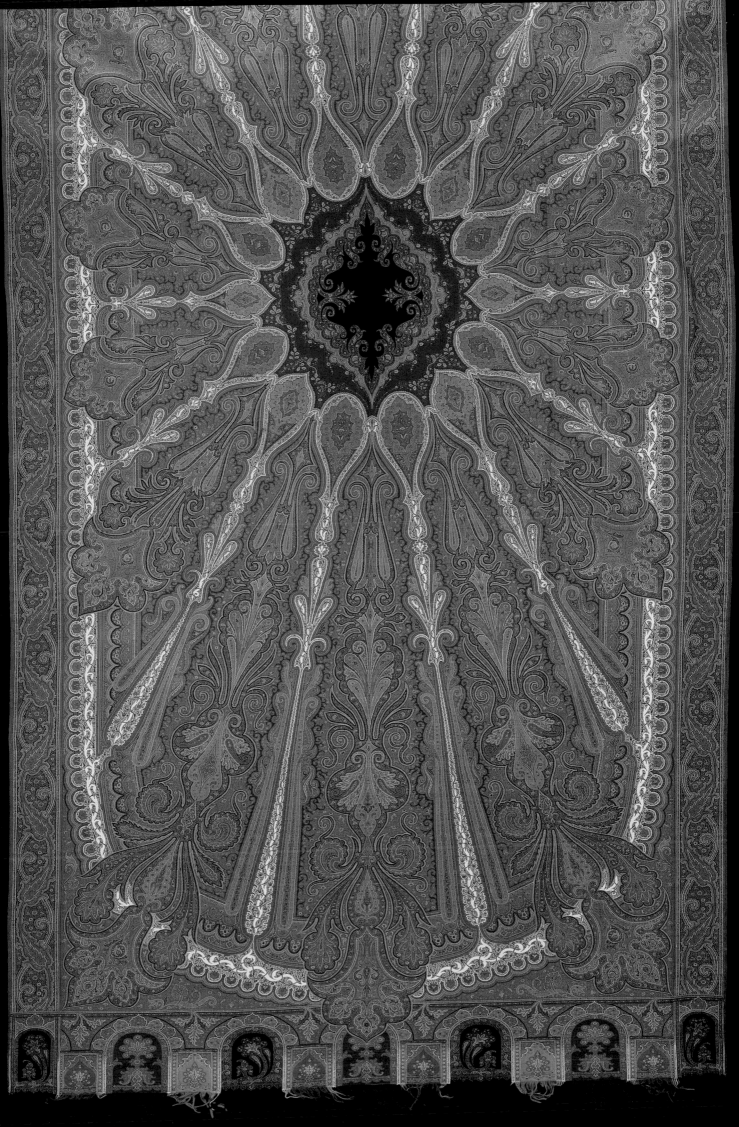

Glossary

Bobbin Small wooden cylinder on which weft thread is wound for passing weft through the openings in the warp.

Border The early shawls have several distinct borders:

Horizontal or cross border: narrow border parallel to the weft. An outer horizontal border comes between the main border and the fringes. An inner horizontal border sometimes comes between the main border and the field of the shawl.

Main border: deep border at the two ends of a long shawl, usually containing the pine motif, which became known as the Paisley pattern.

Vertical or side border: narrow border parallel to the warp, running along each side of the shawl.

Cashmere Term used for:
1) a shawl made in Kashmir;
2) cashmere fibre, the wool of the shawl-goat;
3) design derived from Indian shawls, hence, by association, European shawls so designed.

Chinage à la branche *See Tie-dyeing.*

Corner motif Pine or other ornament repeated in the four corners of the field.

Découpé Trimmed or shorn. The term denotes that loose weft threads at the back of the shawl have been trimmed off.

Drawloom Loom in which the pattern of the textile is determined by tying together warp threads that come at the same point in each repeat of the pattern, so that they can be raised together by the drawboy who assists the weaver.

Ends Narrow band of weaving at either end of a shawl between fringe and border.

Harlequin ends: the band is woven in blocks of several different colours that extend into the fringe.

Espoliné *See diagram opposite right.*

Field Large area between the borders, the middle of the shawl, devoid of ornamentation or covered with small repeating patterns or stripes.

Fringe Either formed by the warp protruding at each end of the shawl, or made separately and sewn onto the shawl.

Fringe gates Decorated ends developed from harlequin ends.

Gallery Band of decoration based on the inner horizontal and vertical borders, running round the central field.

Inner gallery: further band of decoration within the gallery, encroaching on the field.

Jacquard Attachment to the loom that dispenses with the drawboy. The warp threads raised to make the pattern are determined by a series of punched cards selecting hooks to operate the warp threads.

Jamewar Indian term for a gown-piece, a shawl cloth with small repeating patterns, often striped, without any borders.

Au lancé *See Weaving au lancé.*

Mise en carte A textile design transferred onto squared paper.

Paisley *See Pine.*

Pashmina Term applied to true Kashmirian shawl cloth of goat's wool.

Pentes Term used to denote the two large areas of decoration between fringes and central reserve on later shawls that no longer have clearly defined end borders. There is no English equivalent.

Pine The most common motif on Indian shawls, later known as the Paisley pattern.

À pivot *See Shawl: Pivoting design.*

Point paper Squared paper on which a design is worked out for weaving.

Printed warp Warp printed before weaving to provide areas of different colour on a single thread.

Reserve Small unpatterned area in the centre of later shawls.

Selvedges Very narrow, sometimes strengthened, strips of unpatterned weave at the sides of a shawl or piece of cloth.

Shawl Derived from the Persian word *shal*, meaning cloth woven from fine wool. The main types of shawl and shawl design are:

Boiteux: see *Shawl: lopsided.*

Burnous: shawl to be worn without folding, like a cape, with the plain reserve placed towards one side.

Filled ground (also known as 'all-over ground'): shawl completely covered with ornamentation, having no central reserve.

Harlequin: in which the pines of the borders are in compartments, each with a differently coloured ground.

Lopsided (also known as 'boiteux'): shawl with only one main border.

Medallion (also known as 'moon shawl'): usually a square shawl with a medallion in the centre and a quarter medallion repeated in each corner.

Pivoting design (also known as 'à pivot'): on a long shawl, a design that repeats only once, turning 180 degrees in the centre of the shawl to pivot about a central point.

Rich: shawl woven with cashmere yarn and more than seven colours in the weft.

Striped: shawl covered with stripes decorated with small motifs, with or without borders (*see Jamewar*).

Turnover: square shawl, with wide borders sewn on two sides to form a right angle, and narrow borders similarly placed on the other two sides but sewn on back to front, both sets of borders showing their right sides when the shawl is folded in a triangle.

Shed Opening in the warp made by raising certain warp threads, through which the shuttle or bobbin is passed.

Simple Bundle of threads connected to the warp threads on a loom, which was pulled by a worker known as a 'drawboy' in order to raise the warps and create a design. The Jacquard mechanism, which replaced the simple, was operated by the weaver himself, using a pedal.

Tie-dyeing (also known as 'chinage à la branche') Method of tying bundles of warp threads tightly to prevent dye from penetrating; after successive tying and dyeing, polychrome warp threads are produced.

Twill A weave in which the weft may pass not over one warp thread and under one, as in plain weave, but over two and under two, or over three warp threads and under one; the binding points of warp over weft in successive passes make diagonal lines across the cloth (*see diagrams below*).

Twill tapestry A twill weave in which the weft does not pass from selvedge to selvedge but, as in tapestry, is turned back to form areas of colour interlocked at the edges.

Vernis Scaled-up version of a shawl design on varnished paper. To enable clients to select a pattern, the designer first produced a design drawn in pencil on white paper, representing a quarter of a shawl at a reduced scale. The *vernis*, or scaled-up version of the design, was then created. The outlines of the motifs were painted on one side; the fill colours were added on the other side.

Warp Threads placed parallel between two beams on the loom, running lengthways in the finished cloth or shawl.

Weaving au lancé Type of weaving in which pattern wefts are passed from selvedge to selvedge.

Weaving espoliné Tapestry (*see diagram below right*).

Weft Threads passed at right angles to the warp, woven over and under the latter to form the cloth.

PAGE 314
Corner section of a long shawl, c. 1820.
Woven au lancé, trimmed on back, silk, cotton and wool,
248 × 126 cm (97⅜ × 49⅝ in.).
The fringes have been sewn on.
Paris, author's collection, no. 4.

Espoliné weave in 2/2 twill, as practised in Kashmir.
In the decorated parts of the shawl, the colour wefts
are interlocked, forming a two-coloured ridge on the
back. (All illustrations below are based on designs by
Gabriel Vial.)

2/2 Twill
The weft threads (horizontal) pass over two warp threads (vertical) and under two warp threads.

3/1 Twill
The weft threads (horizontal) pass over three warp threads (vertical), and under one warp thread.

An anatomy
of the shawl

Vertical border

Corner pine or corner ornament

Gallery
(running decoration around
central field)

Inner horizontal border

Pine

Outer horizontal border

Fringe

Field (single colour)

Main border

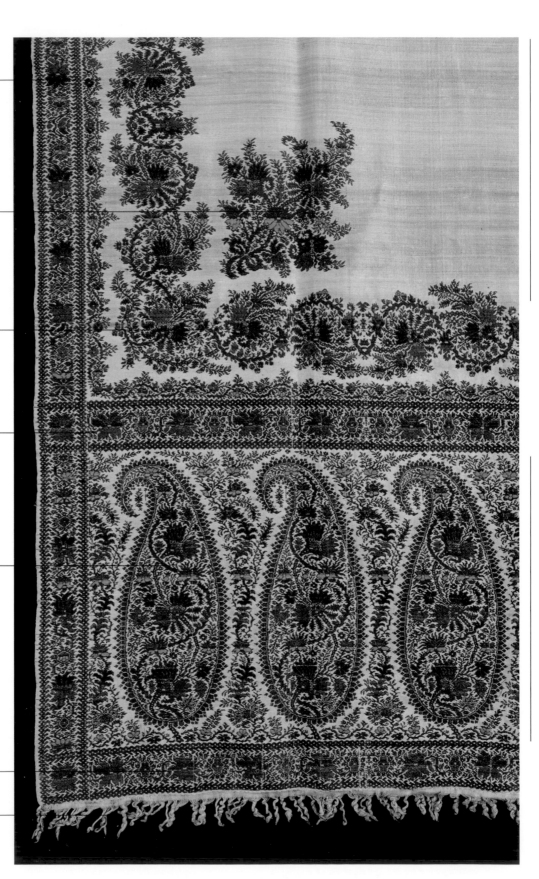

Dating nineteenth-century European shawls

Here are some guidelines that may be of help when trying to date shawls. Each feature, when considered in isolation, has only a relative value as a clue, in that it fixes a date before which the shawl could not have been woven. Only when several features of the shawl corroborate this evidence can a more definite date be postulated. When various elements of a shawl do not tally with respect to the period of manufacture, then the most prudent course is to accept the latest possible date and then explain any features that may indicate earlier dates (for example, the producer's conservatism in retaining techniques or characteristics belonging to an earlier era). It may well be, however, that the shawl is a composite creation, assembled from various pieces woven at different times.

These criteria are valid for the best quality, luxury-market shawls, which adopted different ornamentation as fashions changed. Examples manufactured for a less discerning market to less demanding standards are more problematical and can only be dated by someone familiar with the development of products from each regional shawl-making industry.

Width of long shawls: from 130 to 165 cm (51⅛ to 65 in.), widening steadily between 1800 and 1850.

Width of square shawls: increasing steadily from 135 to 195 cm (53⅛ to 76¾ in.) between 1800 and 1850.

Arrangement of pines: beginning with ten pines on the main border, the number was gradually reduced to eight, then seven (1830), and then six (1840); in three pairs, back to back or facing one another, then four (1850) grouped in two pairs, finishing with two giant pines (after 1865).

Height of pines: these gradually increased in size from only 25 cm to 120 cm (9⅞ to 47¼ in.).

Width of the vertical border and horizontal border: from less than 2 cm (¾ in.) at the beginning of the nineteenth century, these attained a maximum width of 18 cm (7⅛ in.) around 1840, and then gradually shrank to an average width of 10 cm (3⅞ in.).

Corner ornament: first appeared after 1810.

Gallery: introduced between 1815 and 1820; at first this running ornament only decorated the shorter sides of the single colour field; it was subsequently used on all four sides.

Secondary gallery: introduced after 1825. All this additional ornamentation inevitably reduced the size of the single colour field.

Harlequin fringes: first introduced on striped shawls, then adopted as fringe gates also in shawls with harlequin pines (1819). After 1834 all the best quality shawls were made with two harlequin shawl ends, comprising rectangles in several colours that were joined on regardless of the design of the shawl. After 1848 ornamentation was added to these rectangles which became square and then changed back to rectangles but arranged vertically (see 1867 shawl end, right, bottom).

Pure or true colour backgrounds: obtained by a special dye-press process for the warp threads before weaving, introduced in 1844.

Quartered shawls: after 1834.

Shawls 'à pivot': after 1848.

Development of harlequin shawl ends

Before 1820

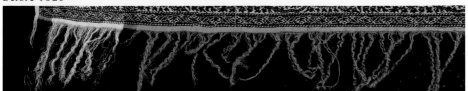

1820–30

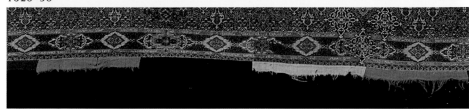

1840

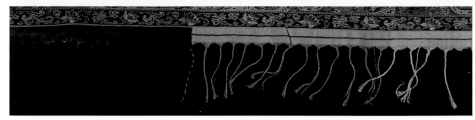

1845

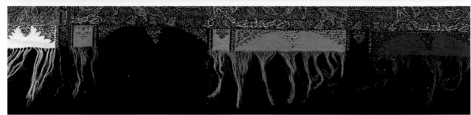

1850

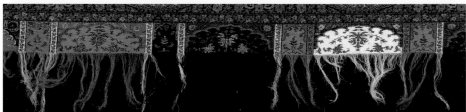

1855

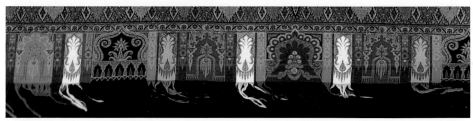

1860

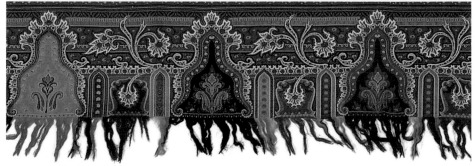

1865–70

Bibliography

Duchess of Abrantès, *Mémoires*, Paris, 1835, vol. VI

Frank Ames, *The Kashmir Shawl and its Indo-French Influence*, Woodbridge, Suffolk: Antique Collector's Club, 1997, 3rd edition

Anonymous, *Mémoires et souvenirs d'une femme de qualité sous le Consulat et l'Empire*, Paris: Mercure de France, 1966

Honoré de Balzac, *L'Illustre Gaudissart*, Paris: Gallimard/Bibliothèque de la Pléiade, 1947, vol. 4

Honoré de Balzac, *Gaudissart II* in *La Comédie humaine*, Paris: Gallimard/Bibliothèque de la Pléiade, 1950, vol. 6

François Bernier, *Voyage dans les États du Grand Mogol* (1670–71), Paris: Arthème Fayard, 1981

Jean Bezon, *Dictionnaire général des tissus anciens et modernes*, 8 vols. and 1 atlas, Lyons: Imprimerie et Lithographie de T. Lépagnez, 1856–63, 2nd edition

Laurent Biétry, *Réponse à une brochure d'un fabricant de châles, le châle cachemire français, le châle des Indes et la marque de fabrique*, Paris, 1849

Matthew Blair, *The Paisley Shawl and the Men Who Produced It*, Paisley: Alexander Gardner, 1904

Adolphe Blanqui, *Histoire de l'exposition des produits de l'industrie française en 1827*, Paris: Renard, 1827

Countess of Boigne, *Mémoires de la comtesse de Boigne, née d'Osmond*, 2 vols, Paris: Mercure de France, 1979

Silvia Bordini, 'Amédée Couder e "l'Architecture et l'industrie comme moyen de perfection sociale"', *Storia dell'Arte*, nos. 30–31, 1977

Jules Burat, *Exposition de l'industrie française, année 1844*, Paris: Challamel Éditeur, 1845, vol. 1, part 3

A. de Champeaux, 'Les artistes de l'industrie', *Revue des Arts Décoratifs*, vol. 10, Paris, 1889–90

Pamela Clabburn, *Shawls in Imitation of the Indian*, Shire Album 77, Aylesbury: Shire Publications, 1981

Amédée Couder, *Analyse du dessin des cachemires et moyens de rendre les schalls français supérieurs à ceux des Indes*, Paris, 1834

Amédée Couder, *Notices explicatives de ses dessins exposés au Conservatoire impérial des arts et métiers*, manuscript conserved in the Conservatoire National des Arts et Métiers, Paris, no date

William Cross, 'Descriptive Sketch of Changes in the Style of Paisley Shawls…', *The Paisley and Renfrewshire Gazette*, Paisley, 1872

Victor Delaye, *Album indo-parisien. Motifs de dessins industriels entièrement inédits*, Paris, no date (before 1867)

Jean Deneirouse, *Traité sur la fabrication des châles des Indes*, Paris: Papeterie Industrielle et Commerciale de Dessaigne, 1851

Jean Deneirouse, *Notice sur la nécessité de remplacer par un tissage mécanique les brochés à la main*, Corbeil: Imprimerie de Crété et Fils, 1863

Description de l'Égypte, Paris: Imprimerie Impériale, 1809, vol. 2

Pierre Falcot, *Traité encyclopédique et méthodique de la fabrication des tissus*, 2 vols., Mulhouse: J. P. Risler, 1852, 2nd edition

Fleury Chavant, *Album du Cachemirien*, Paris, 1837

Fleury Chavant, *Souvenir de l'exposition des produits de l'industrie française de 1839*, Paris, 1840

Edmond de Goncourt, *La Maison d'un artiste*, 2 vols, Paris, 1880

Olga Gordejewa, Louisa Jefimowa and Rina Belogorskaja, *Russian Kerchiefs and Shawls*, Leningrad: Aurora, 1986

Michiko Hirayama and Ikuo Hirayama, *Kashimiru ori*, Tokyo: Kodansha, 1985

Carl von Hügel, *Kaschmir und das Reich der Siek*, 4 vols, Stuttgart, 1840

Adèle Foucher Hugo, *Victor Hugo raconté par un témoin de sa vie*, Brussels: Lacroix, 1863

John Irwin, *Shawls: A Study in Indo-European Influences*, London: Victoria and Albert Museum, Her Majesty's Stationery Office, 1955

John Irwin, *The Kashmir Shawl*, London: Victoria and Albert Museum, Her Majesty's Stationery Office, 1973; revised edition of *Shawls: A Study in Indo-European Influences*, 1955

Victor Jacquemont, *Voyage dans l'Independant les années 1828–1832, Journal*, 4 vols., Paris, 1841

Eugène Labiche, *Le Cachemire X.B.T.*, in *Théâtre complet*, Paris: Calmann-Lévy, 1892, vol. VI

Frédéric Le Play, *Les Ouvriers européens*, monograph no. 7: 'Tisseur en châles de Paris', Paris, 1887

Jean-Antoine Letronne, *La statue vocale de Memnon*, Paris, 1933

Moléon, Cochaud, Paulin-Désormeaux, *Musée industriel. Description complète de l'exposition des produits de l'industrie française faite en 1834*, Paris, 1835, vol. 1

Monique Lévi-Strauss, *Cachemires*, Paris: Adam Biro, 1987

Monique Lévi-Strauss, 'Dendera, Threads of Deception', *Rotunda, The Magazine of the Royal Ontario Museum*, Fall 1988, vol. 21, no. 2, Toronto

Monique Lévi-Strauss, *Vernis Cachemires*, Paris: Adam Biro, 1990

Monique Lévi-Strauss, *Il Cachemire*, Como: Collezione Antonio Ratti, 1995

Monique Lévi-Strauss, *Cachemires parisiens, 1810-1880: à l'école de l'Asie* (see exhibition catalogue), Paris: Paris-Musées, 1998

Monique Lévi-Strauss, 'Jean Deneirouse, un fabricant de châles à Corbeil au XIXe siècle', *Aventures industrielles en Essonne*, Comité de Recherches Historiques sur les Révolutions en Essonne, 2008

Louis Marie Lomüller, *Guillaume Ternaux: 1763–1833, créateur de la première intégration industrielle française*, Paris: Éditions de la Cabro d'Or, 1978

Alphonse Maze-Sencier, *Les Fournisseurs de Napoléon et des deux impératrices d'après des documents inédits, etc.*, Paris, 1893

M. F. Peyot, *Cours complet de fabrique pour les étoffes de soie*, 2 vols, Lyons: Louis Perrin, 1866

Antoine-Rémi Polonceau, *Notice sur les chèvres asiatiques à duvet de cachemire*, Versailles: J. P. Jacob, 1824

Reports by the Juries of the Expositions des Produits de l'Industrie Française, Paris: 1801, 1806, 1819, 1823, 1827, 1834, 1839, 1844, 1849

Reports by the Juries of the Great Exhibitions, London: 1851, 1862; Paris, 1855, 1867, 1878; Vienna, 1873

Jean Rey, *Études pour servir à l'histoire des châles*, Paris, 1823

Cyril Howard Rock, *Paisley Shawls: A Chapter of the Industrial Revolution*, Paisley: Paisley Museum and Art Galleries, 1966

Ed Rossbach, *The Art of Paisley*, New York: Van Nostrand Reinhold Company, 1980

Alexandre-Henri Tessier, 'Mémoire sur l'importation en France des chèvres à duvet de Cachemire', *Annales de l'agriculture française*, series 2, vol. XI, Paris, 1819

Arnold Van Gennep, *Manuel de folklore français*, 4 vols, Paris: Picard, 1938–58

Élisabeth Vigée Le Brun, *Souvenirs de Madame Vigée Le Brun*, 2 vols, Paris: Bibliothèque Charpentier, no date

Godfrey Thomas Vigne, *Travels in Kashmir*, 2 vols, London, 1842

George Wallis, *The Exhibition of Art-Industry in Paris, 1855*, London: Virtue & Co., 1855

Dorothy Whyte, 'Edinburgh Shawls and their Makers', *Costume, The Journal of the Costume Society*, no. 10, London, 1976

Exhibition catalogues

The Kashmir Shawl, New Haven, CT: Yale University Art Gallery, 1975

The Art of the Shawl, Farnham: West Surrey College of Art and Design, 1977

Indian and European Shawls, London: The Antique Textile Company, 1982

La Mode du châle cachemire en France, Paris: Musée de la Mode et du Costume, Palais Galliera, 1982

Le Châle cachemire en France au XIXe siècle, Lyons: Musée Historique des Tissus, 1983–84

Kashmirsjaals, The Hague: Gemeentemuseum, 1985–86

Nîmes et le châle, Nîmes: Musée du Vieux Nîmes, 1988

Châles Cachemire, Geneva: Musée d'Art et Histoire, 1989

Cachemires parisiens 1810–1880: à l'école de l'Asie, Paris: Musée Galliera-Musée de la Mode de la Ville de Paris, 1998–99

Picture credits

All photographs in this book taken by Massimo Listri, with the exception of the following:

p. 8: © Bibliothèque Forney/Roger Viollet
p. 15: Debuisson collection
pp. 18, 19: © RMN-GP (Musée Guimet, Paris)/ Thierry Ollivier
p. 20: akg-images
p. 21: © RMN-GP (Musée Guimet, Paris)/Thierry Ollivier
p. 23 above: © RMN (Musée du Louvre)/ Daniel Arnaudet
p. 24: Private collection
p. 25: © RMN (Musée du Louvre)/Michèle Bellot
p. 27: © Photo Josse/Leemage
p. 28: © RMN (Musée du Louvre)/ Gérard Blot
p. 29 above: Private collection
p. 29 below: © RMN (Musée Guimet, Paris)/ Thierry Ollivier
p. 30: © RMN-GP (Musée du Louvre)/Gérard Blot
p. 31: © RMN-GP (Musée du Louvre)/Gérard Blot
p. 32: © RMN-GP (Musée du Louvre)/Gérard Blot
p. 33: © BNF
p. 34: Private collection
p. 36: © Domaine National de Chambord
p. 40: © Debuisson collection
p. 47: © Musée d'Art et d'Histoire de Troyes/Jean-Marie Protte
pp. 49, 52: © BNF
p. 54 left: © Bibliothèque Forney/Roger-Viollet
p. 55: © Bibliothèque Forney/Roger-Viollet
pp. 57 and 58: Private collection
p. 63 above and below: © RMN (Musée Guimet, Paris)/Thierry Ollivier
p. 68: © Eric Emo/Musée Carnavalet/Roger-Viollet
p. 69: © Debuisson collection
p. 73: Private collection
p. 76: © Photo Josse/Leemage
p. 77 above: © Stéphane Piera/Galliera/Roger-Viollet
pp. 78–79: Photo Les Arts Décoratifs, Paris
p. 81: © RMN (Musée d'Orsay)/Hervé Lewandowski
p. 82 right: Private collection
pp. 84, 85, 86, 87: Author's collection
pp. 96 and 114: © Debuisson collection
p. 115: Private collection
pp. 116–117: Private collection

pp. 120–121: Private collection
pp. 122, 216: Photo Les Arts Décoratifs, Paris
p. 123: Debuisson collection
p. 128: © Musée des Arts et Métiers, Paris/photo P. Faligot
p. 133 right: © Musée des Arts et Métiers, Paris/ photo P. Faligot
p. 137: Debuisson collection
p. 146: © Stéphane Piera/Galliera/Roger-Viollet
p. 151: © Bibliothèque Forney/Roger-Viollet
p. 166: © Bibliothèque Forney/Roger-Viollet
p. 167: © Stéphane Piera/Galliera/Roger-Viollet
p. 170: Debuisson collection
p. 172: Private collection
p. 186 right: © Karin Maucotel
p. 190: Private collection
p. 191: © National Museum of American History, Smithsonian Institution
p. 198: Debuisson collection
p. 207: © Bibliothèque Forney/Roger-Viollet
p. 212 left (above and below): Private collection
pp. 212 right (above and below), 213, 214 right (above and below), 215 below, 216 above, 217: © ROM
pp. 214 left (above and below), 215 above, 216 below: © BNF
p. 244 left: Photo Les Arts Décoratifs
p. 244 right: Photo Les Arts Décoratifs
p. 245 left: Photo Les Arts Décoratifs
p. 245 right: Photo Les Arts Décoratifs
p. 246 right: Photo Les Arts Décoratifs
p. 246 left: Photo Les Arts Décoratifs
p. 247: Photo Les Arts Décoratifs
p. 248 left: Photo Les Arts Décoratifs/Jean Tholance
p. 248 right: Photo Les Arts Décoratifs, Paris
pp. 252, 253: Photo Les Arts Décoratifs, Paris
pp. 262, 263, 264, 265, 266, 267: Photo Les Arts Décoratifs, Paris
p. 274: Photo Les Arts Décoratifs/Jean Tholance
p. 275 left and right: Photo Les Arts Décoratifs, Paris
p. 282: Private collection
p. 285: Debuisson collection
pp. 294, 306, 307, 308, 309: J2R Photo, Galerie Les Indiennes Archives, Paris
p. 297: Debuisson collection
p. 305: Debuisson collection
p. 319: Private collection

Illustrations on p. 313 based on designs by Gabriel Vial.

Acknowledgments

I would like to thank all of those who helped me with my research and gave me permission to publish works from their collections.

Private collections: Gerolamo Etro and his assistant Carla Stella in Milan; Roxane Debuisson and her daughter Florence Quignard; Piedade da Silveira; Philippe Guyot and Servane de Layre-Matheus; Berdj Achdjian and Virginie David.

Public collections: Aurélie Samuel at the Musée Guimet;
Pierre-Yves Gagnier at the Musée des Arts et Métiers, CNAM;
Véronique Belloir at the Musée de la Mode et du Textile;
Agnès Masson and Brigitte Lainé at the Archives de Paris.

I would also like to thank Maurice Olender, who had the idea for this book, and all those at Éditions de La Martinière who helped to make it a reality: Valérie Gautier, Stéphanie Zweifel and Maëva Journo.

Last but not least, I owe a great debt to Massimo Listri, who photographed most of the shawls.

To all those mentioned above, I would like to say what a pleasure it has been to know them and work with them.

Why 1875?, dress, designed by Paul Poiret. Photograph. Registered 15 February 1921, no. 5521. Paris, Paris Archives, Designs and Models collection, D12U10, art. 303.
Paul Poiret had a soft spot for cashmere. Although nobody wore cashmere shawls after 1875, he sometimes incorporated the fabric into his designs, as seen in this lampshade and the quirky question mark hanging from the belt of the dress.

Index

Page numbers in *italic* refer to illustrations.